'*Situated Listening* is a robust theoretical an[...] building situated sonic knowledges. Through di[...] versations and co-narratives, the volume offers [...] body, the sonic politics of place, space, and cu[...] technological biases inform what is heard and unheard.'

Milena Droumeva, *Glenfraser Endowed Professor in Sound Studies, SFU*

'This book writes listening in collective but myriad lines that challenge us not to hear but to imagine within its plural and collaborative approach a future of infinite voices, in contradictory co-presence, without chapter breaks, making the indivisible simultaneity of sound heard.'

Salomé Voegelin, *Professor of Sound, University of the Arts London*

'Spanning a range of cultural contexts and epistemic concerns, *Situated Listening* convincingly argues for greater critical engagement with listening. This includes an examination of the structural inequalities often impacting aurality as well as how listening itself may impose forms of harm. Through an emphasis on collaborative writing from a diversity of contributors, *Situated Listening* raises the volume on the importance of listening studies.'

Brandon LaBelle, *Artistic Director, The Listening Biennial*

SITUATED LISTENING

Grounded in a conviction that how we listen matters deeply in the context of ongoing social, political, and ecological crises, *Situated Listening: Attending to the Unheard* sets forth a collection of methodologies and creative proposals for listening, advancing the framework of situated listening as both a theoretical concept and a methodological practice that investigates relationships between the listening body and the politics of place, space, and culture.

Drawing from an array of scholarship that engages sound studies broadly, this 15-chapter book is written entirely collaboratively and from a multi-disciplinary perspective. Each section includes scores for situated listening, which take the form of diagrams, instructions, exercises, images, and meditations. The scores offer alternate modes of sharing the central ideas of the associated chapters, inviting the reader to shift from theory into practice. This book contributes to decolonial, feminist, anti-racist, and anti-capitalist scholarship in the field of sound studies, by centering listening as a relational practice.

This book brings together a roster of accomplished, international contributors, making it essential supplementary reading for advanced undergraduates and researchers in sound studies. It will be of interest to faculty and students in the fields of Sound Studies, Music, Feminist Science and Technology Studies, Urban Design, and Sound Art.

Stephanie Loveless is a media artist whose research centres on practices of listening. She is senior lecturer in Arts, Director of the Center for Deep Listening at Rensselaer Polytechnic Institute, and editor of *A Year of Deep Listening: 365 Text Scores for Pauline Oliveros*.

Tullis Rennie is a composer, improviser, recordist, and researcher in socially engaged sound practices. His creative work encompasses audio composition, installation, participative community projects, and live/improvised performances presented in over 20 countries. He is senior lecturer in Music at City St George's, University of London.

Morten Søndergaard is an internationally acclaimed curator and Associate Professor at Aalborg University, Denmark. He is the head curator at Momentum Biennial 2025 and founder of the conference series POM – Politics of the Machines. He has published on sound- and media art and curated exhibitions including ZKM, Eyebeam, and Roskilde.

Freya Zinovieff is a sound artist, researcher, and curator. Freya's research covers the intersections of sound, violence, ethics, and activism. Freya holds a PhD from Simon Fraser University, a First-Class Honours degree from Cambridge School of Art at Anglia Ruskin University, and an MFA from the University of New South Wales, Sydney.

Sound Design
Series Editor: Michael Filimowicz

The *Sound Design* series takes a comprehensive and multidisciplinary view of the field of sound design across linear, interactive and embedded media and design contexts. Today's sound designers might work in film and video, installation and performance, auditory displays and interface design, electroacoustic composition and software applications, and beyond. These forms and practices continuously cross-pollinate and produce an ever-changing array of technologies and techniques for audiences and users, which the series aims to represent and foster.

Electronic Visual Music
The Elements of Audiovisual Creativity
Dave Payling

Art of Sound
Creativity in Film Sound and Electroacoustic Music
Andrew Knight-Hill and Emma Margetson

The Routledge Handbook of Sound Design
Edited by Michael Filimowicz

Situated Listening
Attending to the Unheard
Edited by Stephanie Loveless, Tullis Rennie, Morten Søndergaard, and Freya Zinovieff

For more information about this series, please visit: www.routledge.com/Sound-Design/book-series/SDS

SITUATED LISTENING

Attending to the Unheard

Edited by
Stephanie Loveless, Tullis Rennie,
Morten Søndergaard, and Freya Zinovieff

LONDON AND NEW YORK

Designed cover image: Photographic print, part of the artwork "From Maize With Love, a Disseminated and Relational Monument", Janna Holmstedt, 2019.

First published 2025
by Routledge
4 Park Square, Milton Park, Abingdon, Oxon OX14 4RN

and by Routledge
605 Third Avenue, New York, NY 10158

Routledge is an imprint of the Taylor & Francis Group, an informa business

© 2025 selection and editorial matter, Stephanie Loveless, Tullis Rennie, Morten Søndergaard, and Freya Zinovieff; individual chapters, the contributors

The right of Stephanie Loveless, Tullis Rennie, Morten Søndergaard, and Freya Zinovieff to be identified as the authors of the editorial material, and of the authors for their individual chapters, has been asserted in accordance with sections 77 and 78 of the Copyright, Designs and Patents Act 1988.

All rights reserved. No part of this book may be reprinted or reproduced or utilised in any form or by any electronic, mechanical, or other means, now known or hereafter invented, including photocopying and recording, or in any information storage or retrieval system, without permission in writing from the publishers.

Trademark notice: Product or corporate names may be trademarks or registered trademarks, and are used only for identification and explanation without intent to infringe.

British Library Cataloguing-in-Publication Data
A catalogue record for this book is available from the British Library

Library of Congress Cataloging-in-Publication Data
Names: Loveless, Stephanie, editor. | Rennie, Tullis, editor. | Søndergaard, Morten, 1966– editor. | Zinovieff, Freya, editor.
Title: Situated listening : attending to the unheard / edited by Stephanie Loveless, Tullis Rennie, Morten Søndergaard, and Freya Zinovieff.
Description: Abingdon, Oxon ; New York, NY : Routledge, 2025. | Series: Sound design series | Includes bibliographical references and index.
Identifiers: LCCN 2024060335 (print) | LCCN 2024060336 (ebook) | ISBN 9781032391328 (hardback) | ISBN 9781032391304 (paperback) | ISBN 9781003348528 (ebook)
Subjects: LCSH: Listening—Social aspects. | Music—Social aspects. | Listening (Philosophy) | Positionality (Sociology) | Sound—Social aspects. | Sound (Philosophy) | Sound art
Classification: LCC ML3916 .S557 2025 (print) | LCC ML3916 (ebook) | DDC 153.6/8—dc23/eng/20250220
LC record available at https://lccn.loc.gov/2024060335
LC ebook record available at https://lccn.loc.gov/2024060336

ISBN: 978-1-032-39132-8 (hbk)
ISBN: 978-1-032-39130-4 (pbk)
ISBN: 978-1-003-34852-8 (ebk)

DOI: 10.4324/9781003348528

Typeset in Sabon LT Pro
by codeMantra

CONTENTS

List of figures and tables *xiii*
List of contributors *xv*
Acknowledgements *xxv*

Introduction 1
Gabriela Aceves Sepúlveda, Janna Holmstedt, Stephanie Loveless, Louise Mackenzie, Tullis Rennie, Morten Søndergaard and Freya Zinovieff

PART 1
Methodologies of Listening **9**

Introduction 11
Stephanie Loveless and Freya Zinovieff

1 Listening to Noise: Lines of Affinity and Feminist Sono-Techno-Political *Artivisms* from the South 15
 Ana Alfonsina Mora Flores, Amanda Gutiérrez, Gabriela Aceves Sepúlveda, Laura Balboa and Victoria Polti

2 Listening to Our Listening: Deep Listening in Critical Sites 33
 Stephanie Loveless and Freya Zinovieff

3 Unlistening 52
Budhaditya Chattopadhyay and Elen Flügge

4 Listening with, or the Impossibility of Inhabiting Another's Ears 73
Janna Holmstedt and Louise Mackenzie

5 The Weak Power of Listening: A Conversation between Ayreen Anastas, Rene Gabri and Rolando Vázquez 94
Ayreen Anastas, Rene Gabri and Rolando Vázquez

PART 2
Apparatuses of Listening **109**

Introduction 111
Tullis Rennie

6 Audible Ghosts 115
Alejandra Bronfman and Laura Wagner

7 Technologies, Precariousness and Coloniality 126
José Cláudio Siqueira Castanheira and Melina Santos Silva

8 Addressing Deep Code Problems: Listening to Opera through the World's Liveness 143
Nina Sun Eidsheim and Juliana Snapper

9 Endarkened Listening 159
Liz Gre, Matilde Meireles and Tullis Rennie

10 Amplified States: Listening as Coming to Know 176
jake moore and Mark Peter Wright

PART 3
Cultures of Situated Listening **193**

Introduction 195
Morten Søndergaard

11 The Sound of Hate: White Nationalist Epistemology
 and Neo Nazi Nation Building on Telegram 199
 Helena Krobath and Freya Zinovieff

12 Mythic Sonic Beings: A Multitrack Conversation 218
 *Alex E. Chávez, Cog•nate Collective (Amy Sanchez
 Arteaga and Misael Diaz), Sandra de la Loza,
 Monica De La Torre and Josh Rios*

13 The Sonic Sensorium: Listening with the Un(der)heard 237
 Marie Koldkjær Højlund and Morten Søndergaard

14 Transperceptive Listening: Sonic Meditations for
 a Pluriverse 252
 Anna Nacher and Victoria Vesna

15 Collaborative Composition: An Exchange of Sounding 271
 Spy Dénommé-Welch and Catherine Magowan

Afterword/Invitation 283
*Stephanie Loveless, Tullis Rennie, Morten Søndergaard
and Freya Zinovieff*

Index 285

FIGURES AND TABLES

Figures

1.1	*Feminist Sonographies of Situated Listening*, documentation of The Institution of Knowledge opening event and installation, photo by Michael Woolley (2023). © Michael JH Woolley 2023 under a Creative Commons Attribution-NonCommercial-ShareAlike 4.0 International license (https://creativecommons.org/licenses/by-nc-sa/4.0)	18
2.1	Schematic 1 from *Dispatch*, Candice Hopkins and Raven Chacon (2020)	43
2.2	Screenshot from *Cry of the Third Eye*, Lisa E. Harris (2020)	46
3.1	An example of "unscoring" from The Nomadic Listener (Chattopadhyay 2020)	70
4.1	A feeling for the organism, Janna Holmstedt, 2019. Photographic print of an ear of corn grown as part of the project Anthropomorphic Interfaces, by Holmstedt, Siltberg & Nilsson. Photo: Janna Holmstedt	76
4.2	BE THE SEA, Mackenzie and Jenkins, 2023. Participant listening to limpets on a rock, Roker Beach, Sunderland during BE THE SEA workshop. Photo: Louise Mackenzie	86
7.1	Gatorra #22 (photo courtesy of Marcelo Conter)	134
8.1	Juliana Snapper, Watermouth Coda, part of Ridykeulous: The Odds Are Against Us, in WACK! Art and the Feminist Revolution at P.S.1 Contemporary Art Center, New York, 2008. Photo: Sheana Corbridge	148
9.1	A score for endarkened listening	174

12.1	Living Crossfader, Embodied Mixing Board	235
14.1	Augmented reality image from Noise Aquarium	260
14.2	Distributed team from Left to right: Paul Geluso (NY); Victoria Vesna, Zeynep Abes, John Brumley (LA), Rhiannon Catalyst (NY, Eli Joteva (LA), Clinton van Arman and Ivana Dama (LA), Anna Nacher (Poland), Debra Isaacs (LA). Installation	262
15.1	Frequency spectrum from July 19, 2023 recording of Coyote by Spy Dénommé-Welch (scales & numbers removed)	273
15.2	Frequency spectrum from July 19, 2023 recording of Coyote by Spy Dénommé-Welch	274
15.3	Coyote in the woodlot. Photo taken by Spy Dénommé-Welch	276
15.4	Screenshot of Samson the dog's vocal improvisations with piano. From video captured by Spy Dénommé-Welch	276

Table

| 8.1 | The Ten Most-Performed Operas Worldwide (2019–2020 Season) | 145 |

CONTRIBUTORS

Gabriela Aceves Sepúlveda is Associate Professor at the School of Interactive Arts and Technology at Simon Fraser University and Director of the research-creation studio cMAS. Her research centres on the histories of women, feminism(s), art, media, science, and technology. She is the author of the award-winning book *Women Made Visible: Feminist Art and Media in Post-1968 Mexico* (2019) and several publications on Latin American feminist media art and archival practices. Her research-creation practice concerns the production of multimedia projects investigating the body as a site of cultural, gendered, and techno-scientific inscriptions.

Ayreen Anastas, a body in search of gestures, words, phrases, sentences to disactivate and destitute the impositions, forms, including the form of biography, this form of self, to bring about some forces which give potency to life, to bodies, with and around them. How to not separate one 'self?' from a commons that helps shape life and gives it intensity and meaning? How to become unintelligible, incomprehensible, opaque to the fabricated machines of subjectivation and self-making? How to write in a language that only friends-to-come receive, a language that wrestles with language to keep the relations to all the palestines and to their forms of life alive?

Laura Balboa is a Binnizá (Zapotec) independent researcher, radio producer, and artist based in Sweden who uses orality as a technological framework for participatory activist documentation of sound experimentation by female-identified, trans, queer, and non-binary producers in Mexico. Her artworks in multimedia have a socio-technological interest, and her research work is based on engaging with localized cultural production and community

interactions. She has participated in different groups and projects ranging from open-source technologies and live coding communities in Latin America to marginalized female prison populations in Mexico City. She works in the research and development area at Arduino, an open-source hardware and software organization.

Alejandra Bronfman (Princeton, 2000) is Professor in the Department of Africana, Caribbean, Latin American, and Latinx Studies at the University at Albany, SUNY. A cultural historian of the Caribbean, her research interests lie at the intersection of the production of knowledge, racialization, and technology's role in the amplification of marginalized voices. She is the author of *Measures of Equality: Race, Social Science and Citizenship in Cuba, 1902–1940* (UNC Press, 2004) and *Isles of Noise: Sonic Media in the Caribbean* (UNC Press, 2016).

José Cláudio Siqueira Castanheira is Professor at the Communication Department and at the Postgraduate Programme in Communication at Federal Fluminense University and at the Postgraduate Programme in Communication at the Federal University of Ceará. He is the leader of the research group GEIST (Group of Study of Images, Sonorities and Technologies), coordinator of the International Conference of Research on Sonorities (CIPS), member of National Institute of Science and Technology in Informational Disputes and Sovereignties (INCT/DSI), member of the International Association for Media and Communication Research's International Council and IAMCR Ambassador for Brazil, and a researcher in the areas of digital culture, music, sound studies, and film studies.

Budhaditya Chattopadhyay is a media artist, researcher, and writer. His works have been widely exhibited, performed, or presented across the globe. He is the author of five books, including *The Nomadic Listener* (2020), *The Auditory Setting* (2021), *Between the Headphones* (2021), and *Sound Practices in the Global South* (2022). Chattopadhyay holds a PhD in Artistic Research and Sound Studies from the Academy of Creative and Performing Arts, Leiden University. He is currently a Visiting Professor at the Institute of Experimental Design and Media Cultures (IXDM), Basel, Switzerland, and a Marie Curie postdoctoral fellow at the Faculty of Fine Art, Music and Design (KMD), University of Bergen, Norway.

Alex E. Chávez is the Nancy O'Neill Associate Professor of Anthropology at the University of Notre Dame. As a musician, producer, and practitioner, his scholarship, cultural advocacy, and creative work investigate sound as an aesthetic site of cultural citizenship and window into the experiences of Latinx America. His book, *Sounds of Crossing: Music, Migration, and the*

Aural Poetics of Huapango Arribeño (Duke University Press, 2017), represents the first extended study of how Mexican migrants construct communities amid U.S. immigration politics through the music and poetry of huapango arribeño. In 2016, Chávez worked with Smithsonian Folkways Recordings to make the label's first huapango arribeño album. His recent project, Sonorous Present, mixes aspects of Latin American folk elements, jazz, poetry, dance, storytelling, and ethnographic songwriting to take listeners on a journey of collective mourning and hoped-for futurity across the US borderlands.

Cog•nate Collective (Amy Sanchez Arteaga and Misael Diaz) develops research-based art projects, public interventions, and pedagogical programmes that explore how culture mediates social, economic, and political relationships across borders. Their practice documents and contends with the evolution of the U.S.-Mexico border, as it is simultaneously erased by free trade policies and militarized to limit the movement of bodies. Drawing on critical pedagogy and feminist methodology, Cog•nate engages sound's capacity to establish and sustain connections across transnational, local, social, cultural, and political divides. Their project Borderblaster, a series of hyper-localized radio broadcasts made at the San Ysidro Port of Entry, draws upon 'border blaster' radio stations, which transmit their signal from Mexico into the United States.

Sandra de la Loza's trans-disciplinary practice uses photo and video-based installation, performance, and intervention to investigate the exclusions, erasures, and past and present silences of the multi-layered lands of the Tongva, Gabrielino, and Kizh, also known as Los Angeles. Their research includes various forms of listening practices that engage walking, field recordings, digging through archives, conducting interviews, and participating in and organizing community events, processions, and workshops that foreground community voices. De la Loza's recent project, Unsettling the Settled: Archival Glimpses of Abolitionist Futures (2022), focuses on the former Lincoln Heights Jail, built in 1927, which became the Aztlan Cultural Arts Foundation, a community cultural space active during the 1990s. By listening to the cultural centre's archival sounds of clashing and fusing musical styles, feminist performances, political visions, and rallying calls, Unsettling the Settled centres Chicanx, Indigenous, Black, and Filipinx youths' counter narratives to the neoliberal, neo-colonial, anti-youth, anti-immigrant mythologies of the 1990s.

Monica De La Torre is Associate Professor of Media and Expressive Culture in the School of Transborder Studies at Arizona State University. Their research and teaching practices bridge Chicana feminisms, Latinx feminist

media studies, radio and sound studies, ethnic and women and gender studies, digital media, and archival production. De La Torre's book, *Feminista Frequencies: Community Building through Radio in the Yakima Valley* (2022), tracks the emergence of the first Spanish language radio station in the United States, which served migrant agricultural workers in the Pacific Northwest in the 1970s. Grounded in Chicana feminist methodologies that centre listening to the untold stories either missing from or hidden within the archive, De La Torre's digital project, feministafrequencies.com, gathers and shares artefacts, oral histories, and audio archives related to Radio Cadena (KDNA, 91.9 FM) Soul Rebel Radio (KPFK 90.7 FM), including the personal archives of Rosa Ramón, the first station manager of KDNA.

Spy Dénommé-Welch, PhD (Algonquin-Anishnaabe), is a composer, sound designer, librettist/playwright, producer, and scholar. He wrote and co-composed the Dora-nominated opera Giiwedin (2010), and premiered his second opera, Canoe, in September 2023. Other selected composing and writing credits include Transpositions (2022), RADAR (2019), Rouge Winter (2019), Contraries: a chamber requiem (2018), Sojourn (2017), Bottlenecked (2017), and sound design and composition for Come Home: The Legend of Daddy Hall (2024). Dr. Dénommé-Welch is an Associate Professor and Canada Research Chair in Indigenous Arts, Knowledge Systems and Education at Western University. He is co-founder and Artistic Director of Unsettled Scores.

Nina Sun Eidsheim is an artist, vocalist, and writer who works in and through voice, race, words/concepts, listening, and materiality and is Professor of Musicology at the University of California, Los Angeles. Some of her publications include *Sensing Sound: Singing and Listening as Vibrational Practice* and *The Race of Sound: Listening, Timbre, and Vocality in African American Music*; co-editing *Oxford Handbook of Voice Studies*; co-editor of the Refiguring American Music series. She is also a vocalist and the founder and Director of the UCLA Practice-based Experimental Epistemology Research (PEER) Lab, an experimental research lab dedicated to decolonializing data, methodology, and analysis, in and through multisensory creative practices.

Ana Alfonsina Mora Flores is a musician, educator, and a PhD candidate at the Instituto Nacional de Bellas Artes y Literatura. Her research interests are focused on experimental sound practices in Latin America by womxn and non-binary artists. The relationship between art, science, and technology is also present in her sound and interdisciplinary work. She is co-producer of the radio programme Minga broadcast by Radio CASo, collaborator on the MUSEXPLAT platform (Latin American Experimental Music), and board director of the World Listening Project and the collective Sono(soro)ridades. She is Piano Professor at the University of the Americas Puebla.

Elen Flügge is a writer, researcher, sound artist, and new mom. Her interest is in personal and urban sound space, site-specific works, and listening perspective. Flügge enjoyed undergraduate studies at Bard College NY, and a Sound Studies master's at UdK, Berlin. Her PhD, Listening Practices for Urban Sound Space in Belfast (2022) completed at SARC, UK, used methods from sonic arts and ethnography to explore inhabitants' auditory experience in public space. She performs in various ensembles (violin and voice) such as Belfast's HIVE choir. Publications include a chapter in Bloomsbury Handbook of Sound Art (2020). She lectures at SoundS, UdK.

Rene Gabri is another name for that process of recovering stolen life. The name is not gendered, though it has engendered enough confusion to assign to it all sorts of pronouns and prescriptions. It is a non-native name calling forth a native life, a life constantly pushed to the margins of oblivion. It recalls sites of previous and ongoing battles. It remains steadfastly associated with the wind, which is the closest kin or resembling of a homeland. In this searching, a question which re-emerges: is wind origin, destiny, or the unforeseen push toward a dissemination of the seeds of whatever could become recovery?

Liz Gre is a vocalist, new music composer, and aspiring ethnographer who finds comfort between the sides of records. She aims to unearth and tell stories with her music. Whether simple or complex, universal or rare, she serves as the vessel.

Amanda Gutiérrez is a Mexican-born artist who explores the experience of political listening and gender studies by bringing into focus soundwalking practices. Trained and graduated initially as a stage designer from The National School of Theater, Gutiérrez uses a range of digital media tools to investigate everyday life aural agencies and collective identities. Approaching these questions from aural perspectives continues to be of particular interest to Gutiérrez, who completed her MFA in Media and Performance Studies at the School of the Art Institute of Chicago. She is currently elaborating on the academic dimension of her work as a PhD candidate in Arts and Humanities at Concordia University in the Arts and Humanities Doctoral programme.

Marie Koldkjær Højlund is an Associate Professor of sound studies, audio design, and musicology at Aarhus University as well as a composer, musician, and performing sound artist. She is interested in listening and sonic citizenship in a variety of contexts from a practice-based and artistic approach, where auditory boundaries blur between the private and the public, the individual and the community, unravelling questions of privilege – Who holds the right to raise their voice, to be heard? How do we harmonize through attuning practices?

Janna Holmstedt, PhD, is a transdisciplinary artist and researcher. She explores listening and storying as critical-creative modes of inquiry, the cultivation of care and environmental attention, and composition in the expanded field of genre-disobedient art practices. Her work includes sound-based installations, participatory performances, walks, storytelling, writing, growing, and collaborative projects, which have been presented in exhibitions and festivals internationally. She has been invited to Artists-in-Residence programmes such as Rupert, Lithuania, HIAP and Sumu, Finland, NIFCA, Estonia, Bemis Center, USA, and TCG Nordica, China. She is a longtime member of the research group The Posthumanities Hub, Linköping University, and PI of the art and research project Humus economicus, National Historical Museums in Sweden, which explores how multiple forms of inheritance and potential futures meet in the subject and matter of soil.

Andrew Infanti is a Franco-american pianist, composer, and musicologist. He has collaborated with Juliana Snapper for many years on boundary-pushing projects. He currently teaches music in Paris, France.

Helena Krobath is a sound artist and educator exploring ways that information is created, communicated, and made meaningful. She uses listening, recording, and composition to consider infrastructures and narratives in places like ports, neighbourhoods, and nature zones. Her sound art has appeared in festivals, radio specials, and publications. She recently facilitated a youth mentorship programme using audio storytelling to convey renter experiences and has presented many workshops on working with audio field recording. Helena volunteers with the Vancouver Tenants Union and is a co-host of the Soundscape Show on Vancouver Co-op Radio.

Stephanie Loveless is a sound and media artist whose research centres on practices of listening in place. Past works include a mobile web-app for geo-located listening, and sound works that channel the voices of plants, animals, and musical divas. Her most recent project, This Street is a Song, emerges from a decade of exploring practices of listening in a once-abandoned city lot. She currently lives and works in upstate New York, on the shores of the Mahicannituck (the river that is never still), on the ancestral homeland of the Mohican people, where she is a lecturer in the Department of Arts and Director of the Center for Deep Listening at Rensselaer Polytechnic Institute. She is the editor of *A Year of Deep Listening: 365 Text-Scores for Pauline Oliveros* (2024).

Louise Mackenzie, PhD, is an interdisciplinary artist, curator, and writer. She is a Director of ASCUS Art and Science, Edinburgh; lecturer at Duncan of Jordanstone College of Art and Design, Dundee; and artist researcher at

both Newcastle and Northumbria Universities in the UK. Her artworks have been exhibited nationally and internationally, including ZKM, Germany and BALTIC, UK, and she has written for Bloomsbury, Manchester University Press, Intellect, Springer, *Leonardo Journal* (MIT Press), and *PUBLIC Journal*, Canada. Recent projects include BE THE SEA, a collaboration with composer Hayley Jenkins that foregrounds listening strategies to ask how we can live with the coast in ways that are mutually sustainable and Non-Human Sense, a research approach to understanding our existence across species boundaries.

Catherine Magowan is a composer, sound designer, conductor, wind musician, and Managing Director of Unsettled Scores. She is first-generation Canadian of Jewish-Hungarian ancestry. Catherine was nominated for a Dora award for her first opera, Giiwedin (2010), which she co-composed with her collaborator, Dr. Spy Dénommé-Welch, and her second opera (also with Dr. Dénommé-Welch) premiered in the fall of 2023. Other recent co-composing credits include Transpositions (featured composer, 2022), RADAR (2019), Rouge Winter (2019), Contraries: a chamber requiem (2018), and Sojourn (2017), as well as sound design and composition for Audrey Dwyer's play Come Home – The Legend of Daddy Hall (2024).

Matilde Meireles is a sound artist and researcher who makes use of field recordings to compose site-oriented projects. Her work has a multi-sensorial, durational, and multi-perspective critical approach to site, where Matilde investigates the potential of listening across spectrums and scales as ways to attune to various ecosystems and articulate plural experiences of the world. Some examples include the inner architectures of reeds and complex water ecologies, resonances in everyday objects, local neighbourhoods, and the architecture of radio signals. Her work is presented regularly in the form of concerts, installations, album releases, community-based projects, and academic publications.

jake moore is a neurodivergent intermedia artist whose primary medium is space and its occupation. She works at the intersection of material, gesture, text, and vocality to make exhibitions, events, and other kinds of interventions public. She has a national exhibition history in Canada, and her critical and creative writing has been published in C MAG, ESPACE, ESSE, Canadian Art, .dpi as well as in many exhibition texts and catalogues. She is currently the Director of University Art Galleries and Collections and Assistant Professor in Art and Art History at the University of Saskatchewan on Treaty 6.

Anna Nacher, PhD, is an Associate Professor at the Jagiellonian University. Her research interests include digital culture, cultural theory, media art,

sound studies, and e-literature. She currently pursues a three-year long research project on the aesthetics of post-digital imagery on a grant from Polish National Science Centre. She is the author of three books in Polish, the newest one published in 2016 focuses on the locative media imagery, and a number of articles and chapters in edited volumes. She is also a part-time musician and sound artist focusing on field recordings.

Victoria Polti is a sound anthropologist, musician, performer, and lgbtiq+ activist. She is a PhD student in Social Anthropology (UBA) under the direction of Alejandro Madrid (Harvard University) and Silvia Citro (University of Buenos Aires). She is a Professor in the Master in Art and Sound Studies (UNTREF) and in the careers of Ethnomusicology and Argentine Popular Music (CSMMF, GCBA). Her research interests focus on the political and symbolic efficacy of sound in feminist activism, performative listening, and sound and aural identities and memories. She is a member of the Anthropology of the Body and Performance Team (UBA), GRAMa Transversal Program (UNTREF), LASA, IASPM, and ICTM.

Tullis Rennie is a composer, improvising trombonist, electronic musician, and field recordist. His work encompasses sound installation, community-engaged participative projects, multi-channel concert works, video, mixed media, and live/improvised performances. He is co-founder of participatory arts organization Walls On Walls with visual artist Laurie Nouchka, and a founder member of the Insectotròpics audio-visual collective, based in Barcelona. His writing has been published in *Organised Sound* (Cambridge University Press), *Leonardo Music Journal* (MIT Press), and TEMPO. His recorded work is released by the labels Accidental Jnr, Moving Furniture Records, Luminous, ZeroWave, and Efpi Records.

Josh Rios is a contemporary artist living and working in Chicago, IL, with cultural and familial ties to the U.S.-Mexico borderlands. They are faculty at The School of the Art Institute of Chicago where they teach courses in social theory and research-based practice. As a media artist, writer, and educator, their projects deal with the histories, presents, and futurities of Latinx and Chicanx subjects and hemispheric resistance to globalization and neocolonialism. In 2019, they founded Sonic Insurgency Research Group (SIRG) with Anthony Romero and Matt Joynt. As a collaborative, their critical creative work investigates the relationship between sound, power, culture, and public space. Other projects include a series of ongoing conversations and autonomous study groups on sound and power sponsored by the online platform, *MARCH: A Journal of Art and Strategy*.

Melina Santos Silva was a postdoctoral researcher at the School of Communications, Art and Design – Pontifical Catholic University of Rio Grande

do Sul (2018–2022) and holds a PhD in communication from Fluminense Federal University. Her research interests include topics such as music genre, decoloniality, intersectionality, African and diasporic metal production, technology, and cultural studies.

Juliana Snapper is a contemporary opera singer and artist. She is known for cultivating new operatic vocal techniques like using inversion to initiate internal gravitational shifts to the vocal mechanism, "Bouche a l'eau" allowing her to sing underwater, and a "Listening Vocality" re-routing cycles of transmission and reception between audience and performer. Snapper's works have been presented across the UK, Europe, Asia, and North America. Her intermedia compositions have featured in the Guggenheim Museum and PS1/MoMA in New York, the Warsaw Contemporary Art Museum, and The Broad Museum, Los Angeles. Snapper is currently on the voice faculty at Bilkent University, Ankara, Türkiye.

Morten Søndergaard is an internationally acclaimed curator and Associate Professor in media and sound art at Aalborg University, Denmark. He is Academic Director of the Erasmus Master of Excellence in Media Arts Cultures. On top of his own sound practice, Morten Søndergaard is presently engaged with sound curation at SUNY College in New York, Struer Sounding City in Denmark, and Momentum Festival in Norway. He is the founder of the conference series POM – Politics of the Machines (with Laura Beloff) (since 2017) and ISACS – International Sound Art Curating Symposia (w Peter Weibel) (2010–2017). He has published and curated several sound- and media art exhibitions internationally, including at Kiasma, ZKM, Rupertinum, Ars Electronica, Eyebeam NY, Utzon Center Aalborg, Kunsthal Aarhus, and Museum of Contemporary art in Roskilde.

Rolando Vázquez is Professor of Post/Decolonial Theories and Literatures at the Faculty of Humanities, University of Amsterdam. Since 2010, he co-directs with Walter Mignolo the annual Maria Lugones Decolonial Summer School. He is fellow of the Van Abbemuseum in Eindhoven and advisor for the artists in residence at the Jan van Eyck Academie in Maastricht and at the Rijksakademie in Amsterdam. He is the author of *Vistas of Modernity: Decolonial aesthesis and the End of the Contemporary* (Mondriaan Fund 2020).

Victoria Vesna, PhD, is an artist and Professor at the UCLA Department of Design Media Arts and Director of the Art|Sci Center at the School of the Arts (North campus) and California NanoSystems Institute (CNSI) (South campus). With her installations she investigates how communication technologies affect collective behaviour and perceptions of identity shift in relation to scientific innovation (PhD, CAiiA_STAR, University of Wales, 2000). Her work involves long-term collaborations with composers, nano-scientists,

neuroscientists, and evolutionary biologists, and she brings this experience to students. Victoria has exhibited her work in 20+ solo exhibitions, 70+ group shows, has been published in 20+ papers, and gave 100+ invited talks in the last decade.

Laura Wagner is an anthropologist, fiction and nonfiction writer, and translator. From 2015 to 2019, she was the Radio Haiti Project Archivist at Duke University's David M. Rubenstein Rare Book & Manuscript Library. Her research interests include disaster, humanitarianism, human rights, and everyday life amid crisis. She is currently writing a book that interweaves the story of Radio Haiti-Inter and its legacy with stories of the 2010 Haiti earthquake and its long aftermath.

Mark Peter Wright is an artist, writer, and researcher. His practice combines installation, text, and performance to amplify forms of power and poetics within the creative use of sound and documentary aesthetics. Operating between the site and studio, field and gallery, he has exhibited work internationally and published peer-reviewed articles widely. His monograph *Listening After Nature: Field Recording, Ecology, Critical Practice* is published by Bloomsbury (2023).

Freya Zinovieff is a sound artist, researcher, and curator. Freya's research covers the intersections of sound, violence, ethics, and activism. She is invested in radical praxis and how to mobilize decoloniality as a collective project. She is the founder of Radical Praxis Lab, an independent qualitative research lab that studies cultures of resistance and the activist forefront of political change. Freya holds a PhD from Simon Fraser University, a First-Class Honours degree from Cambridge School of Art at Anglia Ruskin University, and an MFA from the University of New South Wales, Sydney.

ACKNOWLEDGEMENTS

Thank you to Morten Søndergaard: for bringing many of us together in the first place in the context of the RE: SOUND conference in 2019 (of which he was the General Chair, together with Laura Beloff from Aalto University) at Aalborg University in Denmark, and for gathering our contributions together in print as part of the special section, "Sound as Evidence," in (what turned out to be the very last edition of) *The Leonardo Music Journal* (2020). This book emerged from conversations among all of us who appeared in "Sound as Evidence" – including Gabriela Aceves-Sepúlveda, Marie Koldkjær Højlund, Janna Holmstedt, Louise Mackenzie, and Morten Riis – each of whom added their energy, ideas, insights, commitments, and ways of thinking to the multi-authored, multi-coloured, sprawling, shared Google document where our ideas about the politics and practice of listening emerged. We are further indebted to Janna Holmstedt and Brandon LaBelle who each invited us to present our work publicly at crucial moments of its development: via an online panel hosted by The Posthumanities Hub in 2020 and an online roundtable and performance hosted by Listening Biennial in 2021.

We are grateful to the contributors (Gabriela Aceves Sepúlveda, Alejandra Bronfman, Janna Holmstedt, Louise Mackenzie, and Mark Peter Wright) who provided friendly editorial feedback and support for chapters in the volume other than their own, and deeply thankful for the brilliant colleagues and loved ones who lent an ear and an eye to our works in progress (Alexis Bhagat, Anne Bourne, Roo Bernatek, Joseph Browning, Milena Droumeva, Adam Harper, Li(sa) E. Harris, Sha Labare, Natalie Loveless, Chrysi Nanou, Sharon Stewart, Ellen Waterman, and Sheena Wilson, Hildegard Westerkamp).

Contributing to an edited volume involves an enormous amount of labour – particularly in the collaborative form upon which we have insisted. Given this, we are especially grateful to everyone who crafted a chapter in response to the prompt of this book and agreed to do so in a fully collaborative manner. While this kind of labour is not always rewarded in academia, it is a place where community and solidarity-building can be developed and affirmed. We hope that this book has been a place where authors could take more risks and write more authentically and collaboratively than may be possible in other venues and contexts. New forms of thinking together are crucial to respond to the polycrises in which we are all living.

With that, we offer our deepest thanks to each of the contributors of this volume: Gabriela Aceves Sepúlveda, Ana Alfonsina Mora Flores, Ayreen Anastas, Laura Balboa, Alejandra Bronfman, José Cláudio Siqueira Castanheira, Budhaditya Chattopadhyay, Alex E. Chávez, Misael Diaz, Sandra de la Loza, Monica De La Torre, Spy Dénommé-Welch, Nina Sun Eidsheim, Elen Flügge, Rene Gabri, Liz Gre, Amanda Gutiérrez, Marie Koldkjær Højlund, Janna Holmstedt, Helena Krobath, Andrew Infanti, Louise Mackenzie, Catherine Magowan, Matilde Meireles, jake moore, Anna Nacher, Victoria Polti, Josh Rios, Amy Sanchez Arteaga, Melina Santos Silva, Juliana Snapper, Rolando Vázquez, Victoria Vesna, Laura Wagner, and Mark Peter Wright.

Finally, we thank Janna Holmstedt for allowing us to use her photographic print, from the artwork "From Maize With Love, a Disseminated and Relational Monument" (2019), on the cover of this book, suggesting the multiplicity of authors and perspectives that have come together to form one ear here.

INTRODUCTION

Gabriela Aceves Sepúlveda, Janna Holmstedt, Stephanie Loveless, Louise Mackenzie, Tullis Rennie, Morten Søndergaard and Freya Zinovieff

Grounded in a conviction that what we listen to, and how we listen, matters deeply in the context of ongoing social, political, and ecological crises, this book offers a collection of novel methodologies and creative proposals for listening. The texts in this collection result from collaborative efforts spanning diverse disciplines. They include theoretical propositions and analyses of creative practices, as well as text-based listening scores that aim to bridge the gap between the written word and the embodied experience of the reader/listener. In this introduction, we explain what we mean by *situated listening* and share some of the ways in which our listening, as collaborative editors and authors, is situated. We introduce the framework of situated listening as both a theoretical concept and a methodological practice that investigates relationships between the listening body and the politics of place, space, and culture. Throughout the chapters, authors further examine the significance of our sonic interrelations: how race, class, and gender define our relations to crisis, and how human and technological biases inform what we hear, and what remains unheard.

The disciplinary parameters of this book are drawn widely through the range of fields engaged by our authors, including musicology, acoustic ecology, sensory ethnography, anthropology, art practice, art history, cultural theory, communication studies, and feminist STS (Science and Technology Studies). While each of these disciplines can use sound as a lens, filter, or focus of critical analysis, they may or may not comfortably fit within the amorphous discipline of sound studies, the boundaries of which are still being debated and defined (Hilmes, 2005; Zinovieff, et al., 2023). Our expansive approach furthers the imperative behind Angus Carlyle and Cathy Lane's 2013 edited volume *On Listening*, which offers a "wide-ranging,

multidisciplinary perspective on listening as an applied practice" (Carlyle & Lane, p. 10). *On Listening* responds to the rising popularity of the subject of listening in the first decade of the 20th century. The decade since has seen this interest in listening as practice, process, and method develop into a new disciplinary field that we might call "listening studies." This shift, broadly speaking, moves us from an objective position relative to the materiality of sound toward one defined by how listening engages us with our surroundings.

Collaborative Ethos

Our intention in co-creating this book is one of collective endeavor: all authors are listed alphabetically throughout and are understood to have contributed equally to each chapter that includes their name. At the core of this ethos is a desire to challenge academic hierarchies and ask how we might remediate these outdated structures in our collective writing. Seeking to redress these hierarchies, and with the more specific aim of putting feminist ideals and methods into action, we center the kind of thinking, knowing, and practice that emerges in the space between collaborators. The interweaving dialogues that constitute much of our process-as-research feature 39 voices from diverse geographic and political standpoints, from tenured and untenured positions, from inside and outside the academy, and from an expanse of creative vantage points. This book – from its conception and development to its writing and editing – has been a process always in company, always made together.

In most instances, we invited single authors to contribute and asked them to choose others to write with. Many authored chapters are written in pairs, others in trios or larger groups. Each writing collective was invited to respond to the book's core concern – how we listen from different situated perspectives in the context of crisis. In the hopes of nurturing the kind of research that might not be possible in solo-authored academic articles, we have encouraged and made space for dialogues, conversations, and storytelling alongside more traditionally theoretical texts. This is a way to facilitate thinking that is slippery, ephemeral, entangled, embodied, uncontrolled, process-oriented, and often rooted in creative practice.

The first seed of this book was planted in 2019, at the RE: SOUND Media Arts Histories Conference in Aalborg, Denmark, where all four co-editors and several contributing authors met. Based on the resonance of our conference contributions, our papers were put in conversation with one another in a special section of Leonardo Music Journal, titled *Sound as Evidence* (Søndergaard, 2020). This publication was followed by an online roundtable, hosted by multi-university network and "collaboratory" for more-than-human humanities, The Posthumanities Hub (Holmstedt, 2021), where ideas found within the special section began to pollinate and cross-contaminate.

In 2022, on the invitation of the non-university affiliated research initiative Listening Academy (*The Listening Academy*, n.d.), we presented a roundtable discussion, online performance works, and participatory listening scores for "Situated Listening." Emerging from the momentum of this research, we began working toward this book as a collective endeavor.

What began as a hopeful, even idealistic project, in practice made visible the extractive nature of the academic system within which the editors and many contributors are embedded. At the same time, it has led to many fruitful and surprising connections and collaborations. Through the sometimes-difficult process of attempting non-hierarchical practices of listening and knowledge co-creation, we have been confronted with different agendas, worldviews, and theoretical lenses that we needed to navigate – highlighting an urgency for inclusionary approaches to be proposed and presented from *within* the established academy.

Situatedness, Positionality, and Listening

What does it mean to listen from a situated perspective? Situated listening is not limited to the ear, nor even to the auditory processing of the brain. Rather, situated listening is a method for navigating sensory experience – an embodied act, formulated through relationships to location and time. It is also a theoretical proposition for how we orient ourselves to sound. The term "situated listening" has been used by scholars to variously articulate listening as embodied, embedded, and contextual. Stefan Östersjö, for instance, uses the term in *Listening to the Other* (Östersjö, 2020) to reference intersubjective, ecological listening in the context of musical performance. Within a film studies context, Giorgio Biancorosso uses the term to differentiate cinematic representations of listening in passing circumstances ("situations"), from those that form part of a larger narrative (Biancorosso, 2016).

Within the context of rhetorical studies, Timothy Laurie, Tanja Dreher, Michael Griffiths, and Omid Tofighian use the term to point to the inherent positionality, embeddedness, responsiveness, and responsibility of the listener (Dreher et al., 2021). Sanne Krogh Groth brings the frameworks of situated knowledges and Deep Listening together to propose "Deep Situated Listening" as a method of analyzing electroacoustic music concert environments (Groth, 2022). Finally, and most resonant for our project here, Gascia Ouzounian proposes "situated listening" as a method for considering the ways that sound art can reveal "the particular, contingent situations of hearing as these occur within specific listening environments" (Ouzounian, 2006, p. 72).

The chapters in this collection each understand listening, situatedness, and positionality in distinct ways that facilitate new conversations and co-narratives when read in tandem. Many of the authors in this volume engage Donna Haraway's now-canonical theorization of "situated knowledges" (Haraway, 1988),

which brought attention to the historical and cultural embeddedness of all forms of knowledge, and biases concerning the processes of knowledge creation. Within this frame, Haraway examines vision as a tool wielded to enforce the notion of objectivity – a gaze that asserts its authority as an all-seeing, all-knowing purveyor of truth. In line with a long tradition of feminist research and critique of Eurocentric knowledge formations in the natural, social, and human sciences, Haraway advocates for ethical feminist approaches to objectivity that acknowledge unequal power dynamics and difference. The embodied forms of knowledge production in Chicana Feminisms and Indigenous knowledge traditions that Haraway both cited and thought alongside were largely written out of the narrative as her work circulated (Sandoval, 2000). Nevertheless, Haraway's work set the trend for *situating* and *positionality* as approaches that guide feminist and other practices in the Global North.

In sonic research and academia more widely, there is sometimes a conflation of *situating* and *positionality*. Situatedness, as a feminist practice, brings attention to the relational, theoretical, and methodological lineage of our practice. It asks that we clarify our rules of engagement with this lineage and articulate our own disciplinary parameters. Situated practice extends from considerations of the theoretical and methodological boundaries and norms we engage, to the entities with which we are in relation, including human and non-human agents. Positionality, on the other hand, is the reflexive stance taken by the researcher concerning their intersectional power relations and the research inquiry itself (Zinovieff et al., 2023). First Nations scholar and artist Dylan Robinson (Stó:lō/Skwah), whose work is engaged in many chapters throughout the volume, suggests critical listening positionality as a means to examine the ways our identities, locations, and histories shape how we listen, framing what is audible or inaudible to us (Robinson, 2020). In addition, the work of 20th-century composer Pauline Oliveros influences numerous discourses included here via her philosophy of sonic and social attunement, Deep Listening; a situated sonic practice that brings the listening subject into heightened receptivity to the environment in all its complexity (Oliveros, 1974, 1993, 2003, 2022). Both situatedness and positionality rely on the researcher's (self) reflexivity and responsibility toward ethical practice, and their intent to cultivate more careful modes of knowing and engaging. They both ask us to be accountable to the histories and lineages we are respectively embedded in, and to acknowledge that which we don't know, and cannot see, hear, or sense.

Methodologies, Apparatuses, and Cultures of Situated Listening

We have organized the book into three sections that consider situated listening through three channels: methodology, apparatus, and culture – acknowledging that these are inextricably interrelated. All three sections

offer proposals to sidestep dominant attitudes and apparatuses, re-situating and disrupting the collective ear with alternative modes of listening and offering strategies for navigating times of crisis through and with sound.

Part 1, *Methodologies for Situated Listening*, brings together provocations, approaches, and methods for reimagining the practice and process of listening. The chapters in this section do this by considering listening in the context of violence (femicide, genocide, existential erasure), listening across differences (between species and temporalities), and from positions of relational plurality embodied by feminist and decolonial praxis. Grounded in experiential insights, these chapters propose practices of attuning to "noise," attending to critical sites, listening with other species, and listening as testimony. Listening is examined through the vastly different subjectivities (from colonizers to corn), temporalities (from erased histories to speculative futures), and politics (from community gardens to conflict zones) that define any location in time and place.

Part 2, *Apparatuses of Listening*, explores how our listening practices are shaped by sonic technologies, ranging from recording devices to voice notes, and posits that our bodies constitute the primary technologies of listening, recording, and sonic archiving. The authors investigate how systemic injustice, ecological concerns, and ethical responsibilities manifest within the bodies of creative sound practitioners and their audio devices. Across five chapters, the authors emphasize the non-neutrality of tools and embodied experiences, countering the dominance of historical attitudes surrounding recording technologies, and examining how the human body functions as a transductive listening device. The chapters sound out modes of resistance to hegemony variously through DIY cultures, sonic ephemerality and opacity, digital decay, meshworks, and the search for extraterrestrial life.

Part 3, *Cultures of Situated Listening*, examines the cultural frameworks and tensions that shape listening practices in contested environments, addressing themes such as white supremacy, bordered landscapes, and the interplay between human and non-human beings. The chapters consider how listening is influenced by sociopolitical power dynamics, urging critical engagement with pressing contemporary issues. The authors employ methodologies ranging from analyzing neo-Nazi audio content on social media to exploring the relational dynamics of interspecies listening between composers and backyard coyotes. By situating listening as an ethical and political act, the authors propose methods for understanding sound as a mode of knowledge production with the capacity to challenge dominant narratives and foster kinship with the more-than-human world. Through diverse case studies and collaborative compositions, the authors advocate for more attuned and politically engaged listening practices that recognize the complexities of cultural and ecological contexts.

Listening, Lingering, and Lines of Affinity (and of Discord)

Rather than charting a course, this volume lingers in the fissures between theory and practice, between collaborators and conversants. We aim to capture the context-specificity of a range of voices, all of which insist on similar ethics, materials, and ways of working, rather than predetermined outcomes. Decolonial thought teaches us to be wary of universal solutions, and in this spirit, the voices we include represent a plurality of positions, perspectives, and versions of what situated listening might mean and might make possible. We recognize that attempts at plurality are never complete, and have embraced undefined, experimental, and emergent ways of working together. The artists and scholars whose practice, writing, and thinking make up this book all understand listening as central to how we navigate, create, and (re)create the world around us.

As an invitation to the reader to shift from theory into practice, this book offers a series of scores for listening, which take the form of diagrams, instructions, exercises, images, and meditations. These scores offer alternate modes of sharing the central ideas of the associated chapters. Together they constitute a call to action for the reader-listeners; a call for embodied, speculative, purposeful, and pragmatic resistance to hegemony. Such resistance is situated, encountered, explored, and enacted through sound and listening.

We invite readers to trace their own lines of affinity as they read, to listen in the spaces between chapters, between words, and within the scores. In setting forth the imperatives of this project, we invite listeners to develop their own methodologies, technologies, collaborations, and cultures of situated listening, as local projects that form part of a global community of situated listeners.

References

Biancorosso, G. (2016). *Situated listening: The sound of absorption in classical cinema.* Oxford University Press.

Carlyle, A., & Lane, C. (2013). On listening. Uniformbooks.

Dreher, T., Griffiths, M. R., & Laurie, T. (Eds.). (2021). *Unsettled voices: Beyond free speech in the late liberal era.* Routledge.

Foucault, M. (2002). *The order of things: An archaeology of the human sciences.* Routledge. https://search.ebscohost.com/login.aspx?direct=true&scope=site&db=nlebk&db=nlabk&AN=139122

Groth, S. K. (2022). Deep situated listening among hearing heads and affective bodies. In Eds., Linda O Keeffe and Isabel Nogueira, *The body in sound, music and performance*, pp. 51–64. Focal Press.

Haraway, D. J. (1988). Situated knowledges: The science question in feminism and the privilege of partial perspective. *Feminist Studies, 14*(3), 575–599. https://doi.org/10.2307/3178066

Hilmes, M. (2005). Project MUSE – Is there a field called sound culture studies? And does it matter? *American Quarterly, 57*(1). https://muse.jhu.edu/article/180095/summary

Holmstedt, J. (2021, January 15). The posthumanities hub seminar "re:sound – Sound as evidential medium in an age of crisis", ONLINE 28th January at 13:15 (CET). *The Posthumanities Hub*. https://posthumanitieshub.net/2021/01/15/the-posthumanities-hub-seminar-resound-sound-as-evidential-medium-in-an-age-of-crisis-28th-of-january-at-115-pm-cet/

Oliveros, P. (1974). *Sonic meditations*. Smith Publications.

Oliveros, P. (1993). The earth worm also sings: A composer's practice of deep listening. *Leonardo Music Journal, 3*, 35–38.

Oliveros, P. (2003). *Deep listening: A composer's sound Practice*. Deep Listening Institute.

Oliveros, P. (2022). *Quantum listening*. Ignota Books. https://ignota.org/products/quantum-listening

Östersjö, S. (2020). *Listening to the other*. https://orpheusinstituut.be/en/publications/listening-to-the-other

Ouzounian, G. (2006). Embodied sound: Aural architectures and the body. *Contemporary Music Review, 25*(1–2), 69–79. https://doi.org/10.1080/07494460600647469

Parikka, J. (2012). New materialism as media theory: Medianatures and dirty matter. *Communication and Critical/Cultural Studies, 9*(1), 95–100.

Robinson, D. (2020). *Hungry Listening: Resonant Theory for Indigenous Sound Studies*. Minneapolis/London: University of Minnesota Press.

Sandoval, C. (2000). *Methodology of the oppressed*. University of Minnesota Press. https://www.upress.umn.edu/9780816627370/methodology-of-the-oppressed/

Søndergaard, M. (2020). *Sound as Evidence, 30*(84). https://direct.mit.edu/lmj/article-abstract/doi/10.1162/lmj_a_01096/97065/Introduction-to-Special-Section-Sound-as-Evidence?redirectedFrom=fulltext

The Listening Academy. (n.d.). Retrieved July 9, 2024, from https://listeningbiennial.net/academy-editions

Zinovieff, F., Droumeva, M., & Sepúlveda, G. A. (2023). Elephant in the matrix. *Resonance: The Journal of Sound and Culture, 4*(4), 325–347. https://doi.org/10.1525/res.2023.4.4.325

PART 1
Methodologies of Listening

PART 1
Methodologies of Listening

PART 1
Introduction

Stephanie Loveless and Freya Zinovieff

The first section of *Situated Listening* brings together provocations and approaches for reimagining the practice and process of listening. The five chapters propose theories and methods for listening as it relates to resistance. Together, they argue that both the act of listening and the aesthetic and material qualities of what is heard have the potential to uphold or resist existing power relations. Each chapter asks how listening might facilitate necessary practices of unlearning and untangling from the "coloniality of power" identified by Aníbal Quijano as a system of domination over economic, social, and political structures (Quijano, 2000, 2007). Implicit in these proposals is the understanding that listening is more than receptive: it is generative, and sometimes also transformative.

In some chapters, listening is understood as a process of moving from inattention to attention – a way of expanding our individual and cultural capacity to hear marginalised stories, voices, and subjectivities. In others, listening becomes a conduit for relation across lines of profound ontological difference. Further chapters propose methods of listening that contend with historical rupture and political violence. The reader will encounter "listening to noise" as a method of feminist research creation; they will be asked to consider Pauline Oliveros' germinal philosophy of Deep Listening (Oliveros, 2005) in relation to its historical context and contemporary sites of violence; they will read stories of "listening-with" more-than-human others in attempts to recalibrate human self-identity, and of "unlistening" as a framework for understanding what lies outside of the biases of learned patterns of perception. The final chapter in Part 1 reflects on listening as a form of mourning and of testimony – a "weak power" against the total erasure of colonial violence.

Listening to Noise: Lines of Affinity and Feminist Sono-Techno-Political *Artivisms* from the South

The opening chapter, by Ana Alfonsina Mora Flores, Amanda Gutiérrez, Gabriela Aceves Sepúlveda, Laura Balboa, and Victoria Polti, proposes "listening to noise" as a method for both political disruption and feminist community-building. Noise here is considered through two distinct but interconnected channels: as an epistemological framework for disobedience, and as an aesthetic quality that unites their intersectional, feminist, and multidisciplinary praxes. Through both theoretical and practice-led inquiry, noise is imagined as a force of energy with the potential to contest the coloniality of power. The authors critique theoretical hierarchies in sound studies (and academia more broadly) and demonstrate how scholarship situated in the Global North has prioritised vision and literacy while relegating sound and orality to domains of the Global South. They delineate how coloniality has shaped the narratives and the archives of sound art and sound studies, and how feminist lines of inquiry can make these transgressions audible.

Listening to Our Listening: Deep Listening in Critical Sites

The second chapter of Part 1 considers the liberatory potential of American composer Pauline Oliveros' Deep Listening in relation to current contexts of crisis. Stephanie Loveless and Freya Zinovieff examine the work of artists who engage Deep Listening in two significant sites of disruption: the Standing Rock Reservation of North Dakota, a place of ongoing struggle for Indigenous self-determination, and Houston's Fifth Ward, a historically Black neighbourhood in the American South, currently undergoing processes of gentrification. The authors reflect on the ways that Deep Listening is practised, challenged, and built on in these contexts, situating Oliveros' legacy within a historical and cultural framework that grapples with critical questions of ethics and appropriation. This historical context includes the political turmoil that influenced Oliveros' first scores for mindful listening and collective sonic performance – a period marked by American-led genocide in Vietnam and the silencing of dissenting voices; one that resonates viscerally with the time in which we are writing today.

Listening with, or the Impossibility of Inhabiting Another's Ears

In the third chapter, Janna Holmstedt and Louise Mackenzie describe the motivating desires, the failures, and the discoveries of their creative-research projects, which attempt to unsettle their anthropocentrism through listening to non-human species; from maize to microbes to molluscs. Their individual case studies trace the contours of their collective desire to listen with plants and marine life. Holmstedt and Mackenzie offer a historical overview of the

creative uses of amplification, audification, and sonification that grapples with the knotty relationships between aesthetics and technology. They guide the reader through this technological history of "listening" to plants and microbes, from contact microphones and hydrophones to potentiometers and electrodes, while acknowledging the sensationalism, pseudoscience, and scientific reductionism inherent in this history. This brings us to the core of their exploration – and what binds their individual stories – the inevitability of the distance that their projects yearn to overcome, and the place where the difference of the other is resistant to our human desire to know and consume.

Unlistening

Budhaditya Chattopadhyay and Elen Flügge explore situated listening by examining its *inverse*. They introduce the term "unlistening" as a way to think through the ways in which we filter, disregard, or negate auditory information in everyday situations, whether consciously or not. The authors consider instances of unlistening that range from automatic perceptual filtering to deliberate interpersonal disengagement, from systemic power dynamics to the filtering algorithms of communication apps. At a broader scale, the authors propose unlistening as a theoretical framework through which to examine the social dynamics that marginalise and oppress immigrant and diasporic artists and thinkers from the Global South. Here, an understanding of unlistening helps us grasp its impact on communication and sociopolitical dynamics, providing openings for listening anew.

The Weak Power of Listening

Part I concludes with a transcribed conversation between Rolando Vazquez, Ayreen Anastas, and Rene Gabri that considers the nature and the task of decolonial listening. Over the course of their conversation, they distinguish between forms of silence (from that of colonial erasure to that of generative reception), concepts of voice (from the enunciation of the individual and the cacophonous "white noise" of social media to the relational plurality of "coming to voice"), and experiences of time (from the artifice of the empty present to a decolonial temporarily infused with memory and ancestrality). They grapple with the question of what decolonial listening allows, makes possible, and serves, and consider the role of listening in the necessary shift from the logic of property and representation, towards relationality and togetherness. They consider the question of what has been silenced under coloniality, and how we can listen across differences. As a tentative response, Anastas, Gabri, and Vázquez come to the "weak power" of listening as testimony, as remembrance, as mourning, and for healing, in the face of violence and erasure.

References

Oliveros, P. (2005). *Deep listening: A composer's sound practice*. iUniverse.

Quijano, A. (2000). *Coloniality of power, eurocentrism, and Latin America*. Duke University Press.

Quijano, A. (2007). Coloniality and modernity/rationality. *Cultural Studies, 21*(2–3), 168–178. https://doi.org/10.1080/09502380601164353

1

LISTENING TO NOISE

Lines of Affinity and Feminist Sono-Techno-Political *Artivisms* from the South

Ana Alfonsina Mora Flores, Amanda Gutiérrez, Gabriela Aceves Sepúlveda, Laura Balboa and Victoria Polti

Introduction[1]

On June 3, 2015, a feminist demonstration led by the Argentinian-based collective #NiUnaMenos (#NUM) in Buenos Aires was simultaneously replicated across several urban centers, consolidating a renewed wave of feminist protest throughout Latin America. The demands for justice against femicides and the need to make visible the extremely violent living conditions imposed on women and nonconforming gender people living in contexts of social exclusion quickly spread through social media platforms, inspiring feminist groups and movements in other countries such as #Vivasnosqueremos in Mexico, and homonymous movements in Chile, Bolivia, Uruguay, Peru, Costa Rica, Guatemala, and El Salvador (Mora 2022; Mendiola-Vásquez 2022). These movements and collectives laid the groundwork for organizing the International Women's Strike on March 8, 2017. Songs and performative actions from these demonstrations have spread throughout Latin America and beyond through social media. By denouncing violence against women and transcending language and geographical boundaries, the sharing of these expressions through digital platforms has created global networks of solidarity.

As Victoria Polti (2021) has noted, the song and choreography "Un violador en tu camino" (A Rapist in Your Path) by the Chilean artivist collective Lastesis has been performed in cities around the world, acquiring an international dimension through local adaptations in different countries such as India, Brazil, and Belarus. Considering the gaps in technological access in Latin America, it is important to point out how, in some cases, digital platforms amplified and strengthened the possibilities of carrying out interventions in

DOI: 10.4324/9781003348528-4

multiple parts of the globe, supporting the creation of networks and sharing resources. For example, in 2016, the Argentinian-based Vivas Collective developed a sound bank to promote the expression and sound recording of the transfeminist movement of women, lesbian, trans(gender), "travesti,"[2] and nonbinary, which works as an open archive of field recordings of manifestations from various parts of the world (Polti 2023).

In recent years, feminist scholars have assumed a transfeminist and intersectional perspective to understand these movements and deepen the analysis of patriarchal domination. For Sayak Valencia, transfeminist movements arise "to open spaces and discursive fields to all those practices and subjects that distance themselves from the neoliberal reconversion of the critical apparatuses of feminisms, a reconversion that we know today as biological essentialist policies or cis-women policies" (Valencia 2018, 31). These movements consider "the transitioning of states of gender, migration, mestizaje (mixed race), vulnerability, race, and class as a transversal force to make emancipatory alliances" (Valencia 2018, 31). The spread of these movements through social networks, their reliance on sound, and on sharing, adapting, and transcoding lyrics and dances to local contexts are expressions of what we call contemporary feminist sono techno-political-artivisms. We fuse the term techno-political activisms (Fuentes 2020) and the term feminist artivism (a neologism composed of art and activism) to denote the contemporary practices of self-identified feminist or transfeminist activists who employ their art practices to make political claims and denounce gender-based violence. The term highlights the historical connection between art and politics through a feminist lens (Aceves Sepúlveda 2019), combining Diana Taylor's understanding of how artivism, understood as performance, blurs the boundaries between art and politics (Taylor 2015, 115) and Julia Antivilo's conceptualization of artivist production "as a political-aesthetic practice that works simultaneously in the social and cultural spheres of its production" (Antivilo 2018, 334).

Inspired by this multitude of sonic expressions and interest in bringing attention to the work of sound artists and activists in Latin America, in 2020, we began to organize around the concept of *sono(soro)rity* to propose an intervention in the archives of sound art and activism.[3] We proposed this neologism formed by the combination of sorority and sonority as a critical frame that interrogates the sonic dimensions of capitalism and heteronormative patriarchy. This term highlights the potential of the sonic to unveil and make audible unequal power dynamics in which gendered, racial, and class violence are perpetuated.

As scholars, activists, and artists of Latin American origin based both in and outside the region, we are interested in bringing attention to the contributions of similarly minded feminist Latin American-based scholars, artists, and activists interested in the political dimension of sound.[4] This way we seek to support and create north/south networks to facilitate the flow and

exchange of information, to question the imagined discursive superiority of the North-based academia, and to propose the South as a non-exclusionary and diverse epistemological field.

In this chapter, we propose the term listening to noise to describe our collective and individual trans-inclusive research creation praxis using feminist frameworks centered in a dialogue with contemporary sono-feminist-techno-political artivisms in Latin America. We thus listen to noise beyond the strictly sonic. That is, we take noise as a metaphor for something outside the norm, for what disturbs, challenges, and questions. We understand the potential of noise as a signifier of disruption to describe our collective action centered on finding ways to express and demand resistance to gender violence and social inequality. Noise is also present in our collaborative practice as an aesthetic sound quality. As a transgressive sonic expression, noise links our practices with multiple feminist collectives that employ it as a means of affective expression and construction of situated political solidarity. This transgressive quality also points to noise as a liminal configuration, a space where plural, diverse, overlapping voices can coexist along with varying degrees of resonances that depend on different listening habits and positionalities. In this way, noise acts as a mobilizing micropolitical agent of resistance and change, as a generator of knowledge in spaces and communities in which it dwells and co-constructs.

Chela Sandoval (1994) and Donna Haraway (1988) offer insights that inform our approach to listening as an embodied and situated practice and noise as a potentiality that can provide other forms of being and knowing in the world. We situate their works as central nodes in the lines of affinity connecting our approach to two different listening modalities: (1) listening as situated intersectional feminist practice and (2) listening to noise as epistemic disobedience (Campos Fonseca 2020). These two modalities ground our approach to listening to noise as a latent oppositional force to contest hetero-patriarchal capitalism and imagine worlds outside its reach.

Listening to noise *with a feminist ear* (Ahmed 2021) enables us to hear beyond acoustically intelligible patterns and tune in to low, diffuse, muffled frequencies and voices to understand how acoustic assemblages (Ochoa Gautier 2014) are articulated from the wefts of sound tensions in which some voices stand out, align, or overlap and where different understandings and meanings of what the use of voice, silence, or noise implies coexist. These "variegated," noisy, ch'ixi assemblages (Rivera Cuiscanqui 2012) allow us to articulate, re-signify, and transform our situated practices and thoughts beyond their geospatial and temporal positioning. In doing so, we find affinities with numerous critical assessments against the colonial and patriarchal order and the Eurocentrism that characterizes academic knowledge production (Rivera Cusicanqui 2012, 2018; Segato 2016, 2018; Lugones 2010; Anzaldúa 1987). To accompany this chapter, we offer our sound installation

FIGURE 1.1 *Feminist Sonographies of Situated Listening,* documentation of The Institution of Knowledge opening event and installation, photo by Michael Woolley (2023). © Michael JH Woolley 2023 under a Creative Commons Attribution-NonCommercial-ShareAlike 4.0 International license (https://creativecommons.org/licenses/by-nc-sa/4.0).

Feminist Sonographies of Situated Listening (2023) as an example of how listening to noise with a feminist ear is activated in our research-creation praxis as Sono-Soro[ridades] (Aceves-Sepúlveda, Zinovieff, and Gutiérrez 2021). The installation frames our collective research-creation in connection with individual multidisciplinary practices enacting decolonial feminist methodologies in sound (Figure 1.1).[5]

Lines of Affinity

Listening as the Invisible Mobility Below the Surface

In "feeling-thinking" what listening to noise means to us at this moment of heightened awareness when we are called to lend "a feminist ear" (Ahmed 2021) to a multitude of expressions demanding an end to epistemological, gender-based, and environmental violence, we turn to Haraway as a portal and to Sandoval's "methodology of the oppressed (2000)." Sandoval shows how Haraway's concepts of cyborg feminism and situated knowledge developed in dialogue with the work of Chicana and Black Feminists. She traces "lines of affinity that occur through attraction, combination, and relation carved out of and despite difference" (1994, 82). Furthermore, Sandoval positions

Haraway as a portal that allows her to reinsert the work of social activists and theorists that throughout the 20th century have been attempting to construct theories of opposition paying particular attention to Chicana and Black feminists including Gloria Anzaldúa and Audre Lorde (76). Haraway's use of figurations (cyborg, the coyote, the trickster) shows other ways of being and perceiving the world that inspire the lines of affinity we draw on to craft listening to noise as a situated feminist epistemology. Haraway's move to recognize the entangled materialities and subjectivities enmeshed in unequal power relations that account for more than human agencies in the production of knowledge echoes with Rivera Cusicanqui's anti-colonial critique, Voegelin's philosophy of listening, and Anzaldúa's La Facultad.

Anzaldúa proposed *La Conciencia Mestiza* (mestiza consciousness) as a critical and hopeful reflection on her condition of living between two cultures and navigating her lesbian and Chicana identity. For Sandoval, this awareness is both a theory and method of oppositional consciousness, "the mixture that lives through differential movement between possible beings" (1994, 83). An integral part of Anzaldúa's consciousness is La Facultad (the faculty), defined as "the capacity to see in surface phenomena the meaning of deeper realities, to see the deep structure below the surface" (1987, 38). Those who are "pushed out of the tribe for being different" or "those who do have experienced all sorts of oppression are forced to develop this faculty" (1987, 39). While Anzaldúa relies on the metaphor of vision to explain this capacity, there is a broader dimension of La Facultad that points to "anything that breaks into one's everyday mode of perception" (1987, 39). This broad perceptual dimension of La Facultad is palpable in Anzaldúa's modes of apprehending reality as a nomad. As Amanda Gutiérrez (2023) has noted, Anzaldúa opens a literary dimension of walking and listening as a poetic experience of being Chicana in the Southern United States. Anzaldúa's literature "evokes soundscapes from an indigenous and migrant positionality that organizes the sense of hearing as directly connected with the ecology of a particular place" (2023, 100), evoking sound from an embodied standpoint.

Taking this broader understanding of La Facultad, we trace a line of affinity with Salomé Voegelin's proposition of listening as a generative and participatory practice that shows us the invisibility of the world and makes us aware of what is hidden from view but always present (2014, 5). However, neither listening nor sound will automatically create a better world for Voegelin. "Sound," as she tells us, "does not hold a superior ethical position or reveals a promised land" (2014, 3). Listening, Voegelin argues, can show us the invisibility of the world. Listening as both actual and conceptual pursuit amplifies how we perceive the world, bringing about an understanding of the world "that knows its surface but also appreciates the hidden mobility beneath" (2014, 5).

Considering Voegelin's understanding of the potential of listening as a way to inhabit the world in relation to Anzaldúa's La Facultad as a situated and oppositional perceptual dimension that pushes us to become answerable for what we learn how to see/hear and how and what to see/hear connects our conception of listening to Silvia Rivera Cusicanqui use of the Aymaran concept-metaphor *chi'xi* (2012). This concept refers to a perceived compound color (an unmixed with contradictory juxtaposition) to denote contrasted, stained, and spotted identities in Latin America (2018, 37). Chi'xi is an anti-colonial gesture acknowledging "the parallel coexistence of multiple cultural differences that do not extinguish but instead antagonize and complement each other" (2012, 105). Rivera Cusicanqui proposes ch'ixi to "overcome the historicism and binarism of hegemonic social sciences" (2018, 47). She mobilizes the term to counter theories of mestizaje, multiculturalism, and hybridity and demands the need to continue the coexistence of many worlds and ways of being at once rather than promote assimilation (2018).

Rivera Cusicanqui's project powerfully reminds us of the antagonisms and contradictions that underscore the possibilities of listening differently, of appreciating the noise and silences as agents of mobilization. Hence, Rivera Cusicanqui proposes chi'xi as a logic to include the third. That which may be invisible to some, but that, in the words of Voegelin, could be akin to that which is nonetheless sounding and thickens our perception.

Like Anzaldúa's La Facultad, Rivera Cusicanqui also accounts for different modes of perception and ways of understanding sonic dimensions including how silence opens up if we see the world through a chi'xi lens (2018, 113). Sandoval, Haraway, Rivera Cusicanqui, and Anzaldúa propose a different scheme of the world via an understanding of the latent potential of an oppositional consciousness built via affinities through difference. With this blueprint, we open the political potential of listening to as a situated awareness that can heighten our perception of nonnormative ways of being in the world.

Listening to Noise as Situated Epistemic Disobedience

Tracing affinities between authors who invite us to decolonize our listening through different standpoints (Ochoa Gautier 2014; Estevez Trujillo 2016; Campos Fonseca 2016), our second line of affinity reflects on the sonic/Global South relation, which has been considered epistemologically inferior to the North/Vision/Literacy triad (Sterne 2003; Ochoa Gautier 2006; Steingo and Sykes 2019). Following this line, listening to noise has the potential to become a tool of epistemic disobedience as Costa Rican composer and musicologist Susan Campos Fonseca proposes: "noise as an expression of epistemic disobedience to redress our 'internal coloniality' and to formulate *ecologías*

de saberes interespecies (multispecies ecologies of knowledge)" (2020, 38). Fonseca's propositions are in dialogue with several scholars of Latin America who in the last decades, have taken up a collaborative methodology centering on sound to question different sociocultural and historical issues in the region, including studies in the fields of music, sound arts, and experimentalists, or proposing to frame sound studies from the South and for/from Spanish speaking perspective, many of which have adopted a decolonial and feminist theoretical framework.[6]

In *Aurality: Listening and Knowledge in Nineteenth-Century* Colombia (2014), one of the first studies to offer a Latin American lens to the study of sound and orality, Colombian-born U.S.-based Ana Maria Ochoa Gautier proposes a critical perspective to understand the dominant south-sound imbrication of sound studies. By demonstrating how sound was historically constitutive of modern-colonial history and problematizing the scope of aurality as an account for the sonorous and the vocal in Latin America. Ochoa Gautier analyzes the diverse modalities in which different auditory techniques and forms of listening have been transduced into textual archives. This transduction subsumed various senses and cultural expressions into a modern onto-epistemological framework that effectively silenced, marginalized, or labeled as noise that could not be apprehended through it. To understand the heterogeneity of voices and forms of listening crossed by different modalities disciplined by the dominant onto-epistemological framework, Ochoa Gautier offers the concept of "acoustic assemblage" (2014, 23). For Ochoa Gautier, acoustic assemblages circulate between separate listening entities through multiple practices of sound inscription: rituals, writing, acoustic events, etc., which, in turn, are also listened to, implying mutual transduction as well as potentially transformative processes of sound inscription that interrelate listeners and sound "objects" (2014, 22). Ochoa Gautier's "acoustic assemblages" calls us to attend more broadly to different modalities of listening and inscription technologies in which sonic traces may be found.

In a similar vein and situated for/from a Latin American perspective, Ecuadorian Mayra Estévez Trujillo articulates the existence of a colonial regime of sonority (2016) through an analysis of the deployment of sonic technology in the region and its ideological underpinnings. Estévez Trujillo invites us to consider "colonized listening" as the sonorous imprint of technology that, in the name of progress and capitalist development, establishes the regime of noise in diverse cultural landscapes (2016). In this sense, Estévez Trujillo understands Latin America as the product of economic, political, social, and cultural transformations managed through the violent use of warfare technologies. These technologies range from living machines such as horses and dogs trained to kill in the West Indies and the Americas to specialized technologies such as the LRAD (long-range acoustic device or sonic blaster), a loudspeaker with extremely high-decibel capacity that can cause irreversible ear damage

used for crowd control (2016, 84). These technologies are the product of imperialistic and neocolonial ideologies which mobilize a masculine-patriarchal world order based on violence, war, and destruction. This ideology orients the use of sonic technologies toward territorial, ecological, and social domination, control, and exploitation. Estévez Trujillo's elaboration on using sound technologies as tools of power, control, and destruction speaks to Campos Fonseca's critique of the Eurocentrism of musicology and the Cartesian framework that has colonized our listening (2016).

Through an analysis of the contemporary electronic and experimental music scene in Costa Rica, Campos Fonseca deploys the concept of noise anchored on an understanding of noise-based practices as expressions of dissent against the dominant discourses (2016, 158). For Campos Fonseca, noise, as a method to unlearn and deconstruct our colonized mentality (38), can reverse the functional practices of tonal listening, thus enabling "other forms of listening" (2016, 155). Moreover, noise can become an epistemic form as "a sound that dis-informs and attacks the paradigm of harmony, rhythm and logos as the principle of the logic of sound discourse" (2019). Hence, noise as a decolonizing tool for Campos Fonseca can operate as a repository of resilience, of audible worlds that still resist and survive.

Ochoa Gautier, Estévez Trujillo, and Campos Fonseca's diverse standpoints on the aural, technological, and epistemological dimensions of listening and calls for decolonizing its practices resonate with Haraway, Sandoval, Anzaldúa, Cusicanqui, and Voegelin's situated approach. They all offer critical appeals to listening in/to/from a particular context and within its complexity.

Feminist scholars have further demonstrated the links between "modern colonial patriarchy and gender coloniality" (Lugones 2010). Besides the already mentioned Anzaldúa, Sandoval and Rivera Cusicanqui, Rita Segato (2016), bell hooks (2015), and María Lugones (2010) among many others, have offered an intersectional viewpoint that considers how power relations are intertwined by sex, gender, ethnicity, class, (dis)abilities, and geopolitics, among other conditions and/or identity affiliations. Intersectionality, as an analytical tool, makes it possible to account for structural inequalities that operate at different levels, contexts, and times, highlighting the colonial past and structural poverty as determining the relationships that shape and underlie our societies, social groups, and subjectivities.

Others have also turned to the auditory to demonstrate how sound is imbricated in the construction of gendered and racialized identities and mobilized both as a category of oppression and contestation (Anzaldúa 1987; Eidsheim, 2009; Ahmed 2010, 2021) For Sarah Ahmed being heard or not being heard is an enactment of hierarchies. "We learn how only some ideas are heard if they are deemed to come from the right people; right can be white" and male (2021, 4).

As scholars, artists, and activists who straddle multiple worlds, we hope to open spaces so that others can hear what we hear. Hence, these lines of affinity also connect us to what we label as contemporary feminist sono-techno-political artivists who are making themselves heard by employing Anzaldúa's La Facultad to bring to the surface that which is hidden for many but always present: violence against women and sexual dissidence.[7]

From this ontological, epistemological, geopolitical, and sono-corpo-sentient articulation, we propose noise as a terrain of audibility of difference, diversity, and sexual dissidence. Situated and reflective listening allows us to attend to the complexity of our local contexts with an ear to the distant and the peripheral with accountability.

In the Interstices of Our Collective and Messy Lines of Affinity

The lines of affinity that can be traced among us build diverse connections at various levels according to the inner complexities of our diversified beings made of our experiences, identifications, knowledge background, practice, labor, political views, geolocation, migration status, class, and bodies, as well as the alternative initiatives of the conglomerate of groups, individuals, communities, movements, and projects we engage with.

We use mediated modes of transmission to amplify these dialogues, sharing speech through radio, podcast, music production, video, performance, and theoretical thinking. We are scholars, sound producers, musicians, and independent artists whose cultural ancestry relates to the Global South geographically and theoretically. Some of us live, work, and are rooted in the Global North and others in the South. Therefore, dialogues and critical conversations on the political relationship with global colonialism and its interdependence are echoed in our experiences and writing reflections as we research these complex and interconnected contexts.

In writing this chapter, we are conscious of our differences and commonalities as we decided to converge in listening to the different noises we produce, find, and amplify. We disobey epistemically to situate our discourses in making diverse notions of noise, sound, and music flexible and present.

Listening to noise takes a different dimension when it comes to the openness and full embracing of situational listening. As a people of the clouds (Binnizá), Laura Balboa reflects on the semantics of the Zapotec word *hridxi*, which can be used to denote sound, high volume, noise, voice, shout, hubbub, or thunder. With non-western language used as a point of reflection, Balboa brings a notion and appreciation of sound and noise that includes the individual and communitarian voices to welcome the heterogeneous. Since 2020, her project Bulla Radio works as a platform of participatory activist research, PAtR (Hunter, Elke, and Gregory 2013) focused on

documenting sound and music production of female-identified, gender non-conforming, nonbinary, and LGBTQIA+ artists in Mexico via conversation and listening. *Hacer bulla* translates to "make noise" to broaden experimentation in sound from non-hegemonic practices. Bulla Radio has anti-colonial, anti-patriarchal, and anti-capitalist ideation and praxis for the inclusion of different standpoints that converge on fighting discrimination based on language, ethnicity, education, sexuality, gender identification, class, and origin, as well as fighting consumerism and exploitation (Rivera Cusicanqui 2018; Aguilar Gil and Cumes 2021).

For Balboa, orality and conversation are radical technologies understood as ancestral and contemporary memory systems (Twenty Summers 2022, 0:35:31) and Bulla Radio follows the community radio tradition of indigenous nations in Mexico that defend their land and territory (Sánchez 2016). Balboa seeks to escape from the essentialist definitions of genealogy, archive, ethnography, historical record, journalism, and documentary to collect and share unfiltered experiences including trifles as research material.

Bulla shares practices such as live coding that emancipated a composer who was never given a chance in hegemonic institutions; rearranging hardware detritus with circuit bending to create ephemeral instrumentation; performing live on the floor and refusing to release records on labels; building custom whistling vessels and hydraulic sound instruments with Mesoamerican technology; diverse vocalizations in abandoned places to regard echoes as dialogue and improvisation; quitting the music conservatory to build a full-time career on free composition and establish free jazz in Mexico in the 1970s, among many others. Bulla Radio is a living database to listen to each other and make noise to be heard through improvised conversation from a relational stance as active participants and complex people in challenging environments, as an act of individual and collective recognition, advocacy, and self-determination.

Making noise can happen in the dimension of being heard. With a scope of feminist collectives and collectivity, *Feminopraxis ruidistas* is a situated and embodied concept proposed by Ana Mora to name sound feminist and collective practices making noise as an expression of agency from a complex place like Latin America. This neologism follows the conversations of artists and authors like Alonso Minutti (2018; 2019), Campos Fonseca (2016; 2020), Nogueira and Mello (2018), and Romano Gómez (2012), whose works have a focus on the intersection of noise, feminisms, technology, and most importantly, collective work. Likewise, the *sentipensares* (feeling-thinking) and actions of feminist and experimental sound collectives such as Híbridas y Quimeras (Mexico), Feminoise Latinoamérica (Argentina), Sonora (Brazil), Sonoras (Chile), and Festival en Tiempo Real (to mention a few) that have created safe spaces, and horizontal, fair, and affective dynamics of work for women and diverse minorities, have nurtured the conceptualization

of *feminopraxis ruidistas* as a live and resonant concept beyond theory. Mora states that the sound creation genealogy associated with noise/*ruido* is male-dominated and focused on the production of the Global North. The absence of female and diverse minor identities sound artists, mainly from Latin America, in this genealogy makes evident the workings of the patriarchal system and the ways hegemonic academic discourses silence practices from the periphery.

A situated noise/ruido becomes a robust community and collective tool to decolonize our practices. Making noise by embracing a situated listening can be heard by placing our bodies and taking the public space to raise our voices in protest. Making music with the resources we have and healing through sound is a cathartic way to express ourselves and connect with others, even in a scene dominated by patriarchal values. A situated noise emanates from our daily actions to make a change in our context and community regardless of the gender-based violence to which we are constantly exposed, not only in Latin America, but around the world as women and nonbinary people.

Victoria Polti addresses the noise that is made and heard at the intersection between feminist anthropology, sound studies, artistic creation, and political activism. Polti considers noise as a field of reflection and action based on the generation of sounds and listening to sound recordings of feminist, LGTBIQ+ demonstrations, and transfeminist artivist collectives. Listening to noise implies recognizing the geopolitical situation of listening, and the singularity of one's voice as part of an assembly of voices, sounds, screams, and positions that make up and condense a multiplicity of diverse, overlapping meanings. Therefore, listening to noise for Polti entails sensitizing listening, recognizing tensions and differences, and enhancing forms of political audibility through transmitting and recognizing plural memories and their various senso-corpo-affective resonances. Polti is interested in working at the edges and folds of the academic, artistic, and political fields, transcoding theoretical reflections into performative devices and reflecting on creative processes based on the potential of noise and its listening. According to Polti, noise can express its potential through hybrid methodologies such as sono "performance-research" (Citro 2016) which allows linking multiple aspects such as the updating and transmission of memories into diverse fields; drawing counterpoints between sound biographies and matrices of political audibility, and addressing the political efficacy of noise through aesthetic devices that operate as resonators.

Polti's practice encompasses the creation of sound clips and individual and collaborative sound performances that incorporate a wide variety of contemporary and historical ethnographic records and live performances that aim to reactivate cultural and political memory through sound. Some of her recent works capture the fight for gender rights in Argentina, address sexual-gender dissidences or the legacies of the last civil-military dictatorship in Argentina.

For example, Ruidos (2019)[8] is a sound-performative investigation based on interviews with survivors of the clandestine detention center "El Atlético," ethnographic and archival material, and a live performance in which Polti subverts the timbre of her voice on stage to highlight the contexts of horror, torture, and extermination deployed against the population by the military.

For Amanda Gutiérrez, the Soundwalk is a vital methodology in her artistic practice that she employs to build relational connections to the local context where it is enacted, considering the humans, more-than-humans, and its specific acoustic environments. When someone listens while walking, they do not only hear from their ears but also from perceptions and experiences given through their ethnic, racial, and gender identity. The participatory dynamics in Gutiérrez's soundwalks engage through aural amplification using portable speakers, engaging in dialogue participants' personal impressions and the space. Gutierrez's main subjects are related to sound of oral histories, music, and noise, created by female-identified and LGBQI+2 music producers sonically overlapping with the "urban noise." Enacting their sonic amplification is a disruption and political act of occupying the streets, while sharing knowledge through walking collectively the public sphere. Therefore, listening to the space means hearing the loudness of what we know as "noise" considering critical listening positionality (Robinson 2020) embedded in our experience within the spatial contexts that we inhabit. Gutiérrez's sound walking practices resist the dichotomies between noise versus silence experienced in unwanted urban spaces as the opposite of quiet natural environments as a commodity. The walks invite participants to embody the noisy and higher volumes of socially segregated public spaces to critically listen to our positionalities within these locations.

Listening to noise in Aceves-Sepúlveda's research-creation practice is a methodology that attunes her politics to what is not readily perceptible (2023). It is linked to Anzaldúa's (1987) La Facultad and Voegelin's understanding of listening as generative and participatory practice that can show us what can be unperceivable (2014). Noise is related to an exploration of archival exclusions, to the power of the archive to define what counts as knowledge and who is considered a valid knowledge producer in different contexts and periods. In other words, listening to noise as a research-creation methodology for Aceves Sepúlveda allows a reflection on the back and forth between what is considered an archive and counter-archive in different periods, contexts, and cultures of practice. In this sense, a counter-archive is akin to Sandoval's "oppositional consciousness" (1994), a series of technological apparatuses, discourses, media, and knowledge traditions that have the potential to question that which is dominant and excluded from the archive. She has theorized the archive/counter-archive relation through an exploration of the role of feminist artists, archivists, and curators as agents of the archive and of the archive as a living and contested "site of production of

knowledge and not only as a destination of knowledge already produced" (Stoler 2002, 23). This understanding of the archive /counter-archive unstable relation grounds her research on the contributions of Latin American artists and composers in media arts.

Aceves Sepúlveda's interest in sound stems from her video art practice and historical research on feminist media art and archives in Latin America (Aceves Sepúlveda 2019). She defines her work through the broad and complex term of research-creation (Loveless 2019) because it encompasses how her life as a scholar, artist, professor, mother, wife, sister, daughter, and friend is embodied, entangled, and inseparable. For Aceves Sepúlveda, research-creation is a flexible, inter- and transdisciplinary term that values process over the finished product. It does not create a hierarchy that valorizes theorizing and writing over making. Defined through a feminist framework, the hyphen between research and creation points to their intertwined origins and the messy, lived, embodied experience that joins them.

Together, our individual and collective practices offer working definitions and approaches to what we label a practice of *listening to noise*. As scholars, artists, and activists who straddle multiple worlds at once, we seek to bring attention and lend a feminist ear to the work of contemporary trans-feminist sono-techno-political artivists in Latin America. We also share an interest in bringing attention to the contributions of women artists based in Latin America or Latin American origin in the narratives and archives of sound art more globally. A multitude of authors and artists inspire our methods and approaches. In this chapter, we traced a web of connections or lines of affinities among them. We extrapolate ideas from one and put them in dialogue with another, causing dissonances and reverberations. Ideas are transcoded, translated, and re-interpreted. Ultimately, we offer a messy web of concepts and political projects that inform our working approach to *listening to noise* as a crucial element in our individual and collective research-creation feminist praxis. We understand that *listening to noise* allows us to make audible and understand sensibly the different worlds we inhabit and how we inhabit them differently.

Listening to Noise: Collaborative Score to Be Performed Together at a Long-Distance

Sono(soro)-rities collective

We propose a score that is meant to be practiced while working at a long distance in collaboration with others, preferably located in different places across the Global North and/or South. Each participant is in a public space that is meaningful to them (a social demonstration, a public square, a beach, a forest, a classroom, a park, a family gathering, etc.)

1. Open a call with your collaborators using a platform that is accessible to all. Everyone's microphone should be on mute (do not use noise-canceling headphones).
2. Walk for a minute listening to the sounds in your surroundings.
3. When the minute ends. Everyone stops walking. At the count of three, everyone opens their mics at the same time to listen to the collective sounds for one minute.
4. During this minute, close your eyes and listen attentively to the sounds coming from all participants' microphones and to the sounds of your own surroundings. Try to identify which sound you first paid attention to, which sound was louder, which one sounds more distant, and which sound is closer to you. Try to identify which sounds have an association with the human body (breathing, running, walking, voices, shouts, etc.) and which sounds relate specifically to the location of one of your collaborators (traffic, animals, wind, rain, glitches, and interference from the connection, microphones, etc.).
5. Put the mics on mute and listen to your surroundings for a minute.
6. Open the mics again and as a group reflect on the following: *(if one of your collaborators is in a space where it is difficult to have a conversation, allow some time for them to find an appropriate place).*

- Sometimes what we perceive as noise are sounds that we cannot understand or interpret, but that transmit a sensation of joy, anger, sadness, etc. When you think about noise, what sonorities come to mind?
- Was there a particular sound that you would label as noise in comparison to others?
- What noises, sounds, and silences, from this experience are constitutive of your own identity as a sexed, gendered, classed, racialized, neurodiverse, or able body?
- Which of these noises could be defined as feminist and why?
- What would it be like for you to listen with a feminist ear? And how would you listen to noise with a feminist ear as a collective working at a long distance?

Notes

1 Authors are listed in alphabetical order by name. All authors contributed equally to the writing and conceptualization of this text.
2 In Argentina, "travesti" has been consolidated as a gender identity. Although there are no closed definitions, it is considered by some authors as a performative gender that goes beyond the practice of crossdressing (Fernández, 2004).
3 The members of our collective are Ana Alfonsina Mora, Laura Balboa, Victoria Polti, Amanda Guitérrez, Freya Zinovieff, and Gabriela Aceves-Sepúlveda. Mora, Balboa, Polti, Gutiérrez, and Aceves Sepúlveda are the authors of this chapter. Zinovieff invited us to participate and is an editor of the volume. For more on our projects, see https://criticalmediartstudio.com/portfolio/feminist-sonographies-of-situated-listening/
4 The authors of this text are all born in Latin America; however, not all members of our sono(soro)rity network are of Latin American origin.
5 The installation *Feminist Sonographies of Situated Listening* was presented at the group exhibition for research-in-action performances and installations by The Institution of Knowledge, organized as well as curated by Geoffrey Rockwell and Natalie Loveless in University of Alberta Canada. Video documentation and the main audio piece are available in the following link: http://www.amandagutierrez.net/eng/portfolio/feminist-sonographies-of-situated-listening/
6 Some few examples of these include: Rocha Iturbide 2006; Dominguez Ruíz 2007, 2019; Verdana 2008; Rivas 2015; Alegre 2019; Castanheira 2020; Chávez and Iazzetta 2019; Alonso Minutti, Madrid and Herrera 2018; Nogueira and Mello 2018; Romano 2012; Estévez Trujillo 2016; Campos Fonseca 2019; Bieletto Bueno 2019; Polti 2021, 2022; Mora Flores 2021, 2022; Pola Mayorga 2021; Minsburg 2015.
7 The term sexual dissidence is used in Latin America and the Caribbean to name and vindicate the politicization of identities, cultural practices, and social or political movements that question heterosexuality as the hegemonic social norm. Although this term poses challenges for its translation into English, it allows us to understand its expression more broadly.
8 See: https://www.youtube.com/watch?v=Ue5drqvj7IQ

References

Aceves Sepúlveda, G. (2019). *Women Made Visible: Feminist Art and Media in Post-1968 Mexico City*. Lincoln: University of Nebraska Press.

Aceves-Sepúlveda, G., Zinovieff, F., and Gutiérrez, A. (2021). "Sono-Soro[ridades]: Feminist Interventions in Sound Art". In *Borderline Sonorities/Sonoridades Fronteiriças II CIPS*, Federal University of Santa Catarina, Florianópolis, Brazil (UFSC), June 9–11. https://en.sonoridades.net/c%C3%B3pia-ii-cips-chamada-de-trabalhos

Aguilar Gil, Y. E., and Cumes, A. (2021). "Entrevista Con Aura Cumes: La Dualidad Complementaria y El Popol Vuj". *Revista de la Universidad De México* Ciudad de México. https://www.revistadelauniversidad.mx/articles/8c6a441d-7b8a-4db5-a62f-98c71d32ae92/entrevista-con-aura-cumes-la-dualidad-complementaria-y-el-popol-vuj.

Ahmed, S. (2021). *Complaint!* London: Duke University Press.

Ahmed, S. (2010). Orientations Matter. In D. Coole & S. Frost (Eds.), *New Materialisms* (pp. 234–257). Duke University Press. https://doi.org/10.1215/9780822392996-011.

Alonso Minutti, A. R. (2019). "The Potential of Noising Borders". In *Rocky Mountains Music Scholar Conference Keynote Address*. El Paso, TX, March 2.

Alonso Minutti, A. R. (2018). "Gatas y Vatas. Female Empowerment and Community-Oriented Experimentalism". In Alonso-Minutti, A. R., Herrera, E., and Madrid, A. (eds.) *Experimentalisms in Practice: Music Perspectives from Latin America*, 131–160. New York: Oxford University Press.

Antivilo, J. (2018). "Ni víctimxs, nipasivxs, sí combativxs. Visualidades feministas, autorrepresentación de cuerpos en lucha". *Revista Anales, 7* (14): 333–353.

Anzaldúa, G. (1987). *Borderlands / La Frontera*. The New Mestiza. Aunt Lute Books.

Campos Fonseca, S. (2016). "Ciberfeminismo y Estudios Sonoros". *Interdisciplina-UNAM, Feminismo, 4* (8): 141–162.

Campos Fonseca, S. (2019). "El Ruido como desobediencia epistémica. Ruido y colonialidad interior". *Conferencia y performance*. Museo Universitario de Arte Contemporáneo, Universidad Nacional Autónoma de México.

Campos Fonseca, S. (2020). "Auralidades de Mundos Heridos". In *Border-Listening/Escucha-Liminal* (Vol. 1). Radical Sounds of Latin America.

Castanheira, J. C. et al. (2020). *Poderes do som. Políticas, escutas e identidades*. Florianópolis: Insular.

CCCB (Director). (2020, December 16). *Donna Haraway and Vinciane Despret. Phonocene* [Video recording]. Accessed August 30, 2023. https://www.youtube.com/watch?v=87HzPIEiF78

Citro, S. (2016). "Indagaciones colectivas de y desde los cuerpos". In A. Reyes Suárez, J. Piovani y E. Potaschner (coord.), *La investigación social y su práctica*. Mendoza: Uncuyo.

Dominguez Ruiz, A. L. (2019). "El oído: un sentido, múltiples escuchas". Dossier "Modos de escucha". *El oído pensante, 7* (2).

Dominguez Ruiz, A. L. (2007). *La sonoridad de la ciudad de Cholula: una experiencia sonora de la ciudad*. Ciudad de México: UDLA-Porrúa.

Eidsheim, N. (2009). "Synthesizing Race: Towards an Analysis of the Performativity of Vocal Timbre". *Revista Transcultural de Música, Nº 13*, pp. 1–9.

Estevez Trujillo, M. (2016). "Estudios sonoros en y desde Latinoamérica: del régimen colonial de la sonoridad a las sonoridades de la sanación". *Tesis doctoral*. Quito: Universidad Andina Simón Bolívar Sede Ecuador.

Fernández, J. (2004). *Cuerpos desobedientes. Travestismo e identidad de género*. Buenos Aires: Edhasa.

Fuentes, M. (2020). *Activismos tecnopolíticos. Constelaciones de performance*. Buenos Aires: Eterna Cadencia

Gutiérrez, A. (2023). "Aural Border Thinking as a Decolonial Soundwalking Methodology". In J. Smolicki (ed.) *Soundwalking*, 1st ed., 96–115. London: Focal Press.

Haraway, D. (2016). *Staying with the Trouble: Making Kin in the Chthulucene*. Durham, NC: Duke University Press.

Haraway, D. (1988). "Situated Knowledges: The Science Question in Feminism and the Privilege of Partial Perspective". *Feminist Studies, 14* (3): 575–599.

hooks, b. (2015). *Talking Back. Thinking Feminist, Thinking Black*. New York: Routledge.

Hunter, L., Elke, E., and Gregory, M. (2013). *Participatory Activist Research in the Globalised World : Social Change through the Cultural Professions*. Dordrecht: Springer.

Loveless, N. (2019). *How to Make Art at the End of the World*. Durham, NC and London: Duke University Press.

Lugones, M. (2018). "Volume 2, Dossier 2: On the Decolonial (II): Gender and Decoloniality | Center for Global Studies and The Humanities". Accessed April 17, 2022.

Lugones, M. (2010). "Toward a Decolonial Feminism". *Hypatia*, 25 (4): 742–759.

Mendiola-Vasquez, M. (2022). *Temas de Nuestra América*, 38 (72), Costa Rica.

Minsburg, R. (2015). "El recuerdo del que escucha", *Revista Afuera N° 15*. Buenos Aires.

Mora Flores, A. (2022). "Colectivas Feministas en México y nuestra América: Hacia otros mundos sono-sororos posibles". In *Cuadernos de Música UNAM*. Mexico: UNAM, 54–71.

Mora Flores, A. (2021). "Híbridas y Quimeras: Ruido y Sororidad Colectiva en la Ciudad de México". *ESCENA. Revista De Las Artes*, 81 (1): 320–343.

Nogueira, I., and Tania Mello, N. (2018). "Mujeres en la música experimental y colectivos de música en Brasil". *ESCENA. Revista de Las Artes*, 78 (1): 98. https://doi.org/10.15517/es.v78i1.33793.

Ochoa Gautier, A. (2014). *Aurality: Listening and Knowledge in Nineteenth Century Colombia*. Durham, NC: Duke University Press.

Ochoa Gautier, A. (2006). "Sonic Transculturation, Epistemologies of Purification and the Aural Public Sphere in Latin America". In J. Sterne (ed.), *The Sound Studies Reader*, 388–404. New York: Routledge, [2012:2006].

Pola Mayorga, M. (2021). ""Hablar de lo que importa". Escucha afectiva y desidentificación". en L. Alegre y J. D. García (coord.), *Sonido, Escucha y poder*. Ciudad de Mexico: Ed. UNAM.

Polti, V. (2023). "Archivos colaborativos y escuchas performativas transfeministas: el Banco de sonidos #Vivas". *Revista Eletrônica Da ANPHLAC*, 23 (35): 63–81.

Polti, V. (2022). "Y el miedo…? Que arda!": performatividad sonora en artivismos transfeministas en Buenos Aires: el caso de ARDA" N° 26, *Revista Transcultural de Música*, Madrid.

Polti, V. (2021). "Escucha performativa y artivismo (trans)feminista: Lastesis y sus resonancias sono-corpo-políticas", *Revista de Estudios Curatoriales, Escuchar el presente*, Año 8, N° 13.

Rivas, F. (2015). "Fenomenología política del ruido", Pareyón, G. (ed.) *Ixaya. Revista Universitaria de Desarrollo Social* N° 9.

Rivera Cusicanqui, S. (2018). *Un Mundo Ch'Ixi es possible. Ensayos desde un presente en crisis*. Buenos Aires: Tinta Limón.

Rivera Cusicanqui, S. (2012). "Ch'ixinakax Utxiwa: A Reflection on the Practices and Discourses of Decolonization". *South Atlantic Quarterly*, 111 (1): 95–109.

Robinson, D. *Hungry Listening: Resonant Theory for Indigenous Sound Studies*. Minneapolis: University of Minnesota Press, 2020. https://doi.org/10.5749/j.ctvzpv6bb.

Rocha Iturbide, M. (2006). El arte sonoro en América Latina. *Contrastes: Revista Cultural*, (45): 43–49.

Romano, A. M. (2012). "Jaqueline Nova: De la exploración a la experimentación de la libertad". In Quintana Martínez and C. Millán de Benavides (eds.), *Mujeres en la música Colombiana. El género de los géneros*.

Sánchez, M. (2016). *Aire No Te Vendas: La Lucha Por El Territorio Desde Las Ondas*. México: IWGIA.
Sandoval, C. (2000). *Methodology of the Oppressed*. Mineapolis, London: University of Minnesota Press (Theory out of bounds).
Sandoval, C. (1994). 'Re-Entering Cyberspace: Sciences of Resistance', *Disposition, XIX* (46), 75–93.
Segato, R. (2016). "Patriarchy from Margin to Center: Discipline, Territoriality, and Cruelty in the Apocalyptic Phase of Capital". *South Atlantic Quarterly, 115* (3): 615–624.
Steingo, G., and Sykes, J. (2019). "Introduction" *Remapping Sound Studies in the Global South*, April.
Sterne, J. (2003). *The Audible Past: Cultural Origins of Sound Reproduction*. Durham, NC: Duke University Press.
Stoler, A. (2002) *Along the Archival Grain, Epistemic Anxieties and Colonial Common-Sense*, Princeton, NJ: Princeton University Press.
Taylor, D. (2015). *Performance*. Buenos Aires: Asunto Impreso Ed.
Twenty Summers. (2022, October 3). "*Indigenous Futures: A Conversation with Yásnaya Elena Aguilar Gil | Twenty Summers 2022*". [Video]. https://youtu.be/7VXbGmHG6X8.
Valencia, S. (2018). "El transfeminismo no es un generismo". *Pléyade. Revista de Humanidades y Ciencias Sociales, 22* (Julio–Diciembre): 27–42.
Voegelin, S. (2014). *Sonic Possible Worlds*. New York: Bloomsbury Publishing.

2
LISTENING TO OUR LISTENING

Deep Listening in Critical Sites

Stephanie Loveless and Freya Zinovieff

Listening to Our Listening

This chapter addresses contemporary engagements with and decolonial critiques of Deep Listening, the practice of sonic awareness developed by the late American composer Pauline Oliveros. We consider the influence of Deep Listening as it is practised within the fault lines of settler-colonial violence in the United States and Canada. In our creative work as sound artists, we navigate these fault lines in locations that range from vacant city lots (Loveless, 2024b) to maritime borders and rivers (Zinovieff, 2023a, 2023b; Zinovieff et al., 2022; Zinovieff & Aceves Sepúlveda, 2020). In this co-authored chapter, we examine the influence of Deep Listening in artworks that respond to two sites of settler-colonial violence and disruption: *Dispatch* and *Cry of the Third Eye*. *Dispatch*, by Candice Hopkins (Carcross/Tagish) and Raven Chacon (Diné-American) was written in response to Chacon's experiences at the Standing Rock Reservation in North Dakota, a place of ongoing struggle for Indigenous self-determination (Hopkins & Chacon, 2020). Li(sa e.) Harris' *Cry of the Third Eye* is an opera-film grounded in Houston's Third Ward, a historically Black neighbourhood in the American South undergoing rapid gentrification (Harris, 2020). In what follows, we situate Oliveros' legacy within the specifics of its historical and cultural context and engage the important questions of ethics and appropriation we hear being asked of Deep Listening in our contemporary moment. To this end, we critically examine both the potential role of Deep Listening in decolonial, anti-imperial, and anti-capitalist projects and the ways that practices of decoloniality might contribute to Deep Listening. We write with a shared voice for the substance of the chapter but begin with personal reflections as a way of situating the individual stakes that drive our collaborative inquiry.

DOI: 10.4324/9781003348528-5

Stephanie

In 1999, Pauline Oliveros wrote a playful and expansive collection of observations, speculations and predictions for listening in the new millennium, titled "Quantum Listening: From Practice to theory (to practice practice)." Woven throughout the text are provisional definitions of something she calls quantum listening, described variously as listening "to more than one reality simultaneously," listening "in both places at once," "being changed by the listening," and (my favourite of these definitions, and the one to which I keep returning) "listening to our listening" (Oliveros, 2022, p. 59).

Over the nearly 20 years in which I have engaged with Pauline's work, I've been struck again and again by the way new understandings unfold as I reread her words at different times and in different contexts. Now, as the current director of the organisation that stewards her practice, the Center for Deep Listening at Rensselaer Polytechnic Institute, I've been hearing the phrase "listening to our listening" in new ways – ways that deepen my respect for the prescience and relevance of her work, but that also support me in listening to and engaging critique.

I hear, of course, resonance with the Buddhist tenet of "observing the observer," reflective of her long engagement with various Eastern movement and meditation practices (Oliveros, 2005). Pauline engaged deeply and respectfully with many of these. She named and cited her studies in Tibetan Buddhist Shine practice with H.E. T'ai Situ Rinpoche, Za Zen practice with John Daido Loori, Yoga meditation with Dr. Rammurti S. Mishra, Chi Kung from Taoist Master T.K. Hsih, and Shotokan Karate with Lester Ingber (in which she earned a black belt) (Oliveros, 2005, p. 93; von Gunden, 1980). At the same time, this resonance brings me into the troubled territory of appropriation of non-Western cultural materials in the 20th-century Western avant-garde. In her invitation to "listen to our listening," I hear resonance, too, with the imperative set forth by Indigenous, Black, Chicanx, and feminist scholars to acknowledge the social, historical, and geopolitical positions that shape our perspectives and perceptions (Anzaldúa, 2012; Haraway, 1988; hooks, 1981). From my position as a white person, a settler, a practitioner of Deep Listening, and the person currently directing the organisation that stewards her practice, these resonances bring me into such questions as: When engaging in any listening practice, can we listen to the listening of the practice itself? Can I attend to the biases built into my own practice, and listen for what it may not hear? Can I acknowledge the limits of the context in which Deep Listening emerged and, alongside my reverence for what it continues to offer, hold space for the places where it is being called to shift?

Freya

Alongside Stephanie, I think about the potential for Deep Listening to contribute to individual and collective forms of decolonial praxis. Rather than retreat in the face of the horror of colonial violence, Deep Listening offers tools that might be useful guides for listening in uncertainty, complexity, and sorrow. In the recent book A Year of Deep Listening *(2024), which includes 365 scores in celebration of Oliveros' legacy, I was honoured to contribute "A Score for Listening to that which we Cannot Hear." In this score, I think through some of the nuances and tensions I experience around listening on Indigenous sound territories where I live – the lands of the xʷməθkʷəy̓əm (Musqueam), Sḵwx̱wú7mesh (Squamish), and səlilwətaɫ (Tsleil-Waututh) Nations in British Columbia, Canada, stolen by my British colonial ancestors – alongside larger contexts in which I am implicated via the use of my tax dollars by the military industrial complex and my position within the military colonial academic industry. In the score, I prompt the listener towards analytic engagement with their embodied and politically situated experience: "Listen to discomfort, listen to your knowing, might it be undone?" (Loveless, p. 444).*

At this moment, my listening is shaped by deep sorrow about the continued violent legacies of the British imperial project, including colonial genocides of the Indigenous populations in Canada and occupied Palestine. I feel great cognitive dissonance around the utilitarian potential of my listening in relation to the languages of denialism and propaganda that seek to deny both of these genocides. Within this armature, I reflect on the historical moment of the Vietnam War, which shaped Oliveros' development of Deep Listening and her decision to "retreat" into the practice of listening. Oliveros' proximity to the imperial violence of those times was instrumentally formative. So too, as listeners in the Global North, situated, at the moment of writing, in various proximal relationships to the imperial violence and genocide in Canada and Palestine, we are tasked with urgent questions around what kind of response is required of our listening in these times of abject brutality.

To what use might our listening be put as an insalubrious act that does not seek to sanitise the horrors of colonial violence, nor sanitise listening? The "our" here of course is an intersectional project. How might our collective acts of rage, kinship, sorrow, and togetherness shape how we listen and bear witness to colonial violence? I do not think Deep Listening is the answer, but I do want to underscore the value of its practices as potential tools in the collective project of decolonial resistance.

Colonial and Anti-colonial Listening

Theories and actions to resist ongoing acts of domination implemented by the historical and contemporary practices of colonialism are heterogeneous and emerge from diverse contexts and places. Given this diversity, it matters which anti-colonial frameworks are engaged, by whom, and where. As sound scholars currently living and working in the context of the United States and Canada, in this chapter we focus on artworks and decolonial scholarship and practice that are grounded in the sonic and that emerge from Turtle Island.

We centre our inquiry in relation to the contributions of *xwélmexw (Stó:lō/ Skwah)* scholar Dylan Robinson, whose influential 2020 publication, *Hungry Listening: Resonant Theory for Indigenous Sound Studies*, offers an analysis of both Indigenous and settler-colonial forms of listening in the context of Canadian Indigenous sound territories. Robinson comes to the term hungry listening (*shxwelítemelh xwlala:m*) through the pairing of the Halq'eméylem words for "listening" (*xwélalà:m*) and for "white settlers" (*xwelítem*, a word that translates to "starving person," in reference to early settlers' hunger for both food and gold) (p. 2). Hungry listening is described as a rigid, extractive, and instrumentalising form of perception that both shapes and is shaped by settler colonialism. As a first step towards unsettling this hungry listening, Robinson argues for settlers and Indigenous folks alike to practise what he calls "critical listening positionality," or "guest listening" – an ongoing critical analysis of how our identities and histories within the settler-colonial context formulate how we listen. While Robinson proposes no overarching solution or one-size-fits-all alternative to the fixed rigidity and extractive nature of colonial forms of listening, he encourages Indigenous peoples to reclaim their cultural modes of listening. In tandem, he calls for settlers to develop their *own* forms of allied listening – forms that must resist colonial logics while refraining from consuming "alterity and Indigenous content" (Robinson, 2020, p. 72).

Robinson carves out space in the conclusion of *Hungry Listening* for this settler work, inviting two trusted settler colleagues – sound scholar and musician Ellen Waterman and ethnomusicologist Deborah Wong – onto the page to process their responses to his book. In the course of their written exchange, Waterman and Wong consider the potential of Deep Listening as a starting point for non-colonial settler listening. Robinson's response, however, is hesitant. While acknowledging a somewhat limited exposure to Deep Listening, he observes: "in my experience the meditative opening up of listening through the body has also seemed to distance me from the particularity of listening positionality" (Robinson, 2020, p. 247). This response inspires our central question: Do Deep Listening practices have the potential to subvert settler listening habits? In other words, is the practice of Deep Listening

compatible with critical listening practices that prioritise awareness of our positionality and situated relationships?

Deep Listening

Deep Listening is a creative practice that cultivates sonic awareness through improvisation, the expansion of listening beyond the ear to include the whole body, and attention to listening in dreams and imaginal states. Oliveros developed her first collection of listening scores, *Sonic Meditations* (1971/1974), in response to both the heterosexist musical forms and cultures in which she was embedded, and to the violence of the Vietnam War (Oliveros, 1974b). Within the political context of the first televisual witnessing of American-inflicted war crimes and widespread protest,[1] Oliveros spent two years workshopping non-violent, non-coercive, feminist, and lesbian frameworks for listening and creative response (Mockus, 2007, p. 40). She did this within an all-female-identified research collective that she called the ♀ Ensemble.

In her discussion of Oliveros' practice in relation to feminist consciousness-raising groups of the 1960s and 1970s, musicologist Martha Mockus points to the qualities of accessibility, relationality, embodiment, and non-hierarchical organisation within *Sonic Meditations* as formative of Oliveros' "lesbian musicality." These scores provide opportunities to practise forms of social organisation that function otherwise from those offered in Western patriarchal musical structures and make space for individual and collective healing in the face of imperial violence. Might these scores, and the practice of Deep Listening itself, also offer alternatives to the fixed instrumentalism of settler-colonial ways of perceiving, knowing, and doing?

Oliveros understood listening as a practice of attunement, connection, and creative response that could and should be available to all, and she designed the scores in *Sonic Meditations* to be accessible, participatory, and constitutively relational. Composed with words rather than musical notation,[2] the scores generally require nothing more than a body and a voice to participate. While Oliveros wrote scores for traditional ensembles and orchestras, recorded albums, and performed in front of audiences, these scores preclude a separate viewing/listening audience; all present are at once composer, performer, and audience, with and for each other. Participants attune collectively to their own bodies and breath rather than to a centralised conductor and scores develop gradually, making space for diverse bodies and voices to find their own sounds, pitches, and rhythms. Typically, the beginning of a sonic meditation is marked by an intake of breath, with endings left to emerge through subtle non-verbal negotiation, via instructions such as "continue as long as possible, or until all others are quiet" (Oliveros, 1974). In this way, performers are invited to listen and respond to themselves and whatever and

whomever it's possible to hear and sense, negotiating agency and surrender, relationally together.

In contrast to the "single-sense" orientation of hungry listening (Robinson, 2020, p. 69), Deep Listening scores and exercises cultivate an experience of listening that is both embodied and multidimensional. For Oliveros (2000), the practice of listening "in every possible way to everything possible to hear" (p. 47) included not only sounding with rocks, rivers, and emerging technologies but also listening with the body and in dreams. Oliveros developed an understanding of the "deeply listening body" that listens through movement, through the bottoms of the feet, or through the eyebrows (Oliveros, 1974, p. 8; Whitney Museum, 2014) in collaboration with movement artist and T'ai Chi/Qi Gong instructor, Heloise Gold (2018). Practices of listening across the universe, interdimensionally, and in dreams were developed alongside her life partner, the writer, director, and avowed dream specialist, IONE. Oliveros articulated this expanded understanding of listening through the three areas of practice around which her retreats and courses were, and continue to be, organised: sonic awareness, movement, and dreaming.

Deep Dreaming

Imaginal states have always been central to Oliveros' work, from her early experiments in the amplification of subaudible frequencies to the scores in *Sonic Meditations* that involve both playful and serious experiments in imagination and telepathy. Oliveros' collaboration with IONE deepened this attention to imaginal states in her work. A descendant of a long line of Black abolitionist women, IONE has dedicated her life to creating spaces where dreams can flourish, unhindered by the rigidity and control of what she calls "colonial mind" (Ione, 2013, 2023). We understand the attention to dreaming in IONE's work (which includes an Annual Dream Festival, now in its 29th year) as situated within a radical Black lineage that runs from the Afrofuturism of Sun Ra (Reed, 2013) to the resistant rest of Tricia Hersey's The Nap Ministry, where dreaming is "the way we move toward Liberation because it is a direct disturbance to the collective reality of Life under capitalism" (Hersey, 2022, p. 112). Indeed, IONE describes Deep Listening as a transformative practice that, through its insistence on the boundless wisdom of the body and of dream, has the capacity to unsettle colonial logic and rewild our creative capacities. It is from this perspective that we understand attention to dreaming within Deep Listening not as a form of escape, but as one of creation and community-building that works with and beyond the edges of technology and our accepted perceptual limits.

In the context of 20th-century musical culture, Deep Listening emerged as a radical practice that prioritised the relational responses of the body through both multi-sensory and dream awareness. Through its continual evolution within different environments and communities, Deep Listening retains this

relevance today and, in this context, it is not surprising that Waterman and Wong offer Oliveros' practice as a potential pathway towards decolonial sensory practice. At the same time, it is unsurprising that Robinson, as an Indigenous sonic theorist and practitioner, should express scepticism.

Staying with the (Settler) Trouble

While Deep Listening is now articulated through an increasingly diverse global following, it emerged from a specifically situated settler context: the 20th-century musical avant-garde within what is colonially known as the United States of America. Despite the ways that Oliveros' identity as a woman and a lesbian complicates her relationship to the heteropatriarchy of these contexts, her work cannot be extricated from the "total climate" (Sharpe, 2016) of colonialism and of anti-Blackness that has built our cities, birthed our institutions and continues to shape settler culture in the United States, and indeed in Canada. In this regard, there is no possible "move to innocence" (Tuck & Yang, 2012); we are all implicated, in positionally dependent ways, in the ongoing systemic and cultural violence that defines these places. In light of this reality, and our collective intent to challenge our relationships to listening and the disciplinary structures with which we engage, we seek to "stay with the trouble" (Haraway, 2016) of the settler histories of Deep Listening. Part of this work, for us, involves acknowledging the aspects of Oliveros' work that reflect the Indigenous erasure and appropriative "interculturality" of both the mid-20th century musical avant-garde, and of the New Age movement.

Following earlier 19th- and 20th-century forms of esotericism, such as Spiritualism, Theosophy, and the Human Potential Movement, the New Age movement emerged in the early 1970s at least partly in response to the technocratic, murderous systems at play around the time of the Vietnam War and to the rabid capital and consumerist ideologies of the 1980s (Sebald, 1984). In their search for new forms of ethics and meaning-making, New Age romantics appropriated a variety of Indigenous, European, and Eastern traditions, extracting them from their original contexts. While Oliveros dismissed the "new age" label as a "marketing term" and expressly did not identify with it (The Morning Call, 1987), her work was contemporary with the new age movement, has often been associated with it, and arguably shares many of its characteristics.

In a similar manner, and during the same time period, the 20th-century musical avant-garde – a movement with which Oliveros *did* identify – also found new sounds, sonic forms, and musical approaches in a range of non-Western traditions. Here, we think of John Cage's uses (and mis-uses) of Zen Buddhist thought and the I Ching as a tool for indeterminate composition (McMullen, 2010), of La Monte Young's studies with Pandit Pran Nath (Keefe, 2010), alongside the way in which Deep Listening integrated a range of Eastern movement and meditation practices. Some of these practices

were gifted from specific knowledge holders and some were internationally popularised and transmitted by lineage-bearers who wanted to make them available to a wider, global audience. Yet other forms were simply appropriated. Oliveros' misappropriation of Lakota ritual, musical practice, storytelling, and spirituality in the work *Crow Two: A Ceremonial Opera* (1975), for example, is well-documented by Choctaw ethnomusicologist Tara Browner. Browner describes Oliveros' Crow Two as problematic from the outset, arguing: "In inspiration, conception, realisation, and publication, Crow Two was a work of musical whiteshamanism" (Browner, 2000, p. 259). In the context of Oliveros' marginalised identity, Browner asks: "does membership in one oppressed group – female/lesbian – confer rights to use another oppressed group's cultural property without permission for the sake of artistic expression?" (Browner, 2000, p. 252).

More recently, Lakota artist and scholar Suzanne Kite guest-edited a special issue of *Ear Wave Event* that critiques Deep Listening through its association with the New Age movement, whiteness, and privilege (Kite, 2023). The special issue, which Kite frames as an Indigenous response to Deep Listening, is made up of a series of interviews with, and artworks by, Indigenous composers. In "Discussion with Raven Chacon," Chacon critiques Oliveros' framing of listening as a "selective" act. He is referring to a much-circulated quotation from the promotional materials of Oliveros' Deep Listening Institute, defining the practice as one that "explores the difference between the involuntary nature of hearing and the voluntary, selective nature – exclusive and inclusive – of listening" (Deep Listening Institute, 2014, p. 1). We note that in Oliveros' writing, she more often differentiates the conscious act of listening from the automatic sense of hearing with words such as "conscious," "active," "aware," and "attentive" (Oliveros, 1974, 1984, 2000). Nevertheless, Chacon is pointing to important questions of agency, privilege, and power in relation to listening. As he argues in the context of the sonic experience of the Standing Rock encampment, "I can't volunteer to hear [...] the LRAD (long range acoustic device) from the cops beaming at me or people screaming at me, telling me to get off the camp [...]" (Chacon & Kite, 2023). In articulating the dissonance of Oliveros' words in the context of Standing Rock and of sounds that violate the listener without their consent, Chacon suggests the idea of listening as a "selective" act only makes sense from a place of safety. Indeed, a stable and safe environment is a prerequisite for attending to the intricate patterns of our sonic attention. This is in fact exactly the kind of environment that Oliveros retreated to, and created retreats for, as she developed her listening practice.

From Rose Mountain Retreat to Standing Rock Encampment

I came to UCSD in 1967 and the Vietnam War protests and atrocities were at their height. A student at UCSD sat in the plaza, poured kerosene on

himself and burned himself to death. Then I was watching my television set when Robert Kennedy was assassinated. I had been asleep, just before it happened I woke up and saw it. I felt the temper of the times. I felt the tremendous fear and – what can I say – the opposite of calm. Everybody was in an uproar and I began to feel a tremendous need to find a way to calm myself. The pressures were too great. The social events were simply mirrors of what was inside. I began to retreat.

(Oliveros in Roth, 1977, p. 11)

We assume that as humans we hear in the same manner although not all ears have the same acuity. And, because we do not all share the same culture, we definitely are not all listening in the same way with the same attention. [...] Soon we will be faced with an unprecedented exponential acceleration in technology. [...] How do we understand normal hearing? What are we listening for? [...]When we cannot process complex information we tend to shut down our senses and retreat. What if such retreat was impossible?

(Oliveros, 2000, pp. 56–57)

Oliveros described many moments that contributed to the development of Deep Listening. These include the sounds revealed through a microphone hung from her San Francisco apartment window in 1958 (Oliveros, 1984, p. 182), the practice of singing long tones (Oliveros, 2015, p. xvii), and experiences of heteropatriarchy within the music world (Oliveros, 1970). Of great significance, however, was her experience of sorrow and social turmoil wrought by the Vietnam War (Roth, 1977). These experiences drove her to turn inwards and experiment with the potential "healing power" of sonic practice in community with others (Oliveros, 1974, p. 1).

In 1999, Oliveros wrote, "When we cannot process complex information, we tend to shut down our senses and retreat" (Oliveros, 2022, p. 57). She was speculating on a predicted future of information overload. This resonates sharply in our contemporary moment; we are living in that future. Presumably, in using the word retreat here, Oliveros is not referring to her own Deep Listening "retreats," gatherings set in bucolic natural environments. However, as we consider Oliveros' work, it is worth exploring the connections between retreat as a withdrawal (defined in relation to what one is moving away from) and retreat as a dedicated time and place for training and/or restoration (defined in relation to what one is moving towards).

The Deep Listening retreats that Oliveros developed with IONE and Heloise Gold, first offered in 1991, were intended to provide a "whole learning situation" set in an expressly "beautiful natural mountain environment" (Oliveros, 2000, p. 50). While these retreats were dedicated to an *opening* of the senses, they also offered a space of retreat from the overload of violence,

heteropatriarchy, and complications of everyday life. These retreats were of course only accessible to those who could take time off from work, make their way to northern New Mexico, and pay the required tuition. Shaped by capitalism, white middle-class tourism, and the absence of connection to local Indigenous cultures and histories, the retreats both rendered *invisible* and *reflected* the historical violence and complexity of their site, while at the same time providing a protected environment for mutual study. Returning to Oliveros' words about retreat in the face of overwhelming complexity, her next words are important: "What," she asks, "if such retreat was impossible?"

As differently positioned sonic practitioners (one of whom attended more than one of these retreats), we argue that, while it may be at times necessary and important to practise *in retreat*, if we *only* practise in specialised and curated locations, we are in fact closing our ears to what we do not want to hear. Together with Kite and Chacon, and at a time when retreat (which was never available for some) is increasingly unavailable, we suggest that the violence of our current moment demands that we bring our attention to sites of existential, physical, emotional, psychic, ecological, and social struggle. The violence of this moment demands that we dedicate our community-building practices to remediating injustice, and that, whenever and wherever we can, we *act* rather than *retreat*. Within this context, listening might be confronting, complicated, painful, and insalubrious.

Studies for Deep Listening in Critical Sites: Dispatch

> Dispatch is either a transcription of events around the 2016 DAPL encroachment at Standing Rock, a prompt for an ecological oral future, or at the very least, a critique of the privilege of meditative Deep Listening. This score can be realized as a performance or as a series of imagined events. It can also be enacted in the real world [...]. In an increasingly fractured society, new paths and new formations are needed to refocus our attention in an attempt to find truth [...].
>
> *(Chacon, 2020)*

A call for protection of land, *Dispatch* (Hopkins & Chacon, 2020) is a three-part instruction score made up of a series of prompts, diagrams, and protocols "derived from an analysis of the dynamics and organisation of the Water Protectors in defence of Standing Rock during the noDAPL movement, not glossing over the miscommunication, profiteering, and injustices" (Hopkins & Chacon, 2020). *Dispatch* was written by Hopkins and Chacon in response to Chacon's experiences at Standing Rock in 2016–2017 during the resistance movement against the Dakota Access Pipeline project.[3] The score is informed by diverse tribal stories: such as the way that rocks are sung into being for Tlingit people (C. Hopkins, personal communication, August 15, 2023) and the way that nonhuman harmonics are understood in Anishinaabe

ontologies, following the work of Dolleen Manning (Chacon and Hopkins, 2021). It is shaped equally by the history of the American Indian Movement and contemporary Indigenous resistance through direct action (R. Chacon, personal communication, August 15, 2023).

In a 2021 online talk hosted by The International Institute for Critical Studies in Improvisation (IICSI), Chacon states that *Dispatch* was written to "relay the concerns of those who are protecting the land, and perhaps even the land itself" (Chacon & Hopkins, 2021). The score unfolds over a series of three dispatches: The Call, The Gathering, and The Aim. The first of these dispatches grounds the score in the land – the rock – that is under siege. Participants, or players, are asked to gather at the site of this rock and, importantly, to consider their own role in this place, be they a Front-Line Activist, a Helper, a Witness, an Artist, or a Temporary Sympathiser. The second dispatch offers a set of prompts, or protocols, for engaging with others and with the land, on site. These prompts range from listening and witnessing, to broadcasting, to initiating a larger gathering. The third dispatch asks performers to reflect on the needs of the land and its stewards, on their own roles and resources, and on the social and structural dynamics of the gathering. This leads to the final prompt of the score, which offers participants a series of possible paths towards the creation of new gatherings, at this site or at another in need of defence. In their program notes, Hopkins and Chacon suggest that *Dispatch* can be understood as a transcription of events at Standing Rock, as a "prompt for an ecological oral future," or as a "critique of the privilege of meditative Deep Listening" (Chacon, 2020; Figure 2.1).

The relationship between the score and Deep Listening is both complex and generative. In their IICSI talk, Hopkins describes *Dispatch* in the context of an ongoing inquiry into decolonial listening and asks whether "Deep Listening, perhaps divorced from its roots, can help us tune out the colonial

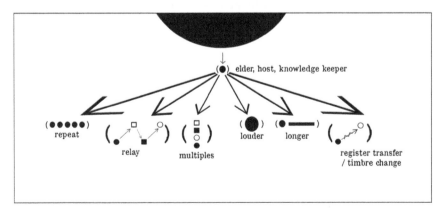

FIGURE 2.1 Schematic 1 from *Dispatch*, Candice Hopkins and Raven Chacon (2020).

subfrequencies that surround and infiltrate us" (Chacon & Hopkins, 2021). We understand this caution towards the "roots" of Deep Listening to refer to its emergence in the context of the primarily white, settler, Western 20th-century cultural avant-garde. While the score is framed in part as a critique of Deep Listening, it is also indebted to Oliveros' influence.[4] *Dispatch* asks what happens to our depth of listening when we are surrounded not by the privilege of retreat, but by the chaos of water cannons, protest chants, and disinformation campaigns. It reorients the listening body in relation to site and imagination.

Importantly, in centring Standing Rock, *Dispatch* asserts the inextricability of land – its harmonics and its agency – from experiences of listening, of body, and of dream. While Oliveros' scores bring the human performer into sensitive relational attunement to, and improvisation with, human and more-than-human others, the individual human body remains the starting point in Deep Listening scores. This marks the practice's historical enmeshment, despite itself, in settler ideologies of human supremacist individualism. Conversely, *Dispatch* begins and ends with the *site*. The agency, personhood, and needs of the land are centred: the listener is asked to attune to the harmonic frequencies of Standing Rock, to listen to *its* body and *its* needs, and to heed *its* call. The listener is called upon to travel to sites in need of protection and place their listening and fundamentally vulnerable body at risk.

At the same time, one of *Dispatch*'s provocations is that it can be enacted not only at different sites but also as "a series of imagined events" (Chacon, 2020). While the score is a serious activist invitation, it allows equally for the unknown and unknowable power of what IONE would call "the dream of reality and reality of the dream" (Ione, 2023). Imagination is invoked as a site of anticolonial transformation, alongside material, on-the-ground engagements. Importantly, the score is not limited to imagination, and any "imagined events" are ignited by the knowledge that the score has previously been, might currently be, and ultimately *must* be enacted on the ground. This is what *Dispatch* offers those who work within and care about the lineage of Deep Listening in a time of poly-crisis, a redirection of listening, embodiment, and dream from individual human bodies to the calls of the land itself.

Studies for Deep Listening in Critical Sites: Cry of the Third Eye

Deep Listening includes three areas of practice: listening, movement, and dream. These three orientations towards listening are also foundational to the work of Li(sa E.) Harris – an interdisciplinary artist, creative soprano, composer, educator, and long-term Deep Listening practitioner who collaborated with both Oliveros and IONE. Harris has voiced her deep resonance with Oliveros' work, describing her, along with IONE, as a "living ancestor" (L. Harris, personal communication, March 19, 2024). These resonances are evident in Harris' *Cry of the Third Eye* (2022). Twelve years in the making,

this three-part, award-winning opera-film documents the colonising forces of gentrification in the Third Ward, a historically Black neighbourhood of Houston, Texas. Both Harris and Oliveros were born and raised in Houston and, with this in mind, Harris has described the city itself as a site of origin for Deep Listening, asserting that she and Oliveros shared an understanding of "the symphony that is the soundscape of Houston" (L. Harris, personal communication, March 19, 2024).

Through lyrical sequences, parodic playacting, candid interviews, and surreal imagery, *Cry of the Third Eye* offers a testimony of embodied joy, creativity, and resistance to the corporate values and gentrification that seek to destroy irreplaceable aspects of community. The film depicts capitalism as a totalising force of modernity that seeks to abolish the textures of local life and culture, and it shares the creative forms of perception and expression that resist and flourish in the face of that force. The film follows the real and fictionalised lives and stories of Third Ward inhabitants over a space of 12 years, ultimately including Harris herself as her own home is threatened and then demolished. Offering poignant and tender insights into the intimate details of life in the Third Ward, the film examines larger histories and narratives around race, class, and capitalism with care. Throughout, *Cry of the Third Eye* demonstrates the resistive potential for creative practices of embodied movement, collaborative sounding, and radical dream in this particular site of critical conflict.

As an opera film, *Cry of the Third Eye* is organised around song, sound, and silence. Harris' voice threads throughout, serving alternately as narrator and commenting chorus. Songs – sometimes in the form of recitative and sometimes aria, sometimes blues and sometimes pop – shift in tone and tempo from lament to joy to relentless propulsion. Beyond song, many of the most striking moments of the film are transmitted through sonic elements: the shock of a wrecking ball recurs throughout the film, reverberating ominously without warning; a heart-rending scream accompanies the screeching of a relentless train. In contrast, numerous silent sequences underscore the absences – of people, of homes, of relationships – with which the film reckons. In the film, relationships to place and the experience of belonging are expressed primarily through the vibrational languages of the sonic, and the audience is asked to experience the film through their listening.

The film's storytelling is articulated through the shifting rhythms, temporalities, interruptions, and surrealism of dream. The story itself rides the hypnagogic line between reality (the cast is made up of Third Ward residents) and magic (a little girl pedals a glowing bicycle along telephone wires, across rooftops, and over the forearm of a local storyteller). Within this liminal space, Harris' characters/collaborators express their full, embodied, creative, and joyful humanity in the face of dehumanising systems of erasure. All of the residents who appear as characters in the film play more and less fictionalised versions of themselves. Only the encroaching gentry – the house-hunting

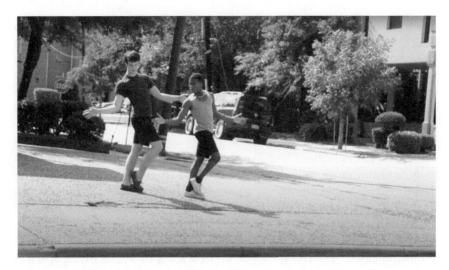

FIGURE 2.2 Screenshot from *Cry of the Third Eye*, Lisa E. Harris (2020).

couple and their real estate agent – are presented as fully fictional roles: within the logic of the film, they are stereotyped characters rather than authentic or "real" (Figure 2.2).

Expressive movement is another central motif of *Cry of the Third Eye*. The surreal, or "dreamy," interludes described above are often articulated through dance. Characters perform movement improvisations in vacant lots, on cement blocks, and on street corners. The exuberant excess of their movements asserts their creative lifeforce in the face of the dehumanisation of racialised geographies. Saidiya Hartman theorises these racial-colonial geographies through the framework of the "afterlife of slavery," which describes how the persistent devaluation of Black life impacts the physical and infrastructural environments of majority Black communities (Hartman, 2008). Importantly, the beauty and exuberance of the movement sequences in *Cry of the Third Eye* are not superimposed onto their environments; rather, they emerge from the performers' deep connection to these places where they live, work, love, and mourn. Despite its embeddedness in a site of ongoing civic and environmental injustice, the film is imbued with a sense of joy. This is expressed in the voice of one of the film's protagonists, a young girl, who introduces the chant that becomes the core chorus of the film: "Third Ward is our home, YES! Third Ward is our land."

In resonance with the way in which *Dispatch* centres all Players, prompts, and protocols around the call of Standing Rock itself, Harris moves beyond human exceptionalism by identifying Third Ward itself as "the main character of the film" (L. Harris, personal communication, October 30, 2024). Through the redistribution of human/land power dynamics, each of these

works demonstrates the reverberation of Deep Listening when grounded deeply in community, and critically tied to location.

Conclusion: Deep Listening Futures

As sound artists and scholars, we understand listening as a dynamic, reflexive, situated process that is central to how we perceive, internalise, and (re)create the world around us. Our forms of listening matter. Following Robinson's suggestion that settlers generate their own allied listening methodologies (Robinson, 2020, p. 239), we argue for the potential of Deep Listening as one such method. Deep Listening involves listening to dreams and imaginal states (where we conceive of other worlds), listening through socially and politically situated creativity (where we practise other ways of being), and listening in situated, embodied localities (with land, site, and context).

In light of this, it is important to *acknowledge* – to not step over – the cultural appropriation baked into the 1970s avant-garde music and somatics work that formed the context out of which Oliveros' practice emerged. We believe strongly that it is only in grappling with these difficulties, accepting them as a troubling part of our history and present, without purity (Shotwell, 2016), that we can collectively sit with the complexities of inherited practices and chart new ways forward, grounded not in the pretension of innocence, but rather in the understanding of *where* we are speaking from, *why,* and to *whom*. Furthermore, we argue that there is potential for Deep Listening within this endeavour. As a pedagogical and community practice, Deep Listening is not, nor was ever designed to be, prescribed, dogmatic, static, or fixed. Oliveros was known to insist that she didn't know what Deep Listening was any more than the students in the room. Instead, she invited us into the process of continuously figuring that out, together (Loveless & Zinovieff, 2023, p. 2).

In these practices and philosophies of expanded, soft, more-than-cochlear listening, we actively co-create futures beyond the dominant colonial, white supremacist, cisheteropatriarchal, and genocidal matrices of power. This horizon is not one of absolution. Rather, we acknowledge the tangled mess of multi-layered complicity, accountability, and relation. We affirm the urgency of this task and situate listening as a more-than-individual and more-than-human project. It is with this in mind that we turn to projects such as *Dispatch* and *Cry of the Third Eye* – projects that critically, lovingly, and collaboratively expand the practice of Deep Listening in ways attuned to the current moment.

Score for Situated Listening (for a Gathering of Humans, Online, or in Person)

Stephanie Loveless and Freya Zinovieff

Let your attention move around the room (whether virtual or fleshy) in which you are gathered and notice all the other bodies in the space.

How does it feel to be connected to these other bodies, as part of this temporary or ongoing community?

Notice the contact between your body and the chair, your clothes, your shoes, and everything that touches your skin. Notice the feeling of breath as it moves out of your body and in again.

Notice the sounds around you, near and far, and the precise moment that sound meets your body.

You can close your eyes here. Can you perceive a moment of connection between your body and the sounds you can hear? Where are you situated in relation to the sound around and within you?

Can you expand your listening to the resonances and dissonances of the partial perspectives of all the bodies that you are aware of, and of all of the bodies that you are not aware of – microscopic, infinite, past, and future, across the vastness of time?

Come back to your own body now, situated, in place.

Consider: What murmurings can you hear beyond that which you have been taught to understand as intelligible? How are your ears shaped by your unique identities and histories? How might we heed the call of the land itself on which we are located?

Having considered this – through writing, through drawing, through conversation, through improvisation – what sound, song, shape, gesture, demand, or action are you now moved to perform?

Create a collective plan, score, project, or agreement to bring this offering into the world, whether publicly, privately, or somewhere in between.

Note: A version of this score was published in the paper "Situated Listening: Partial Perspectives and Critical Listening Positionality" in the Acoustic Ecology Review Vol. 1 No. 1 (2023).

Notes

1 We cannot help but draw parallels here between Oliveros' witnessing of the first televisual broadcast of American war crimes, in Vietnam, and our collective experience as we write this chapter, during the first American-led genocide to be mediated by the digital as Palestinians live stream their ethnic cleansing in real time.
2 For more on the form of the instruction score in Oliveros' work, see Loveless (2024, p. 12).
3 Since 2014, the Standing Rock Sioux Tribe has fought against the Dakota Access Pipeline, which threatens unceded Indigenous lands with a crude oil transport system. In 2016, Indigenous youth brought global attention to their cause via social media, igniting a movement that drew thousands of activists to Standing Rock in months-long protest. This resistance was met with intense violence.
4 Hopkins and Chacon offered their score for inclusion in a publication organised by the Center for Deep Listening honouring Oliveros' legacy. In this act, we read both a generous gesture that allows the score to be seeded wherever it is invited and a "calling in" (Trần, 2013) of the Deep Listening community towards collective anticolonial listening futures.

References

Anzaldúa, G. (2012). *Borderlands / La Frontera: The New Mestiza* (4th ed.). Aunt Lute Books.
Browner, T. (2000). "They could have an Indian soul": Crow two and the processes of cultural appropriation. *Musicological Research, 19*, 243–263. https://doi.org/10.1080/01411890008574774
Chacon, R. (2020). *Dispatch* (introduction). https://disclaimer.org.au/contents/unsettling-scores/dispatch
Chacon, R., & Hopkins, C. (2021). Thinking spaces 2020–21: Raven Chacon and Candice Hopkins. https://improvisationinstitute.ca/document/thinking-spaces-2020-21-raven-chacon-and-candice-hopkins/
Chacon, R., & Kite, S. (2023). Discussion with Raven Chacon. *Ear Wave Event, 7*. https://earwaveevent.org/article/discussion-with-raven-chacon/
Deep Listening Institute. (2014). *Second Annual International Conference on Deep Listening*. https://deeplistening.org/site/sites/default/files/files/DLC2014_conferenceprogram_FINAL.pdf
Gold, H. (2018). *Deeply Listening body*. Deep Listening Publications.
Haraway, D. J. (1988). Situated knowledges: The science question in feminism and the privilege of partial perspective. *Feminist Studies, 14*(3), 575–599. https://doi.org/10.2307/3178066
Haraway, D. J. (2016). *Staying with the trouble: Making Kin in the Chthulucene*. Duke University Press. https://doi.org/10.1215/9780822373780
Harris, L., E. (2020). *Cry of the third eye*, a new opera film in Three Acts. https://lisaeharris.com/cry-of-the-third-eye
Hartman, S. (2008). *Lose your mother*. Farrar, Straus and Giroux. https://us.macmillan.com/books/9780374531157/loseyourmother
Hersey, T. (2022). *Rest is resistance: A manifesto*. Little, Brown Spark.
hooks, b. (1981). *Ain't I a Woman: Black women and feminism*. South End Press.
Hopkins, C., & Chacon, R. (2020). Dispatch.
Ione, C. (2013). *Pride of family: Four generations of American women of color*. Broadway Books.

Ione, C. (2023, March 24). *Deep Listening futures: Beyond colonial mind*. [Public talk]. The Center for Deep Listening.

Keefe, A. (2010). Lord of the Drone: Pandit Pran Nath and the American Underground. *Bidoun*, 20. Bidoun Projects.

Kite, S. (n.d.). Listening Beyond. *Ear Wave Event*, 7. Retrieved July 9, 2024, from https://earwaveevent.org/article/listening-beyond/

Loveless, S. (2020). Tactical soundwalking in the city: A feminist turn from eye to ear. *Leonardo Music Journal, 30*, 99–103. https://doi.org/10.1162/lmj_a_01100

Loveless, S. (2024a). *A Year of Deep Listening: 365 Text Scores for Pauline Oliveros*. Terra Nova Press.

Loveless, S. (2024b). This street is a song. https://sonorities.net/2024/events/this-street-is-a-song/

Loveless, S., & Zinovieff, F. (2023). Situated listening: Partial perspectives and critical listening positionality. World Forum of Acoustic Ecology: Listening Pasts, Listening Futures. Florida, USA.

McMullen, T. M. (2010). Subject, object, improv: John Cage, Pauline Oliveros, and Eastern (Western) philosophy in music. *Critical Studies in Improvisation, 6*(2). https://doi.org/10.21083/csieci.v6i2.851

Mockus, M. (2007). *Sounding out: Pauline Oliveros and Lesbian Musicality*. Routledge. https://www.routledge.com/Sounding-Out-Pauline-Oliveros-and-Lesbian-Musicality/Mockus/p/book/9780415973762

The Morning Call. (1987, January 23). For Her, New Age Music Is Old Hat. https://www.mcall.com/1987/01/23/for-her-new-age-music-is-old-hat/

Oliveros, P. (1970). And don't call them 'Lady' composers—The New York Times. *New York Times*. https://www.nytimes.com/1970/09/13/archives/and-dont-call-them-lady-composers-and-dont-call-them-lady-composers.html

Oliveros, P. (1974). *Sonic meditations*. Smith Publications.

Oliveros, P. (1984). *Software for people: Collected writings 1963–1980*. Smith Publications. https://familiartrees.com/products/software-for-people-collected-writings-1963-1980-by-pauline-oliveros

Oliveros, P. (2000). Quantum listening: From practice to theory (to practise practice). *MusicWorks*, 75 (Plenum Address for Humanities in the New Millennium). https://digitalrepository.lib.hku.hk/catalog/8910qv53t#

Oliveros, P. (2015). *Deep Listening: A composer's sound practice*. Deep Listening Institute.

Oliveros, P. (2022). *Quantum listening*. Ignota Books. https://ignota.org/products/quantum-listening

Reed, A. (2013). After the end of the world: Sun Ra and the Grammar of Utopia. *Black Camera: An International Film Journal (The New Series), 5*(1), 118–139. https://doi-org.libproxy.rpi.edu/10.2979/blackcamera.5.1.118

Robinson, D. (2020). *Hungry listening: Resonant theory for indigenous sound studies*. University of Minnesota Press. https://doi.org/10.5749/j.ctvzpv6bb.4

Roth, M. (1977). Interview with Pauline Oliveros by Moira Roth. Pauline Oliveros Papers. MSS 102. Special Collections & Archives, UC San Diego.

Sebald, H. (1984). New-age romanticism: The quest for an alternative lifestyle as a force of social change. *Humboldt Journal of Social Relations, 11*(2), 106–127.

Sharpe, C. (2016). *In the wake: On blackness and being*. Duke University Press.

Shotwell, A. (2016). *Against purity: Living ethically in compromised time*s. University of Minnesota Press.

Trần, N. L. (2013). Calling IN: A less disposable way of holding each other accountable. *BGD.* https://www.bgdblog.org/2013/12/calling-less-disposable-way-holding-accountable/

Tuck, E., & Yang, K. W. (2012). Decolonization is not a metaphor. *Decolonization: Indigeneity, Education & Society, 1*(1). https://jps.library.utoronto.ca/index.php/des/article/view/18630

United Nations Press Release. (2023). *Israel must rescind evacuation order for northern Gaza and comply with international law: UN expert.* The Office of the United Nations High Commissioner for Human Rights. https://www.ohchr.org/en/press-releases/2023/10/israel-must-rescind-evacuation-order-northern-gaza-and-comply-international

von Gunden, H. (1980). The theory of sonic awareness in the greeting by Pauline Oliveros. *Perspectives of New Music, 19*(1/2), 409–416.

Whitney Museum of American Art. (2014, May 6). *Pauline Oliveros | Video in American Sign Language (ASL)* [Video]. Youtube. https://www.youtube.com/watch?v=WvP4MxvFpP0

Zinovieff, F. (2023a). *Grating flesh: Radical hate and the Rio Grande.* Latin American Studies Association Congress, Vancouver.

Zinovieff, F. (2023b). Green, greasy, river thames, Tamesis, dark one, how i love to sink my fingers into your muddy archive, smell your silt, hear your undulations, taste your acrid slime on my skin, my river, bone birther, pipe smuggler, carrier of ancient fat, and murky secrets, the resonance of our pagan rituals still find home with the eels in your water, forgotten, mostly, except by the dear ones, Tamesis, the imperial powers found a way to exploit you, your tides, your depths, your marshlands, your watery organs, harvested for ships like the hms nonsuch, and conquest of a shore that is not ours, and on that shore, human and animal organs violently and savagely harvested, again and again across years and decades, and still continuing [Sound, video, objects found in the River Thames].

Zinovieff, F., & Aceves Sepúlveda, G. (2020). Listening geopolitics and the anthropocene contact zones of the Bali and Georgia Strait. *Leonardo Music Journal, 30,* 114–118. https://doi.org/10.1162/lmj_a_01103

Zinovieff, F., Sepúlveda, G. A., DiPaola, S., & Sun, prOphecy. (2022). Connective tissue and bacterial echoes: Four artists, a river, and an artificial agent. *Ecocene: Cappadocia Journal of Environmental Humanities, 3*(2), Article 2. https://ecocene.kapadokya.edu.tr/index.php/ecocene/article/view/149

3
UNLISTENING

Budhaditya Chattopadhyay and Elen Flügge

Introduction

Underhearing the signal
Misunderstanding the words
Leaving the impulse without response
Ignoring voices of those from the 'outside'

In seeking to understand listening as an everyday practice and method, we can also consider its negation or its boundaries, in terms of "unlistening." As much as we hear and attend to the world around us, we could also be said to *unlisten*. Through this chapter, we speculate on a notion of unlistening along a spectrum of practices, acts, and methodologies from routine psychoacoustic processes to unresponsive and oppressive political positionalities. In this chapter, we identify and call out different possible instances of unlistening. By considering and probing scenarios of unlistening in micro and macro contexts, we aim to build knowledge around the margins of situated listening.

Unlistening may occur on multiple levels of experience, emerging in interaction – as well as in absence of interaction – entailing various degrees of intention. Perceptually, we automatically filter out the otherwise overwhelming inputs of everyday auditory stimuli and information. Depending on the circumstances, an act of situated listening demands a degree of filtering and interpretation – a *positionality*. Beyond perceptual and physiological examples, cases of unlistening emerge in our interpersonal interactions as well, shifting from an unintentional process to a deliberate action or attitude that we may influence. As part of an avoidance tactic to conflict, an unlistening can become part of interpersonal power dynamics. Our communication

DOI: 10.4324/9781003348528-6

today can also be understood as shaped by devices that unlisten for us, such as the filtering algorithms in telecommunication applications. Furthermore, unlistening shows itself in various ways on social, political, and institutional scales. When social institutions adopt a practice of unlistening, it affects power dynamics and freedom of expression, especially of marginalized people or communities. In such a case, unlistening is a problematic intentionality that needs to be challenged. Through considering a multitude of situations, and indulging in an authorial conversation as well as in an inner monologue, we form a situated sense of unlistening as a voluntary, more than involuntary, incapacity to listen. We reveal the embodied exploration of this concept by discussion between ourselves in an unfolding conversational approach, revealing multiple questions that it generates.

Rather than seeking to establish a neologism, e.g., "unlistening," in this chapter, we are focusing on understanding the ramifications when unlistening arises with intention in various situations, from personal to public, and from social to cultural.

Perceptual Underhearing

Strolling down a busy street, I hear city birds from nearby trees, passing snatches of conversations, note the hums of an idling bus. I must have missed the airplanes moving above and, until I listen out for them, I did not register the sounds of my footsteps, perhaps being too interested in hearing the kids playing in the park.

Listening is an ambiguous term in English. Compared with general definitions of hearing, listening is a combination of processes that are influenced by not only our physical condition but also our psychology and sociocultural upbringing. When contrasted with hearing, there is often the suggestion that hearing refers to more passive physiological aspects of auditory processing, while listening relates to conscious aspects that can be intentionally directed and trained. However, our understanding of hearing and listening overlap: hearing is more than just the capacity of our body to receive acoustic input – it involves activation and filtering on the part of our auditory system. Listening involves further layers of processing – this means accepting, weighting, selecting, and rejecting stimuli. Thus, an incapacity to listen might already be said to be in operation when we are decoding environmental input since a portion of input has already been discarded by initial "hearing" stages of auditory processing and is not readily available to a more conscious level of listening.

There is a strong relation between listening and attention more generally. Attention is a complex phenomenon. Studies (Chabris and Simons 2011) have shown how much information we miss when our attention is directed elsewhere. This is true of any type of sensory input, including acoustic.

Psychoacoustics considers this a process of "informational masking," where one sonic input or event is covered, masked, by another – likely resulting from activity at several stages of auditory processing (Kidd et al. 2008, Sterne 2012a). Making sense of a constant stream of auditory input requires us to ignore or reject parts of this stream, and to make judgments about the importance of the rest. Much of these discernments are not conscious, but happen before we are aware they have taken place. This stems from a useful and necessary physiological-psychological process of filtering and structuring an otherwise overwhelming flow of sensory, perceptual input. Insofar as this is involuntary, we might not think of this as unlistening just yet, but more as an underhearing which is part of what can become an overall voluntary and intentional listening (or unlistening) process.

This level of filtering or selective attention has been characterized in various ways, such as in the sonic effect of *synecdoche* described by Augoyard and Torgue:

> For someone listening to a complex sound ambience, the synecdoche effect is the ability to valorize one specific element through selection. Selective listening, a fundamental capacity, is involved in all everyday sound behaviours. It is produced by simple acoustic vigilance, by the determination of a predominant functional criterion, or by adhesion to a cultural schema establishing a hierarchy.
>
> *(pp. 123–124)*

As stated above, the reason for certain inputs being brought to conscious attention and others being disregarded might relate to the functional value of that input, or to a cultural schema which we have developed through our socialization. In other words, while this happens involuntarily, it can be shaped by conditions we can consciously influence or alter. Another related phenomenon is the cocktail party effect, a form of selective listening in which we are able to focus attention on relevant speech located in a space with a plethora of surrounding stimuli (Augoyard and Torgue, p. 28).

In both synecdoche and the cocktail party effects, a degree of awareness and intention comes into play. At this point, we could begin to think of this intentional selectivity as not just an unhearing or underhearing, or a partial incapacity to listen, but an unlistening, to the extent that it is also learned and shaped by experiences we might choose. We could say that in these scenarios, in order to focus and *listen to* some things in a situation, we unlisten to others.

Besides being used to reference multiple levels of perceptual processing, listening is also connected to various actions, behaviors, or skills – often relating to some voluntary directing or switching of attention (Sterne 2012b, Pinch and Bijsterveldt 2013, Flügge 2022). Sonic arts and conceptual sound

art frequently play with this capacity for intentional perception. There is a tradition of works as awareness exercises which utilize this fact that we have automatically filtered out – but can also voluntarily bring attention back to – aspects of the auditory environment. Works that stimulate us to redirect and reframe our sonic awareness or listening attention have been created by numerous artists, in the form of installations, instructions, and listening scores, as well as soundwalks (Sanio 2008, Fluegge 2014, 2020). Scores by Pauline Oliveros, soundwalks by Hildegard Westerkamp, and the series of listening points (Oto-date) works of Akio Suzuki are just a few well-discussed examples.

Oliveros' scores emanate from collective listening practice with her ♀ Ensemble and reflect her practice of Deep Listening, which is an opening up to all possible sounds around (Oliveros 2005). Consider, for instance, one of Pauline Oliveros' sonic meditations (Oliveros 1971): XVIII "Re-cognition"

Listen to a sound until you no longer recognize it

Here, Oliveros invites an intentional unraveling of one's perceptual capacity for hearing and propensity for understanding an acoustic input. A key aspect in this score is the implication that this will take time: the listening is to be done "until" the perception is altered. The element of time is important. While "not listening" or the occasion of a mishearing implies a fixed event or state, unlistening suggests an ongoing process in which information is gradually perceived, selected, modified, or discarded intentionally.

Composer Hildegard Westerkamp is known for soundwalks that seek to "reactivate" hearing. She has explored listening as a practice that "tends to become a way of life that inevitably reveals and amplifies that which is ignored or normally avoided" (Westerkamp 2015). Moreover, she frames listening as disruptive in "the sense of stopping routines, habits, unconscious gestures, reactions and behaviors" (Westerkamp 2015). From practices like Westerkamp and Oliveros, we get a sense that listening means a continued probing, questioning, and reactivation of awareness of one's environment as well as reflections on one's own listenership. Listening is a personal practice which, beginning with individual transformation, can echo in a broader social sphere. If so, then unlistening can be posited as nondisruptive, having instead an attitude shying away from probing current situations, turning critical attention *away* from conditions that might deserve intervention.

In Suzuki's *Listening Points* series, which he has done in numerous cities since 1996, the artist explores urban spaces and finds points which are interesting to attend to in some way. These are marked and mapped so that people can come and stand at that spot to listen for themselves on site. This represents another common aspect of listening in sonic arts: the focus on site and situatedness. If we are here considering unlistening in juxtaposition to situated listening, then we need a definition to work with, such as that by sound theorist Gascia Ouzounian, who describes situated listening as "revealing the

particular, contingent situations of hearing as these occur within specific listening environments" (2006: 72–73). Furthermore, Ouzounian frames it as an embodied reception which is attending to an interplay of the listener's body with other bodies that are present in "social, physical and psychic networks; revealing, in the process, how space, place, sound and embodiment can be understood to produce and constitute one another" (2006: 72–73). Thus, a situated listening is embedded and contextually specific; moreover, it contributes to creating place: it emplaces. Whereas situated listening suggests an increased awareness and mindfulness of nuances – across various levels (social, physical, etc.) – unlistening evokes a lapse into a disregard for those specific and concrete subtleties. In that regard, unlistening suggests a process by which experience becomes detached from the contingencies of an environment – unembodied, untethered to the actual specificities of the given situation. In turn, unlistening could be framed as contributing to a *dis*placement.

From this we can speculate on an unlistening as an attitude of choosing what one deliberately wishes to hear (or not hear), according to prescribed values and system of priorities without regard to actual contingencies. It evokes a tendency to gloss over the specificities of the present condition, imposing one's own expected realities, and picking up on only a few cues from the given environment, forgetting or disregarding what is in between. Unlistening suggests an ongoing state of synecdochical perception, deselecting aural input not just on the basis of what is functionally unimportant but deemed to be aesthetically, morally, or perhaps politically undesired.[1] Instead of a listening, which probes and "reveals" situated contingencies and which returns attention to interstitial detail, an unlistening fabricates its own unsituated cloister.

Technological Unlistening

A work call comes in while commuting. I place popcorn-sized audio devices in my ears and toggle through modes. The surrounding hum of the train and even chatter of passengers vanish: technically suppressed. I hear the voice of my colleague – or most of it. Enough of the signal to recognize his characteristic patter, though perhaps not all its timbre.

In our relationship with today's technologies, it is also possible to find forms of unlistening, such as the popularity of noise-canceling headphones, or earbuds. We use these hearing technologies to intentionally discard aspects of the acoustic situation in which we are immersed; we are closing ears with audio devices, frequently in order to better attend to other chosen aspects – perhaps a voice or music. Doing this welcomes a sonic cocoon that creates a listening positionality, one of withdrawal and individualism. Such a sense of individuality is often associated with the western modernity's

obsession for exclusivity, segregation, and othering, and extractive engagement with land and human resources, that bleed into its technologies of (un)listening.

For example, we can consider the use of location recording and studio sound design in film sound production. Film sound technologies traveled from the west to the east via colonial routes. Recent research (Chattopadhyay 2023, 2021, 2017, 2015) has pointed out the limitations of listening, set in place by industry norms and regulations related to mass production of films which often unlisten or filter out many layers of sounds, especially site-specific environmental and incidental sounds as "noise." Early cinemas incorporated recording techniques and equipment that had somewhat limited dynamic sound recording and reproduction ranges, leading to voice and music being at the top of the priority list, ignoring incidental and environmental sounds. After the magnetic recordings emerged in the postwar period, the capacity to capture a better dynamic range from the available sound sources on the site appeared. But this period of sound production was studio-centric, and the setup unlistened to most of the site-specific nuances in favor of a synthetic mass-production aesthetics such as ADR (automatic dialogue replacement, dubbing, and playback (Chattopadhyay 2021, 2023) standardized in the studio systems. The digital revolution in the 2000s (Chattopadhyay 2016, 2021) seemed to take over film production (Kerins 2011), in which recording in higher dynamic ranges (20 Hz to 20 kHz) became possible, and on-site sync sound techniques could "listen better" to manifold environmental and incidental sounds and record them in multi-track systems. However, the set industrial rules of film and media technologies did not allow inclusion of sonic environments present in the site, and created a framework for unlistening that advocated human-centric storytelling by unlistening to the locative, environmental, and spatial dynamics. This selective and intentionally suppressing listening approach of film and media production became the standard, normative practice.

Delving deeper into limiting practices of recording and archiving, one may develop a polemical position against the unlistening embedded in the recording device itself. Researcher of archival practice, Moushumi Bhowmik, suggests that the act of recording cannot capture the layers of situated realities – it always remains incomplete and "uncatchable" (2021). Due to the inherent limitations of recording technologies, from earlier optical to mechanical to today's digital systems, recording devices and recorded archives cannot fully listen to the nuances of the situated realities, and often unlisten in order to uphold a colonial, extractive, and white anthropogenic order. The in-between grains of the colonized voices remain outside the capture-all technologies' radar and their capacities of contextual, reciprocal listening erode away.

Contemporary post-digital audio technologies and devices arrive already prepped with decisions about what information is relevant for us as listeners to hear. Jonathan Sterne, among others, has discussed how populist formats such as MP3 used auditory processing as a tool that supplements the information actually provided in its input (Sterne 2003, 2006, 2012a). Meanwhile, audio technologies used in our communication devices have algorithms that, for our convenience, select and respectively highlight or suppress parts of the audio signal. In other words, these initiate an unlistening for us, discarding what is bluntly considered by the technologies as useless or meaningless layers of noise to the sonic signal and transmitted sans the alleged noise that is irrelevant or even a nuisance to the speaking voice in focus.

And yet even in the spoken voice let through, there is something lost. It is the grain of the voice (Barthes 1977) that is often compromised during the transmission process. It is no wonder that Alexander Graham Bell's first words with his assistant Thomas Watson in the newly invented telephone was to "come here, I want to see you." Perhaps Bell was missing the grains of Watson's familiar voice in the technological unlistening of the telephone. We may consider how we communicate through electronic devices, analogue, digital, or hybrid, and how often the familiar grains of our close one's voices are lost through machine unlistening. Barthes suggests that grains are important for communicating, as they are traces of the body in the voice. Their affective aura works beyond the language systems of semantic coding and decoding to connect the bodies.

When parts of an auditory situation are shut out by a device, that is, by its design, this does not necessarily come across as ill-intended on the surface – it is "simply" a consequence of the technologies and techno-logics born out of the western modernities. Of course, the design of technologies does not happen in a vacuum but within cultural structures that unfold through studies of the micro- and macro-worlds we inhabit. Their use is further subject to the world of our biases and habits.

Interpersonal Unlistening

"You're not listening to me!", my friend complains. *I try to recall all the things we have been saying – I hear their voices perfectly well. What did I miss?*

We talk about not being listened to, recognizing listening as a behavior that we can intentionally influence and that others can control and monitor in themselves.

Even in the absence of technological mediation, we unhear, under-hear, or "mishear" (Flügge 2022) our environment and others in our everyday interactions. When the shutting out occurs in a live, in-person, situation, and the input shut out is also a person speaking, we can more readily recognize

critical social and political aspects. An unlistening that is conscious or intentional, acquires a more sinister quality than that generated by technologies. Choosing not to listen, as in the use of silent treatment or "stonewalling," can be a form of abusive technique in personal relationships. This can be an avoidant response to conflict which can be done as an alleged self-defensive withdrawal, but it is in long term a damaging rather than constructive way of handling conflict (Gottman 2018). Whereas active listening – in which one attends to, recalls and responds to what an interlocutor expresses – can be part of a constructive communication behavior, unlistening, as a counterpoint insinuates an ignoring, invalidating, or forgetting of the words of others.

An enabling silence (Franklin 2001) that invites listening and thus makes space for expression is of a different tenor than a silence that performatively denies listening and withholds response. Listening is frequently discussed in relation to empowering others and a part of validating identity. It is even an act that can help constitute personhood, as in the case discussed by Gavin Steingo of fetal auscultation: the practice of midwives monitoring prenatal heartbeat in utero by stethoscope (Steingo 2019). Such listening-in is part of the process by which, in South Africa, a fetus might eventually be ascribed a "fetal personhood" or be said "to be alive (or not), have agency (or not), or participate within the social field (or not)" (Steingo 2019: 155). Lispeth Lipari discusses the idea of listening as a transitive verb – as a vital but overlooked part of the power potential we often ascribe to speech/speaking, positing it as a crucial way of being with others as an ethical relation (Lipari 2014). We acknowledge the existence of others in part through showing we are listening to them, signaling they are worth allocating some of the finite resources of our attention. Moreover, those who are given more social space in society tend to occupy more sound space or determine that of others – shaping what others may hear and how they might sonically contribute to a common environment (Odland and Auigner 2009, Flügge 2011, 2022). If listening to others is construed as vital for empowering and humanizing, then unlistening might, in contrast, indicate a process of tuning out or withdrawing attention, thus disempowering and dehumanizing others – and, in doing so, ourselves.

A key difference between this social level of listening and the perceptual filtering discussed initially is that in a true incapacity to listen we do not have agency to change this condition – the incapacity is not under the influence of the listener but due to, for example, their own physical, spatial, or social constraints. Here, in the present case of interpersonal dynamics where conscious and voluntary shifting of attention is in question, the listener has agency to change their listening (and unlistening) capacities. Unlistening more clearly becomes a choice. This becomes a factor in a person, or group's sonic agency (Labelle 2018, Flügge 2022). Sonic agency here is meant as "the capacity to determine or negotiate – sonically, spatially, and socially – auditory input

and output, and capacity to influence a sonic domain" (Flügge 2022: 191), such as choosing to respond to an input or having the option to physically walk away. Turning from personal exchanges to social dynamics, analogous imbalances of auditory power – in which one party ignores the other – can be found between persons, groups, and institutions. A consequence of this interpersonal level of (un)listening is the formation of a listening positionality. We can consider that such positionality is as much about what one listens to, and attends to as what one unlistens to: i.e. what one voluntarily does not hear, notice, or leaves unvalidated.

An Internal Monologue of Budhaditya[2] on Unlistening in the Socio-Political Contexts

Am I not speaking to you? If I am, then why do you look away from me?

Unlistening by not-responding is a political tactic employed to undermine the integrity of the sender/speaker and his/her/their vociferous voice. The tactic reflects the gesture of ignoring the other voices that differ from the receiver's views – politically, socially, or even emotionally. The potential pleasure derived by a receiver not responding to an email or text message lies in the game of practicing power and establishing a hierarchy where the sender is deliberately placed at the lowest position. As a sender I am forced to leave the legitimate messages in thin air, and keep the expectation of receiving a due response on hold. The message embedded in the adopted silence can be deciphered in many ways, which can vary from "you wait, I will see" to something like "you don't exist in my perception." Be it an institution or an individual, "not-responding" as a strategy on unlistening can trigger "negative expectancy" in communication, forcing the sender to abandon communicating, which is the motive behind the receiver's deliberate closure of response.

It is possible that you do not listen to me

Irrespective of the lack of equilibrium in the environment of intentional unlistening, a few people do continue to reach out with sheer resilience. Their voices may not trigger responses from the self-proclaimed authorities, but the sounds of their voices can be heard at every moment if one opens an honest pair of ears intent on listening. Should we then contend that these bodies of power, and institutions as well as corporations are intentionally unlistening to the ardent voices? "Unlistening" is then a gesture showing hostility to the sender. It treats a sender as pure noise – unwanted, and without having a significant identity of their own. If my calls and cries are not listened to, let alone receiving a substantial response, I am stripped of my social agency and I am forced not to exist.

The face of a man looking at me across the street seems to be hostile and unfriendly

If I listen to contemporary times without a hurried or frenzied frame of mind, I can mostly hear the silence of fear. With careful attention, the sounds that envelop me everyday in this continent where I have been living more or less for the past 15 years, unfold with a sense of increasing discomfort. On the streets and inside institutional corridors of Denmark and Scandinavia, or in some by-lanes of Austria, Germany, France, or the UK, I have met faces that refused to let me walk freely, with my dignity or a sense of safety intact. The looks in these eyes have dripped with fear and loathing for the *different*; their ears refused to listen to my entirety, due to the dissimilarity in reference to a dominant mode of hearing and seeing in terms of color, skintone, accent, and language. Which Europe is this, and for whom? Not everyone is safe here. Not everyone feels equally respected, duly appreciated, and valued.

An outsider is he, who lives in the margin of thoughts, and intends to come to the center of thinking-process. Thus he becomes a noise.

I wake up from a deep slumber. The enlightened Europe I grew up with in my mind from childhood through its music, arts, and literature, is slowly fading away into a protectionist-conservative frenzy. Thanks to those intolerant eyes and ears on the streets, inside academic institutions and in the larger public sphere, I finally get up from my sleep and realize what real Europe will become in the near future. These very personal experiences trigger a serious course of permanent disenchantment. A land, which cannot respect and include the dispossessed, is not able to respect itself.

You will push the margin up to my inner silence if you cannot silence me.

The rise of ultra-nationalist governments shines in Europe and beyond. The institutions behave increasingly conservative and exclusive for a populist ideal. Equal opportunity remains only in the official paper as a tick in the box, but in real politics the consideration for color, language, and the accent of the voice reign. Listening around and further, the contemporary world seems to be marred by intensified conflicts between nations, and within various sects and segments of people. Surely contemporary human societies need to learn how to resolve such conflicts of interests, values, and beliefs. Needless to say that a sense of plurality, enriched by acceptance and reciprocity is essential to nurture now to navigate the challenging times ahead, which is marked by an unprecedented human-made decay in the environments, leading to possible Anthropocenic calamities. If we really fail to listen to these impending catastrophes alongside the "other voices" in our societies, there will be hardly any time later for regret. It is difficult to believe that there is no collective resistance heard. As if a deep sense of inertia and complacency seems to have permeated in the public. In this regressive state of affairs, anyone *different* is unwanted, and unlistened to.

From the other side of the margin I continue to move my lips, and the sounds coming from my inner beliefs refract into a fearful resonance challenging your ears.

If ones who are keen to send the message across and desperate to receive a response, on which their life and death depends, "unlistening" can challenge their spirit to the core. There are disruptive measures people embrace when institutions and communities do not listen to them, such as embracing noise as resistance. It is needless to say that disruption can be effective if it respects the delicate fulcrum of democracy and stays fervent to seek sincere ways to make all the voices heard. Disruption can be effective if it is creative, positively minded, and innovative. Disruption can be effective if it keeps the space for dissent and humor. Disruption can be effective if its inner motive is to reconstruct remnants of the ashes into diamonds.

A Reflective Dialogue and Conversational Conclusion

The co-authors meet to reflect on their text and come to a mutually responsive conceptualization of unlistening.

Elen: *We have been considering unlistening here from quite different perspectives. I began by discussing perception and interpersonal communication, and you are reflecting on technological as well as social and political dynamics, including your own experience of being unlistened to in European academic and artistic contexts.*

Budhaditya: *In the initial discussion we could have started with humans' perceptual limitations, and the physiological conditions that set the thresholds for hearing. This discussion would set how we define the term unlistening differently from physiological limitations to hearing and other involuntary acts. For example, we do not have the capacity to listen beyond 20,000 hertz, and also below 20 hertz. As the Cocktail Party Effect suggests (Arons 1992), humans may have limitations in hearing when many sounds are present at once. Renowned sound designer Walter Murch suggests that the human "brain simply can't keep track of everything!" (2022) – his "Law of Two and a Half" points out how human ears can only pay attention to 2 and half sounds at once, which is a useful premise for film sound design. These are examples of physiological limits of anthropogenic listening conditions. Such selective hearings are always practiced by the human ear by default.*

Elen: *While I think this filtering is important I would question whether that in itself constitutes unlistening, unless there is a possibility of voluntary influence. I'm not sure you can unlisten to something you never had the possibility of hearing in the first place.*

Budhaditya: *I would say the limitations of the body are the simplest form of incapacity to hear... things are happening but we cannot hear them. We cannot do anything about it. Other species can hear far better than humans. The ability to predict the environment and climate upon listening is far more present in ants, cats, dogs, elephants, dolphins and in many other species. In these ways a physiological incapacity to hear is an inherent human condition. In reference to such instances of involuntary unhearing, what we call unlistening is underscored as an intentional practice. In this conversational unpacking of the term, I am more interested to unpack the intentional unlistening acts than other forms of incapacity to hear or listen beyond our human agency. I think that is something we have been trying to address and explore here together: the social and political impacts of this mode of unlistening.*

Elen: *Perhaps we can agree that a scenario of unlistening presupposes the agency to change a given capacity-to-listen to an incapacity. For instance we could say that physiological limitations can contribute to unlistening if they can be said to be voluntary – for example, we can change our perceptual and physiological conditions through earplugs, or substances that alter our mental or emotional state, etc.*

Budhaditya: *Yes, I agree with you that agency and intentionality are crucial factors here that help to distinguish between unhearing, under-hearing, and unlistening. The former may not be instances of 'unlistening' the way we understand the concept here, but more like unhearing or under-hearing given the degree of intentionality and agency involved, and whether it is voluntary or involuntary in nature. However, I also wonder how does a sense of personal insecurity or hesitation prompt one to avoid listening (and responding) in the context of interpersonal communication?[3]*

Elen: *Personal insecurity, as you say, might well be a reason for adopting an attitude of unlistening – the question is whether that insecurity is justified. Is this a case of a person who is insecure because their safety is being threatened, or is this an institution 'insecure' because its dominance is being threatened? So far, unlistening is an ambivalent concept. Even if we have been implying that ignoring or shutting out tends to be a negative behavior, this is not always the case. There are situations in which unlistening is called for. A person might rightly choose to block input that is hurtful to them – in both physical or psychological senses – and not listen (in the sense*

of validate) opinions by other persons or by institutions that are detrimental to their wellbeing.

Budhaditya: *As humans, our perceptual and cognitive associations are entangled with the social constellations we belong to. The perception of sonic phenomena in our everyday environments emerges from this sense of social positionality. For some years I have been interrogating the entanglements between social positionality and the dynamics of the social formations including marginalization and oppression of some communities, and their listening perceptions (Chattopadhyay 2022). In this ongoing research, I have been unpacking the processes through which migratory, diasporic and Global Souths' artists and scholars are (un)listened to. The ways in which these often marginalized bodies of artistic and scholarly works are perceived are firmly rooted in their social positionality in Europe – the voices that go unheard within the social or political systems of European society.*

Elen: *You're saying we are experiencing these works of artists and scholars through a filter shaped by European history and priorities – and thus contributions from beyond this Eurocentric social system are not fully appreciated; these would be best heard through a filter shaped by endemic history and priorities? But why say 'unlistening', which evokes a gradual process of deconstruction or denial, rather than 'selective listening'? Is there something about the process that can be identified and critiqued? My suggestion would be that unlistening is a more apt way to refer to scenarios where there is a continual and systemic filtering or tuning out rather than a single event – and where this tuning out is voluntary.*

Budhaditya: *I am saying that the voices of Global Souths' artists and scholars and the works of immigrant and diasporic artists and thinkers, for example, have not been listened to with care and attention in the European contexts. Look at the canonical scholarships that form the seminal corpus of literature in the field of sound studies (Sterne 2012, Bull 2018, Pinch and Bijsterveld 2013) – how many contributions can you count from the artists and thinkers I just mentioned above? Almost none. Along with this lack of curious listening to their work, their unique systems of knowledge remain on the periphery of discourse and canonization, that only Eurocentric and white scholars enjoy being a part of. The gross acts of unlistening, along with deliberate silencing and erasure constitute the*

	field's Eurocentrism. This is an example of forming perceptual biases on social dynamics.
Elen:	Do you see bodily limitations and psychoacoustic filtering as analogous to the social unlistening we are discussing in that there is art and scholarship which is not being 'heard' (in the sense of recognized) because of structural boundaries of our Eurocentric system – (as the metaphorical socio-political body)?
Budhaditya:	The sociopolitical body you mention is not "given" – it's a historical construct that can be undone through historical unmaking – which a hyperused term like 'decolonization' cannot do enough justice. Unlike the human ear and other sensory apparatus that cannot hear enough, this European socio-political body can develop self-critique to hear better, especially to the others on the margins of its societies.

You brought up sonic art works that seek to activate listening, but I also wonder how the institutional formations of disciplines such as sound studies and sound art limit the possibility of listening outside of their narrow institutional remits? |
| Elen: | Hm yes, I see. Acts of listening in sound art, even if many seem to question institutional conditions, can themselves be indicative of an institutionalized culture of listening (Flügge 2020). While an interrogative listening can disrupt institutions by re-directing habitual practices, the strong tradition of 'interrogation through listening' that can be traced in sound art can itself be understood as becoming a formalized i.e. institutional practice within the field (2020). Keep in mind, we as listeners are inevitably acculturated, being both products and producers of institutions. This means that even a field like sound studies and sound art – which alleges to concern itself with listening and offers a plethora of techniques for listening – can lapse into forms of unlistening. If it, and its institutions – constituted fundamentally by groups of people with various biases– do not remain open to an ongoing, situated listening, one that attends reflexively to itself and perpetually reconsiders its own priorities, then we may find unlistening developing instead. I mean not only a failure to notice certain things but a voluntary dismissal of, for instance, certain practices or persons, as you've just mentioned. |
| Budhaditya: | Can we come to some conclusions on what we are hoping to understand through probing different ideas of unlistening? In this chapter, we have been charting different forms of |

unlistening, from perceptual rejects to physiological or auditory limitations, to technological dispositives and algorithms that filter out sound, to the intentional unlistening in the interpersonal dynamics of communication and conversations, to the institutional conditioning of systems that are made to not listen. In this overview of unlistening as an act as important as listening, there seems to be a thrust on studying the intentional act of unlistening that stands out for further inquiry, especially in the light of critical race theory, feminist studies and decolonial studies.

Elen: What our exploration underlines for me, is how we apply notions of listening to vastly different phenomena. In kind, unlistening can imply diverse situations: Someone 'unlistening' to another person intentionally may have nothing to do with their underlying auditory faculties, or ability to hear that person, but with their decision to interact or not. Voices remaining unheard due to an 'unlistening' Eurocentric system is fundamentally a metaphor expressing how work does not receive acknowledgement or is not disseminated in the system, (though it can also be literal in cases when the work is, for instance, music and audio files of a person singing or speaking that remain inaccessible). We have been discussing at least three distinct scenarios: 1. not hearing something 2. not consciously noticing something 3. not acknowledging something. Each of these can involve a voluntary incapacitation of listening but I would argue that 2 and 3 are most relevant. If we are framing unlistening as either a condition or behavior that needs to be addressed, then for a given case of unlistening the underlying reason (of why something or someone is being unlistened to) and mechanism (how the unlistening is happening) needs to be better identified before it can be properly addressed. We have a spectrum of unlistening – not all instances are problematic.

Budhaditya: The problem of unlistening is its intentionality. Contrary to the set physiological limitations, intentionality can be changed or we can be made aware about it. It's this sociopolitical awareness and action needed to question intentional unlistening and push the horizons of the listening fields that we have aimed to underscore here. What do you think on these lines?

Elen: I agree that intention is key. On a social level the realm of what is perceptually under our control can be changed. We could, and should, recognize our unlistening conditions and behaviors. There are various steps and practices that can aid in revealing and where needed, addressing one's own unlistening

	habits – I would start with various scores and works proposed by artists previously. For instance, Cathy Lane's Score for Everyday Tender Listening (2017) comes to mind, in which she suggests listening with a reflection on how various conditions, such as one's age, health, education, gender, mobility, and so forth, affect one's listening and then to further reflect how a change in any of these would influence listening while going about one's everyday activities. Soundwalking practice recently has seen much more adoption as a disruptive practice and means to question the status quo. For example, Alli Martin uses soundwalking as a black feminist methodology, writing, "Black feminism centers and humanizes black women, and I utilize soundwalks to humanize myself in a soundscape that would otherwise disregard my sonic perceptions in favor of white hearing as the default standard of sound." (Martin 2019). During her soundwalks, Amanda Gutierrez, besides highlighting female and queer experience in the content of the walks, has more pointedly directed her participants to write down Black, Indigenous, People of Color scholars and artists who have influenced their own practice. Doing such a direct inventory in relation to one's own artistic or scholarly practices is a good starting point. Then there are works such as Ximena Alarcon Diaz app soundwalk INTIMAL which seeks a deep listening to migratory experience (Diaz 2023). In some respects we have more access to works by marginalized practitioners than ever, the question is whether we use that potential. Intentionally seeking out works and inviting marginalized voices – whether this means for reasons of ethnicity, nationality, gender, sexuality, ability, class etc. – into one's own practice can be a guide toward further steps to dismantle systemic structures because these artists so often have to, of necessity, confront and reflect these systemic limitations. So there are already many productive, disruptive, revolutionary ideas out there. In seeking to change our systems to be more equitable we could be led by marginalized voices. What do you think could be the next steps?
Budhaditya:	*I think to challenge intentional, and systematic unlistening, which are often embedded in the institutional and infrastructural level when it comes to the European/western contexts, one needs to take a radically polemic positionality that may embrace transgressive and subversive tactics. As I mentioned in the blog post, which reappeared above in this essay, making noise and being vocal on the streets in the form of demonstrations are as essential as trying to bring these polemics*

into the discourse itself in various forms and formats, in both artistic and scholarly works. I think the conversational approach of this text bears testimony to how the transformative changes in the formats of discursive articulations may sensitize a debate and the readership to the need for dialectics and reciprocity in regard to questions of unlistening. I think more concretely the dialogic emancipation of this discourse here may open it up for more participatory interventions of the unheard voices, BIPOC scholars' writings and works, and those who are concerned about the acts of unlistening embedded in today's societies. I think that we also need to be mindful of the power of affective engagement with voices outside of the systemic radars of listening, those that evade capture and quantification, those that fall outside of the rigid semantic chains of communication. I believe that recognizing the strength of this radical sense of affect is the next step to become more inclusive and equitable in a planetary society beyond mere provincialism, by dismantling (colonially) set hierarchies and power structures that have legitimized acts of unlistening for so long.

Unlistening prompts

Elen Flügge

1. **Unlistening points (homage to Akio Suzuki)**
 Find spots in your neighborhood or city that are acoustically interesting – e.g., having a characteristic sound or ambiance. Standing at a point:
 a. cover your ears with your hands, close your eyes, and hum for a few minutes. Try a bucket over your head. Try a blanket.
 b. wear noise cancellation headphones. Play soft noise through them. Toggle through modes to see what is filtered. Scroll through your phone.
 Don't let others know about these interesting spots. Don't encourage them to find their own.

2. **Unlistening walks**
 Walk around with earplugs or hands over your ears; daydream as you wander.
 If no daydreams easily come, try practicing equations in your head (if arithmetically inclined, otherwise foreign language declensions suffice).
 Returning, count your breaths.
 Walk around wearing noise cancellation headphones. Try different modes. Play soft noise or tones through them. Increase their volume until no outer ambiance impedes.

3 **Unlistening events**
 - For a day, do not listen to anyone:
 If someone speaks to you, pretend you do not hear them
 Variation 1: Repeat 'I'm not listening right now / I'm not listening to you'.
 Variation 2: Wear conspicuous headphones. Counter attempts at communicating by indicating headphones and shaking head.

 If someone speaks with you, intentionally misunderstand their meaning.

 - For a week, disregard calls, emails, and texts. Give no reason if asked why.
 - For a month, only consume content from persons/groups in positions of power.
 - Remain oblivious to as much sound and content as possible, for as long as possible.

Disclaimer: Unlisten at your own risk. Author not responsible for any resulting accidents, damaged relationships, tarnished reputation or furthered ignorance.

Unlistening/Unscoring

Budhaditya Chattopadhyay

I am concerned about the invitation to contribute a "score," which can be argued to be a provincial practice in Eurocentric cultures of listening, musicking, and sounding. In this culture, a written or registered score dominates how sound can be composed or communicated in public settings. Coming from a non-Western listening culture of intersubjectivity, I may not align with such a fixed "score" to map listening acts into fixed visual representations, unless it's turned performative to consider improvisation and ephemerality as essential to listening and sounding. Below is an example of such an "unscoring" from *The Nomadic Listener* (Chattopadhyay 2020) acknowledging multiple possibilities of a listening situation beyond a fixed visualized score (Figure 3.1).

FIGURE 3.1 An example of "unscoring" from The Nomadic Listener (Chattopadhyay 2020).

Notes

1 What comes to mind here is, for instance, the tendency of categorizing the heard environment, such as one finds in early Acoustic Ecology, encouraging a description of listening in prescribed terms, such as of "human sounds," "machine sounds," and "natural sounds". The tendency is in some sense a form of unlistening, as it imposes a schema of expected categories as opposed to inviting an attitude of open awareness toward a given sonic flow and letting new meanings emerge. Thus, it alights on elements – as with the synechdoche – as representative of others.
2 An earlier version of this section was previously published in the *Sonic Field blog*. https://sonicfield.org/the-politics-of-not-listening/
3 Authors note BC: Here, we were considering whether the Lacanian notion of the unconscious and ego might help unpacking the conditions of (un)listening and inaudibility. The Lacanian theory of the register (2006) suggests that there are three primary layers of registers: the imaginary, the symbolic, and the real. If we consider listening as an act of registering, the movements between these three layers and the various psychosocial constellations that emerge may form the subjectivity by the ways in which the unconscious is organized. More research would be needed to uncover these various layers of registry that unfold upon listening, and at what level unlistening occurs.

References

Arons, B. (1992). "A Review of the Cocktail Party Effect". *Journal of the American Voice I/O Society* 12/7: 35–50.
Augoyard, J. F., & Torgue, H. (2005). *Sonic Experience: A Guide to Everyday Sounds*. Montreal; London: McGill-Queen's University Press.
Barthes, R. (1977). *Image, Music, Text*. Translated by Stephen Heath. London: Fontana.
Bhowmik, M. (2021). "Incomplete Listening, Unfinished Writing: Sound and Silence in Archival Recordings from the Early Twentieth Century". *South Asia: Journal of South Asian Studies* 44 (5): 1000–1015, DOI: 10.1080/00856401.2021.1970307
Bull, M. (2018). *The Routledge Companion to Sound Studies*. Abingdon, Oxon: New York: Routledge.
Chabris, C., and Simons, D. (2010). *The Invisible Gorilla: How Our Intuitions Deceive Us*. New York: Crown.
Chattopadhyay, B. (2023). *Sound in Indian Film and Audiovisual Media: History, Practices, and Production*. Amsterdam: Amsterdam University Press.
Chattopadhyay, B. (2022). *Sound Practices in the Global South: Co-listening to Re-sounding Plurilogues*. London: Palgrave Macmillan.
Chattopadhyay, B. (2021). *The Auditory Setting: Environmental Sounds in Film and Media Arts*. Edinburgh: Edinburgh University Press.
Chattopadhyay, B. (2020). *The Nomadic Listener*. Berlin: Errant Bodies Press.
Chattopadhyay, B. (2017). "Reconstructing Atmospheres: Ambient Sound in Film and Media Production". *Communication and the Public* 2/4: 352–364.
Chattopadhyay, B. (2016). "The Politics of Not-listening". *Sonic Field blog*, November. https://sonicfield.org/the-politics-of-not-listening/
Chattopadhyay, B. (2015). "The Auditory Spectacle: Designing Sound for the 'Dubbing Era' of Indian Cinema". *The New Soundtrack* 5 (1): 55–68.
Chion, M. (1994). *Audio-Vision: Sound on Screen*. Translated and Edited by Gorbman, C. New York: Columbia University Press.
Diaz, X. A. (2023). *INTIMAL Project*. https://www.ximenaalarcon.net/intimal-app
Franklin, U. (2001) "Silence and the Notion of the Commons". *Soundscape: The Journal of Acoustic Ecology* 1 (2): 14–17.

Flügge, E. (2022). *Listening Practices for Urban Sound Space in Belfast* (Doctoral dissertation), Queen's University Belfast.

Flügge, E. (2020). "Sounding in Paths, Hearing through Cracks: Sonic Arts Practices and Urban Institutions." In *The Bloomsbury Handbook of Sound Art*, edited by Sanne Krogh Groth and Holger Schulze, 297–318. New York: Bloomsbury Publishing USA.

Flügge, E. (2014). Sonic thinking: how sound-art practices teach us critical listening to space. Conference Proceedings Invisible Places, Sounding Cities, 18–20 July 2014, Viseu Portugal: 661–672.

Flügge, E. (2011). "The Consideration of Personal Sound Space: Toward a Practical Perspective on Individualized Auditory Experience" *Journal of Sonic Studies*, 1 (1): 1–16.

Gottman, J. (2018). *The Seven Principles for Making Marriage Work*. London: Hachette UK.

Kerins, M. (2011). *Beyond Dolby (Stereo): Cinema in the Digital Sound Age*. Bloomington: Indiana University Press.

Labelle, B. (2018). *Sonic Agency: Sound and Emergent Forms of Resistance*. London: Goldsmiths Press.

Lacan, J. (2006). Écrits: The First Complete Edition in English (transl. by Bruce Fink). New York: W.W. Norton & Co.

Lipari, L. (2015). *Listening, Thinking, Being: Toward an Ethics of Attunement*. University Park PA: Penn State University Press.

Martin, A. (2019). "Hearing Change in the Chocolate City: Soundwalking as Black Feminist Method". *Sounding Out* 5.

Murch, W. (2022). "Sound Designer Interview By JJ Lyon". *Sound Magazine*. https://sound.krotosaudio.com/walter-murch-interview/

Odland, B., & Auinger, S. (2009). "Reflections on the Sonic Commons". *Leonardo Music Journal* 19 (1).

Oliveros, P. (2005). *Deep Listening: A Composer's Sound Practice*. New York: iUniverse.

Oliveros, P. (1974). Sonic Meditations. Baltimore MD: Smith Publications.

Ouzounian, G.(2006). "Embodied Sound: Aural Architectures and the Body." *Contemporary Music Review*, DOI: 10.1080/07494460600647469.

Pinch, T. and Bijsterveld, K. (2013). *The Oxford Handbook of Sound Studies*. Oxford: Oxford University Press.

Sanio, S. (2008). "Ästhetische Erfahrung als Wahrnehmungsübung?" in Klangkunst, ed. Ulrich Tadday, Musik-Konz. Text + Kritik, 47–66.

Steingo, G. (2019). "Listening as Life: Sounding Fetal Personhood in South Africa". *Sound Studies* 5 (2): 155–174, DOI: 10.1080/20551940.2019.1621082

Sterne, J. (2012a). *MP3: The Meaning of a Format*. Durham, NC: Duke University Press.

Sterne, J. (ed.) (2012b). *The Sound Studies Reader*. London: Routledge.

Sterne, J. (2006). "The Death and Life of Digital Audio". *Interdisciplinary Science Reviews* 31 (4): 338–348.

Sterne, J. (2003). *The Audible Past: Cultural Origins of Sound Reproduction*. Durham, NC: Duke University Press.

Westerkamp, H. (2015). *The Disruptive Nature of Listening* Keynote Address *International Symposium on Electronic Art*. Vancouver, B.C. Canada August 18, 2015. https://www.hildegardwesterkamp.ca/writings/writingsby/?post_id=11&title=the-disruptive-nature-of-listening

Westerkamp, H. (1974). "Soundwalking". *Sound Heritage* 3 (4): 18–27.

4

LISTENING WITH, OR THE IMPOSSIBILITY OF INHABITING ANOTHER'S EARS

Janna Holmstedt and Louise Mackenzie

In this chapter, we will share practices at the limits of listening that ask, what might it mean to listen with others, across differences and to non-human beings? We venture into explorations of seduction, sonification, failure as resistance and the body as a technology for listening. Through our individual 'verkberättelser', or work stories (Bärtås, 2010), i.e. the storied web of relations, actions, materials and considerations that emerges around a work of art and its making, we get into the nuts and bolts of creative processes, including the experience of being seduced by the very way of learning and exploring that one seeks to escape. We allude to certain patterns in Western scientific knowledge practices that we have been trained to embrace, where habitual anthropocentrism and dichotomisation, paired with reductionist approaches, objectify the non-human and represent nature and culture as separate entities. How these seductions and resistances have played out in practice will be related below as we approach bodies, environs and technologies as relational bundles that co-constitute each other in processes where the capture of facts (be it signals, sounds, images or field-notes) simultaneously creates values and performs world views.

Louise Mackenzie's attempts to listen to marine life engender a feeling of technological prosthesis that leads towards a practice of non-human sensing that allows us to lean into our bodily limitations (Mackenzie, 2023). Janna Holmstedt approaches listening as a form of cohabitation (Holmstedt, 2017). Through following, listening, sounding and storying with maize, the garden emerges as an experimental site for both learning and unlearning, where domestication could be said to go both ways. The work stories are presented in two parts, interrupted with a joint discussion on their conceptual underpinnings and the many troubles and tensions they stir. This leads

DOI: 10.4324/9781003348528-7

towards joint speculations on how certain setups and apparatuses could be considered decoys for listening *otherwise*, as we have found ourselves, both in our own ways, to explore similar paths and topics.

Two Verkberättelser, Part 1
A Feeling for the Organism – Bonding with Maize

Many years ago, I received a gift. I will try to follow the subtle workings of this seemingly minor event, since it has affected multiple art projects in unexpected ways. Not least a collaborative initiative called Anthropomorphic Interfaces (Holmstedt et al., 2018), which sought to explore the possibilities of strategic anthropomorphism (de Waal, 1999; Bennet, 2010) in creative practices. There was also the lingering presence of a geneticist who spoke of 'a feeling for the organism' (Keller, 1983). The gift consisted of a handful of seeds and on the handmade package was an ink drawing of a majestic plant. Beside it the names *Zea mays* and *Barbara McClintock* were written.[1] The site was an allotment garden. After burying the seeds in moist soil, I finally got around to reading Evelyn Fox Keller's biography on pioneering geneticist McClintock who devoted her life to corn, or maize. She had known every plant and ear of corn in her experimental field intimately, across many generations, and discovered in the 1940s that the maize genome adapted to shocks and environmental stressors in unusual ways through restructuring itself.

The tiny seedlings soon grew strong. I fondly called them Barbara and tried to treat them the best I could, learning about the needs and pollination habits of this domesticated grass. The initial idea I wanted to explore was quite simple. Or, I thought it was simple because many had already done it; to build a device that would pick up the electrical signals in the plant and transform them into sound in processes known as audification and sonification. By transforming the signals into vibrations and letting structure borne transducers make materials in the surroundings shiver and sound, my intention was to enhance the presence of the plants in a physical and almost overwhelming way. I imagined and made present in my mind-body how the old hut in the allotment garden would become a 'sound machine' and act as an amplifier for the growing maize plants in the garden; how the windows, wooden boards and rusty drainpipes would tremble and emit cascades of sounds. The plants would literally shake the human dwelling and sometimes subtly hum through it.

I had first thought of audification as an attempt to amplify the vitality of the maize plants. Or, was I moved by a desire for revealing the hidden and inaudible? Electrical signals, such as action potentials (APs), are present in the cells of both animals and plants. In plants, APs have been found to regulate behaviour, as plants sense and react to pollinators, predators, drought

or sudden temperature changes. APs, which are rapidly propagated electrical messages, can be measured by using non-invasive electrodes, amplifiers and data acquisition devices. This in turn raises questions about speed. To chew or touch a leaf will trigger APs (eventually), but what is rapid to the plant might be slow to a human. Hence, if you lack the controlled environment of a lab, it is extremely difficult to discern what has caused a specific electrical signal. In addition, I soon realised that the technical apparatus also captures fluctuations in electrical conductivity (EC). Regardless of whether I touch the plant or not, I change its electrical field (Leudar, 2016, pp. 60–61). The plant becomes a component in a biofeedback system that could be said to amplify my own presence (Holmstedt, 2021). While following the scientific debates and controversies around plant communication, intelligence and sentience alongside revisiting artistic engagements with plants and sound from the 1960s and 1970s, my struggle with finding sensible technological solutions seemed to wire me harder into anthropocentric networks and notions of human–nature relations that I had tried to avoid, or shift. Meanwhile, the seeds, the act of gifting and the feeling for the organism that slowly emerged through interacting with the plants in the garden as months passed by would silently but persistently shake my human dwelling in very different ways than expected.

Besides capturing the attention of McClintock, the kernels I had received had a most intriguing history. Through them, I had become part of an unbroken chain where seeds had travelled from plant to hand to soil for more than 9,500 years. I was at once mesmerised and humbled. This was nothing like the yellow monocrop corn found in the supermarket. What I held in my hand was an archive; the result of Indigenous biocultures that had brought forth incredibly resilient, adaptive and genetically diverse varieties of maize in what is now known to many as North America (see Figure 4.1). The simultaneous practices of cultivation and sonification had pulled me in different directions. The more time I invested in the technical aspects of reading APs or EC,[2] the more reluctant I became to actually register this activity. The vision of the humming hut suddenly stood out as crude. Why wire up a garden? Had I become more obsessed with technical solutions than with the plants themselves? I felt the joy and desire to know, to get the facts right, to be precise where precision was needed, at the same time I realised the problems of getting correct readings. If it was the pulsating life of these vegetal beings that I wished to foreground, would this hut-as-sound-machine enable people to experience their vibrancy? Maybe, maybe not.

Meanwhile, I found that the maize plants had cultivated me. I had adapted my behaviour to their needs, offered them my urine, fed the soil, learnt to read signs of drought or nutrient deficiency from their leaves. The maize had become an unexpected companion, turning my attention to the soil community we were both part of. Many amateur mistakes had been made during

FIGURE 4.1 A feeling for the organism, Janna Holmstedt, 2019. Photographic print of an ear of corn grown as part of the project Anthropomorphic Interfaces, by Holmstedt, Siltberg & Nilsson. Photo: Janna Holmstedt.

the months that had passed; nevertheless, the plants had survived my misguided care. They bore fruit. I grasped, at miniature scale, a sense of what archaeologist Løvschal has called 'mutual entrapment' (2022) to describe a process of coevolution and adaptation that goes both ways. Plants, humans and landscapes transform and become transformed in an ongoing dance without beginning nor end. As my attunement increased, shifting patterns in the land and multiple, multispecies rhythms became more tangible. I was not in control, I was in relation. The teachings of maize rendered notions such as co-becoming and affective entanglement deeply resonant, through the material relationality of the metabolic life processes that bound us together.

Eventually I resisted the temptation to sonify, despite all the work that had been invested. Instead I started to hum for the new generation of seeds that had matured and dried in the garden. I had learned that maize roots pop and click, audible to the human ear around 220 Hz. The roots grow towards sound in that same frequency range (Gagliano et al., 2012). Why? We do not know. Sounds around 200–300 Hz also help maize seeds germinate (Vicient, 2017). Traditionally, people have sung and danced for seeds. I do not have any songs to offer, no cultural traditions to ground me. Yet, and somewhat embarrassed, I lean over the seeds in the palm of my hand and hum in the lowest registers of my voice.

On Marine Life and Technology – Pops, Clicks, Buzzes and Rumbles

How can we form relations with living beings that we barely understand? I first asked this question when exploring microbes as part of my doctoral research (Mackenzie, 2017). My enquiry led me into a complex, and still evolving, relationship with microorganisms, marine life and technology across several years. My attempts to find ways to connect with these inaccessible forms of life are framed through both the irresistible lure of, and the cumbersome weight of, technological prosthesis. Across this two-part tale, I recount how time spent entangled with microscopes and headphones unexpectedly led to elation when pressing my ear against a cool damp rock.

I was recently invited to be part of a four-year National Lottery funded project in the UK that was working to bring attention to the importance of marine life in the stretch of coastline between the rivers Tyne and Tees in the North East of England (O'Hara, 2020). Historically, the area has been home to shipbuilding, coal mining and glassmaking, with chemical manufacturing still contributing to the area. The coast in this region bears witness to its industrial heritage. Sea glass pebbles litter beaches near Seaham. The infamous Blast Beach, with aposematic pools in hues of orange and rust, was used for decades to offload coal waste from nearby mines. Despite its industrial past, this imposing and beautiful stretch of UK coastline, with its magnesian limestone cliffs and caves, supports a diverse community of marine life.

In reflecting upon ways in which to bring local communities into relation with life in this intertidal zone, I turned to my interest in how we perceive other species. I thought back to my time in a marine science laboratory in 2013, when I looked down a microscope and beheld the microcosm of life before me. Since that day, I have embarked upon a journey of attempting to perceive organisms in ways that are meaningful to me. Rather than the ways in which science might perceive species – by grouping and cataloguing, or monitoring patterns in behaviour – I create scenarios where I try to imagine what it is like to be, or at least to be among, the organism in question. Importantly, I am aware that I cannot inhabit another's perspective, but seek my closest subjective approximation of this.

Technology plays a central role in accessing other forms of life, particularly at the level of the minute or microscopic. This mediated experience simultaneously liberates and limits perception. In 2015, my first experience of 'listening' to microorganisms was what I now consider to be a successful failure. I was interested in the marine microalgae, *Dunaliella salina*, a salt-loving halophile, visible only as a bright green liquid until inspected under the microscope. Mesmerised by the vibrancy of their motion, I wondered how I might also hear them. It is possible to pick up noise in water through the use of a hydrophone or even a contact microphone in the right circumstances, but not at a particularly fine level of detail (neither instrument can

detect microscopic organisms). As a playful start, with limited equipment and experience, I worked with musicians Mark Reed and Daniel Tyson to set up a basic experiment that I knew was bound to fail. We attached a contact mic to the side of a glass vessel containing the microalgae. Intermittently shining red light, similar to that used in stress experiments in the laboratory, I wondered optimistically if it might be possible to pick up an audible response from the collective body of organisms. The resulting sound was both disappointing and enticing. As expected, our equipment was not sensitive enough to pick up anything directly from the microalgae. We did, however, detect a range of pops, clicks and buzzes (presumably interference from the lighting and recording equipment) along with distant snatches of our conversation. Rather than failing to capture what I had hoped for, I realised that my first relation to microscopic life will always be one of technology and noise.

I had been offered the chance to share my experience of these organisms in an audio-visual installation as part of Lumiere Durham, a four-day international light festival produced by Artichoke in the UK (Mackenzie, 2015). Despite our failed experiment, I was sure that sound would help me create an experience of swimming among the *Dunaliella salina*. I learned of advanced technologies that might assist in listening to the microscopic. I worked with Dr. Richard Thompson, who specialises in material flows, to observe the microalgae in their liquid medium moving under the path of a laser beam in an atomic force microscope (AFM). Deflections in the laser beam registered the movement of the organisms as they passed under its focus. I then worked with professor of computer science and sonification, Dr. Paul Vickers, on how to represent these deflections audibly. Our first few attempts to sonify the data using software such as Photosounder and Max/MSP resulted in a high-pitched sine wave sound that fell far short of what I had hoped for. Then Vickers created a Python script that determined the frequency of the deflections in real time and brought this frequency into audible range. Gratifyingly, this produced a rumbling bass sound that matched my imagined sense of being small in the presence of the microalgae. This experience undoubtedly created a different *sense* of these organisms than I had when viewing them as green liquid in a glass beaker. Something troubled me however. Although the experience had (through my imagined insight into their world) drawn me closer to the microalgae, having been through numerous layers of technology to arrive at these results, I felt simultaneously farther than ever from them – distanced by prostheses of metal and plastic, microscopy and computation.

Discussion and Reflections on Troubles and Tensions

The Prosthetic Effect of Technological Layering – Amplification, Audification and Sonification

It is this relationship with, and distancing from, technology in the pursuit of connection to other species that becomes the focus of our chapter. As our work

stories about maize and microalgae attest, our means of accessing the sensory worlds of non-humans are so severely limited by our bodily capabilities that we can only use prostheses (Tsing, 2021), and even then, we can only clumsily guess at what we find in doing so. In the field of sound theory, Hermann et al. point out that when 'extending the human auditory sense with technology, the process of listening to data can be thought of as involving data, conversion, display and perception' (2011, p. 304). The corresponding techniques: *amplification, audification* and *sonification*, we describe below in terms of what we consider to be an increasing distance between source and resulting sound.

Amplification concerns volume, raising a barely perceptible sound into our audible range. It is possible to capture specific sounds produced by plants, for example, water and air bubbles moving in the stem or trunk. With a young tree, it may be possible to hear these sounds with the human ear, but in most cases, this requires highly sensitive contact microphones and amplifiers. Moving deeper still into what we cannot (but strive to) hear, another technique is *audification*. Frequencies outside of human hearing range, infra and ultra sounds, are pitched up or down to become accessible, rendering existing waveforms audible. Other forms of information can also be audified, as we have seen in the example of microalgae moving in water. Whilst definitions vary, audification is generally considered to require a direct relationship between data points and sounds heard. A third and altogether broader technique is that of *sonification* – the overarching term given to the creation of sound from data. In this case, there is no need for a direct relationship between the original data and the resulting sounds. One such example from art is John Lifton's installation Green Music (1975), where six plants were connected through electrodes to an analogue computer, and the processed signals fed to a sound synthesiser so that music was generated algorithmically in real time. Another more recent example is Mexican collective Interspecifics who developed *The Energy Bending Lab* (Lopez & Garcia, 2014), a custom-built instrument that uses modular synthesisers to generate sound from the electronic properties of bacteria.

From a musical perspective, such practices could be seen as belonging to a tradition of generative music. That is, instead of composing a piece, the artist sets up a system that creates the music. In critical visual art practices, a similar interest in systems has been theorised as 'systems aesthetics' (Burnham, 1968), where there is a conceptual focus on the relation of relations (Skrebowski, 2006). From an ecoart, or a more recent multispecies and bioart perspective, tuned to more-than-human (Abram, 1996) and feminist posthumanist approaches, ecology rather than cybernetics serves as inspiration for explorations into natureculture entanglements (Haraway, 2003), affirmative radical relationality (Braidotti, 2013) and affective political ecologies (see, e.g., Bennet, 2010; Demos, 2013).

As soon as we start to consider the physical components of common electronic equipment, such as the microphone, it becomes possible to understand

how casually we accept our prostheses; the many layers that enable us. The copper coil that forms the electromagnet, the cobalt, lithium and other minerals that form the battery, the sand that becomes the silicon which forms the transistor.[3] Technology draws us in to witness the previously unimaginable, expanding our knowledge of the world, to the extent that we forget the layers. But the materials persist, evident in the vast electrical waste heaps of the Global South, the miles-long internet cables in our oceans, and in the mantle of plastics and concrete now manifest in the Earth's crust as signifier of the Anthropocene. There is, therefore, a paradox in the 'ready-to-handness' of our listening prostheses (Heidegger, 1977) – the ability of technology to hide as much as it reveals.

Our prostheses could thus be considered relational bundles of bodies, environs and technologies, testifying to the 'intra-action' (Barad, 2007) of matter and meaning. Each technique described above offers a specific configuration, a techno-relational prosthesis that shapes our perception, as well as the world. What kind of material relationality is generated, hidden or revealed in the process of making audible the signals emitted by plants, algae and bacteria, and what agencies can be traced in the process? In the following, we present a brief overview of how artists and scientists have engaged with the agency of plants and microorganisms, before delving deeper into these troubles.

A Frayed and Tangled Tale of Listening to Non-humans in Science and Art

As we attempt to trace historical bundles of relations that have shaped our own research, we find that facts, values, language and worldviews perform a dance that is hard to disentangle. The idea of listening to non-humans is bound to questions of sentience that poke at the hierarchies set up between different life forms. Already in the mid-19th century, electrical and chemical activity in plants and cells were reported by scientists. Jagadish Chandra Bose showed that plants have a 'nervous system' akin to that of the one in animals (1926). Similar language use, as in the term 'plant neurobiology' (Calvo, 2016), causes controversy today (Mallatt et al., 2021) since such metaphors indicate the equivalence of a brain, while mechanical metaphors are more readily considered neutral descriptions.

The last decades have seen a proliferation of artistic installations and performances where non-humans, such as plants, fungi and microbes, have been technologically augmented to produce sounds. Artists and musicians have to different degrees referenced science, and used more or less instrumental, or scientific methods for sonifying living matter and making what popular media often refer to as 'plant music' (Patrão, 2018). There has also been a surge in interest in non-human sentience and communication, mirrored in titles

of popular science books such as *Brilliant Green: The Surprising History and Science of Plant Intelligence* by Stefan Mancuso and Alessandra Viola, and *Entangled Life: How Fungi Make Our Worlds, Change Our Minds and Shape Our Futures* by Merlin Sheldrake, to mention just two well-known examples.

In the 1970s, this poking at hierarchical boundaries also tickled an interest in non-human sentience, typified in the bestselling book *The Secret Lives of Plants* (Tompkins & Bird, 1973), in which the authors seamlessly blended science, parapsychology, farming and spirituality. Several scientific myths can be traced back to this book and the experiments conducted by Cleve Backster that feature in it, who connected a plant to a 'lie detector' and was baffled by the results. Through this setup, he claimed to have accessed the inner life of the plant and encountered their pain. Other experiments from the same time aimed to show how plants react negatively to rock music while flourishing in the company of J. S. Bach (Retallack, 1973). The widespread circulation and uncritical reproduction of both the stories and technologies stifled serious scientific research on plant communication and sentience for decades to come (Mescher & De Moraes, 2015).

The early prototype of Backster's polygraph has been the inspiration for various technical solutions shared among makers through DIY and open-source initiatives such as github and Hackteria. Even spiritual communities such as the ecovillage Damanhur have developed sound-producing devices that have found their way to a consumer market. These gadgets may have made it easier to extend the notion of sentience also to the lives of fungi (Larsson, 2022). Yet other technologies opened up similar possibilities for microorganisms. In her research on the chemical signalling of bacteria, molecular biologist Bonnie Bassler described her work in terms of 'how bacteria talk' (2009). This sensational anthropomorphic language led to a TED Talk and several news headlines. Around this time, art projects such as Audio Microscope (Davies & Egan, 2000) and Dark Side of the Cell (Pelling & Niemetz, 2004) sought to find ways to listen to life at the cellular level. This latter project, inspired by physicist Pelling and nanotechnologist Gimzewski's nascent field of sonocytology (the study of the sound of cells), placed yeast cells and human cells in different chemical environments that they describe as causing the cells to move from 'singing' to 'screaming'. Such anthropomorphic sensationalism serves to remind us that we are far from understanding how to 'listen' at the level of the plant or microorganism, and that manipulation, surveillance and control are integral to our techno-relational prostheses.

The application of research on non-human signalling and behaviour is fast expanding, which creates further tensions and ambiguities within extractivist logics and techno-industrial regimes. Apart from artistic or music-making devices, there is educational equipment for schools that captures electrical activities in plants, as well as scientifically developed sensors and crop health

diagnostic systems that monitor plant and microbial reactions for the agricultural industry. This fusing of non-humans and technology also opens avenues for plant-based robotics and tech-enabled non-human cyborgs designed to serve as environmental watchdogs for toxic compounds (Trafton, 2021), to harvest energy (Meder et al., 2022) or to act as sensuous interactive interfaces to make human lives less crowded with visible technology (Sareen & Maes, 2019). Such applications and their inherent instrumentalism show that the technological, aesthetic, ethical, political, ontological and epistemological challenges faced in the 1970s are as relevant as ever, if seeking to cultivate a more response-able and ecologically sound politics.

Some Troubles Worth Dancing with

When following how artists, including ourselves, have approached available technologies, aesthetic choices, existing knowledge practices and the non-humans they have involved in their work, some troubles and tensions simmer to the surface that it is worth staying with.

First, *seduction and fidelity*. We have touched on the seductive and promissory aspects of technological protheses, alongside the problem of fidelity of the signal captured and interpretation of the resulting information. Data capture devices have varying levels of sophistication; thus, the resulting data may not represent what we expect it to. Even with specialised equipment, such as the AFM, controlled tests are required to determine the exact source of the data (vibrations of the organism, equipment or even lab bench, for example). Thus, sounds generated through devices and setups used might not be triggered by the non-human alone, but as much by human presence and nearby electronic devices.

Second, *aestheticisation and imagination*. Regardless of how precise the scientific data is, the human choices around how to make this data audible can vary at each layer of technological complexity (adjusting the gain on a recording device, the sensitivity of the hydrophone chosen, the frequencies detected). Thus, there is an awkward relationship between scientific evidence and how this evidence is constructed, and later retrieved (Holmstedt, 2020; Mackenzie, 2020). Sonification is often defined in what might be deemed strict scientific terms as an audible representation of data and yet 'the matter of listening and aesthetics is a tension at the heart of sonification' (Vickers et al., 2017), both in art and science. The use of imagination and metaphors in the translation of information, well established in the visual arts, requires careful consideration. We cannot access 'the world as it appears to the [non-humans] themselves' (von Uexküll, 1934, p. 5), yet we often attempt to make sense of it as if a direct structural equivalence between biology and technology exists. A technological rationality thus easily overwrites

relationality. The boundary between aesthetic interpretation and evidence is a porous one, in science as in art.

Third, *dichotomisation and mythologisation*. The dichotomisation of science and art invites an illustrative approach, where art may serve to communicate and dramatise scientific or technical development. Similarly, laboratory equipment might uncritically be used and displayed by artists, lending an air of scientific rigour to an artistic inquiry, or scientific facts might be woven into the storytelling but taken out of context, or used without proper referencing. Appropriation and sensationalism thus go both ways, reinforcing long-established silos of disciplinary knowledge, which contribute to a mythologisation of scientific objectivity and scientific facts.

Fourth, *accountability and micropolitics*. The above points to the question of responsibility and accountability in critical-creative practices, as the challenges of navigating a sea of commercial tech culture that is fused with a military-industrial complex and a capitalist logic are nothing less than overwhelming. Systems aesthetics offered conceptual tools for critical arts practices in the 1970s, though inspired by a human-centred control and command paradigm dominating early cybernetics. Today, many artists instead explore the possibilities of operating in the micropolitics of sensibility-formation, as suggested and theorised by, among others, Jane Bennet (2010). Bennet's proposal to allow oneself to relax into resemblances between human and non-human bodies, as a technique for enhancing one's eco-sensibility and attentiveness to the lively and energetic play of forces, stirs another trouble, that of anthropomorphism.

Fifth, *anthropomorphism and anthropodenial*. While commonplace in art, anthropomorphism is often critiqued in other disciplines as inadequate in developing our understanding of non-human life. Yet, counter to the rational objectivism of scientific inquiry, it might be used to sensationalise scientific discoveries, as in the aforementioned case of talking bacteria. Bennet's strategic anthropomorphism, on the other hand, aims to counter and complexify such impulses of attributing human-like features, feelings or characteristics to non-human animals or entities. A similarly nuanced outlook is also recognised within human-animal studies, where 'critical anthropomorphism' (Morton et al., 1990) or 'situated anthropomorphism' (Servais, 2018) are offered as considered approaches that contribute more relational understandings between humans and animals. Viviane Despret offers the notion 'anthropo-zoo-genesis' (2004) to address the transformative character of human-animal interactions, where both humans and animals adapt and respond to each other and their surroundings. This in turn highlights what Frans de Waal has called 'anthropodenial' (1999), the mistake of refusing to acknowledge any human mental states in non-humans even though they exist, which brings us to the final trouble in our compilation.

Sixth, *anthropocentrism and affect*. Such a refusal, de Waal argues, is informed by anthropocentrism that positions humans as superior and separate from nature and other living beings. For example, the notion of 'plant intelligence' (Trewavas, 2017) has been accused of anthropo*morphism*, while counter-arguments have been made that point to the inherent anthropo*centrism* in reserving the notions of intelligence only to organisms with brains (see, e.g., Robinson et al., 2020; Baluška & Mancuso, 2020). The im/possibility of overcoming anthropocentrism inspires our project of suspending human subjectivity through critical-creative modes of inquiry, which situates bodies as embedded in more-than-human affective political ecologies. A field recording – as unique as the individual creating it – then becomes a 'vulnerable conduit' for our anthropocentric desires (Wright, 2022, p. 77), rather than serving as a captured fact, evidence or representation. The same could be said of any attempt to live stream or sonify the vibrant (co)presence of non-humans. This vulnerable conduit could nevertheless enable affective relations to emerge, as we form attachments through which we are mutually moved and changed (Lorimer, 2008; Latimer & Miele, 2013). It urges us to find new and interesting ways to navigate the often-times dizzying distances from the subjects of our prosthetic listening, through learning to dance with the anthropo-zoo-genesis that might occur in the encounter.

Two Verkberättelser, Part 2

Acting as If

Unlike the technically complex experience of sonifying microalgae, the amplification of sounds in a rockpool is instantly rewarding. Connect a hydrophone to an amplifier, attach a pair of headphones and you almost literally dive into another world. The intense ripping sounds made by the chiton are uncanny. The whooshing sound of the anemone's tentacles as they pulse in and out is seductive. Yet still the technology induces a sense of remoteness. This uneasy combination of proximity and distance became the root of my research for *BE THE SEA*, the project that composer Hayley Jenkins and I ultimately developed to explore new forms of listening with coastal communities between the rivers Tyne and Tees (Mackenzie & Jenkins, 2021–2023).

On one of our first beach visits, a collaborator suggested I put my ear to the rock beside a cluster of limpet shells. Patiently I waited, and soon realised that I could hear the limpets feeding as they made imperceptible movements before my clumsy eyes. The limpet is a small, ridged, conical-shelled mollusc that attaches itself to a rock so firmly that over time, a specific oval shape (known as the home scar) is etched into the rock. When the tide is low, the limpet resides in this location but as the tide returns and the limpet anticipates the rising water, it begins to move on its singular fleshy foot, the tongue-like radula, to scrape algae from the surface of the rock. Our knowledge of the

limpet's radula is accumulated from detailed scientific observations, too precise for the casual eye that spies an apparently static shell in a rockpool. Yet placing one's ear to the rock brings an immediate sense of movement – of how this mollusc lives.

From this moment in 2021, I began my perceptive relationship with marine organisms anew. What might using my own body, my senses and imagination, as a listening device add to my understanding of another species that technology could not provide? My experience of listening via the rock brought me back to recent attempts to experience the vibrancy of molecular and cellular matter without apparatus (Mackenzie, 2023). I have long felt that my body is not one entity but an amalgamation of ancestral living organisms (cells, mitochondria, microbes and so forth) that I am ultimately descended from (Margulis, 1998, p. 4). I became interested in processes of fermentation and digestion as ways in which to physically experience my microbial relations, those within me and in the environment around me. Through guided sensorial exercises, rooted in the Deep Listening techniques of Pauline Oliveros (1974), I have run sensorial walks that use listening to imagine in new ways those damp spaces where microbes congregate outdoors and workshops that focus on the moist cavities of the mouth, nose, throat and gut in an attempt to attune to the non-humans that reside with/in us.

The practice of *non-human sensing* becomes for me (and the others I share this with) a means to access, in an imagined and yet embodied way, the ümwelt of other species (Uexküll, 1934). Not only through the prosthetic layers of the field recorder or hydrophone, but through attuning my bodily senses to the environment that these species inhabit. Technology is still part of the uneasy dance but equally important is using the human body and mind as sensors – as a way to intuit another's experience. I ran workshops with Jenkins where we used hydrophones to invite participants into the world of the intertidal zone. This began the seduction and responses from our audiences were as expected – delight at hearing sounds never experienced before. Then we put the technology to one side and, not without some embarrassment, worked with the limits of the body to try and gain a different form of perceptual access (see Figure 4.2). Could we emulate the rasp of the limpet's tongue, or will ourselves to feel watery vibrations through the hairs on our arms (as a crab might)?

Allowing oneself this non-human sense seemed to move us conceptually into new territory, where it became possible to develop a more intimate relationship with the living environment of the coast, if not specifically the subjective experience of the individual beings within it. The act of *non-human sensing* becomes an 'acting as if' (Despret, 2016) – a brief insight into our animal selves, through or with or alongside technological prostheses. Now as I kneel at the edge of the coastline with my cheek to a rock, tuning into the strength of the wind as it buffets my body and sensing the repetitive

FIGURE 4.2 BE THE SEA, Mackenzie and Jenkins, 2023. Participant listening to limpets on a rock, Roker Beach, Sunderland during BE THE SEA workshop. Photo: Louise Mackenzie.

yet alluring call of the waves, I find space within my being to relate to the world of the tiny mollusc by my side and *listen with* the limpet.

I struggled at first to find a way to bring this deeply personal experience to a conventional gallery space. Our participatory workshops on the beach *were* the work. What became key therefore was the legacy of stewardship for the coastline that this work engendered in participants – how they had been influenced by the workshops and how we could foster that same stewardship in public audiences. The Word, a library and gallery in the North-East of England, is close to the homes of many of our participants, and importantly, close to the sea. Here, we were able to create an ambient listening space that would blend with the gull cries that pierced the building. An eight-channel audio composition comprised sounds recorded by participants, with an accompanying graphic score incorporating drawings and texts that participants had made in response to the sounds they uncovered. These were also published in a book of *Instructions for Non-Human Listening* (Mackenzie & Jenkins, 2023) that visitors were encouraged to take on their own coastal walks, expanding the capacity for non-human sensing beyond the gallery walls. The project continues as we work intuitively at the coast with a local

choir to develop a deeply personal, yet collective, response in a manner that enables us to feel that we can, in some small way, 'be the sea'.

Nothing More, Nothing Less

There is a significant confluence between our work stories. The sudden urge I had felt to resist sonification opened space for other modes of engagement, as listening to maize had turned out to be a peculiar form of cohabitation. On a winter's night in February 2019, when the sun set early and the allotment gardens were hibernating below a heavy blanket of snow, my collaborators and I invited people to join us outdoors for a silent soundwalk. This was followed by storytelling round the fire, among film projections that moved on the glimmering snow and on the rustling dried maize plants still standing erect in the frozen soil. The empty hut interior served as a resonance box for images and sounds captured during six months in that same place, turning the hut into a time capsule of seasons passed. In the silent walk our bodies had traced the former border of the once vast allotment community founded for and by workers at a time of war and food crisis in the beginning of the 1900s; a community that was almost eliminated in the mid-1960s due to urban exploitation. The storytelling weaved together the silent work of earthworms below ground with that of the Sentinel satellites in the sky, which monitor soil moisture on a planetary scale. The satellites' mode of environmental sensing translates the soil of the allotment gardens into pixels among other soil pixels worldwide, thus aiding in forecasting environmental disasters such as droughts and floods. Our mode of environmental sensing was quite different, as we instead honed our skills of 'becoming sensor' (Myers, 2017a). The popping and eating of popcorn by the fire for a brief moment connected us with people in Peru 4,500 years ago who did the same, reminding us of the remote origin of these seeds that had travelled from plant to hand to soil across millennia.

When asked to host a session at the Royal Music Academy in Stockholm 2021, I brought seeds, their storied relations, fragments of sound and film, tea made of maize silk and the short story *She Unnames Them* by Ursula Le Guin together with an invitation to hum for the seeds. After tasting and digesting the tea, we unnamed – each in their own way – the seeds we held in our hands and started to sound for them. It was intimate, almost private, yet a collective act. Very low-tech, very low-key. We neither gave voice to this other being, nor made the inaudible audible. We were, through sounding and listening, touched by sound. The invitation was tentative and suggestive; a gesture – nothing more nothing less. It was as if, with this invitation, I tried to backtrack and return to a moment that had mattered, that had shaken and shifted my perception and attention; a moment of behavioural change and deeply felt care. Afterwards, people told of a relief not having to perform for

other humans – a welcomed sensorial estrangement, though uncomfortable at first.

The seeds continued their journey. On invitation from Malmö Art Museum 2020, I and my collaborator Malin Lobell in the art platform (p)Art of the Biomass, created a forest garden and an almanack with five celebratory events (Holmstedt & Lobell, 2021). The garden functioned as a scene, a 'Planthroposcene' (Myers, 2017b), not for virtuoso performances but rehearsals. The events playfully ritualised and celebrated collaborations between humans and non-humans, while following the seasons. From January to April, before the maize seeds could be planted outside, they were bathed in sound in an audio-visual installation in the museum gallery. Sounds in the register between 200 and 300 Hz were amplified to help the seeds germinate. When it was time to move outside, participants were invited to form a seed choir and to hum for the seeds, before they were buried in the ground.

The maize plants were, as previously in my allotment 2018–2020, accompanied by bean and squash in the Indigenous companion planting system known as The Three Sisters, with humans being a 'fourth sister', as suggested by Robin Wall Kimmerer (2013). The sisters were in turn joined by other siblings, perennial plants native to Scandinavia that similarly supported, protected or provided nutrients to each other in a growing system known as a forest garden. It was not the controlled, designed and beautified garden – an enclosed and meticulously cultivated piece of nature – we had sought to produce. Rather it was a site of interspecies attunement, of tinkering with sensibility-formations in the domain of the micropolitical.

Leaning into the Dance

These two work stories tell of a moving back and forth, between seduction and reluctance, where listening emerges as a multisensory, situated, collective dance between beings and objects. If Louise approaches listening as a way of making space within the self to open up to other worlds, Janna offers the notion of cohabitation to sensitise the human listener to affective entanglements and co-becomings. These approaches present asymmetrical power relations and unbridgeable distances, as every attempt to augment the sensorium with technological protheses produces unforeseen effects. Ultimately, listening deeply and attempting to develop empathy towards other species might offer a kind of non-human sensing that allows us to lean into our bodily limitations and suspend human subjectivity. Such actions, alongside the tensions and troubles they provoke, have also been addressed through notions such as a feeling for the organism, becoming sensor, imaginative listening, sensorial estrangement and interspecies attunement. Instead of collapsing them all into one overarching concept, we prefer to treat them as a relational bundle of practice-theories and theory-practices. This additive rather than reductive

methodological approach does not seek consensus or classification, as we wish to embrace the plurality and frictions that emerge from following processual flows.

The techno-relational prostheses, and the troubles they stir, inspire us not to transcend as much as to acknowledge human limitations and dependencies, to dance with them. We have touched upon hi-tech, low-tech and non-tech approaches to listening as well as Deep Listening that could be said to function as decoys for listening *otherwise*. The (unavoidable) failure to capture or represent non-human lifeworlds might prompt us to find sensible and interesting ways to fail and to cultivate more careful ways of knowing. Care does not always imply that we need to be deeply involved on an emotional level, care could also demand that we find the right sort of distance in any given situation. While facts create one kind of distance, fiction generates another. Similarly, every technological layer both draws us near and keeps us apart. These tensions permit a vulnerability that we can lean into. Sometimes we might awkwardly mimic or sound a response to remain in relation, without being able to explain why. We could with Despret think of this as "an 'acting as if' that leads to a transformation" (2016, p. 17). It is not a question of becoming the other, of identification, but resonating with the other, suspending the self and welcoming the transformation that may occur (cf. Holmstedt, 2021). Recreating sounds, or sounding for, offers a form of bodily empathy, a way of accessing the animal self. Empathy is in the failing, and in the dance.

Dance with Your Listening

Janna Holmstedt and Louise Mackenzie

Through this score, we invite you to perform a listening session.

You are going to dance with your listening. You can choose the place and time, but the dance will choose you. The desire is to become the dance, be part of its flow. Choose a prosthesis for this special moment. It might be headphones and microphone, hydrophone, stethoscope, bat detector or something quite different.

Slowly and ceremoniously, don your prosthesis, while carefully paying attention to every part and movement needed for it to perform its magic. The softness, the hardness, the lightness and weight, its metal and plastic. Switch it on. What comes to attention? Welcome it and acknowledge it as part of your body. Notice this new creature that is both you and not you, how your movements and attention have changed and shifted. There might be reluctance, or anticipation. Explore this new body in motion with multisensory curiosity until you-not-you are in the mood for dancing.

What non-human being attracts special attention? How does it become part of the dance? This dance is not for one or two, there are more found in the motion. Attune to the rhythms of this sonorous timespace. The movement can be swift. Or slow, hardly noticeable. Take as long as you all need.

Allow you-not-you to lean into the push and pull. Let the attraction that your prosthetic creature enables stir you. Disturb you. What becomes of this captivating and maybe uneasy dance? You are in thrall to technology, seduced yet in control. Consider who wants to dance. Is there a way to ask, you might wonder? Can you begin to embrace these tensions as vulnerability? How else might vulnerability unfold?

With care and consideration, disrobe from your technology. Can you remove the prosthetic creature and still remain moved? In your openness, notice how the rhythms change. Attune yourself anew. Has something been gifted and received that could be passed on?

If so, try to pass it on.

Notes

1 I thank Ylva Gislén for this thoughtful gifting of seeds and relations.
2 I am indebted to Emma Frid and Ludvig Elblaus who ventured into the many technical and aesthetic aspects of plant signalling and sonification with me.
3 This line of thinking flows from new materialist praxes including those of Jane Bennet, Anna Lowenhaupt Tsing and Mark Peter Wright, whose chapter 'Following the Flow' describes in detail the material consequences of field recording (Bennet, 2010; Tsing, 2020; Wright, 2022).

References

Abram, D. (1996). *The spell of the sensuous: Perception and language in a more-than-human world*. New York: Vintage Books.
Baluška, F., & Mancuso, S. (2020). Plants are alive: With all behavioural and cognitive consequences. *EMBO Reports, 21*(5), e50495.
Barad, K. (2007). *Meeting the universe halfway: Quantum physics and the entanglement of matter and meaning*. Durham, NC: Duke University Press.
Bärtås, M. (2010). *You Told Me – Work Stories and Video Essays* (Publication No. 19) [Doctoral dissertation, Valand School of Fine Art, University of Gothenburg].
Bassler, B. (2009). *The secret, social lives of bacteria – YouTube*. TED. Available at: https://www.youtube.com/watch?v=TVfmUfr8VPA (Accessed: 9 September 2017).
Bennet, J. (2010). *Vibrant matter: A political ecology of things*. Durham, NC: Duke University Press.
Bose, J. C. (1926). The nervous mechanism of plants. *Nature, 118*, 654–655.
Braidotti, R. (2013). *The posthuman*. Cambridge: Polity Press.
Burnham, J. (1968). Systems esthetics. *Artforum, 7*(1), 30–35.
Calvo, P. (2016). The philosophy of plant neurobiology: A manifesto. *Synthese, 193*, 1323–1343 https://doi.org/10.1007/s11229-016-1040-1
Davis, J., & Egan, K. (2000). Audio microscope. *Genetics and Culture* [online]. Available at: https://geneticsandculture.com/genetics_culture/pages_genetics_culture/gc_w03/davis_audio_scope.htm (Accessed: 30 August 2017).
Demos, T. J. (2013). Contemporary art and the politics of ecology: An introduction. *Third Text, 27*(1), 1–9. https://doi.org/10.1080/09528822.2013.753187
Despret, V. (2004). The body we care for: Figures of anthropo-zoo-genesis. *Body & Society, 10*(2–3), 111–134.
Despret, V. (2016). *What would animals say if we asked the right questions?* (B. Buchanan, Trans.). Minneapolis: University of Minnesota Press.
de Waal, F. B. (1999). Anthropomorphism and anthropodenial: Consistency in our thinking about humans and other animals. *Philosophical Topics, 27*(1), 255–280.
Gagliano, M., Mancuso, S., & Robert, D. (2012). Towards understanding plant bioacoustics. *Trends in Plant Science, 17*(6), 323–325.
Haraway, D. J. (2003). *The companion species manifesto: Dogs, people, and significant otherness*. Cambridge: Prickly Paradigm Press.
Heidegger, M. (1977) *The question concerning technology and other essays, technology and values: Essential readings*. edited by W. Lovitt (trans.). New York and London: Garland Publishing. https://doi.org/10.1007/BF01252376.
Holmstedt, J. (2017). *Are you ready for a wet live-in?: Explorations into listening* (Publication No. 16) [Doctoral dissertation, Malmö Faculty of Fine and Performing Arts, Lund University].

Holmstedt, J., Siltberg, L., & Nilsson, E. (2018–2019). *Anthropomorphic interfaces* [art project]. With support from The Swedish Arts Grants Committee, Visual Arts Fund.

Holmstedt, J. (2020). Interspecies bodies and watery sonospheres: Listening in the lab, the archives and the field. *Leonardo Music Journal, 30*, 95–98. https://doi.org/10.1162/lmj_a_01099

Holmstedt, J. (2021). Follow the blind, mimic the wind and become a worm: Sonospheric mappings by a bag-lady soundwalker. *Unlikely Journal for Creative Arts, 7*. https://unlikely.net.au/issue-07/sonospheric-mappings

Holmstedt, J., & Lobell, M. (2021). Four sisters for planthroposcene [artwork]. In *Sustainable Societies for the Future* [exhibition]. Malmö Art Museum.

Keller, E. F. (1983). *A feeling for the organism: The life and work of Barbara McClintock*. London: W.H. Freeman & Co Ltd.

Kimmerer, R. (2013). *Braiding sweetgrass: Indigenous wisdom, scientific knowledge and the teachings of plants*. Minneapolis, Minnesota: Milkweed editions.

Larsson, N. (2022). Button pushers: The artists making music from mushrooms. *The Guardian*.

Latimer, J., & Miele, M. (2013). Naturecultures? Science, affect and the non-human. *Theory, Culture and Society, 30*(7–8), 5–31.

Leudar, A. (2016). *Integrating plant electrophysiology and 3D sonic art* [Doctoral dissertation, Queen's University].

Lifton, J. (1975). *Green Music* [artwork]. Edinburgh International Festival, UK.

Lopez, P., & Garcia, L. (2014). *Energy bending lab* [artwork]. https://interspecifics.cc/work/energy-bending-lab-2014/

Lorimer, J. (2008). Counting corncrakes: The affective science of the UK corncrake census. *Social Studies of Science, 38*(3), 377–405.

Løvschal, M. (2022). Mutual entrapment. *Aeon*. https://aeon.co/essays/how-one-modest-shrub-entrapped-humans-in-its-service

Mackenzie L. (2015). *The stars beneath our feet* [artwork]. Lumiere Durham.

Mackenzie, L. (2017). *Evolution of the subject – Synthetic biology in fine art practice*. Doctoral thesis, Northumbria University.

Mackenzie, L. (2020). Microbial sensing: Constructing perception through technological layers. *Leonardo Music Journal, 30*, 104–108.

Mackenzie, L. (2023). *Non-human sense* [Talk] Colloquium, ArtLaboratory Berlin. https://artlaboratory-berlin.org/events/colloquium-11/

Mackenzie, L., & Jenkins, H. (2021–2023). *Be the sea* [artwork]. https://exploreseascapes.co.uk/sunderland-co-lab/sunderland-colab-be-the-sea/

Mackenzie, L., & Jenkins, H. (2021–2023). *Instructions for non-human listening*. Norwich: Eggbox Prints, UK.

Mallatt, J., Blatt, M. R., Draguhn, A., Robinson, D. G., & Taiz, L. (2021). Debunking a myth: Plant consciousness. *Protoplasma, 258*(3), 459–476. https://doi.org/10.1007/s00709-020-01579-w

Margulis, L. (1998). *Symbiotic planet: A new look at evolution*. New York: Basic Books (Science Masters).

Meder, F., Mondini, A., Visentin, F., Zini, G., Crepaldi, M., & Mazzolai, B. (2022). Multisource energy conversion in plants with soft epicuticular coatings. *Energy & Environmental Science, 15*(6), 2545–2556.

Mescher, M. C., & De Moraes, C. M. (2015). Role of plant sensory perception in plant–animal interactions. *Journal of Experimental Botany, 66*(2), 425–433.

Morton, D. B., Berghardt, G. M., & Smith, J. A. (1990, May–Jun). Animals, science, and ethics – Section III. Critical anthropomorphism, animal suffering, and the ecological context. *Hastings Center Report, 20*(3), S13–S19. PMID: 11650362.

Myers, N. (2017a). Becoming sensor in sentient worlds: A more-than-natural history of a Black Oak Savannah. In G. Bakke & M. Peterson (Eds.), *Between matter and method: Encounters in anthropology and art* (pp. 73–96). London: Bloomsbury Press.

Myers, N. (2017b). From the anthropocene to the planthroposcene: Designing gardens for plant/people involution. *History and Anthropology, 28*(3), 297–301.

O'Hara, S. (2020). Seascapes Co/Lab [website]. https://exploreseascapes.co.uk/sunderland-co-lab/

Oliveros, P. (1974). *Sonic meditations*. Baltimore, MD: Smith Publications.

Patrão, C. (2018). Botanical rhythms: A field guide to plant music. *Sounding Out!* https://soundstudiesblog.com/2018/02/26/botanical-rhythms-a-field-guide-to-plant-music/

Pelling, A., & Niemetz, A. (2004). *The dark side of the cell*. [artwork] Available at: https://www.darksideofcell.info/composition.html (Accessed: 14 December 2015).

Retallack, D. (1973). *The sound of music and plants*. Marina del Rey, CA: DeVorss.

Robinson, D. G., Draguhn, A., & Taiz, L. (2020). Plant "intelligence" changes nothing. *EMBO Reports, 21*(5), e50395.

Sareen, H., & Maes, P. (2019). Cyborg Botany: Augmented plants as sensors, displays, and actuators. [Research project, MIT Media Lab]. https://www.media.mit.edu/projects/cyborg-botany/overview/

Servais, V. (2018). Anthropomorphism in human–animal interactions: A pragmatist view. *Frontiers in Psychology, 9*, 2590. https://doi.org/10.3389/fpsyg.

Skrebowski, L. (2006). All systems go: Recovering Jack Burnham's systems aesthetics. *Tate Papers*. https://www.tate.org.uk/research/tate-papers/05/all-systems-go-recovering-jack-burnhams-systems-aesthetics

Tompkin, P., & Bird, C. (1973). *The secret lives of plants*. New York: Harper & Row.

Trafton, A. (2021). A Safer Way to Deploy Bacteria as Environmental Sensors. Phys Org. https://phys.org/news/2021-04-safer-deploy-bacteria-environmental-sensors.html

Trewavas, A. (2017). The foundations of plant intelligence. *Interface Focus, 7*(3), 20160098.

Tsing, A. L. (2021). When the things we study respond to each other – Tools for unpacking "the material" in A. Jaque, M. O. Verzier, & L. Pietroiusti (eds.), *2020. More than human*. London: Serpentine Galleries.

Vicient, C. M. (2017). The effect of frequency-specific sound signals on the germination of maize seeds. *BMC Research Notes, 10*, Article 323. https://doi.org/10.1186/s13104-017-2643-4

Vickers, P., Hogg, B., & Worrall, D. (2017). Aesthetics of sonification: Taking the subject position. In C. Wöllner (ed.), *Body, sound and space in music and beyond: Multimodal explorations* (pp. 89–109). Oxford: Routledge.

von Uexküll, J. (1934). *A stroll through the worlds of animals and men*. New York: International Universities Press Inc.

Wright, M. P. (2022). *Listening after nature: Field recording, ecology, critical practice*. New York: Bloomsbury.

5
THE WEAK POWER OF LISTENING

A Conversation between Ayreen Anastas, Rene Gabri and Rolando Vázquez

Ayreen Anastas, Rene Gabri and Rolando Vázquez

Rene: A good way to begin is from where we are. For us one of the things that has been very enriching about our relation to you is this foregrounding of the question of positionality. Where is one situated and speaking from? In this moment, there's an invasion in Artsakh, not many kilometers from where we are situated, by a regime in Azerbaijan, historically linked to a genocide which took place a 100 years ago against Armenians and other communities. Not only does the Azeri state deny this history, but today it continues to erase the presence of Armenians in the territories it controls and now threatens to kill or displace the Armenians of Artsakh, who have lived continuously in these nearby mountains since the earliest recorded history. It seems to us very urgent to think about questions that are in the centre of your work, as well as ours, in very different conditions/circumstances, and also in a way, different positions, geographically as well as historically.

I think it was actually in and around questions of time that we first met. So maybe we can begin by asking – in what time are we listening in a decolonial listening? What is the temporality of a decolonial listening?

Rolando: The transformation of temporality is at the core of listening. Because listening happens in time. What I mean when I say "time" is that it implies the relational, it implies memory. Whereas the logic of representation and appropriation that are so central to modern civilization don't happen in that deep time of relation and memory. They happen in the space of presence, the space of owning. Appropriating is about owning in the present, and representation

is about what appears in the present. Whereas listening requires that relation that is *in time*, that cannot be reduced to the present.

I think that is what is fundamental about the temporality of listening, and why what we call *decolonial aesthesis* moves away from the paradigm of representation to the logic of reception.[1] To be able to receive, you need to be able to hold the time of others. And to be more than that single self of ownership that is sovereign in the present but has no memory, no time, no plurality. In that sense, what we may call relational listening is only possible through a positionality that enables us to be more than a "single being," using this term from Fred Moten by way of Édouard Glissant (Harney & Moten, 2013; Moten, 2010, 2017, 2018a, 2018b). But the way we use positionality recognizes that we are always made by others, that we all carry forms of ancestrality that we do not own. Positionality in time is what enables you to listen because you have a consciousness that you are always already relational before becoming a single self, and that listening connects you back to that possibility of the plural. And by listening you become capable of carrying and caring for the story of others, the voice of others, and you carry it in memory, not in ownership. You become witness. You become more than yourself through the work of listening.

That's why I thought this question of the temporality of listening is really at the core of the horizon of transformation, of exiting the logic of property, of appropriation, of representation, and moving towards an aesthesis, an experience of life: of relationality, of togetherness, of mourning, of remembrance.

I'm thinking of the work of Rana Hamadeh and the idea of the testimonial subject that comes through Islamic traditions (Mullié et al., 2018). It is this subject that becomes witness and that carries the memories. The carriers of communal memories, like the storytellers from other traditions, are the bearers of hope. Because the violence of erasure is only fully achieved when things are forgotten; the testimonial subject that is capable of listening is what sustains the hope that justice can come someday, that healing can come someday. The testimonial subject is like the last resistance against oblivion and total erasure. When a genocide is forgotten there is nothing left to do, there is no more hope. But when a genocide is still remembered, when there's still the possibility of mourning, then there's some hope that there will be healing.

Ayreen: Do we need different kinds of ears or sensors to listen to what has been silenced? What is the nature of what has been silenced? It is obviously not reducible to audibility nor to language.

Rolando: Yes. It is a question that connects to what we have been asking with decolonial aesthesis: With whose bodies have we been made to dance? With whose eyes have we been made to see? With whose ears have we been made to hear? The way we are taught to hear makes us incapable of listening. How are our ears trained to primarily recognize what is audible for the dominant structures, for the dominant subject.

We might need to distinguish this hearing-as-consumption from the listening that requires that one has different ears, so that one recovers that capacity of relating to others through listening. Can we think of listening as relation, as receiving the other? And what does that imply? I think in some spiritual traditions that implies the possibility of becoming capacious, being able to put aside the single self in order to receive the difference of others. In this way, the notion of listening is not about the appropriation of knowledge, but rather the capacity of reception of other worlds.

The second part of your question has to do with which worlds have been silenced. Decolonial listening is a listening capable of receiving the silences. What has been silenced? What has been under erasure, is under erasure? How can we listen across the colonial difference, and across the colonial wound?

We understand coloniality as a system that erases, that is, that produces oblivion. It holds under erasure other worlds, other worlds of meaning, other Earth-worlds, other Earth histories, other ways of being in the world. We cannot forget that the Zapatistas have signed many of their communiques, with the motto "the war against oblivion." In a way it is that erasure of other worlds – of other alternatives of being with Earth and becoming human otherwise – which calls for decoloniality. What has been silenced, what is under erasure, is what calls for decoloniality.

One of the things that is necessary for us to understand better is, what does this task imply? The disposition towards listening, in order to listen to those silences, is very different from the attitude of hearing to consume, to appropriate or just to be immersed in the endless noise projected around us. What does it mean to listen to silences? And how can we orient ourselves towards reception, how can we develop the disposition of listening? How can we develop that capacious capacity, as an "aesthesic" capacity.

Sometimes in art schools, I ask, "Well, you've been trained for enunciation. What would it mean to be trained for listening, for reception? To develop that capacity?"

Rene: If we say that decolonial listening is connected to the ethical practice of listening to what has been silenced, certainly Earth is at

the centre of that, and all the suffering, all the different forms of life, that are continually under threat or being destroyed in this very moment. And I was thinking that this silence that you were alluding to just now, which is not listening to what has been silenced in the sense of bringing it to enunciation necessarily, but actually listening to the silence, in that sense of silence being the very condition of any listening otherwise. Without that silence, you're listening to what is being channelled towards you. And so I was thinking that this question of silence could be interesting to remain a little longer with. Because it seems that it could be too quick a solution to try to give voice to those things that we think are silenced, as if bringing them to some audibility would be the resolution, whereas maybe it's an attunement that we're interested in, to whatever has been called silence, which is full of a multiplicity of other possibilities for hearing or listening.

So, we had actually written something to ask you in relation to this question of what has been silenced. And then you already anticipated that in what you were just describing as "listening to the silence." At the time of the pandemic, we wanted to think about those pre-existing conditions beyond the biological and physical health of individuals; we wanted to think about those asymmetric vulnerabilities in terms of communities and a more expanded geographic and historic sense of "pre-existing conditions." And so we were trying to create a space where we could listen to each other and think through that experience of having been collectively brought to halt, often locked down in homes. To talk from different places, experiences, political intuitions and histories in an open way was critical for us to make another sense of what we were undergoing together – to listen in and through that silence which was momentarily created and at the same time fragile, vulnerable, needing care to defend and maintain.

Rolando: Given what is taking place not far from you today, I thought to also think together about your film *Black Bach Artsakh*.[2] Would you think of the film as a work that carries the hope of being heard? I see it as a story, a testimony, that doesn't have many words as a narrative, but that needs to be poetically heard. And then what in this hearing – as in this listening as reception – what does this being heard mean as a movement of hope, as a movement of healing, of holding each other, of the possibility of coalition, of learning each-other's struggles?

Because, as you know, I have been worried that struggles tend to be separated from each other in their one-directional challenge to power, and as Maria Lugones used to say, we spend very little time

knowing each other's struggles (2020). The call to listen to each other's struggles is fundamental to create coalitions, but also to sustain some hope and find some healing among us that bypasses the enclosure of that dichotomic bond to oppression and violence. What happens when one is heard and by whom?

I find that the notion of listening as a work of memory is connected to what you were saying on silence, and with it the understanding that the silence that is required for listening is not an empty silence, but is a silence that is capable of weaving memory, of weaving memory together. There's a generative silence – not exactly generative – but more like a dark, deep and fertile soil, a place for cultivation where memory can be held together. It goes against the grain of coloniality, erasure, against the grain of coloniality's silencing. The silencing of coloniality does not hold memory, it produces erasure, oblivion. Where it is more like the expansion of nothingness, of a lifeless nothingness, a nothingness without memory. So I would like to distinguish this silence that holds memory, and that is necessary for the weaving of togetherness, of relationality, of time, from that silencing that produces erasure, that is vacating what has been lived out of time, expelling the lived out of time.

In a conversation in Rotterdam, Cecilia Vicuña said, "The problem with plastic is not that it is dead. The problem of plastic is that it cannot die" (Vicuña, 2019). That is the point of a system that produces artifice, an artifice that has no death and no life. It's a form of emptiness, empty time, where there is no relationality anymore. Whereas when things die, they return, become ancestral and can re-emerge in other presents. They become precedents. But when things are just extracted to produce waste or pollution, there is no life, there is no return. It's just the expansion of that void that produces violence. I think that is the oblivion that Zapatistas are fighting against, and that decolonial listening is moving against. And that requires a silence, but a silence that is like a soul, like the darkness inside the soul, that is generative, that holds together time. It's very unlike the erasure that is an empty darkness, where there is nothing, where there is the dissolution of temporality.

Ayreen: This is interesting in relation to silencing and forcing speech. Which is more oppressive, the silencing or forcing of speech? In a liberal paradigm there is a certain idea of freedom of speech that can be fascistic. It is often forcing speech. That forcing of speech is not only making people speak, but also making them say things and speak in ways that are not their own, on matters which they have no relation to or idea about. So both the silencing and the

forcing of speech can be decisive instruments of control. This is a note that we could come back to in relation to language and the forcing of speech and more specifically certain kinds of speech.

Rolando: I think we can speak about discourse as erasure, or the dominant speech as erasure, such as Gloria Anzaldúa (2012). And so this forcing of one tongue, of one language, like for example through the news, like what you were saying with the pandemic, this forcing of speaking of one grammar as one way of thematizing the problems we're facing… That dominant speech becomes a way of silencing. It is not listening. And it is erasing the tongues, the storytellings, the experiences that are happening. I think in the case of the pandemic we were also talking about this, about the ratio of death, like the deathless death, the death without mourning, the death that became death in numbers for the dominant discourse. There is a speech that is silencing, and that we begin speaking through our mouths. With which tongue are we being made to speak, with whose eyes to see, with whose ears to hear? With whose speech are we speaking? And is that just a cacophony, an echo of the dominant discourse? Or are we speaking through what we have heard? Are we listening? Is our speech the flourishing weave of what we have received or is it just a repetition?

Ayreen: Yes, I had written this question, and it relates to two things that you are mentioning, apropos of radical response to the age of enunciation and representation, that is, as a transformation of experience. What are the sites of the transformation of the experience? Where would it take place? What would help bring it about, prepare the ground, unfold the way to such an experience? And, in a way, the conversations we had in our assemblies during the time of the virus, or that space-time we create in the film-world *Black Bach Artsakh*, could be such places, maybe to open the way for such a transformation, creating a place to be able to find each other and understand the different experiences we each carry with us. However, it's still an open question, because it's a very important aspect, this question of the transformation of the experience.

Rene: Which you connect to decolonial listening in the brief notes you had shared with us. **Rolando:** Positionality is the key of first understanding one's ground wherever we are, a ground that has time. So, our grounding in time. We are not just an identity, we are also from whence we come, and where we are, connected to ancestrality. This "whence" brings about the question of our provenance, from places in time. And that is, I think, what allows the possibility of transformation, of entering that relation that leaves us transformed. Something that, for example, we deeply need to remember

is that we are Earth-bodies. What has made us forget that we are sustained by Earth, and that we are made of Earth? So that deep memory that connects us back is the site of the grounding that you are asking about, which is in contrast with the nowhere of abstract thinking, or even phenomenology, like this flight to reduction, to abstraction, to find forms of concrete experience, but that have no memory, no time. And to an extreme, the artifice manifests itself materially in spaces like the white cube, the black box, the classroom, the shopping mall, the airport. These "no places" that are "no where," that have "no whence." Similarly to how universities train to write 'scientifically' from nowhere coupled with the arrogance of thinking that one can be everywhere (Haraway, 1988).

Being everywhere and nowhere at the same time is to be with no grounding and no memory. Positionality in time requires memory; it grounds us in a plural sense, because we know we come from a plurality beyond the individual self, from plural trajectories that include Earth. Once we position ourselves in time and remember, we cannot escape from an Earth-consciousness, from realizing that we are made of Earth and sustained by the life of Earth. This is part of what we might think of as the work for listening, to be able to listen – that grounding, that positionality, that deep remembrance of who we are collectively or plurally.

And, in our view, it's only from that place that we can construct relations with others, and receive the difference of the other, and be received as well. That construction of the relation comes from also understanding that we are relations, from the beginning, we are always already relations. We are much more than that individual single self.

Rene: Yes, so many different threads. I think one of the threads I would like to stay with, without knowing where it will go, is this question of testimony because you asked a question around that. And it's interesting, because when we made this film-world *Black Bach Artsakh*, it came out of actually a desire to be in conversation and organize some thinking together around this moment in the Fall of 2020, when Azerbaijan invaded Artsakh, which they're invading again, on this very day we speak. As we were organizing what we imagined as a "conference in shards," we were asked to give a historical account from some of the people we were inviting, or tell them more about the conjuncture, to help orient their contribution. And every time we were oriented towards writing something, it seemed so insufficient. It was like being forced into a kind of language that is journalistic or historical. So the film emerged more out of an exigency to share something like a testimony, give

testimony to something. But through a very transubjective, let's say, set of experiences, of encounters that I had recorded in 2007, 13 years after the independence of that self-recognized republic and 13 years before the 2020 invasion. So we were interested in this question of testimony, as opposed to documentation. And we were thinking maybe we should call it a testamentary, not a documentary. It is interesting that you brought up testimony in relation to listening. I don't want to say, "Can you say more about that?" But I want to ask or attend to that question of hope and its relation to testament that you brought up. We live in very challenging times, in relation to that hope of testimony, as I see it, and as we see it, probably all of us together.

Another thread is what we've been thinking about as "white noise," especially since the time of the virus was also the context of the George Floyd uprisings. In that time, to follow all that was going on during lockdown, on the streets, we often had to rely on and enter virtual realms, using so-called social media platforms, where one often finds what could be the most anti-social kinds of sociality. So, that time made us sensitive to the levels of noise around us, especially in such virtual spheres which seem to deny any possibility for a reception of some other kind of testimony, let's say, some other possibility for making sense. So at the same time that we're thinking about listening and testimony, and hope and healing, it seems to me we have a challenge to create the spaces where that kind of transmission and reception can occur. Because in that time, you felt the keen sense, especially being deprived of our capacities to assemble in person, that what we have are these enclosures, the platforms, composed of information bubbles, virtual echo chambers, soap boxes, produced and prescripted by large corporations delivering custom tailored "news products" via individuals, their profiles and the algorithms that attend to what people are interested in, hearing and finding only what they want to hear or will trigger them to respond. And on the user side, you have this kind of overall effect of the generation of noise. This is what we are calling "white noise." Because it has everything to do with the modelling of social behaviours and relations which seem very bounded to whiteness and the type of social repertoire of the suburban white men who own, control and design the majority of these spaces. It has something to do with the wider infrastructures of modernity/coloniality where things are created, instituted, in this case, to privilege, model and moderate the form of relations, the form of speech which pre-empt and smother the possibilities for sharing, relating, receiving and listening otherwise.

So we could ask, how do we struggle against these generators of "white noise" that seem to overwhelm any possibility for attuning to the silence, and the silenced?

We would come back closer to the heart of the decolonial questions that you and all the friends raise, thinking about what modernity displaces and silences.

Whatever we are calling "white noise" is connected to the proliferating sites whereby what is transmitted is less important than where and how that transmitting and receiving occurs. This is what we see in these anti-social media spaces, factories or generators of sounds, of speech, of texts, of images, of noise, that more than what we may share within them – even sometimes very necessary counter-information, images, voices which we are drawn to, because we seek news, ideas, questions from the ground, from comrades, from struggles, like during the uprisings – still have the effect of silencing the possibilities of reception ... and relationality.

Rolando: I think that it's important to notice the noise you are talking about. In a way, it is connected to the artifice of the empty present; it's like the propagation of the empty present, or the temporality of the empty present. It's a noise with no memory. Musicians understand readily that there is no music without deep temporality. If you pause a film you find a still image on the screen that you can see, but if you press pause in a cassette or if you pause the music, there is no music, there is no music reducible to the present. The temporality of music, of listening, cannot be reduced to the empty presence. What this noise does is precisely that expansion of empty time, of the time with no memory, with no possibility of weaving, of relationality. It's just like an expanding cacophony.

It has the effect of silencing, of making impossible the time of listening, the time of reception, the time of memory. This noise doesn't have any of those temporalities. It is the empty time of the empty present of modernity. This noise makes reception impossible and, thus, listening as reception. What does it mean to receive? What are the conditions for receiving something that is beyond our understanding or our horizon of understanding? Can listening bridge that enclosure of our horizon of understanding? When we witness something, can we overcome the horizon of understanding that encircles us, can we breach the enclosure in which we are? I want to think listening as that power of weaving worlds and world travelling (Lugones, 2003) as that possibility of going beyond the enclosure of modernity as well as beyond our worlds of sense and receiving other words. And in that way becoming more than oneself (Moten, 2010).

What does it mean to receive, to be capable of hosting the difference of the other, like the Zapatistas would say? As a condition for decolonial listening, and as a sign of that move away from the logic of property, of *owning*, which is the logic of the documentary, to owing, to a logic of gratitude, of the reception of the other, the reception of what makes "me" more than myself. Owing and the relinquishing of the self is the countermove to the notion of property that makes "me" more of myself.

And what does it mean also to *be* received? Here we come close to deep spiritual worlds, and words, like compassion. What does it mean to be moved by the suffering of others? The condition of this noise, or the enclosure of the individual, is a condition of indolence, of indifference, of not being touched by the difference of the other; of owning, and not owing, of having, but not receiving. It is important to spell out these differences, find this vocabulary and value these practices.

Coming back to the question about the film *Black Bach Artsakh*, what does it mean to be received, if you want, as a weak hope in the face of violence? You may not be able to stop an army, but you may be able to sustain yourself because you have been heard, because others carry your stories, because others carry your pain as well. Here we find the work of mourning, the work of compassion, that is with and among people, and not necessarily in relation to power.

In the work of healing and mourning, there is the work of reception, there is the tending to and the gratitude for the life of others. There is the becoming more than ourselves.

We could locate the distinction between the documentary and the testimony in the way the documentary function is more related to ways of capturing, of appropriation and representation, whereas the testimony would be more in the mode of reception, the gathering of what should not be forgotten and the giving to others. They have different functions, a difference that might be similar to that between archiving and storytelling. Where the archive is this appropriation and classification of historical things and owning them, and storytelling is that transmission without authorship, without ownership. Storytelling needs reception, and it needs transmission again. It needs to be cared for, cultivated.

Rene: There's this beautiful passage in Walter Benjamin's *The Storyteller* where he weaves together that intimate relation between storyteller and listener. And he connects the death of storytelling to the loss of the space and the time of experience, thus of storytelling and of listening.

Rolando: That is a transformation between being a single person or becoming relational. A single person in the face of violence has no hope, and is powerless, and is pushed towards indolence or cynicism, whereas the relational person, and this we have learned from 'First Nations' and 'Indigenous peoples,' that even when they're under the harshest of oppressions, they nonetheless carry on having hope, because their relationality is still alive, they are not over-defined by the condition of oppression. Their memories are still alive, they can know who they are beyond the logic of oppression.

Rene: Something that was striking in a text of yours we were reading is where you write that "coming to voice" is actually deeply connected to the "we" (Vázquez, 2020). And so, what you were saying prompts us to consider that within the modernity coloniality matrix, coming to voice and the we are posed as antithetical to one another. Everything about coming to voice, in the sense you mean it, is deeply connected to a we, to ancestrality, to relationality. Whereas in modernity, having a voice is all about I, possession and property, owning and propriety. Whatever would be a voice or a coming to voice in this decolonial ethics praxis horizon would be completely connected to an attuning through/with silences and processes of listening.

Rolando: Yes! You are anticipating these notes I have here for the conversation: "the coming to voice is what is confronting 'the tradition of silence'" (Anzaldúa, 2012). The coming to voice is that emergence that crosses that silence, and, in that sense, what undoes the silencing. So, we could think of the passage from silencing to the coming to voice, that crossing, as a task of listening. Listening to what has been silenced is what will come to voice, where coming to voice becomes a listening. So, a listening that speaks, that speaks again, what has been silenced, a listening that re-members, restitutes, repairs. That is in this disposition of reception of what this silence is threatening with erasure. Coming to voice would be the accomplishment of the task of listening to what has been silenced. Then, coming to voice is not just gaining the power of speaking, but traversing the silence through listening. It is what can bring about a voice that is not out of my volition, or my authorship. It is about the capacity to receive what is threatened with oblivion, and bring it to voice, through the body, embodying it, giving breath again to what has been consigned to death, to erasure.

The coming to voice is then not this volition of representation, but is that struggle against erasure. It needs the task of listening to what has been silenced in order to embody it again and bring it back to the experience of life.

Ayreen: Let's think of the lifespan of any of us. We are born into oblivion. Everything around us, the language that we learn, the schools that we go to, all the institutions around us, are forming us. Let's set aside the word "form," until we can better name what we are talking about. It is a question of temporality on different scales. At the scale of an entire ecology, of life on earth, of a life span, in which this listening and coming to voice is a transmission of what we carry through our experiences. Parallel to the structures attempting to form us, we live and are affected by these different temporalities which materialize in specific ecologies, in our surroundings, places, gestures, dialects, vernacular forms. It is through these parallel, longer processes of becoming and our attunements to them that hope can transmit. So in a life cycle there can come the occasions, the encounters which allow one to understand certain feelings that one has been constantly feeling that something is wrong in everything that one is living. And when one feels that, and one feels how wrong everything is ... I feel it profoundly, that this listening and coming to voice – speaking a certain truth, that one has *lived*, not a truth that is abstract, but a truth that comes from that "we" that you are also speaking about, that transmits over the generations past, and to come, in my body – this is the living experience. It is what it means to be alive, to live.

Rene: Recently we went to a conference organized by friends involved in the Kurdish struggle, and there was a workshop organized by a collective of mostly Armenians living in Germany and Austria. The workshop was around Armenian Kurdish solidarity, trying to think through some of the challenges. Many of the places that Kurds live today were also central to Armenian life, historically, inhabited by Armenians. And so, whenever Armenians see Kurdistan as a name, projected over certain areas, it's very hard because those were ancestral lands as well for Armenians and are places they were erased from, and effaced, and killed, sometimes also with the collaboration of some Kurdish tribes or groups. And so these are moments of real challenge to building a decolonial politics.

In that conversation, there emerged at some point the thinking about democratic Confederalism as a political horizon. And I said, "Well, you'd have to think about how to form a kind of democratic confederalism with ghosts." Because we have a lot of ancestors there, embedded in those rocks and stones and crumbling edifices and churches, and sacred sites. Even in the most radical kind of political processes that we can imagine, this question of being able to listen to the absence, or of giving presence to the

absence, attuning to that absenting, making it part of our disposition or sense practice ... It's very difficult to do, right? But it seems to us whatever would be called a decolonial listening calls for something like that because of all these states that we are forced to live under the rule of, that are often founded on genocide, colonialism, subjugation, oblivion and continual processes of erasure, denial, destruction and extraction.

So I'm also thinking about what you refer to as the "colonial wound" (Mignolo & Vazquez, 2013) and its relation to listening, not only as a kind of attunement to the ancestral and the memory, but also as a way of traversing or relating to the processes of violence that have been perpetrated and instituted, to the destruction and the harm.

Rolando: When it comes to what has been lost, healing is precisely about not forgetting. Healing has to do with mourning and the possibility of remembering what has happened. And sometimes the loss is irretrievable, like in the face of genocide.

Mourning relates to ancestral memories that don't have any more the possibility of becoming worlds, that are irretrievably lost, like some languages, like some earth-worlds, like some, ecosystems and life-worlds. And still, mourning is there to avoid complete oblivion by remembering the erasure. This healing needs a memory that can receive, and that can host that absence, that heavy absence. When you mention ancestrality and sacredness, this is not about mystical beliefs and the transcendental. It has to do with the sacredness of what has been made absent, and that requires not to be forgotten. The sacredness of what is beyond our selves and beyond the present of oppression. Justice needs a deeper temporality, needs not forgetting, like that testimonial subject we were talking about. Mourning is a form of standing witness, of listening to what has happened, of not forgetting. And that is oftentimes what needs to be done, or what can be done, when the loss is irretrievable.

When we speak about decoloniality there are very concrete demands, like the recovery of lands, the recovery of autonomous education systems. There are very concrete things that can be done in many places. But in other places, for example, in the case of genocide, I think mourning is part of the work of justice that needs to be done. It requires attuning, it requires time and a deep understanding of what listening is capable of doing. I don't find an exact way of saying it; but it is a weak power, the weakest power. It is the weak power that remains in the liminal space against total erasure. Mourning, honouring, not forgetting, are elements of that weak power against extreme forms of violence. And there,

listening might be fundamental to keep that very weak space of justice and hope, that cannot undo what has happened, but that can sustain us – a memory and a dignity that otherwise would be totally erased.

But that is kind of a limit, of where injustice can become total erasure, can become total. And where the last resistance is mourning, is that sacredness, of not forgetting what has been destroyed.

When we address the colonial wound, and here I'm thinking of the angel of history of Walter Benjamin that is gazing towards the past where he sees catastrophe (Benjamin, 1942). We need to be able to stand in the face of that horrible sight of erasure and destruction. We need to be able to stand witness to it as a form of weak justice. Weak in the sense that it cannot undo what has happened, yet it is capable of keeping hope.

Going back to the idea of the testimonial subject, of the subject that can receive. To sustain the task of the decolonial, we need to stand witness in the face of violence. You, Ayreen and Rene, have witnessed so much war and unnecessary violence in Armenia, in Iran, in Palestine, in the United States and in Mexico, the relentless everyday violence, of femicides, against the communities, against the defenders of the land, against indigenous peoples. It is very difficult to sustain that awareness. As individuals, I think it is an unbearable task to sustain the sight, to remember, to stand witness.

We can only sustain the sight of the horror, through the "we," this togetherness, this hope that comes through testimony, through listening and knowing that we are not alone. That's what gives us a grounding in time, to remain standing in the face of violence. As self-standing individuals in networks, the sight of violence moves us into despair or cynicism or indolence.

We can stand witness and listen through a deeper temporality. The horizon of the modern/colonial wound brings us into the awareness that comes from 500 years of people standing witness and fighting against oblivion. Fighting for the coming to voice. Not only the keeping testimony of the violence, but also the coming to voice of the worlds that have been silenced. For me, our most important guides are the "Indigenous" peoples that while having suffered enormous violence, being under erasure and repression, teach us that it is possible to remain hopeful and not only that, they teach us how fundamental it is to safeguard the joy for life.

Rene: I think that there's a lot more to listen, relate to. We are very grateful, thank you. Let's see what happens now tonight, with this brutal campaign, I don't know what to call it.[3]

Notes

1 Decolonial aesthesis is the response to the dominant order of aesthetics that regulates the world of culture and, crucially, that regulates our senses and thus our everyday experience of reality (Mignolo & Vazquez, 2013).
2 Black Bach Artsakh, Ayreen Anastas and Rene Gabri, 2021. For more please see http://centreparrhesia.org/shards/
3 In the ensuing days after the invasion of the 19th, the Azeri military realized their genocidal aims to terrorize and ethnically "cleanse" the more than 100,000 remaining inhabitants of Artsakh from their ancestral lands.

References

Anzaldúa, G. (2012). *Borderlands / La Frontera: The New Mestiza* (Fourth Edition edition). Aunt Lute Books.
Benjamin, W. (1942). *On the Concept of History*. Classic House Books.
Haraway, D. J. (1988). Situated Knowledges: The Science Question in Feminism and the Privilege of Partial Perspective. *Feminist Studies*, 14(3), 575–599. https://doi.org/10.2307/3178066
Harney, S., & Moten, F. (2013). *The Undercommons: Fugitive Planning & Black Study*. Minor Compositions.
Lugones, M. (2003). *Pilgrimages/Peregrinajes: Theorizing Coalition Against Multiple Oppressions*. Rowman and Littlefield. https://rowman.com/isbn/9780742514591/pilgrimages-peregrinajes-theorizing-coalition-against-multiple-oppressions
Lugones, M. (2020, June 29). *The 11th Edition of the Middelburg Decolonial Summer School: the Communal, the Museum and the End of the Contemporary* [Zoom Talk]. https://www.youtube.com/watch?v=7O7Sg7fTltE
Mignolo, W., & Vazquez, R. (2013). Decolonial Aesthesis: Colonial Wounds/Decolonial Healings. *Social Text*. https://socialtextjournal.org/periscope_article/decolonial-aesthesis-colonial-woundsdecolonial-healings/
Moten, F. (2010). *To Consent Not to Be a Single Being* (https://www.poetryfoundation.org/) [Text/html]. Poetry Foundation; Poetry Foundation. https://doi.org/10/02/to-consent-not-to-be-a-single-being
Moten, F. (2017). *Black and Blur*. Duke University Press.
Moten, F. (2018a). *Stolen Life*. Duke University Press.
Moten, F. (2018b). *The Universal Machine*. Duke University Press.
Mullié, J. et al. (eds) (2018). Prix de Rome 2017, Visual Arts Winner, Rana Hamadeh, Amsterdam, nai010 publishers, Mondiaan Fonds.
Vázquez, R. (2020). *Vistas of Modernity | Anagram Books*. Jap Sam Books. https://anagrambooks.com/vistas-of-modernity
Vicuña, C. (2019, September 20). *TALK with Catherine de Zegher: Cecilia Vicuna* [Public talk], Kunstinstituut Melly, Rotterdam.

PART 2
Apparatuses of Listening

PART 2
Introduction

Tullis Rennie

The chapters in this section attend to human entanglements with apparatuses of listening. They hold accounts of creative practitioners who listen for, observe, and interrogate how listening practices are shaped by sonic technologies. Many chapters aim to redress the tacit structural logics found within these technological apparatuses – navigating the hierarchies and biases that audio devices and human bodies all have embedded within them, and around which technologies are systemically designed, constructed, and used. The works in this section are framed by two overarching questions. First, how might practices of listening facilitate the potential decentering of human subjectivity, to challenge our inbuilt anthropocentric biases? Secondly, how might creative sound practices facilitate our unlearning this regard, and guide us toward novel paradigms in which the human isn't always center stage?

The authors of the chapters in this section are all creative practitioners, found variously in studios, concert halls, community and DIY spaces, and in 'the field', at coral reefs and other underwater locations, or taking inspiration from those listening beyond the earth's atmosphere. Each chapter draws on the experiences of these creative practitioners whose processes and practices manifest as research. The ideas they express result from critical work *with* apparatuses of listening and recording – technologies ranging across analogue, digital, embodied, and imaginary forms.

Apparatuses of listening in this section are understood to be any technologies that allow us to perceive differently our connections to the world around us, beginning with the ear and extending outwards. Audio technologies are widely understood to include tools for listening, recording, and reproducing: microphones, amplifiers, mixing desks, recording devices, computers, audio-visual communications via phones, voice notes in messaging applications,

DOI: 10.4324/9781003348528-10

and so forth. In this section, and indeed throughout this volume, we also include the fleshy technology of the human body as a primary apparatus of listening. The chapters in this section underscore the ways this technology precedes the analogue-digital continuum, provides a basis for it, and facilitates listening *beyond* human-made equipment. The authors contend with a supposed need for ever-more 'accurate' and 'transparent' recording and present an array of possible listening technologies understood as inherently biased, non-neutral actors. As proposed in these chapters, apparatuses of listening are not simply tools at the service of human use but are listening entities with agency in and of themselves.

Considering the five co-written chapters as a single entity (or organism) echoes the theories and practices for listening as a method of resistance throughout Part 1. In Part 2, the authors invite us to turn attentively toward recording to redress human loss, to listen more closely for underheard and underrepresented people, to address the hierarchical imbalance and systemic issues of listening/recording and crucially, to imagine possible alternatives through collective actions found through creative listening and sound practices.

Audible Ghosts

Laura Wagner and Alejandra Bronfman address sonic ephemerality which, to them, manifests as the ever-possible yet always-unexpected potential loss of 'everyone and everything – individuals, ecosystems, worlds' – a world which is encountered 'on the brink of ghostliness'. Their chapter explores the ethical considerations of recording ghosts, which may refer to specific paranormal apparitions; a disquieting presence; everyone alive (future ghosts); or the ghostly and haunting traces and echoes of colonisation, enslavement, genocide, capitalism, and domination. The authors emphasise the power of recording to un-silence and honour those who have been silenced, while also raising questions about the ethics of recording, the concept of consent, and of listening as attunement – for example, toward non-verbal animal entities or collectives. The authors reflect on recording practices that include the aftermath of the 2010 earthquake in Haiti, rivers in Puerto Rico, street music in Egypt, and the sonic detection of black holes. In doing so, their argument places significance on listening to and recording (or, actively not recording) the stories contained within ephemeral entities that matter to us – whether ghosts, coral reefs, or ancient galaxies.

Technologies, Precariousness, and Coloniality

José Cláudio S. Castanheira and Melina Santos Silva highlight the relationship between technologies, precarity, and coloniality, to critically examine systemic

issues of access, and question the supposed democratisation of the digital age of music production and consumption. These issues are situated in relation to audio technologies from a variety of eras, sited in the music studios of the Global South, particularly their home nation of Brazil. The authors discuss how dominant (audio) technological systems (e.g. expensive audio recording mixing consoles and microphones) shape society – the inequalities they create, and their influence on what is produced by musicians. From the 1960s onwards, an example of this was the Western high-value analogue studio; now, it includes the digital laptop producer, and streaming listener. A challenge to dominant audio technologies, DIY analogue audio culture is shown to empower non-specialists, and offers an alternative to exclusionary practices, such as through 'Gambiarra' (a Brazilian term regarding the ability to solve everyday problems in an improvised and informal way) and 'Techno-Vernacular Creativity' (TVC) – a rejection or reframing of technological consumer production by often underrepresented and historically marginalised groups.

Addressing Deep Code Problems: Listening to Opera through the World's Liveness

Can we listen for what we have not been taught to hear within a closed (musical) system? Classically trained singers Nina Eidsheim and Juliana Snapper explore the boundaries of listening in music, questioning whether listening can go beyond what it already knows and teaches. They present a snapshot of their ongoing research dialogue, in which they continually challenge themselves and each other to reimagine singing – expanding vocal possibilities through new performative frameworks and listening strategies. Their concern over ways in which listening ontologies affect musical imagination finds that, to listen beyond enculturated limitations we 'must challenge certain creative assumptions and social ecologies that keep us stuck'. This includes Snapper teaching herself to sing underwater, and subsequently making opera for the onset of rising water levels associated with climate collapse. Drawing further inspiration from NASA scientist Jill Tarter's work in listening for extraterrestrial signals, the chapter asks whether contemporary opera has the capacity to listen beyond its own model? This includes discussion of efforts to 'unsettle' opera, both in Snapper's work and George Lewis' opera *The Comet/Poppea*. Eidsheim and Snapper aim (and invite others) to push the boundaries of opera and redefine its potential, beginning with an invitation to listen beyond established assumptions and boundaries.

Endarkened Listening

If a commitment to supposed audible 'clarity' might be a commitment to oversimplification or mistranslation, can a commitment to opacity be heard

as an acceptance of multiplicities of meaning? Practitioners in socially engaged sound arts Liz Gre, Matilde Meireles, and Tullis Rennie propose that making works that embrace opacity and become 'endarkened' – rather than enlightened – is a positive intervention. 'Endarkened co-composition' follows, as a way to disrupt traditional listening and common practices of creative assemblage, and to prioritise the opacity of storytelling as a qualitative research method. This stems from colonial and extractivist ethnographic attempts to simplify the life stories of People of the Global Majority (POGM), to make them 'appropriate' for consumption, leading to a 'dimming and alteration of POGM existence'. The artists present their work through an endarkened text, which re-tells and examines complex instances of field recording, co-storytelling, and collaborative listening. The work of endarkened storytelling centers on folklore, fables, remembering, and imagining – complete with intricacies, intimacies, and details unknown and unknowable to any other. Rather than employing performance, composition, or writing to *clarify* a participative process, these modalities invite artists and participants to engage with the opacity of field recording and its various (mis)interpretations. Such attitudes then allow otherwise unheard or unknowable stories to become tangible for the participatory listening publics.

Amplified States: Listening as Coming to Know

A final chapter details several ideas enmeshed within the extended listening practices of artist-researchers jake moore and Mark Peter Wright. The two authors emphasise the non-neutrality of recording and listening tools, and the significance of embodied experiences – presenting the concept of apparatuses of listening as a 'meshwork' mediating technologies, bodies, and vocality. This chapter serves both to conclude and extend several threads from the preceding four chapters, whilst reflecting themes teased out across the whole volume. It questions the relationship between hearing and listening and explores concepts including Werner Heisenberg's uncertainty principle, the spatialisation of thinking, and the ecological voice of the earth. They stress the importance of situating a critical listening practice in which recording and replaying sound can truly inform our understanding of the world. The idea of boundaries in sonic material is articulated, following Barad, as 'consensual' – i.e. felt together, rather than an extractive process or amplification of existing power relations. The meshwork of ideas that profoundly question our listening and recording in relation to each other and the world at large concludes the section with an appropriately searching set of questions and attunements with which to go forward as a situated listener.

6
AUDIBLE GHOSTS

Alejandra Bronfman and Laura Wagner

Laura: *In my ethnographic fieldwork, there are people whose voices I never recorded – or never captured, to use a somewhat violent metaphor – because the time didn't feel right; or because I felt I hadn't earned it; because I was uncomfortable using people's stories, magpie-like, in my research; because I was hyper-aware of my positionality as a white US American researcher seeking to record Haitian voices. But there is another side to respectful hesitation. I never interviewed my friend Melise because I thought that one day I would have a chance. I didn't want it to be coercive or exploitative. I wanted to wait until the time was right. And then Melise died, in the 2010 Haiti earthquake, in the house where, one floor below her, I was trapped in the rubble. To my knowledge, there are no recordings of her voice anywhere. Within a few years, smartphones would be much more common in Haiti. Today, all kinds of people have video and audio recordings of their friends and family, but when Melise died, that wasn't yet the case. I wish I had recorded her voice, partly because I have tried to tell her story in different ways since the earthquake, but mostly so I could make it available to her surviving family, if they wanted it. Now she is a ghost, by which I mean her life echoes in the empty spaces she left behind. She cannot consent to my telling her story, using her real name. Yet I think that not telling her story (without her literal voice) would be an additional act of violence. Hundreds of thousands of Haitian people died on January 12, 2010. Many of their names are recorded nowhere. Most of their voices are lost forever*

> to the long-term structural violence that made that earthquake the disaster it was. They were literally silenced.
>
> This isn't only a story about Melise, or about Haiti. It's about everyone and everything that is ephemeral, everyone and everything – individuals, ecosystems, worlds – that is on the brink of ghostliness. Who lives and who dies depends on where you are, who you are, what your resources are – the very definition of structural violence – but in the end, we are all ephemeral, one illness or accident or earthquake away from becoming ghosts.
>
> Bòs Jhon, one of the men who saved my life after the earthquake, also saved my laptop (dented, but still functional) and my notebooks from the rubble. I retrieved them almost three months later, when I returned to Port-au-Prince. I was astonished when Jhon told me what he'd done. He said, "I knew you wrote about us, Lolo. I knew you wrote about our lives and how we were treated." This shifted something in me. It didn't vanquish the discomfort or reluctance I sometimes feel when it comes to recording people, especially when there is an intractable power imbalance between us. But it served as an important reminder that recording people's voices and writing about their lives may be welcomed, even desired – especially if you've taken the time to develop an honest and trusting relationship. And I think this extends to spirits, intangible entities, and more than human actors, as well.

We record for many reasons. To remember, archive, reuse, disseminate. Sometimes, the circumstances are violent and extractive (Kangiesser, 2023). Other times, however, we record to unsilence or seek resonances. In what follows, we are interested in what happens when the reach of recording expands to spirits, or more than human actors, or long-dead stars. David Haskell reminds us that humans miss many things that sound:

> Thunder clouds, ocean storms, earth tremors and volcanoes all sing and moan, calling out with sound waves as low as one tenth of a hertz, far too low for our ears to detect. ...the world is speaking, but our bodies are unable to hear much of what surrounds us.
>
> (Haskell, 2022, pp. 30–31)

Some technologies can hear what our bodies can't.

In this piece, we explore some ethical considerations of recording ghosts – but first, who are these ghosts of which we speak? "Ghosts" may refer to specific paranormal apparitions – the souls of the dead returning to the earth to frighten, wreak havoc, seek vengeance, teach the living a lesson, or long for lost life. Ghosts may be a disquieting presence – nuisances,

harbingers, or remembrances we may wish to exorcize to make way for an untroubled present. We might consider everyone alive, including ourselves, to be future ghosts. Or we might take a more expansive view of ghostliness and haunting: the traces and echoes of colonization, enslavement, genocide, capitalism, and domination. As Avery Gordon writes, "…the unhallowed dead of the modern project drag in the pathos of their loss and the violence of the force that made them, their sheets and chains" (Gordon, 2008, p. 22). She suggests that for scholars to truly reckon with the systems of power in which we are all embedded, "we will have to learn to talk to and listen to ghosts, rather than banish them" (Gordon, 2008, p. 23). For our purposes here, we are less concerned with the esoteric than with the ordinary ghosts – of the dead, of the repressed, of myths, of lies – that permeate the spaces we inhabit every day. We are also thinking about how the land, sea, and sky reverberate with the echoes of soundmakers that have been extinguished. Whether perpetrators, victims, bystanders, descendants, or some combination thereof, we are all haunted.

Building on Gordon's work, Tai et al. contend that,

> Archivists not only have a responsibility to help fill the *silences* of the institutions in which they work, but are also personally accountable to ghosts, possessing an ethical imperative to portray the *silenced* in a way that not only honors them, but acknowledges their long run of historical and cultural contributions.
> *(Tai et al., 2019, p. 16) (emphasis ours)*

Elsewhere, Michel-Rolph Trouillot writes that, "By silence, I mean an active and transitive process: one 'silences' a fact or an individual as a silencer silences a gun" (Trouillot, 1995, p. 48). While this metaphor of *silencing* is both powerful and pervasive, for the most part it remains a metaphor for *absence, repression, omission*. Many meditations on who is excluded from the archival record describe *silencing* while not addressing *sound*, or archives thereof – the literal voices that are, or are not, there. What if, following Gordon's suggestion, we could "talk to and listen to ghosts" – *actually* listen to them?

Recording the voices or sounds of ghostly entities and ghosts-still-to-come may be a first step toward unsilencing, but it carries with it a series of concomitant ethical considerations: recording without consent is potentially violent, but a *failure* to record is also potentially violent. If, as Gordon and Tai et al. suggest, haunting is the result of exclusion and silencing, then maybe the framework of "consent," with the presumption of possible harm, isn't always the right one. Maybe there are ghosts/phantoms that want to be remembered. Maybe, in some cases, the harm comes not from recording/documenting, but from *not* recording or documenting.

What possibilities emerge if we think beyond narrow, legalistic definitions of "consent" and focus instead on something like attunement? Nonverbal animals may use body language or vocalizations to express assent or dissent. If we extend this to other kinds of beings – living beings like coral reefs, as well as nonliving or no-longer-living entities – perhaps we can aim to be honest with our interlocutors, audiences, and selves about our intentions as recorders and documentarians. We might ask ourselves if we are approaching our interlocutors with respect, honor, and humility; if we seek to do harm or to avoid harm, and if we understand these entities as having some kind of agency.

This approach leaves open the possibility for researchers to be dishonest with themselves about their own desires and subjectivities. But subjectivities may also lead us in the other direction, and those researchers who are most concerned about ethical, thoughtful, and respectful conduct in recording seem likely to be the same researchers who fear the potential for exploitation and extraction to the point that they never record anyone at all.

Exploration: Coral Reefs

Underwater, scientists have been recording coral reefs for over a decade. It would be just, in the interest of considering the coloniality of recorded spaces, to point out the degradation of coral due to warming ocean temperatures brought about by human use of fossil fuels. Any recording of a coral reef would need to reckon not just with the ethics of recording but with the tremendous harm humans inflict on the planet. Between 2014 and 2017, warming ocean temperatures compounded with El Niño resulted in a global coral bleaching event – the third ever documented and the largest on record. Bleaching occurs when coral expel the colorful algae that live within them, thus rendering them white. Even when it is healthy, coral reefs are combined structures of living and dead exoskeletons of polyps. When bleaching occurs, they careen toward death. Irus Braverman, who studied coral scientists, narrated the transformative impact of the bleaching event: "The world's largest living structure has become the world's largest dying structure" (Braverman, 2018, p. 3) – a ghost town, or a ghost metropolis, if you will.

But it is possible to bring coral back from the brink of death. Something like the efforts to repatriate ethnographic recordings to communities of origin, scientists are using reef recordings to regenerate them. Preliminary studies have found that coral larvae, which use echolocation to seek out a coral reef to attach to and thus survive, will join a degraded reef when it sounds like a healthy reef. In a 2022 Woods Hole Oceanographic Institute/MIT study, scientists placed coral larvae near degraded coral reefs and played healthy reef recordings near some but not others. According to acoustic biologist Genevieve Aoki, "At the acoustically enhanced site, we found much

more settlement – 2 to 3 times more – than without enhancement" (LaCapra, 2023). Unconsenting coral larvae, lured to a dying reef, conscripted by humans in a sonically engineered effort to bring the reef back to life. The ghosts of corals past, speaking through recordings, in the hopes of a brighter coral future. The issue of consent here is elusive, and perhaps less pressing than the debates among coral scientists about how to respond to these devastating losses. This coral has been restored by human intervention yet remains at risk of further degradation given rising ocean temperatures. Many coral scientists object to a "band-aid" approach like this that doesn't address the broader issue of warming waters. The question of the uses to which recordings have been put is at the heart of these debates. While some scientists seem to have prioritized regeneration, using the sonic traces of healthy coral reefs to attenuate the possibility of their permanent silencing, others warn of the futility of these efforts if global air and water temperatures continue to rise.

Exploration: Black Holes

The *New York Times* headline reads *The Cosmos Is Thrumming with Gravitational Waves, Astronomers Find*. Evidently, "radio telescopes around the world picked up a telltale hum reverberating across the cosmos, most likely from supermassive black holes merging in the early universe." According to physicists, this hum was generated by pairs of "supermassive black holes" as they "slowly merge and generate ripples in space-time." The scientists quoted all use the language of sound to describe their findings. Xavier Siemens, a physicist at Oregon State University, notes, "I like to think of it as a choir, or an orchestra." Sean Jones, assistant director for the Directorate of Mathematical and Physical Sciences at the National Science Foundation, extends the orchestral metaphor: "These observations reveal a rolling, noisy universe alive with the cosmic symphony of gravitational waves." Maura McLaughlin, a NANOGrav collaborator at West Virginia University, comes to a simple conclusion: "All we have to do is keep listening" (Miller, 2023). The telescopes recorded this hum that comes from the early universe. We don't know much about, and can barely describe, that space/time, but apparently thinking sonically is one way to do so.

Black hole stories are also, in a sense, ghost stories. These gravitational waves, in the words of cosmologist, physicist, and activist Chanda Prescod-Weinstein, "came from the collision of two neutron stars, a special type of star that is the product of stellar death" that "circl[e] each other in a death spiral caus[ing] sufficiently large ripples in spacetime that we can now detect them…" (Prescod-Weinstein, 2021, p. 40). Moreover, these sounds are a "collective echo," as the *New York Times* puts it, from "ancient galaxies up to 10 billion light-years away" (Miller, 2023). In other words, these vibrations are emanating from ghost stars that collided in what is, to most of us,

an incomprehensibly distant past. The sounds of the "cosmic symphony" roll on, but the musicians, or the instruments, died before the Earth was born.

The ethical challenge stems not from recording the sounds of more-than-human ghosts of stars past, but from the epistemological underpinnings of science itself. As Prescod-Weinstein makes clear, cosmology, physics, and much of Western science not only privilege the contributions of white men while silencing those of people of color and women (especially Black women), but are fundamentally embedded in racist, sexist, and colonial knowledge structures. Perhaps, as the *New York Times* piece suggests, all we have to do is keep listening, but there is also an opportunity to rethink who the "we" is, and who gets to listen.

Exploration: Radio Haiti Archive

The Radio Haiti collection at Duke University's Rubenstein Rare Book & Manuscript Library consists of over 5,300 recordings from Haiti's most prominent independent radio station, Radio Haïti-Inter. Each recording is publicly available via the Duke Digital Repository with detailed multilingual (Haitian Creole, French, English) descriptions and metadata (Radio Haiti Archive). These are recordings *of* Haitian people, *by* Haitian people, *for* Haitian listeners, and they were originally broadcast over the airwaves from the early 1970s until 2003. Presumably, anyone who spoke on Radio Haiti knew what they were doing and consented (even if no legal release was ever signed) – the station's director, Jean Dominique, was the most famous journalist in Haiti, and nearly every Haitian, from high-ranking politicians to smallholder farmers in remote regions of the country, knew who he was and what Radio Haiti represented. But no one – not the journalists, nor the in-studio guests, nor the participants in on-the-street interviews – could have known what the afterlives of these recordings would be: that one day, 30 or 40 years later, their voices would be held by a predominantly white institution in the United States, readily available on the internet. The collection falls under joint authorship, which means that so long as *one* of the creators (in this case, Radio Haiti itself) consents to the recording being publicly available, that's enough. But some people who spoke on Radio Haiti decades ago are displeased to suddenly have their past deeds available via a quick Google search. One man emailed to accuse Duke Libraries of slander, declaring, "Monsieur Dominique was no angel." Many powerful people tried to silence Radio Haiti when it was on the air, through censorship decrees, judicial machinations, and direct violence – including the assassination of Jean Dominique in 2000. Some people would likewise seek to silence the archive. And so there is an uneasy balance between wanting to preserve this archive (because so many people in Haiti care deeply about it, and because so many people in the archive are now ghosts – some by political assassination,

some by structural violence, some by the earthquake, and some by "natural" deaths that cannot be disentangled from living in a country that breaks your heart), and recognizing that not everyone who appears in the archive can consent, or would consent, to having their voices live on in this way.

To linger, for a moment, with the question of individuals who might not consent to having their voices preserved: in the Radio Haiti Archive, you can hear Franck Romain, François Duvalier's chief executioner-turned-mayor of Port-au-Prince, speaking on the radio, justifying an infamous massacre of churchgoers he personally ordered in 1988 by saying they had "reaped what [they] have sown" ("Déclaration de Franck Romain"). Would Romain, or other perpetrators of horrific violence, have the right to consent (or refuse) to having their voices live on in this way – especially in a context like Haiti's, in which public recognition of what happened is the closest thing many people will get to true justice?

For Radio Haiti's surviving staff, especially Jean Dominique's wife Michèle Montas and daughter J.J. Dominique, the imperative to preserve the station's archive – which survived wave after wave of political repression as well as the earthquake – is the primary consideration. If it weren't for this digital archive – however imperfect; however entangled in postcolonial and neocolonial questions of who documents, who retains, who preserves, and who has access – then these voices, which in many cases are recorded nowhere else, and which in many cases are testifying to injustice, would be permanently lost.

Exploration: Music from the Street, Halim El-Dabh

What happens when people living in colonized spaces record and remediate as an artistic and creative practice, with explicit or implicit reference to violent pasts? The spaces in which they record are not pristine; on the contrary, they are haunted by the legacies of colonialism, made audible. These recorded and remediated compositions created in colonial spaces are an opportunity to coax ghosts out of hiding and ask them to talk back, to the extent that it's possible, to colonial ruinations.

Consider the work and career of Egyptian composer and educator Halim El-Dabh. As a student in 1944 he became fascinated with the possibilities afforded by using and transforming recorded sound in musical compositions. He borrowed wire recorders from a local radio station and documented some of Cairo's sounds including what he described as "a traditional women's ritual called the Zār ceremony, in which women chant with various vocal timbres and intensities in order to call spirits from other worlds." His recordings of these efforts to conjure spirits formed the basis of an electronic composition entitled "The Expression of Zaar" which some critics assert was the first example of musique concrète, predating that of Pierre Schaeffer by

four years (Razor Edge, 2012). If we know what the critics thought, we don't have access to what the women, or the spirits for that matter, supposed was occurring to the sonic traces for which they were responsible. Did El-Dabh know, or wonder? Later in his life, an interviewer asked him about the ethics, not of recording, but of remediating and disseminating those remediations. Sometimes, El-Dabh acknowledged, those whose voices he recorded did not want them to circulate. With regards to some of the recordings he made in African villages, he understood that they were not to be heard by others: "it's between us" (Gluck). He seemed untroubled, however, when asked directly about the politics of recorded sound. In response to the observation by the interviewer that "Some would say that transforming those sounds diminishes the culture rather than preserving it," he answered, "I prefer to think that music belongs to all of us. Respectful transformations can be powerful and take us forward into the future" (Gluck). The aim here is neither to retroactively exonerate or condemn El-Dabh but rather to situate these recording and remediating practices. Long before "sound studies" critiqued the Eurocentric origins of sound recording and called for more respectful approaches to differential power dynamics inherent to recording practices, a musician in a colonial setting drew from local soundscapes and troubled our divides between ethnography/ethnomusicology; ethnographic recording/electronic music; us/them; tradition/modernity. For him, the voices of both women and their spirits in Cairo's soundscape were central to an endeavor that understood these less as separate realms and more as a mutually constituted way of listening composed of radio and recording technologies, voices heard and unheard, ritual convocations, and European genres.

Exploration: Music from Nowhere, José Alejandro Rivera

More recently, the sound artist José Alejandro Rivera has created what he calls a "radiophonic river" that confronts the colonial histories of Puerto Rico head on. He does this not by providing contextual information, but by radically decontextualizing so that the strangeness of the sound resonates with the experience of being othered. Rivera interrogates the notion of the spectrum to highlight the acts of alienation, or ghosting, as in "being on a different wavelength" that mark colonial histories. When he makes field recordings, it is not to present nature as untouched, but rather to precisely mark it as a place of memory, human action and violence. Rivera's work explodes our categories of nature, humanity, and even time and space with a jumble of sonic juxtapositions. His composition moves "across neurodivergence and consciousness studies, radio and radar via the electromagnetic spectrum, language and diasporic musings regarding the political and cultural history of Puerto Rico" (Rivera, 2022). *Co-Regulating the Spectrum: Meanwhile, the wave* draws on recordings of poetry, interviews, archived documentaries,

and field recordings to become an "extrasensorial, polyphonic carrier of consciousness; a pulsating presence that is inhabited, and that inhabits, in a myriad Other ways." The aim is to point to multiple acts of othering, and the ways they ignore multiple ways of knowing and being in the world, at their peril. But it also makes audible the seemingly inaudible, whether they are voices that do not have a place to go (aliens), or parts of the universe which sound with sound waves that are too low, as Haskell points out, for humans to hear. As a way of "hearing" Puerto Rican history, Rivera amplifies all that is strange about it. When residents of the island recall the 1901 Supreme Court's pronunciation that Puerto Ricans (and residents of Guam, and Samoa for that matter), were "foreign in a domestic sense" we might empathize with their feeling of vertigo. Where and who are they, and why would a distant institution of nine justices get to decide? To listen to Rivera's work is to remember all of the ways we have been told we do *not know;* where we are, or why. Disquieted and unsettled, we might feel like ghosts.

Alejandra: My mother died while we wrote this piece. Her voice stayed with me for days. I kept hearing her say "Coco Gauff." She loved to watch tennis, and had been rooting for Coco to win the US open. When the voice in my head faded a little I searched my phone for voice mail. There they were. The last one, in which she was in pain. But also one from a year ago, when she thanked me (it must have been after a visit), and told me she missed me already. I have a longer recording, one that accompanies a video I made several years ago. My friend, the artist Gabriela Aceves, had included me in her project about her grandmother's cookbook. She sent participants a pdf version, with instructions to do whatever we wanted. I chose a recipe and convened my mother and two kids. We cooked in English (me and kids) and Spanish (me and mom). We filmed it. Afterwards, when I was listening, watching and writing about the experience, I noticed her laugh. It was a lovely laugh. I wrote "I'm thinking that I don't have any other recordings of my mother, who is now 85. She has a nice voice. She has a wonderful laugh. She wants me to make the salad. I have always made the salad, since I was ten or twelve years old." Later when my mom read that she said she never knew I liked her laugh. I am a ghost in this story. I rarely let my mom in, didn't tell her much about my life, didn't even tell her I liked her laugh. Silenced by the burden of my expectations about her expectations. Did she know me? Did I know her?

 Everyone agreed to be recorded and despite the occasional bickering between siblings this was not a particularly violent scene. But aren't we all haunted? My mother was a child during the Spanish

Civil War, and she and her mother bore the trauma of family separation, refugee status and scarcity as well as of the Franco regime that followed, about which they never spoke. I wanted to put all the women in the kitchen and record our voices because working every day and for long hours in a kitchen, where we might be heard but are often out of sight, is what women do, ushered there by the expectations of patriarchy and capitalism. It might be an act of care to listen, and record them.

References

Braverman, Irus. (2018). *Coral Whisperers: Scientists on the Brink.* University of California Press.

"Déclaration de Franck Romain, Radio Métropole, sur le massacre à Saint-Jean Bosco et la constitution." (11 September 1988). *Radio Haiti Archive.* https://repository.duke.edu/dc/radiohaiti/RL10059-RR-0596_01

Gluck, Bob. (2012). *Interview with Halim El Dabh, Egyptian Composer.* CEC | Canadian Electroacoustic Community. *eContact!* 15.2. https://econtact.ca/15_2/gluck_el-dabh.html

Gordon, Avery F. (2008). *Ghostly Matters: Haunting and the Sociological Imagination.* University of Minnesota Press.

Halim El-Dabh – *"Wire Recorder Piece."* Sound Art Zone. https://soundart.zone/halim-el-dabh-wire-recorder-piece/. Accessed September, 2023.

Haskell, David George. (2022). *Sounds Wild and Broken: Sonic Marvels, Evolution's Creativity, and the Crisis of Sensory Extinction.* Viking.

Kangiesser, A.M. (2023). Sonic Colonialities: Listening, Dispossession, and the (Re)making of Anglo-European Nature. *Transactions of the Institute of British Geographers,* 48(4): 690–702. doi.org/10.1111/tran.12602

LaCapra, Véronique. (2023, May 18). Can Sound Help Save Coral Reefs? *Oceanus: The Journal of Our Ocean Planet,* Woods Hole Oceanographic Institution. https://www.whoi.edu/oceanus/feature/can-sound-help-save-coral-reefs/

Miller, Katrina. (2023, Jun. 28). The Cosmos Is Thrumming with Gravitational Waves, Astronomers Find. *New York Times.* https://www.nytimes.com/2023/06/28/science/astronomy-gravitational-waves-nanograv.html

Prescod-Weinstein, Chanda. (2021). *The Disordered Cosmos: A Journey into Dark Matter, Spacetime, and Dreams Deferred.* Bold Type Books.

Radio Haiti Archive / Digital Collections / Duke Digital Repository. Duke Digital Collections. (n.d.). https://repository.duke.edu/dc/radiohaiti

Razor Edge. (2012). "Halim El-Dabh, Wire Recorder Piece" *Sound Art Zone.* https://soundart.zone/halim-el-dabh-wire-recorder-piece/

Rivera, José Alejandro. (2022, November). Co-regulating the Spectrum: Meanwhile the Wave. *ProxemiaSound.* https://proxemiasound.net/Co-regulatingTheSpectrumMeanwhiletheWave

Tai, Jessica; Zavala, Jimmy; Gabiola, Joyce; Brilmyer, Gracen; and Caswell, Michelle. (2019). Summoning the Ghosts: Records as Agents in Community Archives. *Journal of Contemporary Archival Studies* (6), Article 18. https://elischolar.library.yale.edu/jcas/vol6/iss1/18

Trouillot, Michel-Rolph. (1995). *Silencing the Past: Power and the Production of History*. Beacon Press.

7
TECHNOLOGIES, PRECARIOUSNESS AND COLONIALITY

José Cláudio Siqueira Castanheira and Melina Santos Silva

Technologies, particularly those related to musical creation, have a great influence on what is projected and what musicians can actually produce. Although they impose limitations and generate a specific rhetoric to which artistic discourse adapts, music technologies are usually regarded as important tools for artists and the general public.

Some not-so-recent perspectives on development, uses and resignification of technologies have something in common. Notions such as "Gambiarra" (Tragtenberg et al., 2021), "Techno-Vernacular Creativity (TVC)" (Gaskins, 2019) or "Biophilic Technologies" (Campos-Fonseca, 2019), depart from the principle of the existence of a hegemonic technological model and, therefore, position themselves as a form of resistance to this model. In addition, DIY culture, granting those non-specialised agents the ability and legitimacy to perform tasks that require specific knowledge, positions itself as an alternative to an excluding modus operandi (Crossley, 2023; Guerra, 2020; Jones, 2021). In Brazil, the term "gambiarra" has become synonymous with the ability to solve everyday problems in an improvised and informal way. Despite its specificities, Gambiarra has in common with the other approaches mentioned above the will to adapt exogenous technical protocols when dealing with specific problems, prioritising practicality and the lowest cost of tools already available or developed locally.

Procedures mediated by conventional technologies aren't only expensive and difficult to access. They are also incapable of dealing with non-immediate or non-obvious relationships between human creativity and production tools or between human problems and the solution of these problems. The techno-scientific discourse was built in a pragmatic way in relation to what

DOI: 10.4324/9781003348528-12

can be done, how it should be done and who is able to use specific and adequate means to do it.

The usual idea of "precariousness" (Butler, 2004, quoted in Sellman, 2022) describes these alternative forms to the traditional techno-scientific discourse. A capitalist production model does not recognise these possibilities as effective or worthy of investment. The reason is that they demonstrate a disparity, deficiency or inferiority in relation to globally disseminated technologies.

This chapter presents an analytical framework of technologies, precarity and coloniality based on three thematic blocks. It takes into account the reality of the countries of the Global South and, more specifically, the perspective of Brazilian theorists (as both authors of this chapter) and artists. The first, "models for analysing technologies", approaches the logics of technologies appropriated in different cultural contexts. The second, "precariousness and gambiarra", argues how an uncritical notion of precariousness expresses the inequality of access to technological means in cultural production in the Global South. At the same time, there is a romanticised construction of the ability of individuals with limited access to material resources to develop an initiative that can fit into the general context of artistic production. The last, "old technologies as heritage artefacts", describes the appreciation of old-fashioned apparatuses by certain segments of audio consumers and professionals as an offshoot of the technicist fetish present in techno-scientific discourse. At the same time, our argument also brings to light contradictory elements in the notion of efficiency and general standardisation embraced by contemporary technologies.

Models for Analysing Technologies

First, we should try to explore the logic by which technologies have historically been understood in different countries and, above all, within different social groups. Recent studies on technologies tend to place them in a sociological and historical perspective. While some of these studies point to the complexity of technological environments, showing the coexistence of both human and non-human elements, both with some degree of agency, most of these approaches understand technological systems as "socially constructed and society shaping" (Hughes, 2012: 45).

This notion is present to a greater or lesser extent in the perspectives of social construction of technology (SCOT), large-scale technological systems (LTS) and actor-network theory (ANT), the three approaches listed as constituting part of the "new sociology of technology" (Pinch & Bijker, 2012). Bijker and Pinch also point to an issue that has become increasingly relevant in contemporary perspectives: the relationship between subjects and objects

of technological systems in their active coexistence in the most diverse environments. In a general way, we can summarise the issues raised by these different tendencies by asking: How do different technological systems work, and what are the implications of this for society? For the purposes of this work, however, we need to add another question at a deeper level: how can technological models be thought of as ways of understanding the world, and how can this affect different strata of society? In this way, we examine technologies not only as tools for achieving a certain effect, but also as the result (and producer) of an ordering of the world.

Innovation is aimed at improving society's living conditions, but this perception is not necessarily anchored in concrete experience. In other words, along with new artefacts, new needs are created. Some of these needs may not even be easily assimilated by society. There is a kind of training for problems that were not perceived, at least in the same manner, by the whole of society.

To be recognised as such, problems must refer to aspects of people's daily lives. As these aspects differ greatly between social groups, especially with regard to gender, race, social class, age, etc., technologies that are thought of as inventions, i.e., something that is not entirely clear to most people, end up being placed in an undefined zone. The questions "what is it for?" and "who is it targeted at?" are precariously answered by a dubious discourse in which the fetish of novelty is more seductive than the practical results.

An example that can be mentioned is that of recognition systems using cameras based on AI. The integration of ubiquitous cameras and large databases is fundamental to the idea of smart cities (a very popular term today, although not fully understood by the majority of society). However, one problem that has been mentioned on several occasions is that a large proportion of people identified as possible suspects were black or from another subaltern ethnic group. There is an obvious link between the functioning of algorithms and structural racism in society (Noble, 2018). The uncritical assumption of the impartiality and efficiency of intelligent systems may be a new problem for certain social groups.

The invention paradigm points to a linear logic of technology development: a constant movement towards an ideal of improvement, even if this ideal is not clear or even identifiable in the short term. Empirical research, by sticking to this idealised model, can lead to the repetition of the same parameters of analysis already in use, taking the conditions of existence of different parts of the population as general and immutable. This phenomenon is the result of a generalised assumption of the functions that the technological object should perform, even not taking into consideration the many different social realities.

Bijker and Pinch (2012), defending the sociological model of research on technologies, state that the SCOT perspective proposes multidirectional models in the development of technological objects. Despite the tendency to

endorse the idea of a linear evolution, alternative models may emerge and be objects of study, even if they end up not being successful at all.

For Hughes (2012), technological systems include elements that are not initially identified as technologies such as organisations, banks, government policies and regulatory laws. These elements of technological systems interact and should be considered socially constructed artefacts. Hughes' analysis takes into account aspects such as patterns of technology evolution, invention, development, innovation, technology transfer, technological style, growth, competition and consolidation. Hughes deals especially with large technological systems, and his arguments allow us reflect on something that is not so clearly stated in many analyses of this kind – who has the "right" or the "power" to propose and develop technologies?

Precariousness and Gambiarras

As an example of the inequality generated by the indiscriminate adoption of large technological systems with their respective exogenous and largely exclusionary protocols, we will address the idea of gambiarra and other perspectives of resistance to such models.

Brazil, like other countries of the Global South, is an area where the struggle for national autonomy and technological sovereignty has been reflected over the years in different fields: from the development of infrastructure projects, such as new energy matrices, to the artistic and cultural field, in activities such as music and cinema. If, on the one hand, some of the projects developed by Brazilian technicians/scientists using local raw materials and know-how, as in the case of biofuels, have been relatively successful and recognised by the international community, this is not the case for initiatives related to the various cultural industries.

In the case of the recording industry, despite a remarkable growth in the production and consumption of recorded music, especially since the 1960s, most of the record companies operating in Brazil were foreign companies, such as CBS and Philips-Phonogram. Some national companies ventured into the market, but had less significant results or went bankrupt. The relationship between foreign record companies and the technological infrastructure of large studios, distribution and promotion logistics is an umbilical one, as these companies concentrate the entire music production chain in a verticalised organisation. Each conglomerate controlled the signing of artists (many on an exclusive basis); the publishing of songs; the recording in its own facilities and the production of records and portable cassette-tapes in factories it also owned. This model can be thought of in Hughes's (2012) terms as a large-scale technological system.

This concentration of activities around record production had the immediate effect of reducing the space for artists who were not associated with one

of these companies. Independent artists were restricted to a much smaller circle of activity and, as a cause and effect of this reduced performance, found it more difficult to record and distribute their work. The phenomenon of a scarcity of technological and logistical resources was a problem that a great part of Brazilian artists faced.

This unavailability of means was mainly due to the control of the major record companies over the structure of recording and record production. Studios, especially until the digital turn in the 1990s, were expensive units that required qualified training and maintenance. State-of-the-art equipment was imported and, therefore, beyond the reach of independent artists or even small record labels. One of their survival strategies was to rent out the time in the big studios when they were not recording their own artists. However, the cost of renting these studios was high.

The relationship built around the big studio environment was a fetishisation of both technology and technical training – often acquired outside Brazil – of the professionals working for the big record companies. The symbolic capital acquired through this relationship was also complemented by the rather ostentatious policy of these companies of paying various media outlets to play the songs of their signed artists. As the recording industry has many characteristics associated with the LTS model, the notion of the "big artist" can be seen as almost synonymous with the popular artist.

The shift from analogue to digital technology is commonly said to have democratised the means of production and distribution. This perception is largely attributed to the affordability of digital recording equipment, which has facilitated the emergence of small studios worldwide. The widespread use of software as a fundamental tool for producing and consuming music has created a perception of greater accessibility to the production process and the final product. However, this notion is only partially accurate, as the influence of large corporations' control over technological systems remains significant, albeit in more intricate and less obvious ways, sometimes linked to digital technology developers.[1] Music streaming services such as Spotify, Deezer and Apple Music have emerged to capitalise on the new business model, backed by major players in the music industry.

The fetish spread around foreign sound technology, both instruments and recording equipment, was built on the scarcity conditions and technological "superiority" of international brands. National initiatives to produce equipment that could compete with their imported counterparts were fragile and often consisted of copying the design of the international brand. Due to legislation aimed at protecting the national industry by overtaxing foreign products, audio technologies available in Brazil were lagging behind the United States, Japan and European countries. They were seen as a distant and idealised model, both in technical and aesthetical terms.

There was a widespread belief that national technologies (especially audio) were not of the quality required for a high-level artistic project. With most of the technical structure in the hands of international record companies, the association between national infrastructure and amateur products was relatively common. The idealisation of international knowledge and technical conditions can be seen even after the digital turn and the popularisation of good quality, cheap recording equipment, when many Brazilian artists, although recording in Brazil, took their work abroad for mixing and/or mastering. Some studios in Los Angeles were the destination for well-known artists of different musical styles to perfect their latest work. In the mid-1990s, Milton Nascimento had his entire career work (up to that point) remastered at Abbey Road Studio.[2] In addition to their technical excellence, facilities such as Abbey Road or Los Angeles studios exerted a legitimising power over the work of artists who were already famous in Brazil but wanted to launch an international career. In this way, the creativity of Brazilian musicians, although praised by great international artists, had to adapt to the rigid protocols of globalised production.

Because of material conditions inequalities, the idea of precariousness took hold in Brazilian artistic production and was disseminated in popular imaginary, often transcending the boundaries of the music industry itself. Brazilian cinema, for example, was heavily criticised for the poor quality of its sound. Until the 1990s, when digital technologies became cheaper and it was easier to import foreign equipment, the technical difference between the various stages of sound processing, from direct sound recording to movie theatres sound reproduction, was noticeable. The curious thing is that the public did not perceive the obvious gap between Brazilian and international audio protocols and technical conditions as just a technical problem, but also as an aesthetic issue. In fact, many Brazilian filmmakers, especially those who were heirs to a more transgressive tradition, considered it acceptable and even desirable that the sound of their films did not conform to a global (mainly American) formula. They were looking for a more "local" way of representing the Brazilian social reality. The non-acceptance of a dominant discourse of technical perfectionism and the very inability to keep up with technical infrastructure called into question the artistic capacity of Brazilian cinema professionals.

However, the idea of precariousness, in addition to its obvious negative side, was sometimes seen as something promising, powerful and capable of sparking original creative processes in the cultural industry. The lack of access to the cultural industry's standardised resources has led artists to seek alternative models for composing, performing and recording.

A significant proportion of contemporary artists, the majority of whom are associated with more experimental musical scenes, are renowned for

the creation and utilisation of their own musical instruments, which are frequently crafted from unconventional materials. In Brazil, we may cite the groups Chelpa Ferro[3] and Uakti,[4] among others.

There is a romanticised vision of the ability of individuals who, although with limited access to material resources, are able to create works that can fit into the general artistic production chain. Brazilian gambiarra is appealing both for the creator's talent and the precariousness of the artistic production process.

> In this way, the notion of gambiarra illustrates a vast repertoire of creative practices that transform, adapt and resignify technologies based on material limitations. In some cases, this means working with technologies that have been made obsolete in major economic centers.
> *(Tragtenberg et al., 2021: 7)*

Messias and Mussa state that "the dynamic configuration of gambiarra is a complex and dissonant process of concretisation, governed by precariousness and improvisation" (2020: 175). For Messias and Mussa, gambiarra should be thought of as a type of epistemology, in other words, as a way of knowing and addressing the world. It's not just an ephemeral way of solving problems, but a way of dimensioning and qualifying them.

The epistemological dimension of this type of deviation or technical adjustment is also described by Gaskins (2019) when she presents the idea of TVC. She is interested in investigating how people of colour are oppressed by different technological systems. For Gaskins, oppression can be seen concretely in surveillance mechanisms, in the control algorithms present in various public services, and in the very way that data collected by law enforcement agencies is interpreted to perpetuate inequalities between social and ethnic groups. Gaskins notes that historically marginalised communities – African Americans, Latino/a Americans and Indigenous peoples – are "still largely underrepresented in science, technology, engineering, mathematics, or STEM fields [...] usually labelled as consumers, not producers of technology" (Gaskins, 2019: 252).

Gaskins cites as examples of TVC practitioners, artists from the African diaspora such as Sierra Leonean autodidact engineer Kelvin Doe, also known as DJ Focus, who built his own radio station; or Cyrus Kabiru, from Kenya, who creates wearable objects from electronic waste and found metal objects (Gaskins, 2019: 255).

The case of Tony da Gatorra, an "informal engineer" trained through an electronics correspondence course, is illustrative of the phenomenon observed in Brazil. Tony constructed a musical instrument, a kind of handmade guitar, comprising electronic circuits that manipulate different types of sound

waves. This device, which he named Gatorra, functions in a manner similar to an analogue synthesiser and has attracted the attention of international musicians such as Lee Ranaldo (Sonic Youth) and Nick McCarthy (Franz Ferdinand), who have purchased versions (always handmade) of the instrument. Despite a certain degree of interest from international indie musicians, Tony was unable to generate a sustainable income from his musical pursuits (Figure 7.1).[5]

African American, Latino/a and Indigenous artists and professionals engage in social interventions as a means of satisfying a need for personal expression or even as a means of generating some kind of financial income. These interventions are based on the rejection or reframing of technological consumer production. TVC would be a form of technological agency, demonstrating how these underrepresented groups are developing their own ways of navigating the world, such as reappropriating and improvising technology, thus contradicting much of the official historical discourse that justifies the exclusion of these people on the basis of their lack of technical knowledge or skills.

The perspectives of Messias and Mussa (2020) and Gaskins (2019) are close to those of decolonial researchers such as Aníbal Quijano (2007), Walter Mignolo and Catherine Walsh (2018). Building on previous knowledge, both Western and non-Western, the decolonial option is not a theory; it is not a universal way of doing and understanding the world. One of the issues addressed in decolonial research involves recognising and annulling the hierarchical structures of race, gender, heteropatriarchy and class that continue to control ways of life, knowledge and spirituality, structures intertwined by capitalism and modernity (Mignolo et al., 2018: 17). In the meantime, we have the approach of decolonial insurgency, which characterises the resistance of historical movements to colonial-modern ways of being-in-the-world (Mignolo et al., 2018: 246) as the precariousness of access to the means.

However, we observe that technological systems have been approached by "epistemic disobedience" or Postcolonial studies with a focus on monitoring and privacy exposure devices (Zuboff, 2019) – such as datification and algorithmisation – (Arora, 2019; Milan & Treré, 2019; Noble, 2018) or by Gender Studies in the area of Technology & Engineering (D'Ignazio & Klein, 2020; Perez, 2019). Therefore, we have observed little progress in attempts to overcome the universalism associated with technologies in music production and in the constitution of critical engagements with decoloniality. The few studies on this topic seek to understand the forms of re-existence of social actors, and their interactions with technological precariousness.

The existing gap in sound studies focused on the Global South is a result of the fact that its growth has been driven primarily by those who have studied the historical development of sound reproduction technologies. As a result,

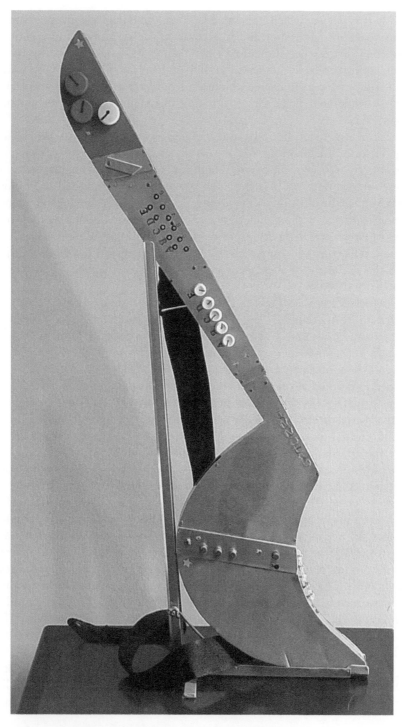

FIGURE 7.1 Gatorra #22 (photo courtesy of Marcelo Conter).

there has been an exclusive focus on exploring the history of technological advancement and innovation (Steingo & Sykes, 2019).

> This emphasis is closely associated with a certain homogenization of the listening subject (in much canonical work, he or she is white and middle class) and tendency to flatten the sonic architecture of urban spaces, rendered simply 'global cities' or 'the city'.
>
> *(Steingo & Sykes, 2019: 7)*

Steingo and Sykes (2019) have elaborated on the defence of the constitution of Southern Sound Studies, whose main aim is to "consider what the Sound 'says' about this narrative". However, they also point out the trap present in this focus, namely the transformation of Sound Studies "into a story of Western influence on the South through the importation of the audiovisual litany and Western audio technologies – neocolonial or imperialist narrative in which the West remains the protagonist" (Steingo & Sykes, 2019: 7).

We should bring to the fore the definition of precarity highlighted in decolonial studies as a "politically induced condition in which certain populations suffer from failing social and economic support networks and become differentially exposed to injury, violence and death" (quoted by Sellman, 2022: 26), referring to the ways in which the conditions of coloniality often increase the vulnerability of women, people of colour, trans or LGBTQ+ people and people with disabilities, whose experiences in capital are marked by saturated regimes of precariousness and oppression (Jarret, 2019).

The authors of this chapter agree with Jarrett's (2019) argument that we must not only interpret precarity as a mechanism for securing domination, but also take "subjective experiences of precaritization [as a] starting point for political struggles" (Lorey, 2015: 6 quoted in Jarrett, 2019: 107). In the author's view, we can learn a lot from understanding how minority groups have engaged in digital labour practices, but also resisted conditions of oppression. DIY culture is another example of these counter-narratives to hegemonic technological models.

Comparative studies between the DIY practice carried out by social actors located in the Global North and the Global South have sought to understand how DIY music is a cultural form with a long history of distinguishing itself from mainstream industry using specific terms (Jones, 2021; Guerra, 2020; Crossley, 2023).

Jones (2021: 3) suggests two kinds of DIY music, which are at least theoretically separable. The first is the broad tradition of "cultural resistance", often undertaken "in the name of greater aesthetic diversity, economic equality and access to participation". The other is correlated with significant changes to the music industry and Communication technologies industries. Jones (2021: 3) explains these changes articulated to a neoliberal discourse

which emphasises the need for individuals to take responsibility, rather than to seek or expect support from state of corporate institutions.

Guerra (2020) explores the kinds of DIY practices and music scenes found in Brazil and Portugal that are essential to an understanding and reinterpretation of DIY cultures as the basis for artistic and musical production in Global South. From Guerra's (2020: 57) perspective, it is possible to comprehend different forms of participation in DIY. However, DIY has always been more of a necessity than an ethos of resistance, according to O'Connor (2008 quoted in Guerra, 2020). This is an interesting question to consider: "is there, in fact, an act of resistance against mainstream culture or is it just that we, intellectuals, wish to see a politicised act of resistance where there is only a mere act of existential need?" (Guerra, 2020: 59).

Silva (2022) discusses how the DIY practice has been appropriated by the Angolan rock movement, following the end of the Angolan war in 2012. Angolan rockers resist the restrictive local structure – searching for and creating cultural production companies, recording studios, rehearsal and live spaces to produce rock in Angolan cities. In her vision, it is not a resistance to a mainstream industry, as occurred in the early days of the constitution of the punk rock ethos. Each step in the production of the musical work carries the individualities of these "craftsmen", used to "refer to consumption activity in which the 'product' concerned is essentially both 'made and designed by the same person' and to which the consumer typically brings skill, knowledge, judgement and passion while being motivated by a desire for self-expression" (Campbell, 2005: 23).

The aim of this section is to understand how an unreflective notion of precarity highlights the unequal access to technological resources in cultural production in the Global South. Steingo and Sykes (2019: 4) offer a critique of the predominant themes, narratives and arguments of the North-centric sound studies field towards the South. In "Remapping Sound Studies in the Global South", Steingo and Sykes shift away from marking the South as a location for sonic divergence and instead create a fresh cartography of sound studies for global modernity. Drawing from Comaroff and Comaroff, Steingo and Sykes (2019: 4) "entails conceptualizing the South as a kind of radical horizon of geopolitics while dislodging the North as the site of the original and the true".

In the next section, we will consider how the technical object, once constituted, also has a life expectancy. This trajectory, when completed, removes the artefact from an evolutionary logic and places it on a borderline between nostalgic fetish and technological meta-discourse.

Old Technologies as Heritage Artefacts

The fetish for old equipment is an interesting phenomenon in the relationship between technologies, the discourse on their constant evolution and a certain

type of user of these technologies. It may seem contradictory that some segments, such as audiophiles, more traditional sound engineers or even younger audiences, understand that old models of equipment and even outdated technical protocols can provide a better result in terms of sound experience.

This attachment to old technologies is not only a challenge to the idea that sound technologies can always offer a better model for recording and reproducing sound, but paradoxically a ratification of the notion of technical perfectionism. Nostalgia for old equipment implies the existence of an even more idealistic (and exclusionary) realm that will affirm that already tested – and less accessible – models are demonstrably better. Technological fetishism becomes even more pronounced when it takes physical objects as the materialisation of a way of listening that is closer to an unattainable ideal.

In the field of music production, the transition from the analogue to the digital model represented an ontological rupture in which the physical nature of what the industry and the end user understood as "sound" changed. Many professionals and audiophiles insisted on criticising digital sound as if it did not have the same living character as analogue sound, even though the marketing campaign in favour of digital presented it as an innovation with benefits for everyone.

Arguments such as the elimination of noise generated by devices, the ability to make infinite copies without loss of quality, and the portability of devices and media were uncritically repeated. In essence, these discourses support the idea that the new technologies are more efficient than the old ones could ever be.

In contrast to this optimistic attitude towards the new devices and the new logic of sound production, some users argue that these changes not only alter the production chain, but also imply a change (for the worse) in the quality of the sound produced.

Take, for example, the case of bands in the 1990s who, in search of a more authentic sound, resorted to recording on magnetic tape and using tube equipment to produce a "warmer" sound. The very idea that analogue technologies were more susceptible to the intrusion of various types of noise was seen as a positive fact.

This great divide between enthusiasts of new technological models and lovers of classic forms (abandoned by the market) was not only due to the phenomenon of technological evolution per se. It was not simply the replacement of an old artefact with a new one, implicit in the technicist discourse, that caused the discord. It was the vagueness with which the digital treated all creative elements, minimising the importance of the material base and behaving in an ambiguous way as to what its function actually was in production spaces that were already very well defined historically.[6]

Thomas Elsaesser (2018) notes that the digital, with the lack of definition of its real purpose and nature, has erased part of the history of media and accelerated the obsolescence of artefacts and ways of relating to them

that were part of our everyday lives. For Elsaesser, the widespread digitalisation of all cultural objects has led to the relativisation of machines, artistic practices, cultural habits, industrial processes and economic activities. As a result, an appreciation of old devices, even if they are excluded from the most current production processes, has become common among older users and professionals.

Some of these professionals share their practical knowledge and collections of technical objects in online videos. One example is music producer Arthur Joly,[7] who, in addition to his work as a mastering engineer for vinyl records, also builds and sells analogue synthesisers. As well as selling the equipment he makes, Joly films and posts technical and creative demonstrations of the various devices he owns and uses in his sonic experiments on his social networks. Sharing these tests consolidates a network of symbolic exchanges between lovers of old technologies, old modes of production and a certain imperfection/obsolescence that these artefacts reveal. They are the fruit of an archaeological inspiration that shows not only old ways of making music, but also resistance to commercial and more impersonal models. We should remember, of course, that in their time these same devices could have represented mainstream values in terms of adapting to a commercial way of making music, but their very outdatedness puts them in a different place. They have become exhibits in a museum of technical artefacts. They represent a simpler and perhaps more humane world from the point of view of their admirers.

In this sense, thinking of technological objects as heritage artefacts adds another symbolic layer of legitimation to practices based on an exclusionary and self-referential technicist discourse. Perhaps even more exclusionary than that propagated by market technologies, since it is not directly aimed at financial return, but at recognising the superiority in terms of knowledge and artistic appreciation of a select few among the listeners. Challenging this kind of symbolic capital is difficult because, in addition to clashing with a very well-articulated techno-scientific discourse, it is also necessary to confront a critical view of consumer society held by this group of "traditional listeners". In this context, old technologies, by representing a more classical form of musical experience, also represent a resistance to the capitalist model of listening (as contradictory as this argument may sound).

Conclusions

Seen as systems, technologies have a complexity and pervasiveness that can transform different social phenomena. In this way, technological systems affect all social subjects. However, only a small proportion of these subjects are capable of proposing and developing technological systems. Firstly, because, as already mentioned, systems involve components of different natures and

therefore defend specific interests within political and economic demands. Secondly, large technological systems generate high costs both for their implementation and for their maintenance. Both the material and the logical bases of these systems trigger interconnected networks of apparatuses and projects in order to achieve their objectives. Thirdly, in order to achieve an adequate result, every system needs society's basic understanding of how it works. Thus, users who are able to interact with such structures, because they have at least mastered a certain set of rules, feel rewarded and can endorse the system's effectiveness. Those who are unable to interact with the system, either because they do not understand how it works or because they cannot afford the cost of purchasing and using one of these artefacts, become subjects who are not integrated into the social dimensions that are now considered essential.

Such reasoning may seem contradictory: that for perfect integration into a contemporary social model, it is imperative to follow the protocols and uses defined by the systems and their designers and, paradoxically, that the logic of the systems is one of constant replacement of technological models. Not that this replacement is extensive enough to stimulate the emergence of new needs of underrepresented social groups, but enough to increase costs (economic, cultural, cognitive) and to pose challenges in the adaptation process.

In this sense, large technological systems determine the functioning of society and are defined by a minority and regulatory segment that maintains itself as such due to the inequalities generated in the implementation of the systems. This does not invalidate the argument that technologies are socially constructed, but the premise of large universal systems only deepens the exclusion and imbalance between people, social groups and countries. We would like to mention the notion of technocoloniality (Castanheira, 2020; 2022) as another consequence of the colonialist historical process, which, through dependence on global technological models, often assimilated in a coercive way, causes irreparable damage to the production structures and alternative aesthetic models of the countries of the Global South.

On the one hand, the perspectives presented in this chapter situate precariousness not only as a consequence of the inequalities imposed by the political and economic model, but also as an articulation between personal and local knowledge and a logic of technological systems that, although they aspire to universality, do not achieve it because they also conform to the capitalist logic of exclusion at different levels. Perhaps the excessive romanticisation of the gambiarra – and similar perspectives – diminishes the impact that the discourse of technological systems can have on society as a whole.

On the other hand, failing to recognise and adhere to the immanent politics of such devices, represented by the authoritarian rules of the manuals and current production processes of the creative industries, could be a key to a fruitful analysis of such artistic practices. The response to this kind of

authoritarianism has been described as a resistance, sometimes heroic, to a hegemonic model and as an idealisation of personal initiatives in search of original solutions.

Notes

1 In the 1980s, the independent record label Kuarup first tested the PCM-digital recording system in Brazil, utilizing U-matic and Betamax format video tapes. The label positioned itself as the inaugural entity to release Brazilian artists recorded in digital format. It ceased operations in 2009 and was reactivated in 2011 through a partnership with Sony Music. The pioneering use of new digital recording systems was insufficient to enable the label to compete with the major international companies. (PCM stands for Pulse Modulation Code, a digital representation of an analogue signal). See: https://www.kuarup.com.br/.
2 Milton Nascimento is often hailed as Brazil's preeminent composer, drawing influences from Brazilian and African folk traditions, as well as European classical music and the Brazilian bossa nova genre. He has collaborated with and inspired several Latin American and American artists. (AllAboutJazz, 2023, online). For more details: https://www.allaboutjazz.com/musicians/milton-nascimento/
3 See: https://www.youtube.com/watch?v=XHCYAld3Ubw
4 See: https://www.youtube.com/watch?v=f_J4A7RNg2g
5 For more details on the construction of Gatorra, see: https://www.youtube.com/watch?v=a_Mtj-qbl7o
6 In 1996, only one major record company in Brazil, BMG, continued to produce vinyl records. However, this was expected to cease soon. The format's return as a nostalgic and audio-philic appeal in the 2000s led to the recovery of old presses from junkyards and their restoration, as well as the rehiring of former professionals who had retired. See Castanheira (2019).
7 https://www.youtube.com/channel/UCnNcPtI2g1V1leWVLb2-1rg

References

Arora, P. (2019). Decolonizing Privacy Studies. *Television & New Media*, 20(4), 366–378. https://doi.org/10.1177/1527476418806092

Campbell, C. (2005). The Craft Consumer: Culture, Craft and Consumption in a Postmodern Society. *Journal of Consumer Culture*, 5(1), 23–42. https://doi.org/10.1177/1469540505049843

Campos-Fonseca, S. (2019). Decolonizar "La ciencia que se busca". Susan Campos-Fonseca: Composer and Writer. https://bit.ly/3TpU2bJ. Acessed 18 August 2020.

Castanheira, J. C. S. (2022). Introduction to the Sociology of Music Technologies: An Ontological Review. *methaodos.revista de ciencias sociales*, 10(2): 419–429. https://doi.org/10.17502/mrcs.v10i2.574

Castanheira, J. C. S. (2020). Studio Sounds: Digital Tools and Technocolonialism. In: Cárdenas, A. (Ed.) *Border-Listening/Escucha-Liminal*. Berlin: Radical Sounds Latin America, 106–119. Available online: https://www.contingentsounds.com/studio-sounds-digital-tools-and-technocolonialism/

Castanheira, J. C. S. (2019). Back to black: o que há de novo nas velhas prensas. In: Amaral, A. et al. (org.) *Mapeando Cenas da Música Pop: Materialidade, Redes e Arquivos*. Paraíba: Marca de Fantasia, 114–144.

Crossley, N. (2023). Doing It with Others: The Social Dynamics of Do-It-Yourself Musicking, DIY. *Alternative Cultures & Society*, 1(1), 74–94, https://doi.org/10.1177/27538702231153112.
D'Ignazio, C., & Klein, L. F. (2020). *Data Feminism*. Cambridge: MIT Press.
Elsaesser, T. (2018). *Cinema como arqueologia das mídias*. São Paulo: Sesc.
Gaskins, N. R. (2019). Techno-Vernacular Creativity and Innovation across the African Diaspora and Global South. In: Benjamin, R. (Ed.) *Captivating Technology: Race, Carceral Technoscience, and Liberatory Imagination in Everyday Life*, pp. 252–274. Durham, NC: Duke University Press.
Guerra, P. (2020). Other Scenes, Other Cities and Other Sounds in the Global South: DIY Music Scenes beyond the Creative City. *Journal of Cultural Management and Cultural Policy*, 1, 55–75, https://doi.org/10.14361/zkmm-2020-0104
Hughes, T. P. (2012). The Evolution of Large Technological Systems. In: Bijker, W. E., Hughes, T. P., & Pinch, T. (Eds.) *The Social Construction of Technological Systems: New Direction in the Sociology and History of Technology*, pp. 45–76. Cambridge, MA: The MIT Press.
Jarrett, K. (2019). Through the Reproductive Lens: Labour and Struggle at the Intersec-tion of Culture and Economy. In: Chandler, D. & Fuchs, C. (Eds.) *Digital Objects, Digital Subjects: Interdisciplinary Perspectives on Capitalism, Labour and Politics in the Age of Big Data*. London: University of Westminster Press, 103–116. https://doi.org/10.16997/book29.h. License: CC-BY-NC-ND 4.0
Jones, E. (2021). The Problem?: Welcome to the Democratic, DIY Music Business. *DIY Music and the Politics of Social Media*. New York: Bloomsbury Academic, 1–20. *Bloomsbury Collections*, https://doi.org/10.5040/9781501359675.ch-001.
Lorey, I. (2015). *State of Insecurity: Government of the Precarious*. Trans. Aileen Derieg. London: Verso.
Messias, J., & Mussa, I. (2020). Por uma epistemologia da gambiarra: invenção, complexidade e paradoxo nos objetos técnicos digitais. *MATRIZes*, 14(1), 173–192. https://doi.org/10.11606/issn.1982-8160.v14i1p173-192
Mignolo, W., & Walsh, C. (2018). *On Decoloniality. Concepts, Analytics, Praxis*. Durham, NC: Duke University Press.
Milan, S., & Treré, E. (2019). Big Data from the South(s): Beyond Data Universalism. *Television & New Media*, 20(4), 319–335. https://doi.org/10.1177/1527476419837739
Noble, S. U. (2018). *Algorithms of Opression. How Search Engines Reinforce Racism*. New York: NYU Press.
Pinch, T. J., & Bijker, W. E. (2012). The Social Construction of Artifacts: Or How the Sociology of Science and the Sociology of Technology Might Benefit Each Other. In: Bijker, W. E., Hughes, T. P., & Pinch, T. (Eds.) *The Social Construction of Technological Systems: New Direction in the Sociology and History of Technology*, pp. 11–44. Cambridge, MA: The MIT Press.
Perez, C.C. (2019). Invisible women. Exposing Data-Bias in a World Designed For Men. New York: Abram Press.
Quijano, A. (2007). Coloniality and Modernity/Rationality. *Cultural Studies*, 21(2–3), 168–178 https://doi.org/10.1080/09502380601164353
Sellman, J. (2022). Shifting Frameworks for Studying Contemporary Arabic Literature of Migration to Europe: A Case for Border Studies. In: Sellman, J. (Ed.) *Arabic Exile Literature in Europe. Defamiliarizing Forced Migration*. Edinburg: Edinburg University Press, 22–45.

Silva, M.A.S. (2022). *We do rock too: Formas de criatividade do movimento do rock angolano*. Rio de Janeiro: EDUERJ.
Steingo, G., & Sykes, J. (2019). Introduction: Remapping Sound Studies in the Global South. In: Steingo, G. & Sykes, J. (Eds.) *Remapping Sound Studies*. Durham, NC and London: Duke University Press, 1–38.
Tragtenberg, J., Albuquerque, G., & Calegario, F. (2021). Gambiarra and Techno-Vernacular Creativity in NIME Research. *NIME 2021*. https://doi.org/10.21428/92fbeb44.98354a15
Zuboff, S. (2019). The Age of Surveillance Capitalism. The Fight for a Human Future at the New Frontier of Power. New York: PublicAffairs.

8
ADDRESSING DEEP CODE PROBLEMS
Listening to Opera through the World's Liveness

Nina Sun Eidsheim and Juliana Snapper

Introduction

For two decades, we—Nina Eidsheim and Juliana Snapper—have been challenging one another to reimagine singing. Well, "reimagining" is a tall order. So, we have started by trying to expand, or, re-situate voices. Early on, where our classical vocal training overlapped, we sang duets by Luzzascho Luzzazchi and Claudio Monteverdi, and began exploring contemporary new vocalities through improvisation, intermedia performance, and new opera. We dreamed of creating vocal expressions that would challenge or transcend the felt constraints of western classical vocal aesthetics and politics. We spent a lot of time experimenting with the aim of discovering or creating new types of sounds. What we discovered was that in order to expand vocal possibility, we have to find new performative frameworks and listening strategies that create openings for unimagined vocalities and modes of exchange.

One of our main concerns is the ways in which listening ontologies affect musical imagination. We find that in order to listen beyond encultured limitations, we must challenge certain creative assumptions and social ecologies that keep us stuck. The projects we discuss here engage different strategies to open up constrained notions of communication and exchange. In this chapter, we share an intersection of our research as it applies to opera. We briefly profile mainstream opera, and some explicit limitations around content and accessibility. We look to the work of Jill Tarter (Search for Extraterrestrial Intelligence [SETI]) and Indy Johar (Dark Matter Labs) who identified *implicit* limitations in their fields, and who developed concrete strategies to move beyond them. Nina describes how Deep Code Problems inhibit musical institutions and foreclose creative agency. We consider three different efforts

DOI: 10.4324/9781003348528-13

to unsettle opera: Juliana introduces her work, and Nina talks about two of Juliana's operatic experiments. Merging our voices again, we reflect on a workshop performance of George Lewis' opera *The Comet/Poppea*, which integrates Claudio Monterverdi's *L'incoronazione di Poppea*. We write primarily in plural and alert the reader when a singular voice steps forward, sharing a period of intense conversation about the deep code problems of opera.[1]

Opera

When we write back and forth about this chapter, Juliana (personal communication, September 2, 2023) remarks:

> What makes opera opera? It's a question that most contemporary musicians and directors aren't asking with sufficient depth or curiosity. They are either too far inside to wonder, or else they feel like outsiders. We – all who love opera – must sincerely ask how to recognize what is alive within opera. What is particular about how opera communicates? (versus theater, music theater, film etc.)

What we might call "core opera repertoire" is the project or side effect of major and medium-sized opera companies worldwide that program the same operas season after season. The repetition of these operas over several decades establishes and perpetuates a repertory canon, and this canon essentially performs for a shared imagination what opera is as a musical entity and institution. At the same time, it entrenches *how* opera happens—from its generative processes, rituals of reception, and parameters of beauty and expressivity. For the professional singer, what is the work of reinterpreting roles that have been sung and recorded countless times? What kind of listening does the opera industry produce if the reenactment of a handful of arias is its product and its pinnacle?

While countless new works are added to the repertoire yearly, there are around 30 operas on annual rotation at major opera stages and, according to Opera-Inside (2023), in the 2019–2020 season the top ten were written by just five composers. The majority are in Italian, mostly in one of two operatic forms (*buffa* and *verismo*). Six were written within the same half-century, in spite of more than four centuries of opera to pick from.

Opera performances, like all staged performances, are rituals enacted by attendees as much as by performers. The air of exclusivity around opera, however, has resulted in palpable anxiety, compared to other musical or theatrical genres. This is evident in the primers many opera companies offer for new attendees.[2] These primers aim to demystify the opera house, addressing everything from what to wear ("there is no set dress code at ENO [English

TABLE 8.1 The Ten Most-Performed Operas Worldwide (2019–2020 Season)

Composer	Opera	Year	Performances	Productions
Verdi	La Traviata	1875	720	160
Bizet	Carmen	1875	640	154
Puccini	La bohème	1896	550	128
Verdi	Rigoletto	1851	500	126
Mozart	Don Giovanni	1787	496	108
Rossini	Il Barbiere di Siviglia	1816	486	112
Puccini	Madama Butterfly	1904	482	114
Mozart	Die Zauberflöte	1791	476	91
Puccini	Tosca	1900	448	442
Mozart	Le Nozze de Figaro	1786	430	92

National Opera]") to when to show up ("Arrive early so you're not rushing. The ushers will close the doors at show time and may not allow latecomers in until a suitable gap in the performance"), and how and when to clap ("... just wait for someone else to start clapping and you can't go wrong"). While such guides may open access to the nervous opera-curious individual, their existence illustrates the closed system, or Deep Code Problem that they attempt to pry open.

Nina: How we are taught to listen, and what we are taught to hear, shape the ways in which we hear voices and vocal repertoire (Eidsheim, 2015). It is our listening capacity that determines what we receive and decipher. Both our everyday language and the specialist technical vocabulary we sometimes employ to talk about music tend to push us toward describing situations in which we listen to voices. In this prepositional arrangement, voices "take place" while music (however challenging to define at times) is an active agent. Within this linguistically and culturally staged scenario, however, both music and voices appear to simply exist, while it is listening which serves to accurately receive and actively decipher what has taken place. Specific musics, and the traditions that surround them, teach us how to listen to them. Listening is enmeshed within strongly scaffolded processes (including music education's ear training and music theory, as well as the music presented in media and performance venues creating a listening norm), and hermeneutics (including the interpretive models criticism, musicology, and ethnomusicology model).

Simply put, the way we attend, and attend to opera (or any other music) is built into that music's "code" (metaphorically speaking) in such a way that it

is very difficult to hear outside of that closed loop. We need listening practices that somehow "break" that code so we might find new agency within the music by hearing music we know in new ways, hearing ourselves differently, imagining and creating new musics.

Listening across Light Years

In our efforts to listen beyond what we can imagine, we look to the work of American astronomer Jill Tarter, who initiated and developed the SETI, to listen for deliberate signals from living beings on other planets.[3] Tarter's work began as a one-woman project with limited resources and was met with substantial resistance to the very concept of listening for extraterrestrial life. She began by simply listening for patterns and asking questions. Over time, she gathered an expansive global community of scientists and supporters. Working with other researchers allowed her to refine listening parameters and develop finely tuned hardware and listening sites (Radio Telescope Arrays). Tarter's central project of listening raised essential questions, "What is life? What is intelligence?" that influenced the practices of other scientists. As a means of recognizing unimagined extraplanetary life forms, for example, astrobiologists began to observe and explore extremophile environments on earth such as Antarctica and the Mariana trench—environments formerly assumed to be uninhabitable where life must be understood in new ways in order to be perceived as life.

Tarter (2013) explains the value in listening for what we don't (yet) know is that it: "allows us to change perspectives…to think about things and to see ourselves in a way that is not often used by the general public." Listening for the "voices" of unknown entities reframes how we identify and relate to one another as humans. Imagining distant or unperceived life forms may begin to dissolve clannish identifications between humans that lead to unequal access to the earth's resources.[4] How we listen affects how we situate ourselves in relation to one another. Tarter elaborates:

> Might it be the discovery of a distant civilization and our common cosmic origins that finally drives home the message of the bond among all humans. Whether we're born in San Francisco or Sudan or close to the heart of the Milky Way Galaxy, we are the products of a billion-year lineage of wandering stardust. We, all of us, are what happens when a primordial mixture of hydrogen and helium evolves for so long that it begins to ask where it came from.
>
> *(2013)*

Indy Johar of the nonprofit civic infrastructure think tank Dark Matter Labs, suggests that, if we want to know where we came from and where we are headed, a type of listening that assumes "interconnectedness and

co-constitutive belonging" is a vital part of the solution[5] (Akómoláfé, 2023). As Johar observes, "civilization can only transcend itself [when recognizing entanglement] and recogniz[ing] the tangle of agency and care and a planet itself. That we are part of a planetary self." The opposite, a "fundamental idea of a theory of control," is the "deep code problem" we have been dealing with "for the last 400 or 6,000 years" because "it's rooted in everything, our theories of identity, our theories of registries, our theories of ownership, our theories, economic rights, our rights agenda" (Akómoláfé, 2023). We could also add that opera is rooted in this theory of control.

Following Tarter, the listener's situatedness as interconnected is indeed key. In the act of listening we become embedded. Because it is *Tarter* who listens, when she listens to the "cosmic larger picture," she is prepared to be taught everything that is there, including extraterrestrial life, in whatever form it may take and with whichever communicative means are used.

Opening up the Operatic Form

Juliana: My connection with opera predates my own career as a singer, reaching back to a childhood spent wedged beneath opera stages and lurking in the wings while my mother rehearsed. I remember the pull to be as close as I could to what was happening when she sang. That original fascination and curiosity drives me still as an interpreter of contemporary opera, and an operatic creator. In various ways, my original projects re-situate the operatic body as a means of materially challenging the operatic voice and resultant dramaturgy. Much contemporary classical vocal writing seems to have given up on the bel canto instrument as a living technology. "Abandoned or embalmed," I lament! By this, I mean that the operatic voice is too often either 1. treated with kid-gloves, unchallenged within challenging harmonic structures and instrumentation, or 2. tossed-aside in favor of "extended techniques" or prosthetic electronic processing. In a way I am still asking Modernist questions about opera: has the operatic voice stopped evolving? Can operatic productions be more than a "bourgeois vacation spot"? I draw inspiration from the dramaturgical strategies of Feminist Actionists[6] whose work is centered in the situatedness of their own bodies, and Queer Body Artists who demand of their bodies new virtuosities. For example, in a scene from *The Judas Cradle*, an operatic duodrama co-created with artist Ron Athey, I oriented my body in space so that gravity became an instrumental problem. I sang Verdi cadenze while swinging upside-down, allowing the gradual failure of the vocal mechanism to dissolve mastery over several minutes. The "problem" of the displaced body formed the musical and dramatic arc of the aria.

148 Situated Listening: Attending to the Unheard

FIGURE 8.1 Juliana Snapper, Watermouth Coda, part of Ridykeulous: The Odds Are Against Us, in WACK! Art and the Feminist Revolution at P.S.1 Contemporary Art Center, New York, 2008. Photo: Sheana Corbridge.

In the section to follow, Nina reflects on two of my later projects, one in which I took opera underwater, and a subsequent experiment in which I sought what I call a "listening vocality" (Figure 8.1).

Nina: In 2013, I began writing about a cycle of operatic performances Snapper sang immersed in water (2007–2018) questioning the elemental dynamics of opera (2015). Sandwiched between Al Gore's *An Inconvenient Truth* (2005), which sounded the alarm for global warming, and Naomi Klein's *The Shock Doctrine: The Rise of Disaster Capitalism* (2007), which showed how the government uses crisis and fear to quash democratic freedoms, Snapper began preparing herself to make opera after the glaciers have melted and the levees lie untended. Her performances, sung at the surface of the water and six feet below, began as 10- to 20-minute arias in bathtubs and dunk tanks and, as her technique and stamina evolved, expanded into a full-length modular opera co-created with Andrew Infanti, *You who will emerge from the*

flood…. Snapper toured the work for over a decade, turning Victorian baths and Soviet Era Olympic pools into multi-prosceniumed opera houses and extending "Site-specific" to "People-specific" by extending an open invitation to the local communities living around these places participate in the production.

To take just one example that ties in with Snapper's concern with opera, the city of Venice, Italy—where what is considered one of the first operas, *L'incoronazione di Poppea*, was first performed in 1642–1643, and where one version of the score was rediscovered in 1888—is slowly being submerged. Venice's average sea level has risen nearly a foot since 1900, and from 1950 to 1970 the city has sunk about five inches due to greedy groundwater pumping. Today, people either know or deny that the earth will cross a critical threshold for global warming within the next decade. By the end of the century, Venice's sea level could rise by two-and-a-half feet, if emissions continue at the current pace.

The city's *Modulo Sperimentale Elettromeccanico* (Experimental Electromechanical Module, or MOSE) is a highly controversial project whose development was fraught with corruption and, as Jason Horowitz and Emma Bubola (2023) put it, "technical ingenuity, but also ... political instability, bad governance, bureaucracy, corruption, debt and defeatism as delays mounted." At four gaps between the lagoon and the sea, giant walls, sectioned into 78 parts, are secured to the sea floor. When the sea level is reasonable, the walls are filled with water and lie flush with the seafloor. When the lagoon needs protection against the sea water, the water is emptied and, hinged to the floor, the sea walls "inhale," or fill with water like lungs filling with air, and rise to the surface, creating a barrier between the city and the rising sea. Like MOSE, Snapper has expanded her own operatic practice through a challenge to the form of opera with the questions: Does it have the capacity to listen beyond its own model, beyond how it has been defined? Like Venice, a city built on stilts over water, can opera survive being built on exclusion? Can it still invent, or is it limited to simple reactive survival like the sea wall's forced breathing?

In *Opera Listens to* You (2011), Snapper asks and performs—quite literally—an existential question for opera: Does it have the capacity to listen to its audience? This piece was commissioned as part of a collaboration between the Walker Art Center in Minneapolis and the Los Angeles artist-run performance and installation space Machine Project.[7] Here, Snapper—the opera singer and composer—invited people to tell her their stories. In doing so, she turns the norm of the operatic protagonist on its head, from performer to listener.

Score/Invitation

Just like your selfish lover, your narcissist BFF, your entire myopic family, Opera has exploited your sympathetic nature, wailing at you for hours at time about her stories, her needs, her feelings without once asking how YOU were! But now – drawing on psycho-acoustical and neurophysiological research, applied therapeutic strategies, and the listening-based music technologies of composer Pauline Oliveros, Juliana Snapper has engineered for Opera a set of ears. Opera is ready to listen! Using this "listening vocality," Snapper and a small ensemble will receive, unpack and render the expressive statements of willing individuals in operatic form: recitative-aria-chorus. There is no problem solving, advice or commiseration. The goal is neither revelation nor redemption, but simply that each audience member that takes part feels deeply and thoroughly heard.

—*Juliana Snapper*

Score/Invitation given to participants as they enter *Opera Listens to You*.

Her chosen setting is a wide tiered corridor on the periphery of the galleries. In the video document, the focus is the bottom of a stairway, a transition between one space and another. Behind the clustered audience I see an open space with a scattering of people, and beyond that light pours in from huge windows, behind which a few cars pass by.

The audience-turned-protagonist is largely veiled by a huge silk parachute that they are collectively holding with raised arms, creating a soft, cocoon-like structure. It is difficult to count the precise number of people, but it might be around eight surrounding the single audience-protagonist. The proscenium stage is not present, but the audience-protagonist is protected within a circle of bodies.

Snapper starts out casually, asking, "What's up?" "Well, I feel like I'm going crazy," the cocooned audience-protagonist responds without a beat passing.

The scene continues lightheartedly. The cocooned audience-protagonist voices self-doubting questions posed during a personal crisis with self-reproaching humor. How does one survive financially while also following creative yearnings? How does one explain such dilemmas to baffled family members? The story slowly transitions into doubts about whether the cocooned audience member would make it as an artist into the larger existential question of how to live. The audience-protagonist is lonely and full of fear as everybody in her family calls into question her decision to move to Los Angeles.

As the story unspools, the cocooned audience member's voice gradually grows in intensity. Laced with laughter, the words are increasingly punctuated with sounds I gradually understand are cries. Weeping, the audience

member wonders: What is she doing here in this tentative state? Where is her life going? Most urgently, what should she do?

Returning to the documentation of *Opera Listens to You*, I notice that it keeps the operatic format, conveying content and actions in the *recitativo* provided by the cocooned audience-protagonist while dwelling on emotions in the aria and chorus. In beginning to vocalize elements of the story, Snapper recognizes the ending of the exposition/*recitativo*, the section where the character's central dilemma is exposed. Members, and then smaller groups of the chorus, slowly join in accompaniment, and eventually everyone in the circle has joined. This trajectory loosely mirrors the traditional structure that operas are often built upon: *recitativo*, aria, smaller ensembles (such as duos, trios, and quartets), and chorus. However, the libretto created *in situ* reflects on elements brought to the opera by the audience; what the cocooned audience member hears are their own words, their own story.

In other words, the focus and performative energy of *Opera Listens to You* are not products, directed at whoever comes into its vicinity. Instead, they arise from the perceived needs of audience members and are held within a circle of performing bodies. Visually protected within these singing bodies, we cannot see the audience-member-turned-protagonist—but, in the video documentation, we can hear their sobbing.

Although *Opera Listens to You* follows the narrow form of a number opera—*recitativo*, aria, ensemble, chorus—it places the audience at its center, shifting both authorship and listening practice. That is, "the opera"—in the form of the performers—is there for the audience. Snapper and the chorus listened intently when the story was first shared. Like Tarter, through the direction of their attention and their extended imagination about what opera could be, they expanded the definition and potential of opera, "making it listen."

Past Future Opera

> Nero and Poppea:
> I delight in you, I enchain you
> I no longer grieve, I no longer die
> You are my life, my treasure
> You are my hope
> Yes, say it, say it to me
> Giovanni Francesco Busenello, libretto
> Claudio Monteverdi, "Pur ti Miro," *L'incoronazione di Poppea*

Silently, immovably, they saw each other face to face, eye to eye. Their souls lay naked to the night. It was not lust; it was not love--it was some vaster, mightier thing that needed neither touch of body nor thrill of soul.

It was a thought divine, splendid. Slowly, noiselessly, they moved toward each other-the heavens above, the seas around, the city grim and dead below. He loomed from out the velvet shadows vast and dark. Pearl-white and slender, she shone beneath the stars. She stretched her jeweled hands abroad. He lifted up his mighty arms, and they cried each to the other, almost with one voice, "The world is dead." "Long live the--" "Honk! Honk!" Hoarse and sharp the cry of a motor drifted clearly up from the silence below.

W.E.B. DuBois, The Comet (1920)

Akin to Tarter's listening for messages across a vast space of time, so does George Lewis' opera, *The Comet/Poppea*, upset operatic listening by director Yuval Sharon placing temporally and spatially distant operatic texts in conversation with one another. Claudio Monteverdi's *L'incoronazione di Poppea* [*Poppea*] (1643)[8] is set in the decline of the Roman Empire, in 62 C.E. Based on W.E.B DuBois' novel, *The Comet* (1920), Lewis imagines 20th-century New York City hit by a comet. *Poppea* retells the historic relationship between Nero and his mistress, Poppea Sabina, as a wager between Cupid, Virtue, and Fortune. Before Nero can marry Poppea, he must banish his wife, Ottavia, and order the death of his advisor, Seneca, who takes his assassination into his own hands. Francesco Businello's libretto gives the Cupid his victory, but it stops short of Poppea's coronation. The final duet, "Pur ti miro," is tender and visceral. The music rubs and releases as each lover pledges their devotion: "You are my life, my hope." We are seduced by the voices, and forget for those minutes the actual ending of the story. Three years after they marry, Nero will kick a pregnant Poppea to death; Rome will burn. In *Poppea*, the yearning for love is a thematic that inspires deep emotion and radical action, but is ultimately impotent; a trick played on humans by bored gods.

While *Poppea* is a historical allegory, *The Comet/Poppea* is a contemporary critique that goes a step beyond the allegorical by challenging us to imagine a different future, and evoking, "A Love Supreme."[9] Douglas Kearney's libretto, based on DuBois proto-Afrofuturist short story, is also a tale of love at the fall of a civilization. Yet where *Poppea* ignites an already extinguished hope, *The Comet/Poppea* asks whether shared crisis might offer a chance to reclaim lost aspects of ourselves and re-situate ourselves in relation to one another. "It was not lust; it was not love--it was some vaster, mightier thing that needed neither touch of body nor thrill of soul." In a moment shared by (seemingly) the last two people on earth, Julia and Jim, love begins where two people might experience themselves and perceive each other beyond totalizing constructs of gender and race. Lewis' setting never disconnects from the devastation and loss that precedes, and enables this luminous moment of possibility.

"Death, the leveler!" Jim muttered.

"And the revealer," Julia whispered gently

In the Los Angeles concert workshop performance, director Yuval Sharon (The Industry, LA) positioned the operas on opposite sides of the stage, bookended on one side by a harpsichord and continuo, and a grand piano and modern percussion on the other. Supertitles for each opera are projected side-by-side (*Poppea* in translation) so that the texts being sung are clear, and also enabling a third text to emerge from the alternating and overlapping musics. Lewis' instrumental writing and the organic lyricism of his text setting allow *The Comet/Poppea* to move distinctly but somehow seamlessly from—and in combination with *Poppea*. What appears at first to be clear division down the middle of the stage begins to erode as singers who performed roles in both operas cross operatic worlds. The interpolation of operatic texts and singing bodies culminates in an expansive revoicing of "Pur ti Miro" sung by all four protagonists, Nero and Poppea in Italian and Jim and Julia in English. It is difficult to describe properly, and we await the full production scheduled to be premiered on June 14, 2024, but it is as if the duet had been unfinished all this time, waiting for a better love, waiting for Lewis to make it whole.

Nina: Engaging these works gives me hope. To me, Tarter, Snapper and Lewis found ways of articulating the status quo in order to enable the creative distance needed to listen anew. Tarter began by imagining the possibility of life on other planets, and the possibility that they might already be communicating. She went from long nights listening alone to bringing nations together to build listening instruments that reach far beyond our galaxy and our time. Snapper shows us how opera might act as a technology of listening, creating strategies that can help us to hear stifled voices, and to imagine an opera that can evolve even as the earth is flooded. Lewis has built an operatic instrument that allows us to hear the history of opera and Western civilization beyond their self-referentiality, as well as to begin a future core operatic repertoire.

Le bonheur est dans le pré (Hommage à Pauline Oliveros)
for two or more sounding bodies, one or more of which are human and at least one that is not

by Andrew Infanti and Juliana Snapper

This score explores musical creation and improvisation in relation to nonhuman animals and other sounding entities by playing sonically with extremes of identity and otherness.

Instrumentation: Voice, meaning all sounds, pitched and percussive made in the vocal tract and/or the mouth. Modes of sound production can expand or shift to accommodate performers.

Staging: Proximities and positionings should be site-specific: formations must allow musicians to hear one another and the nonhuman musical components in the best possible way.

Duration: Variable within each performance. (See paragraph on Direction below)

Sounding Bodies	Sound-Making Strategies
• Humans	• Imitation
• Nonhuman animals	• Sounding an analytical response
• Environmental sources	• Sounding an empathetic affective response
	• Waiting
	• Subjective expression
Temporal Strategies	**Construction**
• Maintain strategy	• Events
• Evolve strategy	• Cycles
• Switch to new strategy	• Direction

Sounding Bodies

In addition to the human participants, these include:

a) Nonhuman animals
b) Environmental sound sources (elemental sounds such as wind or water, machine noises)

Sound-Making Strategies

- *Imitation*: an unmediated attempt to "faithfully" reproduce all the sonic characteristics of a source in a way that is integrative to the sounds as they are happening in real time.

- *Analytical*: adopting a single aspect of sound source such as pacing, pattern, pitch register, or timbre.
- *Affective*: sounding an empathetic affective response reflecting perceived mood or emotion of a sound, such as anxious, mournful, or blissful.
- *Waiting*: This instruction is conceived as an active verb, presuming attention to the global sonic events—it is a musical decision in each cycle of the piece.
- *Subjective expression* (nonimitative, semipermeable, creative)

Temporal Strategies

- **Maintain** *strategy*: Do not change the way you are generating sound vis-à-vis the other sounding body/bodies. The sounds, phrasing, dynamics, and so on may vary, but the framework (imitative or affective) remains the same, even as other sound sources may shift.
- **Evolve** *strategy*: Allow the strategy you are using to grow, either by exaggerating sonic motives, adding new ones, or integrating elements of a second strategy.
- **Switch** *to new strategy*: Change everything.

Construction

An **event** originates with a shift in the nonhuman sonic elements (cow moves, air-conditioner shuts off, etc.), eliciting a musical action (as a conscious response to otherness) enabled by active listening on the part on the human performer(s). Multiple **events** will happen within any given cycle.

Each iteration of the score is made up of individual musical contributions shaped through their chosen *strategies*. The sounds each person makes evolve over time in relation to the other sounding bodies. These sounding **events**, in combination with the sonic whole, combine into sections within any one performance, which we call **cycles**. A **cycle** may be defined freely in duration, but corresponds globally to either the continuation of a musical process or a change in strategy for all musicians. A **cycle** is conceived as part of a **construction**. This, based on communal music-making, seeks to progress from *imitation* on several levels to *creation* without ignoring the "otherness" of environmental and animal sound sources. The keyword remains: "mediation."

Direction

For performances with more than one human, a *director* may be chosen as facilitator. The designated *director* will create and use gestures or sonic signals to organize and guide participants through the **events** and **cycles** in the work.

The *director* should be able to signal the following four interventions:

1 **Breathe**: the performer pauses, breathes, and either restarts or reconsiders her strategy in the current cycle.
2 **Restart**: the human group begins a new cycle but according to the strategies already in progress.
3 **Renew**: each musician reconsiders her strategies, either to technically refine the previous approach, or to completely change the method applied.
4 **Create**: this signal can be directed either to individual musicians or the entire human ensemble—the imitation strategies should henceforth give way to subjective musical expression drawn from the experience formed in the previous cycles (and avoiding reference to any repertory material).

The aim of each stage or **cycle** of this score is that of between extremes of total identification and radical otherness (but not necessarily in that order). Each step is thus inherently tripartite, but not necessarily organized as such—human/human, human/animal, human/inanimate—and not necessarily exhaustive in terms of relating to all the available sound-producing bodies).

Multiple cycles of the above score, whose practical terms are based on "mediation" (between the extremes of identity and otherness), are necessary to realize the creation of new musical material which neither ignores nor fuses with the existing sound elements. Example: After progressively refining the techniques of imitating bovine, human, and environmental sound sources (tonally, rhythmically, affectively, etc.), the personal production of each musician, which could be the sum of her experiences or another kind of "mediating" reflection, allows a personal improvisation/composition which make sense in a collective context.

Notes

1. In the chapter author role, we refer to Juliana by first name. When discussing her performance work, Nina refers to *Snapper*.
2. See, for example, Opera Australia https://opera.org.au/features/the-ultimate-guide-to-going-to-the-opera/; English National Opera https://www.eno.org/your-visit/attending-opera-for-the-first-time/ (who are also offering free tickets to anyone under 21. Outlets like *The Guardian* also have primers "How to survive your first opera," *The Guardian*, https://www.theguardian.com/music/2011/aug/20/how-to-survive-opera]. All accessed on February 27, 2024.
3. Jill Tarter directed the Center for SETI Research during the period 2000–2012. For an in-depth study of communication with extraterrestrials, limited to what could fit onto the format of a LP recording, see Daniel K.L. Chua and Alex Rheding (2021).
4. Snapper was part of an October 2015 session at The Montalvo Arts Center, Saratoga, CA where Jill Tarter spoke to a group of artists over two days. Resident artist Nina Waismann conceived and organized the event. Much of the information discussed is from Snapper's notes.
5. The think tank, The Center for London (n.d.), notes that Indy Johar is a designer and architect and the co-founder of Architecture 00 and Dark Matter Labs. They describe his work as "strategic design of new super scale civic assets for transition—specifically at the intersection of financing, contracting and governance for deeply democratic futures" for which he was awarded the London Design Medal for Innovation (2022). Dark Matter Labs (n.d.) describe themselves as addressing "the consequences of outdated institutions and inadequate infrastructures incapable of coping with planetary-scale challenges." They are "an ambitious not-for-profit designing and building the underlying infrastructure to support this new civic economy, exploring how ownership, legal systems, governance, accountancy and insurance might begin to change."
6. See Valie Export's essay, Aspects of Feminist Actionism. *New German Critique*, No. 47 (Spring - Summer, 1989), pp. 69–92.
7. The Machine Project, 2003–2018, an artist-run performance and exhibition space founded and directed by Mark Allen in the Echo Park neighborhood of Los Angeles.
8. *L'incoronazione di Poppea* was attributed posthumously to Claudio Monteverdi but likely written by more than one composer. Likely candidates are Benedetto Ferrari and Francesco Sacrati, the libretto by Giovanni Francesco Busenello, except for the closing duet, "Pur ti Miro" for which Sacrati likely wrote both words and music. The date of completion and premiere are unknown. The earliest surviving document from the opera is a printed scenario from a performance in Venice in 1643.
9. Lewis' score embeds musical quotations from John Coltrane's 1964 composition, "A Love Supreme."

References

Akómoláfé, B. (Host). (2023, May 24). "Edges in the Middle, III: Báyò Akómoláfé and Indy Johar," [Audio podcast episode]. In *For The Wild*. Retrieved June 2, 2023, from https://forthewild.world/listen/the-edges-in-the-middle-bayo-and-indy.

The Centre for London. (n.d.). Indy Johar. Retrieved January 24, 2024, from https://centreforlondon.org/person/indy-johar/.

Chua, Daniel K.L. and Alex Rheding. (2021). *Alien Listening: Voyager's Golden Record and Music from Earth* (New York: Zone Books).
Dark Matter Labs. (n.d.). *About*. Retrieved June 2, 2023, from https://darkmatterlabs.org/About.
DuBois, W. E. B. [1920] (2021). *The Comet*. Berkeley, CA Mint Editions.
Eidsheim, Nina Sun. (2015). *Sensing Sound: Singing and Listening as a Vibrational Practice* (Durham, NC: Duke University).
Horowitz, J. and Bubola, E. (April 1, 2023). "Venice Is Saved! Woe Is Venice." *The New York Times*. Retrieved April 1, 2023, from https://www.nytimes.com/2023/04/01/world/europe/venice-mose-flooding.html.
Opera-Inside. (2023). "The Most Played Operas Worldwide: Ranking of Operas Top 10/Top 50." https://opera-inside.com/the-most-played-operas-worldwide-ranking-of-operas-top-10-top-50/
Tarter, J. (2014, October 1). "Searching for ET: An Investment in Our Future," NASA Ames Research Director's Colloquium. Retrieved July 31, 2014, from https://www.youtube.com/watch?v=iRkdPhhCdhw&list=PLfnpkfDmrBqZBuDtMJsCH8bVri1F4ojI7&t=12s
Tarter, J., (2013). interview on "Are We Alone in The Universe?". *TED Radio Hour*, with Guy Raz. Retrieved February 15, 2013, from www.npr.org.

9
ENDARKENED LISTENING

Liz Gre, Matilde Meireles and Tullis Rennie

This chapter addresses creative sound practices where artists are simultaneously the performer, the recordist, the composer and the listener. This is a common approach: a type of multi-modal, continuously oscillating form of sonic reception-production. Here, we propose a unique frame and focus for such instances of situated listening and sounding – the 'endarkening' of collaborative creations.

'Endarkened' co-creation is where a sense of the unknown and the unknowable is actively retained, presenting *opacity* as an important, even fundamental aspect of the artistic act. 'Endarkening' through sound is a decisive and positive shift towards non-clarity, one which aims to redress Anglo-Western normative hierarchies and expectations. Endarkened co-creations thus re-centre sounding entities often found outside typical spheres of listening. Endarkened works may attend to these unheard beings and place them as collaborators and experts, but without the need to clarify, justify or focus on them in particular. Endarkened sound arts practices suggest that intentions towards supposed 'clarity' in listening and recording are notions often co-opted as vehicles for oversimplification, mistranslation and reification into hierarchy.

We, the authors of this chapter, regularly engage in creative sonic acts that focus on human experiences, often framed as ethnography through sound. We actively look to share and to disseminate our individual practices in ways which may address and redress unhelpful binaries. We listen for how sound may amplify hierarchies, particularly those present in relationships between audiences and artists.

As artists, we regularly record, process, share and present in sound as collaborative acts – inviting listeners to meet us equally and/or participants

to work together alongside us. We form creative outputs from these interactions: pieces, performances, installations, works, releases, processes, papers, posters, book chapters and further types of creative assemblage. Through descriptions below of three such sonic acts that we have creatively facilitated, we consider routes of collaborative and generative listening in sound practice that *do not* aim to make clear what is heard – a creative, proactive endarkening, a privileging of opacity over clarity.

In the first section, we present theoretical positions to frame our work. In the second section, we write recollections of the act of creating work in situ – to describe where listening, recording, composing and performing have become endarkened. This section then becomes a dialogue in which the co-authors re-evaluate these scenes using the framework from the first section. We do so anonymously, as an exercise in endarkenment for both writers and readers. In the third section, we conclude with thoughts on the complexities and multiplicities of interpretation and (mis)understandings found within endarkened creative sound practices.

We begin by presenting several theoretical positions stemming from creative practice. This creates a constellation of ideas within which we may situate and discuss our experiences of making work in the second section. The multiple artistic roles we refer to in the introduction are all represented here. As listener-recordists, we draw on Andra McCartney's approaches to 'ethical listening' and Mark Peter Wright's sense of 'listening-with responsibly'. As composer-performers, we look to Tavia Nyong'o's consideration of afro-fabulationist performance, all framed within SR Tolliver's 'endarkened storywork'.

Endarkening and Afro-Fabulations

Cynthia Dillard's notion of an 'endarkened feminist epistemology' (2011) presents a paradigm that centres Black feminist thought as an opposition to the act of researching in order to become 'enlightened' – a departure from White feminist thought (Dillard 2000). Building on Dillard's work and incorporating Indigenous storywork, S.R. Toliver (2021) proposes 'endarkened storywork', furthering Dillard's reframing of academic qualitative research. Tolliver argues that, as a research method, this not only makes space for Black stories, but assigns value and meaning to Black storytelling as sovereign and not as luxury. Endarkened storywork as a method is a rebellious act of critical remembering, one that allows the darkness of ephemera left unavailable for easy consumption or dilution to remain unrestricted.

In an endarkened approach to ethnographic research, the art of storytelling itself is both process and outcome, one that centres personal nuance, which may not necessarily be clear for all those receiving the story. When following Toliver's approach, those embarking upon an endarkened research

pathway see themselves as collectors of stories and active agents in the experience of sharing. Rather than only 'receive' the data of someone's experience through an interview, for example, the artist-researcher lends their voice to the dialogue. In this exchange, threads of connection, memories of past lives and epigenetic experiences and present-day resonance may all emerge. Crucially, these non-tangibles only exist within an alchemy of connectedness that bubbles up in uninhibited experiences of storytelling with another, and not within limitations of Eurocentric modes of qualitative research – where experiences are mined like data for inspiring the 'next great work'.

In creative sound practice, *endarkened co-composition* presents a greater and more inclusive possibility for collaborative art making as a qualitative research method. It is a mode that re-centres those who have been considered research 'subjects', realigning their contributions as egalitarian collaborators and experts. For endarkened co-composition, Tolliver's endarkened storywork methodology acts as a tool for the shaping of an ethnographically informed composition practice that rejects the frame of Eurocentric academia, one which has left paths of trauma and hegemony in its wake (Gre 2024).

Endarkened co-composition values and centres storytelling – in the forms of folklore, fables, remembering and imagining. Such co-composition occurs as the experiences and stories are shared through listening and recording – complete with intricacies, intimacies and detail unknown and unknowable to any other. This approach presents questions which we will address in the second and third sections below. As a tool to challenge the socio-political systems of hierarchy and hegemony, what risks arise when making audible these intimacies? Is it through the attempts to simplify life stories of People of the Global Majority (POGM) in order to make them appropriate for consumption, which leads to a dimming and alteration of POGM existence?

Here, we turn to the work of Tavia Nyong'o and his consideration of afro-fabulationist performance (2018). Afro-fabulation stands as a protection where, according to Nyong'o, representationalist considerations of storied intimacies risk 'communicating and rendering overly explicit that which ought more tactically remain camouflaged' (2019, p. 5). Here, opacity becomes critical for 'endarkening'. Afro-fabulations retain the value of opacity. In a departure from Saidiya Hartman's theory of writing with critical fabulation – where storytelling and speculation is used as a means to redress omission and misinterpretation, Nyong'o specifically considers Black and Queer life-as-performance as an example of this thread of fabulation. Endarkened co-composition as a vehicle for fabulative (critical and/or afro-) work roots and routes through opacity. It has been secrecy, protection and veiling with vernacular, colloquialisms and endarkened meaning-making that has protected the vulnerabilities of Black life in and out of the diaspora.

Endarkened practice in co-composition, performance and listening seeks not to clarify or oversimplify the opacity that contributes to the sovereignty

of story within the realm of sonic environment. Such sonic environments are encountered through practices of recording in situ (or 'field recording'), which in itself contains a range of ethical dilemmas. We now discuss these through the work of Mark Peter Wright.

Listening-with, Responsibly

Field recording is a powerful and, at the same time, a fragile and partial practice riddled with complex ethical questions. Field recordings allow those behind the microphone to stretch their ears far and wide – and continue to stretch as they press play. However, harnessing such power by continuously failing to ask questions such as 'Who are we listening to, why, and to what end?', only accentuates field recording's extractive nature. In this chapter, we consider how to navigate these questions in the acts of recording, composing recording and performing, as we contextualise the practical examples presented in written form below. We interchange between the roles of the recordist, composer, performer, composer and listener while conscious of how easy it is to be unexpectedly trapped in neo-colonial processes. We opt to *listen-with responsibly*, as put forward by Mark Peter Wright, and in doing so, attempt attunement and accountability.

As Wright reminds us, '(…) colonisation and ecocide have been built from visual *and* aural cultures, with and without the use of technology' (p. 151). In an attempt to avoid (neo-) colonial processes, recent shifts in field recording practice saw a move towards inclusive ways of listening. Recordists seek kinship, honouring what is recorded and how these recordings are presented. This often means to unlearn Anglo-Western normative hierarchies and expectations of how the practice is perceived, used and conditioned in relation to the human and the non-human, but also the act of listening, recording and presenting. Furthering such processes, what mechanisms are in place to honour these often-abstract sounds, and in particular when playing back and sharing them with an audience?

By retaining opacity – leaving open to interpretation – we re-invent environments, but are we also not complicit within a hungry all-consuming and objectifying aesthetic culture (Robinson 2020)? The recordist, the composer and the performer all contribute to building narratives. But how much clarity do these processes need to speak to others? And is seeking *clarity* an ideal approach, seeing that a quest for clarity often leads to hierarchical, one-sided and oversimplified ways of understanding and representing the world?

A possible answer is a profound and critical recognition – and acceptance – of the inherent fragility and opacity found in field recording. As recordists, and as situated listeners, questioning 'What are we <u>not</u> hearing?' and 'how am I to listen?' is part of the process of how to critically press record – and then also press play.

Ethical Listening

How am I to listen to you? This question is a continual motivator for thinking about, writing on and producing in sound. As a leading practitioner in listening through soundwalking, Andra McCartney's (2016) chapter on soundwalking, intimacy and improvised listening details a working lifetime spent contending with this question. Her writing provides a useful and practical framework for addressing the issues outlined in the 'Listening-with, Responsibly' section – particularly for practice in collaborative and distributed forms.

The same question – 'how am I to listen to you?' – is also examined by philosopher Luce Irigaray. Through Irigaray's conceptualisation of love, McCartney proposes that 'a kind of listening that is open to what is not yet known and not yet coded provides a valuable theoretical model' (p. 39) for her soundwalking practice. McCartney writes that 'using Irigaray's theories of love as a theoretical model for soundwalking leads ideally to increased awareness and valuing of difference, a recognition that no one can be truly known or understood' (p. 40). This is a practical step in recognising the opacity crucial to endarkened storywork, and the critical awareness of recording highlighted by Wright.

McCartney's work emphasises listening as a creative act over being a receptive act. This attitude is underlined in soundwalks she leads, where there is a lack of delineation between performer and audience. McCartney suggests that participants on her soundwalks enact a type of *intimate listening* in combination with *improvisational listening*. *Intimate listening* strives for 'a listening that seeks understanding without objectifying, with that kind of focus and desire for a different understanding, an understanding that makes room for difference' (p. 41). She suggests such an approach requires the particular skills honed within the practice of improvisation. *Improvisational listening* should be actively open, creative, alert to the present moment and to chance. McCartney cites Ellen Waterman's definition of creative improvising as 'intersubjective and dialogic' (2008 in McCartney), which is both an ideal and a challenge when working out of real time, for example, with field recordings.

She describes a sense of opacity as 'partial knowledges'. When describing the act of soundwalking as a collective, she writes that 'our partial knowledges are partial in the sense of being only part of a whole, missing certain parts, and in the sense of being focused on what we are partial to, what we like, what draws our interest' (p. 47). This opacity is a creative act to be embraced and continually searched for in field recording, much as improvising performers do. She concludes with a hope: that ethical listening practices 'can leave space for many such moments of productive confusion and other surprises of creative listening' (p. 53).

Retrospective Disruption

As practising artists, we often engage in creative acts in order to make sense of new ways of thinking. The next section now describes three situations where the author-artists are listening-recording-performing in situ. Each recounts the act of creation, of work-in-process. We look to where practices of shared group listening and of extending our experience with microphones follow Tolliver's lead of endarkening. We retrospectively disrupt our practice and each other's narrative flow, which further enacts the idea of *endarkening*. We bracket-in opacity – a positive move away from supposed high fidelity – to include bumps, clicks, indecision and imprecision. As we listen to each other's stories, we ask ourselves and each other, after McCartney and Wright – how am I to listen to you? How partial is my listening? How might I listen-with more responsibly?

Stories of Sound and Listening, Endarkened

"Can It Be Translated into English?"

Listening-for-listening, embodied and endarkened, means listening while being actively open to opacity. Means being present in the experience, perhaps being unable to understand every word shared. Endarkening is an act to redress systemic power imbalance. This act intentionally creates a distortion in the status quo. For the secondary listener, for the recorder and for the performer, given this intentional distortion – is there the possibility of connection and empathy, without clarity?

Let's start at the end. From an excerpt of the words I shared when opening ثلاثة خيوط ذهبية (Three Gold Threads).

> *This work was meant to create a space of opacity. Where the stories of these women who faced incredible challenges could exist without the push and pull of anyone else's influence or desire for consumption. Not even mine. It was meant to honour these women and women across the globe, and even Anne Hathaway, who take on the role as family archive-holding, protecting their family history in their bones, in their hearts. Carrying them across countless miles of land, through danger and the unknown. Living archives. For their stories are exactly what they are: powerful, comedic, dramatic. They create a legacy that is yet to be seen but is undoubtedly history as we live it.*
>
> *Together, we sparked a sound archive that is rooted in the seeds of our lives- our experiences. The way our mothers told stories. The reasons we find resilience. The sounds that mark our childhoods and that guide us now. The normal, every-day occurrences that tell us we have found a home in an unknown land. These seeds of the archive are the golden*

threads that allow us to see connection among strangers. And tether us to the larger folio of the human experience.

Three Gold Threads lives three lives simultaneously: as a sound installation, a film and a memory of an exchange between strangers and friends. I didn't know what it would be. The work was commissioned by the Royal Shakespeare Company and the brief called for an artist-led, collaborative process by which Shakespeare's First Folio could be reconsidered or reframed.

I consider endarkened co-composition as this nexus route where music making and collaboration and storytelling create these socio-sonic works, holding onto the past, the present and future in pan-acoustic archives.

I've been thinking about opacity in my creative practice for a while now, especially as this idea of endarkened co-composition practice has deepened. As I co-compose with creative participants' recorded voices, maintaining the integrity of the intentions behind each word has been vital. Opacity has always been a primary driver in that commitment – instead of using the aesthetic to clarify the words, phrases, stories and sounds of creative participants, 'opacity' considers the untouched voice to be respected as whole. And further, as considered by Nyong'o, to be a defining element of the aesthetic itself.

And yet in all my thinking, I was not prepared for the challenge of this work. This work was made with and for the women who so generously shared their stories. Shared them in Arabic. Thus, any words shared in Arabic were left untranslated. Opacity as a tool of protection. It was in the first workshop that I saw how the idea of opacity (from whiteness/Englishness/Europeanness) was going to be present. After exploring Shakespeare's First Folio, reading a few of his plays that had been translated into Arabic, and visiting spaces at the RSC, we played a game of performance storytelling. Standing in a circle with a spool of gold thread in hand, I began our story, speaking the last English words of the activity: 'Once upon a time…'. I tossed the spool across the circle to another participant who continued the story in Arabic, and she passed it again. Tossing and passing the spool of thread with each new line of the story, we weaved a fable, a folklore. I think this illustrated so much – the power of a person's story as they are influenced and impacted by community, the power of collective creativity, the way individuals can create a collective narrative. Before we got far into this folklore weaving, the group coordinator, who did not speak Arabic, asked 'can it be translated into English?'

And there it was – the ask for consumption, for ease, for clarity through centring and a mutual enlightenment. Perhaps she was just interested in the story, eager to participate.

In theory, the work of endarkened co-composition is to re-centre the ways of meaning-making integral and intuitive to Black and Indigenous folks globally, but this brought theory into reality. Instead of the story being a vehicle for illustrating the centring of those telling it, translating would have re-centred

whiteness in that space, prioritised the ability for the English-speakers (myself included) to understand what we were hearing. To be able to hear something we could understand. I realised then, that my role here was to centre the creative participants that so generously shared with us, to support them in sharing their stories with little interpretive interference. To strike a balance between translation and transduction. To listen and transfer the signal of the energy, not language, into a composition that maintained that same centring.

Response 1

If listening is a learned skill, a process, then maybe *before* letting go and truly connecting, shouldn't understanding come first? Even if there are indeed moments when we can *feel a part of, a connection or empathy*, as artists, by leaving the work completely open to interpretations and making assumptions that empathy and connection is available and expected from the audience, are we not strengthening over-consumption and perpetuating colonial aesthetics?

Recording practices have a lingering weight to them. They have consistently been extractive practices, which is why perhaps words like *capture* still prevail when referring to the act of recording. They are practices wrapped perhaps in more questions than answers; regarding the relentless hungry hunt of *exotic* sounds; capitalising on the voices of others; the flare for romantic perceptions of nature; the voracious consuming appetite as an audience. When playing back, we should also accept the partiality of any creative process and invite the audience to dwell, make new meanings and extend the work. But when the creative materials derive from recordings, do we not have the responsibility to respect the recorded environments and those recorded – whomever they might be within all-encompassing spectrums of life and matter – by providing some level of *clarity*? For instance, the way that Glissand '... sponsors illuminating opacities that invite us to rethink what we take for granted ...' (Crowley 2006, p. 113).

Setting the context does not imply an automatic understanding, but suggests some level of accountability is needed. In this work, you set the context in the form of performance notes, so maybe your question could be, *once the starting point is grounded and the process is endarkened, shouldn't the audience be able to embody listening for listening?*

A Reply

Clarity can shape the experience of listening. But I'm not convinced it is a straight line from responsibility to respect to providing clarity to listening. The questions I'm hoping this work provokes are, *where POGM lives examined become lives consumed; how are the intimacies of life protected through*

sacred opacity and thus, *what happens when the experience of presence with opacity is the starting point?* You speak of the familiar voracious appetite, the drive to consume. This drive is so often fuelled by context that centres the listener, the audience, the *consumer*, rather than the story-sharer so that the experience of listening for understanding maintains importance. In this way, the accountability taken by a convening artist, or curator (or, or, or...), is to accept the opacity and invite listeners to do the same.

Response 2

I'm interested in two aspects of the way you describe this project, which seem to unsteady the common 'signal chain' found in participatory art practice. The first is how processual the work seems to be, i.e. it was the *act* of endarkened storytelling, by those participants, in that moment, which created a space for redressing the common hierarchies. There is a clarity for participants as to *where* the opacity is sited in that space, in that moment – which is perhaps what Response 1 (above) is looking for? A more enmeshed, tricky complexity arrives when transducing this experience in a tangible 'output' – a repeatable document, a (co-?) composition.

The second unsteadying aspect is the way in which the process creates a space where the act of listening is emphasised – leaned into as an action, an active force in the room, incumbent on the listener to (not) make sense of the work and entangle themselves in the complexity. The participant listener is here asked to make unexpected collaborations and connections – an invitation to join the endarkened listening process.

Vanishing Points

I spent 18 months using sound to register some of my routines.[1] Typically, I work in one place and spend as much time as possible exploring and peeling various layers of sound using multiple modes of field recording – from micro-movements to macro-movements. For this project, I am more interested in the intersections of my moving body with the moving flows around me. This is a way to further engage with how my actions impact and contribute to the tiniest of flows.

I want to be light and portable, and I am not interested in the quality of the recordings per se, but rather, on what the various recording instruments can tell me regardless of their high or low specifications. I interchange between my smartphone and a small hi-spec field recorder connected to an electromagnetic sensor or stereo microphones. I press record on the train, the metro, while walking, cooking and working. As my body moves, the sounds move with me. All together with no distinction. From London to Bristol and in-between. And again. In these sporadic actions, I intermingle with the swoosh of trains and cars, the grinding of the metro, people walking past talking or on their phones, the sizzle

of cooking, alongside the rhythmic crackles of multiple electromagnetic flows coming from close-by and far away devices. Some of them quiet, others overwhelmingly active, these signals shake my body in ways I cannot always tell. Even if I seek to register more than what stereo can offer, like any other recording process, this could never be complete. I reach further afield, but there are always missing parts. After McCartney, field recording is partial and so am I.

At home and at my desk, I open my laptop, download the recorded sounds, press play and listen back. I start constructing a narrative based on my recollection of these moments. I sketch ideas. I overlay sounds, repeat, revisit these often-intense everyday rhythms. I remember each one. Listening back is always a way to re-activate the flow from these initial encounters, don't you think? I attend to all sounds and their entanglements. Listening continues as a creative act. I edit the sounds and select what I am partial to while the documental aspect of the work slowly turns into a drift, it becomes something else.

I also think of how these ghosts of my movements and routines can dialogue with other spaces. I was invited to perform *Vanishing Points* for the first time in Belfast. It felt natural to continue situating these drifts by recording my movements while visiting the city and overlaying these recordings in the live mix – recognisable sounds such as the train station, the supermarket, St George's market and the endless undulating wind. Places and things that were also part of my everyday life when I lived in Belfast. These relatable moments reinforce the performance as an invitation and shared listening experience. But what happens when I arrive too late and the market is closed, or when the landscape welcomes you mostly with intense gusts of wind? Shouldn't these signals also matter? Do these nuances, decisions and journeys need to be clarified to the listeners during the performance or could glimpses be enough?

Following Belfast, I performed *Vanishing Points* in other cities, where I implement the same approach to recording new and familiar places and then overlaying and reimagining these recordings as improvisational gestures. *Vanishing Points* keeps evolving, time ceases to be linear, and all these movements are intertwined. The project sounds different each time as these cumulative moments converse. The electromagnetic signals persistently envelope my body as I move through different spaces and geographies, and the drift continues with no 'clarification' other than the suggestive coexistence of the various layers of sound.

Response 1

I am struck by the notion of your body as a central node within the movement you describe, particularly of the recordist wishing to be as 'light and portable' as the technology. Of course, the body *is* the (central) technology, too – for listening, operating equipment, making judgements based on audio and visual feedback during the moments of recording, and afterwards in a domestic studio setting. I'm equally taken by the notion of the act of recording

as a perpetual 'drift' (found in Loveless 2020) and of the performance opportunity being a moment to situate this drift – also a temporary occurrence.

I wonder: How much of the 'hidden' sounds, which you aim to peel back and present to a listener – will 'reveal' anything to those who didn't make the recordings, who didn't participate in those actions or have a listening experience which relates to those movements? What does one of your recording assemblages say to those who have entirely alternate sonic realities?

While endarkened practice is a shift away from privileging knowledge and meaning as defined by Euro-centric practice, the act of endarkening similarly is to honour equally the contribution of any participant-listener, artist or other listening contributor. What interests me is the crossover. For example, at a performance with recordings gathered from a variety of locations, how does audience familiarity and subsequent response affect things? If your listener suddenly realises 'I know that park/beach/room/laugh' – what changes? How am I to listen to you, in that instance?

A Reply

Listening while recording is a deeply personal experience. However, when these moments are reimagined as performances, they stop being my own. The entanglements and co-relations between the different types of recordings composed in the studio are mere suggestions of possible situations. In retaining the opacity of field recording, I embrace its multiple (mis)understandings. The performance is then an invitation where so many different narratives can come to life. I am taken by your notion of crossover and 'how am I to listen to you?'. Maybe there is not just one answer. I feel each performance serves as a conversation starter and provides context for the following ones. But I have experienced moments of 'active conversation' with those listening with me. For example, someone recognised the radio transmission of a South Africa cricket game and giggled; I giggled in return. This 'conversation' altered the dynamic of the performance, adding a convivial feel and humour.

Response 2

You ask, 'Do these nuances, decisions and journeys need to be clear to the listeners during the performance or could glimpses be enough?' Your experience of recording these sounds, ones which your body and personhood have made unique, is altogether separate from the experience of performing them. Where new sounds and sound environments are created. Where the performance becomes a site of collective presence engaging within a collapsed timeline. It is at this site where clarity becomes a factor to interrogate. As I, too, am wondering about these 'hidden' sounds, perhaps your own experience within the opacity of quiet markets and whooshing wind is something to be

reflected. Rather than succumbing to the drive to simplify and make consumable your own experience, I wonder where you are making space for the indiscernible and unsuspecting intensity?

I continue to wonder, here, where are you in this? Are you solely in the sounds of the recorder flicking on and off? Are you only in the footsteps closest to the field recorder? I wonder about echolocation…

A Reply

I am entangled and present in every step of the process. I am in the electromagnetic pulses of the digital devices I use; in my voice as I record a conversation with my partner over what to prepare for lunch; in my footsteps and in the way I frame the (vague) narrative. I am in the studio where I re-live and re-frame these moments and more importantly to me perhaps, in the improvisatory gestures of overlaying and processing the new recordings in conversation with the original ones on each live performance.

Space also plays an important role as in each performance I consider, explore, react and softly play with the materiality of the architecture of the venue. Echolocation could be a way to think about this because I am also sensing the space; the echoes of what is around me and the information these echoes entail. I find it more useful to use the idea of attunement in thinking about this work because I am with more than just the space. I am with those listening with me while transducing and sharing my previous experiences. I am also inevitably in all the multiple new spaces and geographies I create with these cumulative conversations. This can be either in connections I make by how sounds are overlaid – or which sounds – or by how they are processed. This is a drift. There are moments of clarity and moments of opacity, and they may be different each time and have different meanings, for myself and those listening with me.

Squatting on a Rock

I am squatting on a rock at low tide, eyes closed, listening through my headphones to the sound of two hydrophones gurgling and clicking in shallow seawater. I also hear the same microphones banging and grating against the rock, producing a much more distorted and louder sound on occasion. I shift position occasionally, mainly to keep the blood flowing through my legs to my feet. I create handling noise by disturbing the cables in the process of changing position. I wonder, in my mediated listening through apparatus, am I bracketing-out such 'noisy' happenstance occurrences, only aiming for a 'hi-fi' recording? Eyes closed, trying to focus, I concentrate on the interaction and tiny differences between the sounds played back into my left and right ears, the push-pull flow of the waves phasing between a 'left' and 'right' constructed by the technological mediation. Time passes.

I look up, back towards the beach. I suddenly realise that there is much more water between my position and the shore. I'm forced to remove my shoes and socks, roll my trousers as high as I can up towards my knees, and hold my equipment high as I wade back to land. Drying off in the breezy Spring sunshine, I record a spoken account of the event in situ, laughing at my own stupidity and searching to articulate why I'd got myself in such a ridiculous position in the first place. Was I 'listening-with' with the situation, or listening despite it, in a vacuum?

In the studio, I'm still searching. I play back the recordings in full – fumbling, distortion, clicks, gurgles. I'm listening again and also responding in sound by improvising with analogue electronics – synthesisers, drum machines, effects units. I'm perhaps trying to channel a visceral response to my experience – documented only in sound, but recorded personally with a keen sense of having been there in body and spirit – by allowing my nervous system to take over in the control of the electronic instruments. The Wet/Dry description of effects makes me smile as I work.

Much later, a section of this improvised, one-take mixture of field and studio is included in a commercial solo album release. The final edited version includes some masked words of spoken introduction but is devoid of any context. The decision not to provide detail was a conscious one – on reflection, an endarkened response – to allow the mediated, abstracted sound communicate where possible to any interested listener. I'm still never quite sure if the listener would wish to know any more context or detail, including that I waded from rock to shore to save myself, my microphones and my recording device.

Response 1

Field recording is not in any shape a clear-cut practice. Recordings do not appear tidy on a laptop through a wonderfully pristine and technologically mediated process. It is just messy, and at times awkward. Each recording holds echoes of a unique experience, and there are multiple stories behind each one. Not all are as eventful and comedic as yours, but still, there is always a story. But recordings are never just one thing. They encapsulate much more than just one perspective. It is wonderful to read yours here and try to retrace the consequence of letting go and experiencing this moment. Perhaps listeners would like to hear about this as well, but the sounds and the editing process took you somewhere slightly different. You are still telling the story. Maybe I would venture saying that you are not erasing the moment, simply tweaking and presenting other aspects of this experience. A creative output should not only respect the recorded contents but also allow space for its various components to speak and take you in unexpected directions. My work has strong documentary characteristics, so I tend to provide clues to the stories and the making-of process either in the composition or on the programme notes. But this particular work is not documentary, the intentions are different, and this is key, right?

A Reply

You've articulated my entire dilemma here. Is the creative output – not intended to be documentary, or explicitly auto-ethnographic – evocative and inviting enough for a listener to engage with and find their own story within? Or does this approach avoid the more difficult, potentially extractivist aspect to my seaside field recordings? What *was* I really aiming to do there on the beach, I ask myself in retrospect? Was my decision to include the 'lo-fi' bumps, clicks and shuffling a way to relieve myself of some of the difficult answers regarding my presence there in the first place? Or providing an invitation for both myself and others to interrogate our 'listening-with' the environments we inhabit – both studio and exterior. I should probably record myself working in the studio as equally as I aim to be reflexive in 'the field'. Both are sites of action, decision-making and power.

Response 2

I am struck by your practice of staying with the unknown. In key moments, from the hydrophone meeting a rock, to the sounds of your human interference, you relished in the moments of uncertainty. Perhaps a key feature of field recording as a practice already, but worth noting as we explore endarkening in sound and listening.

Your story brings up the juxtaposition of choreography and improvisation as we seek to inhabit an opaque sound world. The choreography of intentionally placing microphones and the improvisation of audibly chuckling at one's physical position. The choreography of listening and the improvisation of responding.

I think while we are intending to step back from a position of knowledge authority as artists, we are instead allowing the sounds as recorded and our responses that those sounds communicate. An act of trusting the listener while also challenging them to inhabit the opacity.

A Reply

The word 'choreography' is so useful in this context – it's really all a performance, especially as soon as the sound artist hits the record button. Something changes when that happens – it's not just extended listening through microphones anymore, but a type of performance, even if alone. The aspect of inviting a listener to participate in that performance after the fact, through playback of a recording, does indeed require trust – a two-way act. As well as the artists trusting the listener to come to their sound and inhabit it actively, the listener trusts the artist in their re-presentation of an opaque performative recording act. How much of this re-presentation has been edited in post-production? Does that matter, if we're embracing opacity?

Conclusion

Many complexities, nuances and opacities of the thought- and work-as-process behind creative sound practices are not readily available for listeners through repeatable audio artwork. In this chapter, we show the benefits of continually negotiating and foregrounding these complexities, nuances and opacities, through multi-modal reflections on the act of recording. We acknowledge endarkened practice and its theoretical origins in critical Black Feminism and Indigenous storytelling methodology: an interdisciplinary practice positioned both against colonial hierarchical hegemony and outside of the system entirely (Dillard & Bell 2011, Toliver 2021). We have described interchanging roles between performer, recordist, composer and listener in the facilitation of creative work, recognising recurrent hierarchies that are commonly accepted as part of such processes. We propose that making work as an effort to become endarkened is a positive intervention. We suggest that to maintain a level of opacity may communicate the nuances of a sonic experience more accurately than clarity for consumption's sake.

Exploring endarkenment and endarkening reframes the site of listening. ثلاثة خيوط ذهبية (Three Gold Threads), situates listeners in a space where the pull and push of exposure and protection, familiarity, transduction, opacity and clarity created a site of endarkenment that relies on relationship and trust. In *Vanishing Points*, field recording offers a partial glimpse into how the artist's body entangles with the multiple scales of the spaces that surround them, and through caring gestures, they connect and attune to a web of relations – a creative and improvisational listening process. Retroactively examining the experience of *Squatting on a Rock* reveals endarkened aspects embodied and embedded within field and studio practices. Exploring the intricacies, intimacies and detail previously known only to the artist yet available to a listener through storytelling – in effect presenting this 'behind-the-scenes' event as a performance – questions the balance of opacity/clarity within the resulting creative sound work.

A question of access still emerges, however – what does a listener need access to, to experience a connection? While the co-composing and field recording processes for these projects have concluded, recurring sites of endarkenment emerge in the opportunities for listeners, viewers and even passers-by to accept an invitation towards uncertainty, and to resist the urge to find clarity in the consumption of artefact. In the situated performance moments that follow these events, the artist-performers invite others to co-listen and share these journeys, embracing the opacity of field recording and its multiple (mis)understandings.

Rather than performance, composition and critical writing providing a 'clarification' of an endarkened process, these modalities offer an invitation to join the artists and participants, and to sit with the opacity – an acceptance of multiplicity of meaning. This chapter does not clarify such processes, but in revisiting them, may provide new insight and meaning. In staying with uncertainty, we drift, and invite those listening with us to join.

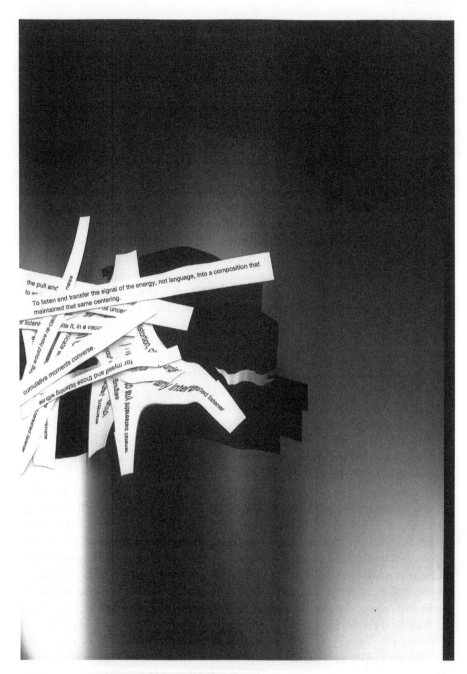

FIGURE 9.1 A score for endarkened listening.

Note

1 The album *Vanishing Points* (2022) was an output of the ERC research project *Sonorous Cities: Towards a Sonic Urbanism* (grant agreement No 865032)

References

Crowley, P. (2006). Édouard Glissant: Resistance and *Opacité*. *Romance Studies*, 24(2), (pp. 105–115). https://doi.org/10.1179/174581506x120073

Dillard, C. B. (2000). The Substance of Things Hoped for, the Evidence of Things Not Seen: Examining an Endarkened Feminist Epistemology in Educational Research and Leadership. *International Journal of Qualitative Studies in Education*, 13(6), (pp. 661–681). https://doi.org/10.1080/09518390050211565

Dillard, C. B., & Bell, C. (2011). Endarkened Feminism and Sacred Praxis: Troubling (Auto) Ethnography through Critical Engagements with African Indigenous Knowledges. *Counterpoints*, 379, (pp. 337–349). https://www.jstor.org/stable/42980906

Gre, L. (2024). Co-Writing a Hymn for Liberation. In E. Johnson-Williams, & P. Burnett (Eds.), *Hymns and Constructions of Race*. Taylor & Francis Group. eBook ISBN: 9781003356677-8

Hartman, S. (2008). Venus in Two Acts. *Small Axe: A Caribbean Journal of Criticism*, 12(2), (pp. 1–14). https://doi.org/10.1215/-12-2-1

Loveless, S. (2020). Tactical Soundwalking in the City: A Feminist Turn from Eye to Ear. *Leonardo Music Journal*, 30, (pp. 99–103). https://doi.org/10.1162/lmj_a_01100

McCartney, A. (2016). How Am I to Listen to You?: Soundwalking, Intimacy, and Improvised Listening. In G. Siddall & E. Waterman (Eds.), *Negotiated Moments: Improvisation, Sound, and Subjectivity*. Durham, NC: Duke University Press, (pp. 37–54). https://doi.org/10.1215/9780822374497-003

Meireles, M. (2022). *Vanishing Points* [solo album]. Porto: Crónica Electrónica (Aug 22). https://cronica.bandcamp.com/album/vanishing-points

Nyong'o, T. (2018). *Afro-Fabulations: The Queer Drama of Black Life*. New York: New York University Press. https://doi.org/10.18574/nyu/9781479856275.001.0001

Robinson, D. (2020). *Hungry Listening: Resonant Theory for Indigenous Sound Studies*. Minneapolis: University of Minnesota Press. https://doi.org/10.5749/j.ctvzpv6bb

Toliver, S. R. (2021). *Recovering Black Storytelling in Qualitative Research: Endarkened Storywork* (1st ed.). New York: Routledge. https://doi.org/10.4324/9781003159285

Wright, M. P. (2022). *Listening After Nature: Field Recording, Ecology, Critical Practice*. New York: Bloomsbury Academic. https://doi.org/10.5040/9781501354540

10
AMPLIFIED STATES

Listening as Coming to Know

jake moore and Mark Peter Wright

This chapter considers apparatus as a meshwork – mediating technologies, bodies, and vocality – of agential relationships. We follow Karen Barad's (2007) lead in acknowledging that neither the mechanical tools used in practice nor the embodied situations of those who grip them are ever neutral. Instead, the adaptive transformation of any apparatus reveals an ongoing set of relations and performative possibilities through the invisible architectures that gird them. Examining the act of sound recording, and its inherent displacement of experience through temporal, spatial, and material means, we unfold these relations and propose listening as a kind of touch. What has one altered in the desire to still or replicate experience? Where and when is the listener located upon entering an amplified state? What hybrid fields are produced in the act of transducing worlds? Furthermore, what possibilities for reciprocity through attunement can ensure the touch of listening is *consensual*, i.e., felt together, rather than an extractive process or amplification of existing power relations. The authors thread these questions with their own situated examples of recording through embodied reflections and critical dialogues. In doing so, this chapter proposes a generative fourth space for listening: a non-linear, sono-materiality of multiple dimensions and a way of coming to know (Cajete, 2000; Ghouse & Holmes, 2022).

Introduction: Transception, Transduction, Transcorporeality

In his germinal work, *The Audible Past*, Jonathan Sterne (2003: 96) asserts that "Hearing is a necessary precondition for listening, but the two are not at all the same thing." This parsing out of passive reception from near simultaneous action offers up the relationality required for reception while hinting

DOI: 10.4324/9781003348528-15

at the myriad agential operations that allow for listening to come into being. Moving past the ableist convention that hearing is audition in order to return to its sensorial ground, we look to Professor of Auditory Neuroscience, Chris Plack's (2005) definition of hearing as the ability to perceive sounds through an organ by detecting vibrations as periodic changes in the pressure of a surrounding medium. We must, then, also consider which organ(s), moving from the expected ear to the haptic reception of the skin, and in which bodies and with what distinct capacities these finitudes might possess. This refining is not seeking relativism, but is instead an articulation of the critical listening positionality put forward by Stó:lō scholar, Dylan Robinson (2020), questioning the one-to-one formation of organ and sense proposed since the Enlightenment that has reduced human senses to only five, and suggested a sixth to be somehow in excess, pathologic, or supernatural.

Not-knowing so that one might come-to-know, manifests the relational and co-constitutional nature of listening. This identification of the complexities that establish a transcorporeality – a term we unpack shortly – of listening is a necessary mapping that continues to evolve and holds indeterminacy as critical to its formation. Transception is the capacity to both send and receive signals of any form. Signal transduction is the action or process of converting something and especially energy or a message into another form well understood by audio recordists everywhere. Transduction without the modification of the term signal, in accordance with the OED, is (1) the transfer of genetic material from one bacterial cell to another by means of a bacteriophage; (2) the conversion of stimuli detected in the receptor cells into electric impulses, which are transported by the nervous system. This intertwining of bodies, epigenetics, signals, and transformation defines the transcorporeality inherent in listening. Beginning with feminist materialist, Stacy Alaimo's (2018: 435) coining, "Trans-corporeality means that all creatures, as embodied beings, are intermeshed with the dynamic, material world, which crosses through them, transforms them, and is transformed by them." Transcorporeality has since extended understandings of what a body might be, it now "pertains to fluidity between material and theoretical bodies, challenging dualities and dichotomies. Transcorporeality assumes inter- and intra-connections, intra-actions, entanglements and transits between human and other-than-human bodies" (Fejzic, 2020: 529).

Writing together/apart requires generosity in both the sense of kindness and plenitude. We have offered what we have come to know and just how we have come to this state through doing and reflecting. We have each arrived through specific methodologies and ways of working: Mark as an artist researcher who works at the intersection of sound arts, experimental pedagogy, and critical theory informed by the methodology of field recording, and jake as an artist/researcher whose primary medium is space, its production and occupation through a material praxis of exhibition, text, and

sound. To establish apparatus as a meshwork, we write the warp and weft of our own intra-action to come. This weaving together takes the form of responsive writing and retelling of independent experiences of acute listening activated by the preconditions of recording. These amplified states simultaneously inflate and breech the recorded moment; they connect to a multitude of spatio-temporal, somatic, and cognitive sites. As writers, we situate ourselves otherwise, as respondents rather than activating the argumentation required for the traditional territorializing of academic writing. This dialogic approach is still deeply spatial, but it does not establish occupation of any one site, instead it enacts the methodologies required to lay bare the transcorporeality of listening, the invisible architectures that define our capacities to receive, and the fluidity required to come to know. We begin with records #1 and #2 that lay the threads for a third section, where we braid our way towards the fourth space of listening.

Record #1: The Warp, Listening to Stones

The recording began long before I pressed record. I was located between marram grass and Europe's second largest blast furnace, my focus drawn to the machinations of industry enmeshed within a site of biodiversity. Creaking knees and back pain registered physically and mentally. Sand covered my feet. In the hum of modernity, I noticed what sounded like pebbles being knocked together. The sonorous materiality reminded me of a Newton's Cradle, a structure where silver metallic spheres are hung and one end of the line is pulled apart and released, activating the pendulum of objects back and forth in a clicking motion. Newton's Cradle is dependent on one sphere transmitting a sonic wave to another, which affects the next.

Grounding these associations, in the field, among the marram grass, I turned my attention to the sound occurring in the time and space before me. Kneeling, I placed my headphones on, positioned the microphone, and pressed record.

It wasn't long before I could hear the sound again. A frail signal transmitted through the air. It had a rougher timbre than my preceding audition suggested, a quality I would liken to clearing one's throat. But it still recalled that same momentum of small pebbles knocking into one another, smoothing and sparking in an incessant back and forth. These sonic associations were soon pierced by the physical appearance of a small bird, impossibly perched on the thin end of a reed. It was reminiscent of a Robin but with a dark head and orange tinge to its front.

I moved the microphone, clunking and crunching myself into a more comfortable position. Amplified, the bird's call vibrated the air, ran down cables, filtered through the microphone's diaphragm, conducted copper coil, and passed through sample rates before rattling between my ears. Newton's

Cradle was well and truly activated, it was inside my skull and provided an effect that both placed and displaced. The former, through its metronome like quality; reliable, grounding; synchronizing the here and now. The latter, from being thrown into the total sensation of the event, the sirens, and mechanical energies of the blast furnace, the hum of shipping containers entering the mouth of the river. Local and global scales dizzied my listening. Where are we in that recorded moment, that amplified state? When are we?

Commonly, amplification involves dialing up or boosting a signal. Another way to think of it is as a technical attunement, a form of focus akin to a visual zoom. We tend to concentrate amplification efforts on the source or subject being recorded or played back. Amplification helps me to hear the bird with more volume, in the field. It also helps me audition sound at appropriate levels in the studio. Amplifying something shows decision-making, even prejudice: one thing is heard over another. But what of amplification's effect on me, the recordist and listener. Where am I in the dialing up of sensory signals and signs? Surely, I too become an amplified agent caught somewhere among the hiss of gain. And what of the space I am in and the one that I imagine, as Salomé Voegelin (2011) evokes: the place of my listening and the place my listening makes.

Angus Carlyle (2022) frames the amplified state of recording, in the field, as a mode of 'cortisol listening.' This pulls in a biological level of introspection to merely turning up the volume. Cortisol is a stress hormone released in the body. Located at the top of the kidneys, these glands regulate blood pressure and metabolic efficiencies among other things. For Carlyle, amplification might involve the body not just on a phenomenological level but also on a molecular plane. This adds another scale to the strata of amplified affects, from the bird's call to the surrounding environmental events, to the pulse of veins and organs, listening passes through a plethora of cultural, spatial, somatic, physiological, and technical gates.

Carlyle's practice explores environments and atmospheres as embodiments of stress and relief, which dovetail well with the notion of cortisol listening. The point being that stress, adrenalin, and pressure, in the air or body, do not reside in the listener-recordist alone; these forces ebb back and forth through the porous skins of site and self. The listening-body and listening-place is a reciprocal relationship, they are not mutually exclusive or separate entities. Pauline Oliveros (2022: 30) reminds us, "what is heard is changed by listening and changes the listener."

What else is being turned up? What is being masked? The prosthetic apparatus of listening – microphones, recorders, SD cards, batteries – are silent yet central to the intimate and distant effects of recording, of being placed and displaced. They are masked in the fight to boost signal. The aim, often, is to silence technology and reduce so-called noise. But noisy knowledge persists. We do not hear Chuquicamata, where the world's largest volume of

copper is extracted in northern Chile; we do not hear the Mount Weld mine of Southern Australia where rare earth minerals such as neodymium, the magnets inside microphones and digital devices come from; we do not hear the health effects on environments and communities in the e-waste sites of Agbogbloshie, Ghana. And yet, as I have written previously (2023), these signals persist, they connect tacitly to both the listening event and the scene of playback. A kind of multiple exposure that haunts all signals. The task is to remember that the unheard or minor details matter, and that material and epistemological artefacts, if noticed, can help to amplify routes/roots elsewhere.

Media philosopher John Durham Peters makes clear that "events have always been happening at the same time" (2020: 29). In his essay "A Cornucopia of Meanwhiles," Peters articulates that there are more things occurring in time and space than what we know. He calls this encompassing and multi-scalar reality 'oblivious simultaneity' and takes on the challenging task of asking whether such multiplicity can be noticed and even harnessed. To do so, Peters explores ancient examples from literature. He seeks out tools and devices that scaffold 'meanwhile structures,' which collapse time and space, or perhaps more accurately, open other spaces. Meanwhile, structures are "techniques for shuttling between two points in time that are too far apart for the unaided human senses" (30). One of the most common tropes for simultaneous narratives in literature is found in the phrase 'meanwhile in...' Newspapers are a typical site for meanwhile structures where an abundance of different events share the same timestamped print date.

Peters' emphasis on techniques, as well the limits of the human senses, sets off another thought experiment for sound recording. Might a close inspection of the apparatus-in-process provide a meanwhile structure? Recording in stereo suggests this line of enquiry can be followed, a little longer at least. When recording in stereo, two separate channels, a left and right are opened. Each simultaneously records the environment, yet each has a distinct perspective different to the other. In a classic X-Y pattern those two channels meet to create a three-dimensional stereo image, but perhaps there are fourth, fifth, and many more dimensions opened in that confluence of signals. Stereo recording might be a micro-technique for shuttling. The auditory scene, along with its artefactual captures and resonances, provides trace evidence of meanwhile structures: materials, people, and cartographies near and far. These materials and mediations are littered in recordings and are often inaudible or on the edges of perception. Within the grip of plastic, the movement of body, wind, and breath reside noisy clues that other agencies and events occur simultaneously: meanwhile the sound of the recordist, meanwhile the impact of natural resource extraction, meanwhile a damaged lung, meanwhile the sounds and unsounds of production lines, adrenalin, infra, and ultrasound. And let's not forget about the meanwhiles of the mind. I have often caught myself thinking

of an elsewhere while being in a specific location recording. The example of the bird, here, transported me to a small structure usually placed on a table or office shelf. I have never owned a Newton's Cradle and yet somehow, within the marram grass I was transported to it. Perhaps this is what Einstein called 'spooky action at a distance,' when, in the field of quantum physics, one particle can know something about another even when those particles are separated.

Quantum physicist Karen Barad's feminist approach to the apparatus of science teaches us that technologies are neither passive nor neutral tools. Rather than fixing time and space they "iteratively reconfigure spacetimematter as part of the ongoing dynamism of becoming" (Barad, 2007: 142). Barad's notion of intra-action in which human and nonhuman forces are inseparable, helps to shift the recorded, amplified encounter into a kaleidoscopic experience, not a zone of one-way extraction but an active milieu where humans, animals, space, and technology bend time and reorient our ethical relationship to the world. Within that revelation the spheres of Newton's Cradle, evoked by the bird's call, become knotted as forces dynamically intersect the linear conception of causality.

Meanwhile, I discovered the bird in question was called a Stone Chat, named due to its vocal signature said to evoke the sound of two stones being struck.

Record #2: The Weft, Vivian Viva Vive

It was a short message. Voice mail. Twenty-three seconds (or is that long?). A woman's voice in warm, metered, speech. It was delivered with a cadence and timbre I know deeply, yet, in these 23 seconds, its grain was new to me. The grain of the voice identified by Barthes (1977) has been explained by Rebecca Lentjes (2017) thus, the grain

> is the body in the voice as it sings, the hand as it writes, the limb as it performs. The 'grain' is more than timbre, it is the language of sound supplementing the language of sense; the summoning not only of a body but of some sort of ineffable essence bound to the effability of language.

In these 23 seconds, the grain of Vivian's voice is pronounced. Its assertion is the difference between this phone message recording and the many other recordings I have heard or produced of this voice. This time, its grain, (her voice) expresses *my* feelings, *my* state. It is now the voice of hearing.

Meanwhile, in the basement of a mid-century bungalow overlooking the Wakaw Valley in Moose Jaw, Saskatchewan, three people and a large golden retriever gather in strange relation. One woman, Vivian Darroch-Lozowski, the source of the voice referred to above, sits in an upholstered armchair

holding a small book. She is equally framed and caged by the carefully delineated wires that lead up to the chair, wind round metallic articulating stands, and connect into two microphones. At their opposite end is the interface bringing the signal into digital notation. Steve Bates receives this direct input from three sources: Vivian, a Josephson C42, and a Beyerdynamic M88. The microphones selected are appropriate for studio recording and a technical specificity necessary when considering the mediation of sound into object vis-à-vis recording, as well as the myriad transformations that occurred in our act of making a record of Vivian's voice.

I am the inbetween of them all, facing Vivian, her chair, and the microphones directly, with a small table that holds both pages of her 1984 book, *Voice of Hearing* in its recent re-release, and my laptop that shares with me a digital copy of the original version of the book. I mediate between the two texts, the reader Vivian, and the recordist, Steve Bates.

We, Steve Bates and I, as *The Dim Coast*, are here to record Vivian for an audio version of the book. He is wearing headphones; I am open-eared. I flag dropped words, question the distinction between the two versions, and point out the difference between what Vivian brings into audition and what language sits on the page. More than once she determines a subtle shift to what has been printed in either version, stating, "this is what I meant."

Very quickly we move from her ventriloquizing the text within a controlled acoustic environment understood as studio, into a kind of field described by John Grzinich (2016) as "an open system where sound cannot be controlled but rather explored and contributed to." The intentionality of the space and its production has been altered: it has transformed with and through the standard application of recording processes that are defined spatially, engaging volumes, geographies, and cartographies. Mechanical processes like transduction are characterized as not only spatial but moving: from the Latin transducer, *to lead across, transfer*, transduction "names how sound changes as it traverses media, as it undergoes [...] both its matter and meaning" (Helmreich, 2015: 222).

This becoming-field bumps up against the schizophonia of R. Murray Schafer (1994: 88) that identifies "sound as severed from its sources"... "split between an original sound and its electroacoustic reproduction" that is enabled by sound-reproduction technologies. Sterne (2003: 20) observes that "(t)he Greek prefix schizo- means "split" and has a convenient connotation of "psychological aberration" for these authors" suggesting that the displacement of sound from source through recording is party to the pathological. Stanyek and Piekut, propose a complete replacement for the term with *rhizophonia,* which "describes the fundamentally fragmented yet proliferative condition of sound reproduction and recording, where sounds and bodies are constantly dislocated, relocated, and co-located in temporary aural configurations" (Stanyek & Piekut, 2010: 19). Their portemanteau of

rhizome and phonia seeks to establish the generative and constitutive nature of recording and the hybrid fields of indeterminacy it might produce articulated by Vivienne Bezoluk so eloquently vis-à-vis Barad: "There are no independently existing entities with determinate and discrete boundaries and properties. Rather, entities or identities are performed and come into being through particular material arrangements" (Bozalek, 2022).

I acknowledge that neither term is fully lacking nor truly adequate. There is little utility in writing over someone or other acts of erasure that serve to reclaim authorial space, instead, there is opportunity in engagement to thicken the discourse, to come to know. This too is an act of listening. While Stanyek and Piekut claim that schizophonia is merely stating the obvious, Sterne identifies the psychological affect, inherent in the term *schizophonia*, that points to an eerie netherworld between source and sound in a deeply Western way that finds discomfort in the creation of emergent ontologies. Both schizo and rhizo fruitfully suggest indeterminacy. One suggests an unsettling response to possible beings that present as energy, spectre, or even perhaps manifest as physical yet are mutable, the other identifies contact as necessary to growth and an ever-expanding origin or ecology. Rhizophonia draws from the biological formation of knowledge popularized by Deleuze and Guattari in *Mille Plateaux* (1987) that operated under the principles of connection and heterogeneity, multiplicity, and asignifying rupture. These principles, assembled in the online Oxford reference, postulates that the "rhizome is not a metaphor for something else (such as modes of social organization), but it is a concept which aims to offer a more radical understanding of ontological processes as dynamic and mutating assemblages (Oxford Reference)."

This metamorphic understanding is key when describing, as we wish to, how voice becomes phenomenon, meaning that in this figuration it can shift in form determined by our chosen method of reception, i.e., becoming wave in recording, becoming particle in measure of its effect in space or other beings. Listening, and recording then, become a method of measure, a means of establishing the form of something else, in so doing we will have touched it.

Braiding and Coming to Know

In our acts of recording, we attune to sonic phenomena that become topological in how they both inform and transform space. The voices we have identified, whether Stone Chat or Vivian, are made of that moment within the *apparatus as meshwork* where individuation occurs, and entity forms with the kind of boundary determination Barad ascribes to the apparatus, while still understanding that boundaries themselves are co-constituted. Stone Chat and Vivian become voice in our recognition of them as ontological and agential, though each were already there and fully formed. We have now come to know them.

Refusing discovery in place of the participatory, temporal, and relational process of coming to know is rooted in the Indigenous science of the First Peoples of Turtle Island. The continent now known as North America is named Turtle Island by many of its original inhabitants. Place names are indicative of world view, or world sense in a more contemporary understanding that does not privilege sight as the primary method of interpreting the world. 'Turtle Island' is drawn from the origin narrative of human species arrival on earth told across the continent. 'North America' was coined as an honorific to Italian explorer Amerigo Vespucci, a name equally evident of world view for the colonial praxis that imagines the land as passive, unoccupied, and discoverable. When we choose our language we are indicating our worldview. To use the name Turtle Island is, therefore, a recognition of another simultaneity or meanwhile structure.

In his book, *Native Science: Natural Laws of Interdependence*, Gregory Cajete (2000) shares how coming to know is a process of participation and reciprocity. To receive something or someone that does not merely reflect ourselves back, requires an attunement made possible through radical openness. It demands great vulnerability in unlearning knowledge as a form of consumption and instead posits that we must arrive at encounter as metabolic exchange. We must understand listening then as an active and chosen gesture towards one another, a form of reciprocal penetration, and ultimately a form of touch. In this form, we then must also consider the ethics of our contact and what form might consent take when we listen in.

We suggest attempting to speak nearby and otherwise (Chen, 1992) and understand that our actions of recording, replaying, and resituating experience are ways of theorizing the world in awareness of its liveness, activation of uncertainty, and overt demonstration of one's positionality at a molecular level. In this way, the meanwhile structures that scaffold simultaneity in ways that inform the grain of any voice begin to make them palpable.

Exploring voice and technics, Dominic Pettman (2017) establishes the term 'Vox Mundi,' as the ecological voice of the earth. It is not a harmonious or holistic voice Pettman offers due to the state of climate and political emergencies, but instead a conglomeration of soundings that bite, beep, sing, and squeal. These are human, creaturely, and technological agents. Whether it's the voice of Vivian, a Stone Chat, offshore drilling, a supermarket scanner, or the click of a phone, Pettman's overarching point, which imposes a planetary limit, is that hearing the cacophonous voice of a world thus defined can help forge intimacy and care. In the case of sound recording, intimacy arrives as part of an amplified state, hardwired into headphones and cables we shift closer to all manner of things. Recording acknowledges human sensorial lack to enact a breach into a fourth space through its heightened condition: the field becomes more-than human while still tethered to us, it becomes a space of address and requires consensual consideration.

Here, it becomes useful to think through the human experience of touch. What we believe to be contact is the experience of repulsion as the electrons composing either composite entity refuse one another to confirm that another is there. The closer we come to something the stronger the force of electromagnetic repulsion is. This charged proximity defines us and it is this haptic and simultaneous understanding of not being alone as well as more convinced of our boundaries that allow for intrarelation to begin. It is exceptionally useful to think about the experience of touch through scientific terms. While much labour is extended to build separation between the perceived/desired rationality of science and the incoherence of affect and embodiment, "touch is the primary concern of physics. Its entire history can be understood as a struggle to articulate what touch entails" (Barad, 2012b: 208).

Touch or contact? As new forms present, listening becomes a form of touch. We identify entities through their refusal of our own passing through or over. In the reordering of time and space enacted by recording, emergent agencies refuse to stay still. In the transduction of recording we are reminded of the force of transception, the doubling of tasks to both send and receive, and how the electromagnetic field of recording is itself a form of measurement. In our definition of voice as a phenomenon, we recognize the boundary-drawing practices of apparatuses as described by Barad yet this recognition of boundaries of entities is a necessary ontological step – one that mutates and shifts within the behaviours of sonic material and our methods of measure.

Conclusion

Werner Heisenberg's uncertainty principle states that we cannot know both the position and speed of a particle, such as a photon or electron, with perfect accuracy; the more we nail down the particle's position, the less we know about its speed and vice versa. The waves of energy received as light differ from the waves of sound that transmit energy through shifting motions of particles. This relational engagement of particle to particle allows the wave to travel, entities such as waves and particles do not have inherent properties and are not bounded entities, the objective referent for concepts such as waves and particles is what he calls 'phenomenon.'

The voice, like many quantum phenomena, can at once be particle or wave, it is active and fully agential until the moment of measurement at which point its behaviour shifts to reflect the metric of measure. To propose the voice as quanta is not to undermine its complexity nor limit its potential. It is an essential valourization that asserts its structural necessity. Quanta names something that can be measured. The act of recording makes this fact evident. Voice or vocality is not necessarily audible, nor even discernible by those not yet prepared to receive it, yet it is there. We say 'prepared' in unison

with Noë's (2008: 1) claim that "(p)erception is not something that happens to us it is something that we do" and that

> The world makes itself available to the perceiver through physical movement and interaction [...] all perception is touch-like in this way: Perceptual experience acquires content thanks to our possession of bodily skills. What we perceive is determined by what we do (or what we know how to do); it is determined by what we do.

When the percussive sound of stones clicking is revealed as birdsong, we question many things, both conservative ideas of the melodic nature of 'song' and the beauty associated with birds, but also how the Stone Chat ventriloquizes the sounds of rocks. The amplification of these amplified states is not only to make larger or greater (as in importance, or intensity), but also increase in number. This takes into account the 'oblivious simultaneity' of John Durham Peters' 'meanwhiles' as well as the phenomenon of vocality that is touched when we listen. When we touch it in this way, we still it, if only for a moment. The entanglement of phenomena across the universes is interrupted, the spooky action at a distance becomes the warmth of proximity as we acknowledge another being in the aether.

This metamorphic understanding is key when describing, as we wish to, how voice becomes phenomenon, meaning that in this figuration it can shift in form determined by our chosen method of reception, i.e., becoming wave in recording, becoming particle in measure of its effect in space or other beings. Listening and recording, then, become a plural method of measure, a means of establishing the form of something else, in so doing we will have touched it.

Apparatus are a meshwork of technologies, bodies, space, and time that transform the polyvocal signatures of humans, animals, and environments. Hence, microphones do not necessarily freeze a subject or capture the so-called signal alone. To release the blinking red button, to record and enter an amplified state, mediates simultaneous meanwhiles that offer up methods of coming to know. The performativity of encounter and apparatus ensure the field's mutable and contingent status. A recording might, therefore, be a measure of something, but it is also more-than. It offers a glimpse into the actions and agents – human, animal, technological – embroiled in the sympoiesis (Haraway, 2016) of making, of touching and being touched in listening. Barad makes clear:

> Measurements are agential practices, which are not simply revelatory but performative: they help constitute and are a constitutive part of what is being measured. In other words, measurements are intra-actions (not interactions): the agencies of observation are inseparable from that which is observed.
>
> *(2012: 6)*

Re-cord and re-play are conditions for reordering and re-enactment that are altered by our touch and co-presence. Engaging in this now theoretical space, unbounded by the actualities of its moment in the time of occurrence, allows for perhaps a different outcome, one that consequently suggests, instead, a justice-to-come (Barad, 2012). Making immanence (à venir/to come) present in the apparatus of reception is the practice of spatialization of thinking that Barad, among others, deploys. It is Barad's placement of seemingly disparate arenas of thought in direct contact (i.e., the scientific engagement of Neils Bohr, Heisenberg, the philosophic and theoretical worlding of Derrida, Lyotard, Haraway) that demonstrates the praxis of coming to know and other methods of mattering. This is not a linear or disciplined development, but an active, ongoing, and immanent relation.

Meanwhile, the sound of the recordist, meanwhile the impact of natural resource extraction, meanwhile a damaged lung, meanwhile the sounds and unsounds of production lines, adrenalin, infra, and ultrasound. Meanwhile, in Saskatoon, Saskatchewan, Canada it is −42°C, 9:29 am. Press send for near instant arrival in 4°C, London, UK, 3:34 pm.

Amplified States: A Score

jake moore

Raven Chacon, Off-tone.[1]

No re-presentation can fully equate any other modality. Regardless of the method of remediation, the object of origin, whether text, image, language, or other material, will have lost certain characteristics and content while simultaneously accruing others. This seemingly obvious observation is often refused in acts of translation or transmogrification that do not reflect the receiver or those that have requested the transformation to take place. This score will not render equivalent the conversation of our essay form, though it may thicken its presence and potential. It creates a new meanwhile, one where glyphs and lines, whose meaning are not yet agreed to, reach towards us and I reach between them to you. I want us to think alongside one another about the myriad tacit and explicit agreements that allow for language as well as identify the disagreements that are read as miscommunication. Mis, the suffix that asserts something as wrong, bad, or erroneous, seems ill suited to the formative desire of communication. For it, communication, to have been bad suggests the receiver is dissatisfied, does not agree, considers what has been communicated to be wrong. This proposes qualitative meaning is evaluated in reception for both parties, the sender feels received or otherwise, and the receiver mirrors the intended volley back, a form of transaction.

I want to acknowledge the structures that are amplified when we refuse other readings of situations, conditions, and relations; when we consider communications to have been wrong, bad, or erroneous as opposed to entering the shared space of listening that requires different protocols than qualitative judgement. It asks that if measurement takes place in the form of evaluation, have we not altered the message? The method of measure always determines

the outcome. What values, beliefs, and world-senses scaffold my evaluative structures and am I able to make them clear to those that attempt to communicate with me? Does active listening require abandonment of ego-based and culturally constructed notions of expertise to fully receive a gesture of connection, be it sonic or otherwise? Is not vulnerability required to engage another outside of evaluative standards. Is my listening an extractive process or one of reciprocity?

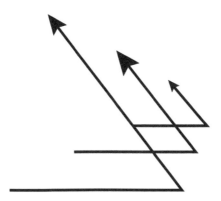

jake moore, Touch.[2]

Notes

1 Two musicians start on the same pitch then slowly drift apart. When this appears in a narrative composition, it often symbolizes inequity between two groups. A Worm's Eye View from a Bird's Beak, eds. Alison Coplan, Katya Garcia Antón, Stefanie Hessler, Sternberg Press, 2024.
2 Our perception of touch is the pulse of electrons pushing away, mapping the surface they have connected with. That our sense of connection is in actuality the coming to know of another perceived singularity and its refusal to let us pass through is central to the methexis of communication.

References

Alaimo, S. (2018). Trans-corporeality. In: Braidotti, R. & Hlavajova, M. (Eds) *The Posthuman Glossary*, pp. 435–438. New York: Bloomsbury.
Barad, K. (2007). *Meeting the Universe Halfway: Quantum Physics and the Entanglement of Matter and Meaning*. Durham, NC: Duke University Press.
Barad, K. (2012a). *What Is the Measure of Nothingness: Infinity, Virtuality*, Justice. Kassel: Documenta 13.
Barad, K. (2012b). On Touching – The Inhuman that Therefore I Am. *Differences*, 23 (3), 206–223.
Barthes, R. (1977). *Image Music Text*. London: Fontana Press.
Bozalek, V. (2022). Uncertainty or Indeterminacy? Reconfiguring Curriculum through Agential Realism. *Education as Change*, 26 (1), 1–21. https://dx.doi.org/10.25159/1947-9417/11507
Cajete, G. (2000). *Native Science: Natural Laws of Interdependence*. Santa Fe New Mexico: Clear Light.
Carlyle, A. (2022). *Guest Lecture*. Sound Arts Lecture Series. London: University of the Arts.
Chen, N. N. (1992). Speaking Nearby: A Conversation with Trinh T. Minh-ha. *Visual Anthropology Review*, 8 (1), 82–91. https://doi.org/10.1525/var.1992.8.1.82
Deleuze, G. & Guattari, F. (1987). *A Thousand Plateaus: Capitalism and Schizophrenia*. Minneapolis: University of Minnesota Press.
Deleuze, G. & Guattari, F. Rhizome. *Oxford Reference*. Available online: https://www.oxfordreference.com/view/10.1093/oi/authority.20110919111808348.
Durham Peters, J. (2020). A Cornucopia of Meanwhiles. In: Durham Peters, J.; Florian Sprenger, F.; & Vagt, C. (Eds) *Action at a Distance*. Lüneburg: Meson Press, 29–50. https://doi.org/10.25969/mediarep/14857.
Fejzic, S. (2020). A Radical More-Than-Human Intersectionality in Ecologically Compromised Times: Toward an Attunement to Nonhumans and Indigenous Knowledges. In: Kuruvilla, M. & George, I. (Eds) *Handbook of Research on New Dimensions of Gender Mainstreaming and Women Empowerment*, pp. 509–529. Pennsylvania, PA: IGI Global.
Ghouse, N. & Holmes, B. (2022). *Coming to Know*. Berlin: Archive Books.
Grzinich, J. (2016). Four Questions: Located Sound. Available online: https://fr4q.wordpress.com/2016/10/22/11-john-grzinich/
Haraway, D. (2016). *Staying with the Trouble: Making Kin in the Chthulucene*. Durham, NC: Duke University Press.
Helmreich, S. (2015). Transduction. In: Novack, D. & Sakakeeny, M. (Eds.), *Keywords in Sound*. Durham, NC: Duke University Press.
Lentjes, R. (2017). Against the Grain: The Essence of Voices. *Van Magazine*. Available online: https://van-magazine.com/mag/against-the-grain/
Noë, A. (2008). *Action in Perception*. Cambridge, MA: MIT Press.
Oliveros, P. (2022). *Quantum Listening*. London: Ignota Press.
Pettman, D. (2017). *Sonic Intimacy: Voice, Species, Technics*. Stanford, CA: Stanford University Press.
Plack, C. J. (2005). *The Sense of Hearing*. Lawrence Erlbaum Associates. New York: Psychology Press.
Robinson, D. (2020). *Hungry Listening: Resonant Theory for Indigenous Sound Studies*. Minneapolis: University of Minnesota Press.

Schafer, R. M. (1994). *The Soundscape: Our Sonic Environment and the Tuning of the World*. Rochester, VT: Destiny Books.
Stanyek, J., & Piekut, B. (2010). Deadness: Technologies of the Intermundane. *The Drama Review*, 54 (1), 14–38.
Sterne, J. (2003). *The Audible Past*. Durham, NC: Duke University Press.
Voegelin, S. (2011). The Place my Listening Makes [Conference session]. Sound and Sound Technology as Spatial Parameters, ETH Zürich. Available online: https://www.academia.edu/6014957/The_Place_my_Listening_Makes
Wright, M. P. (2023). Listening After Nature: Field Recording, Ecology, Critical Practice, pp. 128–135. New York: Bloomsbury.

PART 3
Cultures of Situated Listening

PART 3

Cultures of Situated Listening

PART 3
Introduction

Morten Søndergaard

The chapters in this section critically examine the ways that cultural frameworks, tensions, and distinctions influence the ways we listen in increasingly contested times. These chapters explore themes ranging from the heteropatriarchal and colonial underpinnings of white supremacy, to listening practices in bordered landscapes, to underheard cultures in the North Atlantic, to listening in relation to non-human beings such as sea creatures and coyotes. Each chapter situates listening within broader sociopolitical asymmetries, to listen for the ways that power influences and activates listening cultures in these diverse contexts.

In this section, "culture" is presented as a word that, similar to a concept such as "society", comes with several definitional and philosophical problems associated with it. Culture is an easy concept to reify or make monolithic, to freeze or concretize what is in fact always a series of complex motions and improvisations. Our intent in using the word "cultures" is to call attention to a set of practices with symbolic and communal meaning. At the same time, we might think of culture as in cultured milk or yogurt: more-than-human ecologies and organisms that affect change over time.

Across the five chapters in this section, critical issues such as ecocide, petrocapitalism, and fascism are presented – asking how we might leverage the political potential of listening to counter hegemonic systems of power. Further to this, how might we then foreground the political potential of the sonic as a mode of knowledge production that not only fosters new questions and narratives but also suggests new ways of being in the world? The authors critically engage with these questions, to demonstrate how listening practices are deeply embedded in the cultures from which they emerge, while also refracting those cultures' concerns through the affordances and limitations of

human aural perception. Each chapter, therefore, not only critiques but also offers possibilities for more politically engaged and attuned forms of listening.

The Sound of Hate: White Nationalist Epistemology and Neo-Nazi Nation Building on Telegram

In this chapter, Freya Zinovieff and Helena Krobath trace the rhizomatic spread of neo-Nazism across chat-based social media, to examine how social media algorithms are exploited by the far right, allowing "alternate media ecosystems" to hide in plain sight. Within this digital landscape, the authors identify recurring conceptual and aesthetic themes in the treatment and presentation of audio, focusing on how anti-trans rhetoric has become a central force in populist mobilization, rooted in historical Nazi nature ideologies, Canadian medical eugenics, and colonial purity discourses. Utilizing a case study of sonic memes, podcasts, and media shared within the "echo chambers" of right-wing cultures, the chapter adds sensory, sonic, and material dimensions to the analytical toolbox of cultural studies and communications research. The authors address the global impacts of post-truth citizenship, linking this to Carolyn Birdsall's analysis of German silence during Hitler's rise to power, which uses the metaphor of silence to capture a cultural tendency to turn a "blind eye or deaf ear" to fascism (Birdsall, 2012). This historical context feels acutely relevant today, as questions surrounding the politics of silence are at the center of our critical engagement.

Mythic Sonic Beings: A Multitrack Conversation

This chapter adopts a collaborative format to explore how listening and sound can create connections, challenge dominant narratives, and reveal hidden histories. Instead of relying on a single voice, it includes multiple perspectives from artists, scholars, and community activists who focus on the politics of sound and silencing. Inspired by the view that listening is a collaborative act, the chapter highlights the risks of listening, such as openness to change, which demands trust and a willingness to be affected by others' perspectives. Each contributor's work examines how sound and silence operate across cultural, geographic, and social boundaries, especially in marginalized communities, exploring the relationship between sound, place, and identity in contexts of migration, activism, and cultural preservation. Their work traverses a range of sites (from border crossings and radio broadcasts to archives and sonic commons) and an array of forms (activism, autoethnography, exhibition making, community work, writing, public intervention, workshops, and performance). The essay concludes by encouraging listeners to document their own sonic environments, building an "archive of living crossfaded sounds" as a participatory and performative act.

Introduction 197

The Sonic Sensorium – Listening to the Un(der)heard

As discussed in the opening introduction to this volume, situated listening is deeply indebted to Haraway's concept of situated knowledge. The premise of constructing worlds as raised by Haraway is revisited and renegotiated in this chapter by Marie Højlund and Morten Søndergaard.

They discuss ways in which listening may situate knowledge, and open toward perspectives less structured by domination. Through such renegotiations, they abandon the belief that we can distance ourselves from the world; and consequently, our engagement with objects becomes not a matter of producing knowledge about the world, but instead an ongoing process of not-knowing or listening. Through a series of case studies in North Atlantic contexts, including the historical and contemporary significance of localities, they examine how cultural mechanisms filter auditory experiences and impact our perceptions of community and belonging. They draw on concepts from, among others, Donna Haraway and Susan Leigh Star to highlight the dynamics of sonic citizenship, the importance of context, and the role of technology in shaping our listening practices.

Listening-Care as Ethical Orientation

In *Transperceptive Listening: Sonic Meditations for a Pluriverse*, Anna Nacher and Victoria Vesna propose "Transperceptive Listening," a practice of deep, embodied listening that incorporates human and non-human sound sources, such as oceanic and atmospheric elements, to foster ecological awareness. Inspired by the pandemic-driven transition to online, sound-based meditations, their work encourages listeners to connect with natural phenomena, including plankton and cosmic dust, using guided meditations based on scientific data and sonic visualization. Building on Oliveros' Deep Listening and influenced by Buddhist meditation and recent cognitive science, their sessions use sound to heighten awareness of ecological crises and engage the audience in a shared, participatory sense-making that supports empathy for silent environmental agents. These meditative practices, delivered online during the pandemic, highlight the "silent agencies" affected by human activity and encourage a more attuned, collective response to environmental disruption, emphasizing that both breath and attentive listening can serve as conduits for interspecies communication and ecological responsibility.

Collaborative Composition: An Exchange of Sounding

The book concludes with parting words from Spy Dénommé-Welch and Catherine Magowan, who examine the quieter contexts of listening cultures directly impacted by events described in previous chapters. In contrast to the violence of North American neo-Nazism, yet existing in the same geopolitical

context of Canadian settler colonialism, the authors describe their ongoing research project of listening to the coyotes living in a small patch of wood behind their house. In a project that resituates the colonial anthropocentric loci of power back into the paws of coyotes, Dénommé-Welch and Magowan detail their process of digitally recording coyotes "yips and howls", which are considered as a form of code. These sounds are used in a "call and response" format using improvisation with different instruments, to center the coyote as a "principal composer" and model an alternative definition of culture that includes the coyote as a situated listener, collaborator, or even a "cultural ambassador." Through a series of five reflections, the authors consider how the music they make and the technology they use might foster kinship with the more-than-human. Ending on the premise that "maybe coyote holds the answer," Dénommé-Welch and Magowan prompt the reader to contemplate the ways they might "unsettle" their own practices of listening.

11

THE SOUND OF HATE

White Nationalist Epistemology and Neo Nazi Nation Building on Telegram

Helena Krobath and Freya Zinovieff

Foreword

In the context of the Zionist Regime's[1] genocide of the Palestinian people, far-right groups in Canada and the US are weaponizing antisemitism through infiltration into Palestinian liberation groups and other bad faith activity. This manipulation conflates Jewish religion with Zionist ethnonationalism, underscoring how racial identities are constructed and manipulated to serve colonial projects. This sets a dangerous precedent for those opposing regimes of ecocidal, epistemicidal ethnic cleansing. The authors of this chapter are academics living and working on unceded territories in Western Canada, who are shocked by the Zionist obliteration of every university in Gaza, the assassination of over 100 Palestinian academics, not to mention the hundreds of thousands that have been killed by the Zionist Regime since October 7th 2023 and during many decades previously. We abhor Canada's active support and funding of this genocide and situate this research in conversation with different decolonization discourses that call for Indigenous liberation in Palestine and Canada. As scholars of neo Naziism, we understand the links between Naziism and other forms of fascism that stem from historical fraternization (Brenner, 2010; Sseremba, 2023). Along with Jewish Voice for Peace (nd), and many others who hold dear the concept of Jewish solidarity, we strongly resist the conflation of pro-Palestine support and anti-Zionism with antisemitism.

Introduction (Trigger Warning)

"You're not a victim, you're a weapon, you're here to destroy us… this is about the destruction of culture, it's about genocide." This statement was

DOI: 10.4324/9781003348528-18

made in December 2022 by a white cisgender man as he laments "the trans agenda" on a self-described neo-Nazi Telegram channel, which we do not name for the safety of the authors. In this chapter, we call it Nationalist 1, abbreviated to N1. The speaker, whom we believe to be a central actor in the neo-fascist hate group Proud Boys, also proclaims that "whenever fascism comes to America it will come in the form of a Jewish guy wearing a dress claiming to be a [wo]man." He speaks in a thick Canadian accent for over an hour in a back-and-forth conversation with another self-described white cisgender man. Their elaborate fantasy illuminates a multi-generational plan by a shadowy cabal of Jewish elite to commit genocide against white people. In this fantasy, adults and children are groomed to become trans, and the specter of transness is wielded as the ultimate form of evil.

In the context of active genocides taking place (Bytwerk, 2005; Fontaine, 2014; Said, 1994, 2012; Salamanca et al., 2012; Stoler, 2022; Woolford & Benvenuto, 2015), these unhinged claims might be easy to dismiss; however, a network of tens of thousands of self-described neo-Nazis with cross-border links between the US and Canada is rapidly growing. N1 forms part of a web of interlinked Telegram channels used by far-right groups, including The Base, Canada First, and Patriot Front. When we describe these groups as having cross-border links, what we mean is that they operate in both the US and Canada. They have fight clubs in California, "active clubs" in Alberta, and Canadian members who directly participated in the insurrection of January 6th in the US. Our research distinguishes a blending of Canadian and American perspectives on nationhood, which stem from the white supremacist doctrine of manifest destiny; the expansionist ideology of Völkisch National Socialism and ideas such as lebensraum (the concept of necessary "living space" at the expense of those considered inferior) and Blut und Boden "blood and soil" (the fetishization of relationships to land due to perceived racial superiority).

Despite the distinct histories of violence shaping each country, we contend that North American neo-Nazi groups share significantly entwined, common ideological foundations, and their aims are securely rooted in the same accelerationist movement which seeks to hasten the collapse of society to rebuild an ethnonationalist state. In this state, the territorial border between the US and Canada is of little consequence to its citizens. At the start of writing this chapter in early 2023, there were 1,200 subscribers to the channel, and in August 2024, there were over 2,000. The channel was banned this same month but has since propagated with multiple offshoots.

Approach and Methods

From a sound studies perspective, N1 is interesting in that its content is predominantly sonic. Seven out of ten posts on the channel take the form of

podcasts, songs, voicemails, and other soundbites. The other content takes the form of video clips, memes, and images depicting extreme racist, misogynist, and transphobic content. Much of the content on N1 is forwarded from other similar channels, which we also follow; however, this is the only channel we have found whose content is primarily sonic.

In what follows, we analyze sonic content of N1 to better understand the risks posed by the neo-Nazi movement in Canada and the US, and the pivotal role of sound in the advancement of neo-Nazi ideologies, as evidenced through this Telegram channel, N1. From 2023 to 2024, we meticulously examined the publicly accessible content in N1, to ask: How do neo-Nazis members of such groups leverage sound to disseminate propaganda and organize their violent agenda? We employ a critical analysis of sonic memes, podcasts, and media shared within the far-right "echo chamber" to investigate the interplay between white nationalism and Nazi ideologies as espoused by these groups. Our analysis is an early exploration that focuses on a small number of posts, chosen to represent the discourse in the channel. This choice is made due to the limited sample size and is not a methodological weakness, but a deliberate scope choice for the piece.

Practices of listening can be used as methods to track propaganda, illuminating neo-Naziism and contemporary colonial violence as phenomena emerging from both colonial ideologies and those of Adolf Hitler's Nazi Party. To these aims, we describe the Nazi Party's fetishization of the forest as a place of racial purity and their venerating analysis of the North American reservation system, showcasing how these practices of white nationalist eugenics were successfully implemented abroad (Kuhl, 1994). We employ notions of aesthetic frames and world-building in complement to traditional discourse and frame analysis. Our interest lies in the rhetorical potency offered by sonic media's sensory impact, temporal qualities, and ability to seamlessly transition between background and foreground attention. The nonverbal sonic dimension not only serves as a complement to words or images but also evokes a sense of place and reality through its simultaneously mundane, locative, and evocative presence. To provide additional context, the following section delves into the historical underpinnings of these ideas and their emergence from both colonial and Nazi ideologies.

In scrutinizing sonic traits, their social context, and accompanying material, we identify how white nationalist channels construct and disseminate ideological narratives by employing what we term Rhetorical Strategies for Hate. These strategies, namely, narcissistic nationalism, colonial nostalgia, and the fetishization of cisheteronormativity, constitute intertwined themes and aesthetic forms prevalent in neo-Nazi audio content. The strategies exhibit fluidity, as content under each rhetorical category often intersects with one or more others, building what Gramsci (2011) calls an "organic ideology" through (re)generation and familiarization of Rhetorical Strategies

for Hate across various media products. Thus, the groups foster a sense of community, virtue signal, and mobilize offensive actions. Our analysis attends to how these groups uphold gender-essentialist, binaristic perspectives rooted in colonial history, notably exploiting transgender issues for political advantage.

Nationalist Nation Building on Telegram

N1 serves primarily as a platform to disseminate propaganda, build community, and organize violent action. This can include doxing individuals linked (actually or hypothetically) to Antifa, protesting outside places that provide gender-affirming healthcare, and arranging protests at LGBTQ+ events such as Drag Queen story hour at small local libraries. The podcasts on N1 are part of a billion-dollar industry and have an interconnected, insular stable of guests and hosts who become familiar voices and routinely engage with each other's shows. This dynamic showcases a subdivision of extremists prevalent across multiple shows, as highlighted by Squire and Gais (2021a, b). Mainstream voices occasionally lend legitimacy as guests, but alt-right podcasters do not appear in the mainstream.

N1's potluck of shows, with Telegram's auto-play default, evokes an eclectic programming flow reminiscent of community access television and radio. N1 clips range in production value, from studio quality to home recordings, with room tone, reverb, mic distance, clarity, and loudness levels varying dramatically from show to show. A distinct "place change" sense, created by changing room tones, locates most hosts in non-studio spaces. N1's hosts are homogeneous (white, cisgender men), but their vocal styles vary dramatically: a circus announcer, then a shock-jock, underground diarist, then pedantic intellectual, fiery preacher, then meditative hippie, and so on, with wide-ranging material that often reacts to current events and social issues, revises history, offers homesteading advice, tracks conspiracies, contemplates self-improvement, and so on. The variety of styles and genres implies a plurality of information sources, which may work to boost the channel's legitimacy as an alternative public sphere; however, the shows all circle narrowly defined touchstones and terms of reference.

Online community solidarity in N1 is fostered not only through propaganda but also via jovial discussions about everyday issues like the price of gas and eggs, or back-to-school time. Through these seemingly innocuous conversations, a sense of familiarity is fostered, into which the hosts can slip their insidious content. As researchers listening in from outside, we were struck by extreme contrasts in tone and content. The same speakers discussing their children or homesteading skills would next speak with hateful bigotry dripping from each word. This can take the form of long monotonic lectures, usually by a single male or back-and-forth between two men.

While their sonic tactics are often low-fi, they are also effective – the often-monotonous narrative has a soporific effect that through virtue of its drone, can lull the listener into an almost trance-like state. We found it chilling to navigate the experience of listening to N1, partly because much of it is benign. We suggest that this tactic – seamlessly blending racist and everyday themes, while maintaining the guise of intimate informality – draws listeners together through familiarization and normalization of hateful rhetoric. This touches on De Bois' (2022) examination of alt-right tactics to generate a hegemonic culture by "interlinking moral and political arguments around cultural symbols," layering extremist meanings and symbology onto mainstream cultural products (49; 51).

We perceive these podcasts to be effective tools for recruitment and underscore how the utilization of the sonic dimension is highly effective and constitutive of the actual level of threat posed by these groups. We found it easy to understand how a listener might get drawn in by the encouragement of empathy for the struggle of working-class families under capitalism, with inspiring models of masculinity presented as the antidote. Through emotional manipulation, and the affective proposition of unity against "the man," the curated content of N1 cleverly pushes nationalist narratives through which the hosts encourage their audience to adopt an ideological worldview supported by distorted and false information, which shares space with more neutral topics.

Throughout our analysis of N1, we think deeply with Carolyn Birdsall, whose 2012 book *Nazi Soundscapes, Sound Technology and Urban Space in Germany 1933–1945* provides many frames of reference and solid guidance for this sometimes-grueling project. Like Birdsall, we consider the epistemological dynamics of audio technology (in this case, podcast vs radio). Of particular interest is Birdsall's discussion of what it meant for German citizens to "earwitness" World War II (WWII). In comparison with acoustic ecologist R.M. Schafer's description of earwitnessing, which "sustains a fantasy of immediate access to the past sounds" (Birdsall, 2009, p. 170), Birdsall conceives of earwitnessing in the context of WWII as a "heightened awareness of sound in everyday life" (2012, p. 11) that shapes "remembering and witness testimony" (2009, p. 170). For this research project, we articulate ourselves as earwitnesses to contemporary fascism, with a particular interest in the ways that its discourses are constructed and disseminated through technology and integrated into everyday life to "construct worlds."

Birdsall argues that when attentive listening shifts with inattentive modes in a "'back-and-forth movement' between the unconscious and language" (2012, pp. 19–20), this allows listeners to generate deep, nonverbal associations with the subject matter as well as integrate it into the texture of daily life. The monotonic lectures in N1, which can last over an hour in contrast with shorter cycling of formats and topics, utilize these intersubjective tactics,

which Birdsall describes as World Construction. Often rambling, lengthy, and automatically cued for auto play, the podcasts can become mundane or "tuned out" by an at-times multitasking audience. In this regard, N1's content can provide a sonic routine and/or backdrop to daily activity. Paradoxically, the content does not share an ecosystem openly with the broader popular culture, so the listener is thus located in a media "shadow world." In relation, DeBois and others have found that far-right music forums exploit social media algorithms by using shared search terms. For example, a search for a politically neutral Swedish prog metal track on YouTube can lead to suggestions for explicitly Nazi-coded Swedish metal (p. 51).

One of the podcasts in our analysis, *A Call to Return to the Land* is a meditation-styled monologue posted on N1 as audio, and on YouTube as an audio-video slideshow. We describe the podcast in greater detail later on in this chapter. The YouTube caption contains links to both a mainstream survivalist program and another fringe program, creating associations between far-right content and mainstream survival videos. This can result in the video appearing in the sidebar of neutral homesteading and survival videos, or auto launching once they have ended, providing both a direct path via extremist content in N1, and an indirect path via broader algorithm-curated content.

In our sample, format diversity and strategic framing enabled an alternate media ecosystem. The Contemporary Christian Music (CCM) genre demonstrates a similar precedent, which despite its subcultural image is also a multi-billion-dollar industry. Howard and Streck outlined in the 1990s how CCM is constrained by the religious self-image of fans, who see CCM as serving an exceptional and separate community distinct from sinful or corrupt popular culture. An industry worth multiple billion dollars was sure to garner financial attention (1999, pp. 152–159). Managing to appear distinct from mainstream studio and celebrity systems became an important part of maintaining the market niche. Similarly, there is tension between the identity of networked podcasters in our sample and the multi-billion-dollar value their products can generate for streamers and platforms. Social media platforms like YouTube profit from mainstreaming alt-right/alt-light content, targeting audiences via algorithm filters or leveraging freedom of speech policies (Srnicek, 2017, p. 43). In short, the illusory marginalization of these massive industries arises from dual needs – to separate ideologically but synergize economically. N1, we propose, is designed to generate the sensation of an alternate space where the listener is given an exceptional status.

Nazism in Canada

The narrators of N1 are reproducing age-old rhetoric. Colonial projects revolve around notions of cultural and racial supremacy, through which "incidental" or deliberate genocidal outcomes are enacted. In Canada's early

colonial era, a supremacist rubric was used to rationalize land theft based on gender conformity. Discourse feminizing Indigenous society was used to justify colonial entitlement under a code of white masculine superiority (Kakel, 2011, p. 23). In tandem, white men were depicted as being spiritually threatened by uncivilization, and their complementary opposite – white women – were meant to keep them civilized. This gender-based melodrama both dehumanized Indigenous people but also categorized Indigenous women's gendered behavior as morally threatening, with settler men and government officials scrutinizing, asserting ownership, and enacting repressive reproductive policies against them. BC and Alberta did not overturn sterilization acts largely targeting Indigenous women until the 1970s (McKenzie et al. para 2,3), while Kuhl (1994) highlights a resurgence in the late 1980s of high-profile Canadian pseudo-scientific attempts to put humans into genetic hierarchies; they also linked race with sexual danger and the male specimen with intellectual superiority (p. 18).

By the 1930s, the progressivist eugenics movement, with its fixation on sexual morality, was rife in Canada. It included the so-called Canadian feminist icon Nellie McLung, who called for the sterilization of "immoral" women, associated sex work with "feeble-mindedness," and advocated for internment camps (McLaren, 1990, p. 73). Eugenic goals, purportedly progressive, were whitewashed by women eugenicists assuming a maternal role while providing children with sexual education that emphasized threats posed by "incorrect" categories of sexuality. While other nations provided prophylactics and pharmaceutical options for syphilis after WWI, Canada "summarily rounded up and jailed" a population of sex workers under the Defence Order of Canada (p. 74). Eugenicists emphasized dangers of hereditary immorality, prostitution, and venereal disease to suggest that – just like Canada's natural resources – sexuality should be "rationally controlled," lest it "pose dangers to the nation" (McLaren, p. 72). Throughout all this, top-down control of sexuality was framed as paternalistic (and maternalistic) moral responsibility to oversee the safety of a vulnerable citizenry in danger of fatal corruption.

Across the Pacific, Nazi propaganda hailed "the establishment of sterilization laws in Norway, Sweden, Finland, Estonia, and Canada" as evidence of the ideology's international acceptance (Khul, 1994, p. 88); however, Nazi-adjacent ideology in Canada pre-dates the term itself. Lux (2001) traces high-profile Canadian race scientists or "social Darwinists" to the 19th century, targeting not only Indigenous populations but colonial immigrants. Having "undesirable" ethnic origins was treated as a disability, with such "unfit" immigrants similarly positioned as a medical and religious problem for white society to shoulder (Kakel, 2011, p. 63; Lux, 2001, p. 9). Along with infamous acts of discrimination against Chinese, Japanese, Indian, and Irish immigrants, among others, Canada refused Jewish immigrants before

the Holocaust, nor did it accept Jewish refugees in any number afterward. It did harbor Nazi war criminals, as the Deschenes Commission uncovered in 1986. Ideologies of supremacy and fitness would also shape the 20th-century "progressivism" movement in Canada, including a strong focus on Eugenics by those attempting to inaugurate Canada as a white protestant nation. These histories underpin contemporary Canadian neo-Nazi fetishization of cisheteronormativity and rationalize its ascendency. This scrutiny can shed light on how transness has become weaponized as a form of social disinheritance, while anti-trans rhetoric becomes a core force of populist mobilization.

Nazi Identification with Nature

In the following section, we trace some tangled historical roots of Nazi identification with nature, before discussing ways in which this ideology has been seeded in Canada – a vast expanse of land and forest, ripe for theft and appropriation. Canadian neo-Nazis adopt environmentalism as a signifier of extremist virtues and a mechanism to define their beliefs about purity (Askanius, 2019; Szenes, 2021; Campion, 2023). Furthermore, some environmental rhetoric has become specifically co-opted to propagate neo-Nazi agendas (Nixon, 2020; Stern, 2019). With this in mind, we argue that it's important to understand how German Naziism constructs and lays claims on nature and how neo-Nazis evoke/invoke that legacy, in this case through networked audio media.

Neo-Naziism in Canada is rooted not only in medical eugenics and sexual control but in purity discourse that proposes nature/culture dichotomies and fetishizes wilderness as a state representing whiteness. Canadian neo-Nazi movements intersect with historical and contemporary environmental philosophies that privilege preservation as a purity project. By this, we mean that wilderness is conceptualized as pure and unsullied in contrast to degrees of human corruption. For instance, in *A Call to Return to the Land*, the host emphasized environmental degradation and system collapse resulting from the weakening of white masculinity by corrupt social elements (48:13). Conservation zones were created to protect "pure" nature in its own domain, overseen by worthy and capable stewards (implicitly or explicitly, this meant white colonizers). This perspective was famously advanced by John Muir, whose work was instrumental in founding the National Park system in the US, and by extension, the modeling of the Canadian park system (Warner, 2008). This dichotomy between wilderness and human development deeply influenced ideas of natural purity and wilderness symbology/mythology. It also contributed to contemporary intellectual value systems, including early acoustic ecology and soundscape analyses, as explored by other researchers.

The German Forest was recast as a national emblem during unification, but the phrase "people and forest" had historical and cultural significance long

before then. Johannes Zechner draws on Anderson and Schama's concepts of imagined communities and landscapes to conceptualize how political ideologies and identities can be mapped onto an 'imagined landscape' (Zechner, 2011, p. 19). This concept was taken up in the 1920s by the *German Forest Association League for the Protection and Consecration of the Forest,* who, in their propagandistic materials, used the slogan "the German people and the German forest are at one." This inheritance – "exclusively attributed to Aryan racial ancestry" (Zechner, 2011, p. 23) – underpinned a nature-based, ethnic manifest destiny and rested upon earlier ideas of the "ethnicized forest" articulated by 19th-century writer-philosopher Wilhelm Heinrich Riehl. Riehl described what he saw as corrupt or inept ethnic geographies in which Jewish and Polish people degraded the natural environment, unlike healthy German "forest people." This idea was utilized by the Nazis, as they sought to reconstruct "the imagined landscape of the German Forest" in what they saw as ruined spaces beyond their borders, particularly tree plantations in Poland and Jewish-occupied regions (Zechner, 2011, p. 25).

The Nazis pursued this long-term project of (re)constructing an archetypal German Forest identity and connecting it to manifest destiny and Lebensraum. Himmler organized research into "forest and tree in the intellectual and cultural history of the Aryan and Germanic people," while Rosenberg (editor of the National Socialist Party's newspaper) commissioned a "propaganda film with the telling working title 'German Forest–German Destiny,'" later titled Eternal Forest (Zechner, 2011, p. 23). This film used rhetorical flourishes such as:

> Rotten, degenerated, intermingled with alien races. Oh people, oh forest, how do you bear this burden so unthinkable?... Let's weed out the racially alien and the sick.... Join in to sing the new song of the time: 'People and forest persist for eternity'.
>
> *(Zechner, 2011, p. 23)*

According to Kuhl (1994), Hitler and the Nazis were also interested in the "purity" of North American wilderness. By the same token, "fortress conservationism" of Muir's naturalist preservationist movement in the US was largely inspired by German romanticism and transcendentalism (Stevens, 2014). This ideology demonized and infantilized Indigenous peoples and was used to rationalize the theft of large swathes of Indigenous land in the name of ecological preservation, just as the National Socialist Party had claimed moral ownership over foreign environments by positioning some people as unworthy of the land (Zechner, 2011, p. 25).

In present-day Canada, forests and nature areas are often essentialized in purity terms (consider use of words like "virgin," "pristine," and "untouched"). The polarization of "working" and "preserved" nature zones

emerged in part as transcendentalist movements were forming and Canada had established nature zoning systems and colonial regimes to manage land preservation – and Indigenous people – on moral, economic, and scientific grounds. *Return to the Land*, along with many other of the podcasts on N1 affirm and perpetuate the fetishization of the Canadian forest, to which the neo-Nazi body has rightful ownership. As we describe later on, this nostalgic colonial understanding of woodland space is underscored by preoccupation with what is considered different forms of "degeneracy," one of which is littering or dumping of trash in the forest. Neo-Nazi volunteer litter pickup programs happen across Canada and the US, evidence of which is proudly displayed in N1 and other affiliated Telegram channels.

Before relating these Nazi ideologies more deeply to our media sample, we contextualize N1 content with a brief discussion of radio's role in the advancement of Nazi epistemologies, specifically the tactic of using bridging in radio as a tool for nation-building.

Nazi Radio Epistemology, Nationhood, and Bridging

Radio plays a significant role in articulating nationalist identities and interpolating colonial subjects (Fanon, 1965). The podcast format of N1 fulfills a similar function to conservative talk radio: private space is bridged with public spheres through "published" audio works, lending them the legitimacy of the "broadcast word" (as in the authority of the printed word) and shared territorial identity under authority of the nation. In this case, the authority of the "coming nation" is articulated in the audio feed. Historically, extreme opposition figures also exploited the power of radio, such as Alberta premiere "Bible Bill" Aberhart, a far-right talk radio evangelist, eugenicist, and antisemite whose rhetoric resembles contemporary American radio/internet personalities such as Rush Limbaugh and Alex Jones. Aberhart, like modern counterparts, routinely warned listeners about elite conspiracies and begged for financial support. Beyond on-air fearmongering, Aberhart was instrumental in implementing Alberta's vicious eugenics program (Grekul et al., 2004, pp. 8–31).

Sonic neo-Nazism encompasses historic fascist audio techniques and broader audio epistemology. Nazi broadcasts utilizing radio to bridge private and public spheres (Birdsall, p. 55) reinforce the notion of protecting the collective Us against perceived threats from the ominous Them. A notable tactic is the phenomenon of frame bridging which involves applying specific frameworks to an issue to shape the discourse and make equivalencies (Snow et al., 1986, p. 467). These include white patriarchal underpinnings of Western culture, characterization of radicals hindering Western progress, and linking concepts of "Jewish conspirators" and government elites. These frames produce populist rhetoric that exploits narratives of cultural preservation, societal advancement, and elite opposition.

Building on the historical underpinnings we describe above; we highlight bridging used as a tactic by N1 hosts to foster a redefined sense of patriotism in listeners. This shared project of disseminating disinformation and violent content works to cultivate nationalistic extremes and alternate worlds. We perceive a clear pattern to N1 hosts' bridging techniques; they first identify fears around "white replacement," and once common ground is established, they craft a narrative tying this specific myth to nationalist ideology. Using emotionally charged language and/or music, stories of violence perpetrated by perceived enemies, or calls to action that involve violence, the message of white replacement is reinforced. By cultivating a strong sense of in-group identity among listeners, the "us versus them" mentality can be applied, portraying the in-group as virtuous victims while demonizing out-groups. The goal of this tactic, we suggest, is to foster a sense of patriotic justice that is misdirected toward extremist goals. In the following section, we describe in detail three rhetorical strategies that we observed in N1 and explain how each is mobilized through the shared content.

Rhetorical Strategies for Hate

Populism, as observed in the rhetoric of N1, aligns an in-group's interests with the "true" public while labeling other concerns as "special interests" (Mudde, 2021). The approach relies on melodramatic narratives and Manichaean reductions of good or evil. When an oppressive elite is too far at odds with the so-defined public's best interests, this gives rise to populist movements. Populist discourse typically characterizes social actors as either corrupt (elite) or pure (public) (Mudde, 2007). Blaming an external force for societal problems suggests that different segments of society share a common oppressor, potentially uniting them into a populist public (Laclau, 2005). In this context, the populist framework not only constructs "the people" but also identifies "enemies of the people" (Laclau, 2005; Muller, 2016). This process requires additional rhetorical and symbolic efforts when the in-group is not the actual majority or lacks socially acceptable justification. Thus, the need to which populism responds – providing a formula for collective identification and self-preservation against oppressors – can also provide a ready-made formula for fostering reactionary and hate-driven division.

The Rhetorical Strategies for Hate that we outline here function as bonding agents that mobilize neo-Nazi discussions and identity. They are narcissistic nationalism, colonial nostalgia, and the fetishization of cisheteronormativity. As we mentioned at the start of this chapter, we observe Canadian and American Neo-nazi perspectives on nationhood are largely indistinguishable and rooted in the same ideological foundations. Therefore, these cross-border links are articulated through the rhetorical strategies that both influence and interfuse each other. The sonic aspects of the media shared in N1 construct

and support these strategies, in complement to world-building functions, and affirm the group members of nationalist projects. We describe each strategy, before going into detail about their mobilization through the sonic content in N1.

Narcissistic Nationalism

First, the concept of narcissistic nationalism is described by Chang (2001) as an obsession with power that fosters distorted reflections, where adherents view their "ethnic, religious, or territorial attributes turned into 'glorious qualities'." We draw links here with the German concept of *Völkisch* which translates as the emergence of a particular group, or folk, through the land and is grounded in a sense of spiritually ordained purpose (Staudenmaier, 2001). Both *Völkisch* and narcissistic nationalism point toward the concept of a racial holy war, or as it is discussed in neo-Nazi circles, RaHoWa. This aspect of neo-Nazi ideology was evident in the Insurrection of January 6, 2021, whereby neo-Nazi groups along with provocateurs proclaimed the storming of the US capitol as a holy act for the goal of white supremacy. We highlight how this rhetorical strategy promotes a specific interpretation of American identity, and in turn, Canadian, which draws upon the white nationalism espoused by the founders of the US Constitution. This branch of nationalism finds its ideological foundation in the doctrine of Manifest Destiny, which proclaimed white settlers as divinely authorized to propagate their moral principles throughout the United States. Accordingly, this type of nationalism views white, able-bodied, cisgender heterosexual men as the chosen people of God, and anyone other, a threat. Narcissistic nationalism also relates strongly to the Nazi affinity for western forests and the ideological claims over American and Canadian "wilderness" as a manifest destiny of white supremacists.

One exemplary N1 podcast, a meditation-styled monologue, *A Call to Return to the Land*, incorporates narcissistic nationalism sonically in several instances. The host routinely reminds listeners that they are in danger, regardless of the topic at hand. *They*, the enemy, want to obliterate, demolish, bankrupt/destroy you. At one point, relaxing spa music and classical piano give way to a mounting electronic beat when "the enemy" becomes the direct focus. Next, soft tribal genre music sounds a beat as the narrator describes the new society he hopes to build with listeners. Unlike the dynamic musical accompaniment, the host's voice remains steady and monotonic, giving the podcast an ASMR or guided meditation tone, in contrast to other shows employing theatrics, rational conversation or radio professionalism. Antisemitic conspiracy theories are described with the same inflection as DIY homesteading, connoting equivalence and normalizing casual expression of extremist ideas. This contrasts with melodramatic employment of music that

serves "to frame content, marking a clear division between 'heroes' and 'enemies'" (De Bois, p. 51). In this way, the organization of villains and heroes, as well as fabulist sorting of people into folklore categories like magician and changeling, is supported by the emotive musical soundtrack reminiscent of epic dramatizations.

Narcissistic nationalism also plays out through contempt for average citizens, whose consumption of mainstream information makes them inferior to the in-group members who are aware and prepping for battle, while further articulating the masculine community. The host of the podcast delves into replacement theory by telling men they should not swallow the infamous "red pill" but the "black pill," which demands more mettle. If the red pill "awakens" white men to their oppression, calling them to up their game and strategize as individuals, the black pill demands either suicide or total overthrow of this system, which they diagnose as feminist-, ethnic other-, and deviant-dominated. This rarefied population is encouraged to realize their nationalist destiny and envision war and disaster in terms of personal and collective glory. These aims are securely rooted in the accelerationist movement, which seeks societal chaos and eventual collapse. The narcissistic superiority of the listener is verbalized explicitly and implicitly, for example, when narrators quote so-called leftist progressives, echoing their jargon or terms sardonically (e.g., gender, climate change, and poverty activists).

Colonial Nostalgia

Association of nature with racial purity also relates to two fetishizing behaviors of colonial nostalgia. The first involves idealized notions of a white supremacist European past, conveyed through cultural objects and symbols. The second centers around a longing for a simpler, more "natural" way of life, often expressed through a desire to return to the land. In online messaging exchanges, these two components of colonial nostalgia are observed through the sharing of images depicting classical sculpture, idyllic rural landscapes, historic European architecture, and many, *many* images and discussions of milkmaids. These artifacts are often superficially described and revered as emblems of white Western culture and power. This attitude resonates with the German concept of Lebensraum, which translates as "living space." Lebensraum emphasized the need for land acquisition as both a means to maximize power through geographic expansion and also as a signifier of the potential for crop planting (Lekan, 1999). In tandem with John Muir's project, this expansionism was also at the heart of the Nazi Party's efforts to initiate the European project of Nature Reserves as spaces in which German youth could practice *Völkisch* and affirm the connections between folk and land, between soil and blood – an idea at the core of neo-Nazi movements.

Colonial nostalgia weaves through the content in N1 in various ways that highlight aspects of romanticism as vehicles for nationalism and nation-building. N1 hosts openly describe their romantic ideals as a vehicle to generate "ties to your kin and ties to your land." Conversations on topics such as chicken-raising, natural health, and group litter cleanups, which are frequently documented through photographs featuring participants surrounded by bags of trash, underscore bonding exercises rooted in notions of white righteousness in relation to nature, purity, and hygiene. The often-low-tech, low-organization quality of the content suits an aesthetic politics that rejects the technological while suggesting proximity between the listener and content producer as regular people.

A few podcasts integrate music, generating affective relations with the monologue of a single male voice, like an "underground man" character with the meanest of audio gear to transmit messages from his chosen isolation as the vanguard. In these instances, for example, in *Return to the Land*, soft melancholy synths play in the background as the narrator describes the hardships of the working white man, in contrast to the louder Wagner-esque pulsations that play alongside the narrator's call to arms. N1 also posts nostalgic folk and country music which speak to this frame through the aesthetic of folk instruments, the *Volkisch* lyrics, and the transportation of the listener to a pioneer imaginary via songs such as Buy Dirt (2022) by Jordan Davis and Luke Bryan, a song in which colonial imaginaries of land acquisition are framed by white hetero fantasies of the nuclear family, and Rebel Soldier, a song dating back to the American civil war and sung more recently by Waylon Jennings. In this song, the nostalgic fetishization of both the violence of war and the fancy of a hetero future is sung alongside the ratatat of marching drums.

This nostalgia for times of yore deeply intersects with ideas about gender and the imagined placement of woman within the landscape, the societal system, and the idea of what home ought to constitute. Within this imaginary, the woman takes the role of "trad wife" and exists as the mere votary for the "rambling soldier." Transness is understood as a direct threat to this hierarchical system that sustains the white male in his position of power.

Fetishization of Cisheteronormativity

The last rhetorical strategy, the fetishization of cisheteronormativity, is apparent in subtle and conspicuous ways that equate transness with sex trafficking and pedophilia, while perceiving a targeted emasculation of men by "deviant" identities. N1's narrators mobilize patriarchal, masculinist, and misogynist memes through turns of phrase, inflection, and symbolic meaning. Through both the content and often sermon-like delivery, the podcasts reinforce the notion that frames boys as dangerous, and men as warriors

tasked with protecting society. They depict Queer and straight non-toxic masculinity as threats to this warrior ideal, which underscores descriptions of hegemonic masculinity as a construction of identity that operationally relies on an identifiable "Other" for itself to exist. This is highlighted through the ways speakers frame transness as deficiency or degeneracy and a direct contributor to their "replacement." Emerging from this discourse is the prevalent glorification of martial masculinity, a concept from game theory that links assigned-at-birth males with war-making, to which their social value is tethered (Giocoli, 2003). This pattern justifies the co-optation of male bodies for war-making and affirms their social obligation to perform war, historically and under the modern military-industrial complex. Unfixing gender characteristics disrupts these category-defining obligations put upon men to develop capacity for violence and vie over ownership of women's reproduction. What's more, abdicating martial masculinity is characterized as irrational when violence is seen as an essential part of human nature (Giocoli, 2010); thus, men who do abdicate the martial and heteronormative construction of masculinity can be depicted as weak, irresponsible, and irrational – not "real" men.

For example, the narrator of *A Call to Return to the Land* bemoans the "freefall" of testosterone levels and laments: "this new creature being created wouldn't be recognized as a man in virtually any other age" (9 min). In the audio version, queer or trans identities are indirectly referenced by testosterone panic, and in the YouTube version, listeners are invited to piece together elements of this conspiracy through visuals that fill in the blanks. Images accompanying this version include explicit images of gender queer and trans people juxtaposed against screenshots of tweets and headlines about "pizzagate" (a debunked conspiracy about Jewish and economic elite trafficking children from a pizza parlour basement). Trans scapegoating next intersects with other conspiracy theories around body-snatchers and shapeshifters (13 min) – unnatural, uncanny enemies who feed on the suffering of society. Such claims reinforce longstanding conspiracy theories about clandestine Jewish cabals trafficking humans, which genocide scholar Gregory Stanton traces back to a document called The Protocols of the Learned Elders of Zion. The Protocols, said to be authored by Russian conservative radicals in 1902, claim a Jewish scheme to dominate the world while referencing the fallacious accusation of Blood Libel, which alleges that Jews murder Christian children and use their blood to make matzo bread (Stanton, 2020).

According to the host, the monster is a "global elite whose goal is to cultivate a weaker and lesser sort of man" whose "very biological chemistry" has been changed (8:07–21). Within this fetishization of cisheteronormativity, liberalism is portrayed as a feminized political form and a strawman for true social power, while feminism remains a primary target of hatred. These views align with alt-light tropes, exemplified by the Cultural Action Party (CAP)

question "Is Justin Trudeau FEMINIZING the Male Species in Canada?" and the rightwing fixation on his hair as a marker of femininity (Salzberg, 2019). While the uninitiated may find CAP's question a bit silly, those fixated on neo-Nazi trans conspiracies will recognize it as a dog-whistle and others with concerns or questions about gender identities may draw closer with alt-right views, the full vitriol of which is linked beneath the surface of campaigns like CAP's. If skill and aptitude is explicitly linked to a dominant form of masculinity, a (perceived or real) lack of masculinity would disqualify someone from social leadership and resource stewardship.

Accelerationism/Conclusion

Tools of populism and eugenics programming are starkly familiar (even with new dog-whistles and codes). But a major development is the present hyper fixation on trans identity in mass media. This historically particular moment – in which social media allows for new forms of encoding, dissemination, and networking, along with new visibility of gender rights activism that challenges hetero-cis norms and ideals – points to the ways we understand what we call The Paradigm Battle and its stakes. In this context, neo-Nazis leverage transphobia and fear of male feminization as a recruitment tool.

In our conclusion of this chapter, and the impossible task of neatly concluding such a sprawling and exponential phenomenon, we posit that the anti-trans and antisemitic rhetoric at the core of contemporary neo-Naziism reflects shifting opportunities to empower the masculinist paradigm. In particular, this rhetoric fixates on the role of the male as fighter and the notion that without a strong male category, who is going to take on the role of the warrior, for example, see Nye (2007), Miller-Idriss (2017), and Hinojosa (2010). This is particularly noteworthy within the context of the Accelerationist movement, which as we described at the start of the chapter, is being increasingly adopted by neo-Nazis to hasten the collapse of existing societal and political systems through acts of violence in the belief that this will lead to the creation of a new order; one that is especially relevant as groups call for a second civil war in the United States and both the US and Canada pursue deeper domestic militarization.

With this crisis of masculinity in mind, we question the role that sound has in both understanding some of the intricacies of this crisis and doing something about it. One of the authors recalls a recent event whereby local neo-Nazis on Telegram were calling for violence against a professor of transgender studies and seeking to find her address so that they could commit harm. When contacted, the professor asked for the police to be informed, and after a two-week debacle of multiple calls and lost witness statements, the police response was "You can't 'persecute' people for their beliefs." In tandem with the excessively large police entourage to protect the neo-Nazis

who turned up at the local trans pride parade that same month, it's hard not to get discouraged by the seeming lack of institutional recognition about the level of threat posed. In this context, we suggest that the practice of earwitnessing contemporary fascism deserves time, attention, and research funding. We are interested in ways that practices of situated listening might attend to this real and urgent crisis that represents noncompatible value systems and anti-humanist points of view.

Note

1 We use the term Zionist Regime to ensure the reader understands our differentiation between the Jewish religion and Zionism as an ethnonationalist ideology that supports apartheid and ethnic cleansing; actions that have no place in the Jewish religion.

References

Asha Logos (channel name). (2023). "A Call to Return to the Land" (audio with slideshow). YouTube. https://www.youtube.com/watch?v=WrNOT2OiykE&t=176s

Askanius, T. (2019). "Studying the Nordic Resistance Movement: Three Urgent Questions for Researchers of Contemporary Neo-Nazis and Their Media Practices." *Media, Culture & Society* 41 (6): 878–888.

Birdsall, C. (2009). "Earwitnessing: Sound Memories of the Nazi Period." In K. Bijsterveld and J. van Dijck (eds.), *Sound Souvenirs: Audio Technologies, Memory and Cultural Practices* (pp. 169–181). (Transformations in art and culture). Amsterdam: Amsterdam University Press.

Birdsall, C. (2012). *Nazi Soundscapes: Sound, Technology and Urban Space in Germany, 1933–1945*. Amsterdam: Amsterdam University Press.

Brenner, L. (2010). *51 Documents: Zionist Collaboration with the Nazis*. Barricade Books.

Bytwerk, R. L. (2005). "The Argument for Genocide in Nazi Propaganda." *Quarterly Journal of Speech* 91 (1): 37–62.

Campion, K. (2023). "Defining Ecofascism: Historical Foundations and Contemporary Interpretations in the Extreme Right." *Terrorism and Political Violence* 35 (4): 926–944.

Chang, M. H. (2001). On Nationalism. In *Return Of The Dragon*. Routledge.

De Boise, S. (2022). "Digitalization and the Musical Mediation of Anti-Democratic Ideologies in Alt-Right Forums." *Popular Music and Society* 45(1), 48–66.

Deschenes, J. (1986). Commission of Inquiry on War Criminals, Report – Part I: Public ("Report"), Chapter I. pp. 3–17. Accessed via Government of Canada Jan. 18, 2024. https://publications.gc.ca/collections/collection_2014/bcp-pco/CP32-52-1986-1-eng.pdf

Fanon, F. (1965). "This Is Algeria." In *A Dying Colonialism*. New York: Grove Press.

Fontaine, T. (2014). *Colonial Genocide in Indigenous North America*. Durham, NC: Duke University Press.

Giocoli, N. (2003). *Modeling Rational Agents: From Interwar Economics to Early Modern Game Theory*. Cheltenham/Northampton: Edward Elgar Publishing.

Gramsci, A. (2011). Prison notebooks volume 2 (Vol. 2). Columbia University Press.

Grekul, J., Krahn, H., & Odynak, D. (2004). "Sterilizing the "Feeble-Minded": Eugenics in Alberta, Canada, 1929–1972." *Journal of Historical Sociology* 17(4), 358–384.

Hinojosa, R. (2010). "Doing Hegemony: Military, Men, and Constructing a Hegemonic Masculinity." *Journal of Men's Studies* 18 (2).

Jewish Voice for Peace. (n.d.). *Our Approach to Zionism*. JVP. Retrieved October 2, 2024, from https://www.jewishvoiceforpeace.org/resource/zionism/

Kakel, C. P. III (2011). *The American West and the Nazi East: A Comparative and Interpretive Perspective*. London: Palgrave Macmillan UK.

Kuhl, S. (1994). *THE NAZI CONNECTION: Eugenics, American Racism, and German National Socialism*. Oxford: Oxford University Press.

Laclau, E. (2005). *On Populist Reason*. New York: Verso.

Lekan, T. (1999). "Regionalism and the Politics of Landscape Preservation in the Third Reich." *Environmental History* 4 (3), 384–404.

Lux, M. K. (2001). *Medicine That Walks: Disease, Medicine, and Canadian Plains Native People, 1880–1940*. Toronto: University of Toronto Press.

McLaren, A. (1990). *Our Own Master Race: Eugenics in Canada, 1885–1945*. University of Toronto Press.

Miller-Idriss, C. (2020). Soldier, Sailor, Rebel, Rule-Breaker: Masculinity and the Body in the German Far Right. *In Gender and the Radical and Extreme Right* (pp. 67–83). Routledge.

Mudde, C. (2007). *Populist Radical Right Parties in Europe*. Cambridge: Cambridge University Press.

Mudde, C. (2021). *Populism in Europe: An Illiberal Democratic Response to Undemocratic Liberalism*. (The Government and Opposition/Leonard Schapiro Lecture 2019). Government and Opposition, 56(4), 577–597.

Muller, J.-W. (2016). *What Is Populism?* Philadelphia, PA: University of Pennsylvania Press.

Nye, R. (2007). "Western Masculinities in War and Peace." *The American Historical Review* 112 (2), 417–438. https://doi.org/10.1086/ahr.112.2.417

Nixon, Benjamin Simonds. (2020). "Blood and Soil: Right-Wing Terrorism Poses an Existential Threat to the United States." https://doi.org/10.7282/t3-wr2s-7k13.

Said, E. W. (1994). *Culture and Imperialism* (1st Vintage Books ed). New York: Vintage Books.

Said, E. W. (2012). *Representations of the Intellectual*. Knopf Doubleday Publishing Group.

Salamanca, O. J., Qato, M., Rabie, K., & Samour, S. (2012). "Past Is Present: Settler Colonialism in Palestine." *Settler Colonial Studies* 2 (1), 1–8.

Salzberg, B. (2019, August 18). *Is Justin Trudeau FEMINIZING The Male Species In Canada?* CAP. https://capforcanada.com/is-justin-trudeau-attacking-our-manhood-with-feminization-of-canadian-males/

Snow, D. A., Burke Rochford, Jr., R., Worden, S. K., & Benford, R. D. (1986). "Frame Alignment Processes, Micromobilization, and Movement Participation." *American Sociological Review* 51: 464–481.

Stanton, G. (2020, September 9). QAnon is a Nazi Cult, Rebranded. *Just Security*. https://www.justsecurity.org/72339/qanon-is-a-nazi-cult-rebranded/

Squire, M., & Gais, H. (2021a). *Inside the Far-Right Podcast Ecosystem, Part 1: Building a Network of Hate*. Southern Poverty Law Centre. https://www.splcenter.

org/hatewatch/2021/09/29/inside-far-right-podcast-ecosystem-part-1-building-network-hate

Squire, M., & Gais, H. (2021b). *Inside the Far-Right Podcast Ecosystem, Part 3: The Rise and Fall of the Daily Shoah*. Southern Poverty Law Centre. https://www.splcenter.org/hatewatch/2021/09/29/inside-far-right-podcast-ecosystem-part-3-rise-and-fall-daily-shoah

Srnicek, N. (2017). *Platform Capitalism. Nick Srnicek*. Cambridge: Polity Press.

Sseremba, Y. (2023). *Zionism, Nazism and the Intersection of the Two Genocidal Ideologies*. https://misr.mak.ac.ug/news/zionism-nazism-and-the-intersection-of-the-two-genocidal-ideologies

Staudenmaier, P. (2001). "Fascist Ecology: The 'Green Wing' of the Nazi Party and Its Historical Antecedents." *Pomegranate* 15(Winter), 4–21.

Stern, Alexandra Minna. (2019). *Proud Boys and the White Ethnostate: How the Alt-Right Is Warping the American Imagination*. Beacon Press.

Stevens, S. (Ed.) (2014). "Introduction." In S. Stevens (ed.), *Indigenous Peoples, National Parks and Protected Areas: A New Paradigm Linking Conservation, Culture and Rights*. University of Arizona Press.

Stoler, A. L. (2022). Archiving Praxis: For Palestine and Beyond. *Critical Inquiry*, 48(3), 570–593. https://doi.org/10.1086/718625

Szenes, E. (2021). Neo-Nazi environmentalism: The linguistic construction of ecofascism in a Nordic Resistance Movement manifesto. *Journal for Deradicalization*, (27): 146–192.

Warner, R. (2008). A Comparison of Ideas in the Development and Governance of National Parks and Protected Areas in the US and Canada. *International Journal of Canadian Studies*, (37), 13–39.

Woolford, A., & Benvenuto, J. (2015). Canada and colonial genocide. *Journal of Genocide Research*, 17(4), 373–390. https://doi.org/10.1080/14623528.2015.1096580

Zechner, J. (2011). "Politicized Timber: The German Forest and the Nature of the Nation 1800–1945." The Brock Review 11 (2), 19–32.

12
MYTHIC SONIC BEINGS

A Multitrack Conversation

Alex E. Chávez, Cog•nate Collective (Amy Sanchez Arteaga and Misael Diaz), Sandra de la Loza, Monica De La Torre and Josh Rios

This conversational essay, which borrows and transforms the structure of a conference panel, centres co-authorship. It eschews the authority of the single narrator in favour of something more like an ensemble, a space of being with others and listening. This intersecting moment of sonic scholarship is offered to you in the spirit of imagining new histories, concepts, practices, and forms of conviviality. As Lucia Farinati and Claudia Firth note in *The Force of* Listening (2017), listening is not something done in isolation but is "a passage or a bridge that we need to construct together through acts of exchange" (p. 22). Each of the participating conversants have a long-term investment in thinking about and making work in relation to the politics of sound, emplaced listening, and what "minor figures" go unheard or are silenced within dominant culture (Hartman, 2019, p. xv). As autonomous interdisciplinarians, their projects take an array of forms—activism, autoethnography, exhibition making, community work, writing, public intervention, workshops, and performance. While I encourage you to learn more about them through personal research, an invitation into the context of the conversation can be found at the beginning of the volume, by way of short biographies.

Beyond its collaborative qualities, Farinati and Firth also make an important point about the dangers of listening. "Listening is risky," Farinati and Firth write, "in that it might require change from us. Change that can be painful, frightening or difficult" (p. 22). In this case, listening requires making considered choices about the forces we allow to potentially change us, without knowing what that change will entail. It is risky and a great commitment necessitating trust. I can easily say, having worked previously with each of the participants on an individual level, they have changed me and my thinking regarding sound, what constitutes knowledge, and what it means to

DOI: 10.4324/9781003348528-19

work and be with others, for which I am grateful and privileged. Gathering with people is the unending work of transforming ourselves and the material and symbolic conditions of social life, sonic or otherwise. Our exchange was shaped, and continues to be shaped, by an interest in being changeable by way of each other's practices. It's important to note that the conversation below was originally transcribed from a single live event then edited after the fact for clarification, readability, and out of respect for each other and you.

(((Sounds of Crossing)))

Josh Rios: I thought we might start with the book title, which provides some powerful terms for thinking. What comes up for you all regarding situated forms of listening and attending to the unheard?

Cog•nate Collective, Misael Diaz: We're both children of migrants who grew up crossing the border. My family travelled a lot between Los Angeles and Tijuana. That experience of moving through space, listening to music and stories in the car, influenced how we think about the connection between site and sound. This gave rise to an interest in the histories of sound and sonic technologies, specifically radio technologies at the border, like "border blasters." My dad casually mentioned one day he grew up listening to Wolfman Jack on the radio in Tijuana. My understanding at the time was that oldies radio and Wolfman Jack was a Southern California and Central Valley thing. But it was the opposite. Learning this sparked an ongoing exploration into the way sound transcends and establishes connection beyond borders. Our work ties stories and experiences of migration to specific locations. How does sound establish and facilitate connections across space and time?

Border blasters refer to specific historical radio stations that broadcast from Mexico for a primarily, though not exclusively, U.S. audience.

Cog•nate Collective, Amy Sanchez Arteaga: In terms of attending to the unheard, we're also interested in where and how silence occurs in the [US-Mexico] borderlands. What narratives have been historically pushed to a place of silence? How can we engage those gaps and be attuned to forms of silence or silencing that often correspond to colonial or repressive projects? A lot of our recent work has been attending to stories born from our family's experience of migration, which are also tethered to larger macro phenomena and politics. We're thinking about the abstract

and symbolic nature of borders through collaborative experiments with technologies and the community. This has meant working in places like swap meets, public markets, and at the San Ysidro Port of Entry.

JR: We'll talk more about this later, but can you say a little about your work at the San Ysidro Port of Entry, which is this intense international crossing point between the U.S. and Mexico, one of the busiest land border stations in the world.

CC, MD: The "border blaster" radio we did at the port of entry used a hyper localized FM transmitter to broadcast stories exploring the evolution of the border from the perspective of ambulant vendors who work there and through testimonies of migrants who shared harrowing, traumatic, and life-threatening experiences of crossings the Sonoran Desert—a consequence of border militarization and restrictive immigration policies. Tens of thousands of people line up at the port of entry and wait for long periods to cross from Tijuana to San Diego. But there is very little interaction between anyone. Radio and sound became a way to facilitate different opportunities for collective listening. This was a way of understanding the act of crossing, not just as an individual journey, but as part of a collective, a way of transgressing a boundary that seeks to divide people, territories, and communities.

Monica De La Torre: My own gendered experiences attune me to listen to women's stories, the folks that have been marginalized. A lot of what gets talked about in terms of activist or movement work is very much codified as male. Male leaders get identified. I really wanted to challenge that impetus to name a founder and be more in touch with collective narratives. Even though my book does focus on certain individuals, I really wanted to listen to the collective experience of what it meant to have a radio station specifically built for a Spanish speaking migrant farmworker community in the Pacific Northwest. In a lot of ways, situated listening brings up issues of gender, race, class, sexuality, and how our own embodied practices of listening affect how we listen.

The radio station Monica is describing is Radio Cadena or KDNA 91.9 FM, the subject of their recent book.[1]

Sandra de la Loza: My practice has unfolded in a relatively specific geographic region, what we now call Los Angeles [the historic lands of

the Tongva, Gabrielino and Kizh]. I've spent a lot of time working to understand that space and learning to situate myself in a built environment created by dominant forces. I'm also intentionally moving to the interstitial and the unbuilt. A lot of my work is research based and archival. It's in the archive that I find fragments, clues, and hints of erasures. In relation to situated listening, doing site specific visits, walks, conversations, photoshoots, and field recordings allow for other ways of listening. The sounds that unfold in space remind me of the complexities of the unmapped, that place and space is not static, that it is constantly changing, moving, and shifting. The sounds that come in and out of it help me disrupt the narrative patterns erected and solidified in our collective imagination, what we call history. Situated listening is a methodology and a tool to help disrupt what we think we know.

Alex E. Chávez: Situated listening also invokes the question of place. Placial context is always a necessary question because the work we're all dealing with attends to the broader Latina/o/x community. That's always a placial question, because it concerns the nation, however we think about that, which itself has very finite and allegorical borders. That cascades into other concerns around citizenship, race, and the refusals and disruptions therein. My previous big project around migration and *huapango arribeño* traced how this particular sound existed across multiple places and how it allows for cultural adjacencies. Whether it's in the middle of Central Texas or San Luis Potosi, this sound binds multiple places and people together.

Huapango arribeño is an expressive genre of music and poetry originating in north-central Mexico.[2]

In terms of my work on Chicago, I'm looking at multiple sounds in one very specific place, yet I think similar questions apply. In both projects, I consider situatedness, expressive cultural forms, and place with an attentiveness to what's heard and unheard. One thing I've been considering is how Chicago's cultural poetics about itself has been rendered by a certain white literati that championed the blue collar proletarian, calling out romantic images of the stockyards and steel mills of yesteryear. The subject at the centre of that narrative is the immigrant, but it's of a very specific ethno-national lineage, white Europeans. It's not African Americans coming from the South to Chicago in the wake

of Reconstruction and Jim Crow. It's certainly not Latinxs or people from Latin America.

I teach Latinx Studies and studied these topics in graduate school. I found it to be a problem that when I arrived in the Midwest, I didn't understand Chicago as one of the most Mexican cities in the U.S., home to the sixth largest population of Latinos, second largest group of ethnic Mexicans in an urban area outside of East Los Angeles. Yet, we don't locate Chicago as such in the national imaginary. What makes that silence possible?

JR: Latinx Studies is such a complex and broad field of research and production. Because it focuses on Latin American and Mexican diasporic experiences, past and present, within the geo-political space and history of the U.S., it's kind of a cultural geography project as much as anything else. Clearly, the role power dynamics play in rendering something heard, unheard, or silenced is important.

(((The Unheard and the Silenced)))

CC, MD: Often it's not a question of silence; it's certain sounds being amplified over others. Specifically, our work thinks about how the border is authored—often from places radically disconnected from the actual experience and realities of communities that are living and crossing it. We find ourselves providing platforms and opportunities for closer listening to stories that have been drowned out, those narratives and sounds that are lost in the fray, not accidentally, but by design.

CC, ASA: I was also thinking about the difference between being unheard and being silent. In Eve Tuck and Angie Morrill's (2016) essay, "Before Dispossession, or Surviving It," they write, "The opposite of dispossession is not possession. It is not accumulation. It is unforgetting. It is mattering" (p. 2). There's something resonant in thinking about how we address being dispossessed of the ability to be heard.

JR: This is such a powerful provocation, "how do we address being dispossessed of the ability to be heard?"

MT: In terms of labelling something unheard versus silent, I also found that distinction curious. To say it's unheard means it was audible. It doesn't mean that it didn't exist. That's important because when we use the word silence, it assumes

	the thing doesn't exist or that it never had a presence. The idea of the unheard establishes a presence. I like that question, what does it mean to be unheard versus silenced?
JR:	And what does it mean, not to be so much silenced or unheard, but silent? There are times when one might want to go unheard. It could be a matter of strategy, survival, or a way of sonically operating in fugitivity.
SL:	I also think about how narrow our human spectrum of hearing is compared to the sound that is alive and exists around us. In my own research I'm trying to decentre the human and look at the human in relationship to whole ecosystems. Within the urban environment, ecosystems have been concretized and ploughed down, but are also thriving in interstitial spaces. In the case of Los Angeles, I've come to know the flora and fauna. There are 19 species of bats that live in the city. They travel through echolocation, emitting high frequency sounds that bounce off things. Those frequencies are often above the frequencies humans can hear. It's important to remind myself and to contemplate that there is a whole soundscape operating around me I may be oblivious to.
JR:	This is an important challenge to both our Western- and human-centric modes of understanding. The two perspectives are often entangled. Sandra, in a previous conversation you shared this great thought, "sound is not just heard, but it's somatically felt," which made me think about the privileging of the normalized so-called "human," non-disabled ear.
AEC:	Being attuned to sound or privileging the sonic really does involve a lot of other non-auditory or multisensory aptitudes that aren't just about what you hear. To your point, it's somatic; it's haptic. There are wider dispositions that are cognitive, embodied, or affective.
CC, ASA:	Returning to Sandra's comments about the bats, we've been making recordings of very low frequency radio waves, which are naturally occurring because of the interaction between solar flares and the earth's atmosphere. It's this other cosmic border between our earth and outer space. To record these waves, we have to travel far away from cell towers or other technologies that interfere with the special receivers we use. As I'm listening to those natural radio waves and making those recordings, which sound like ghostly clicks and pings,

I sometimes imagine what it's like to be a creature with a more heightened ability to hear. I pour my imagination into this different ontological container.

Something I've been afforded through those experiments is the opening of a space of *sentipensamiento*. It allows us to pose pedagogical questions to people intergenerationally and in an embodied way, to consider the sounds and radio waves that are naturally occurring as these quasi-envoys of interstitial sites and liminal states that run counter to the fabrication and imposition of colonial borders.

Sentipensamiento references Sentipensante, a sensorial and intellectual way of knowing or sense/thinking, as articulated by Laura I. Rendón[3] *and Orlando Fals Borda,*[4] *among others.*

(((Mixing Board as Archive)))

JR: The fabrication and imposition of a colonial border links in my mind to the fabrication and imposition of a so-called "universal listener" or "listening subject" who is situated in relation to certain structures and containers of knowledge, all of which also strike me as colonial. I don't think it is a coincidence that we all have some kind of archival practice animated by activism or a critical, creative framework. I'm wondering how these ideas of silencing, being unheard, or even the expansion of listening to the affective and embodied register impacts our thinking around the archive? You have this amazing quote in your book Monica (2022), "The archive is also an instrument that gets played and silenced in various ways," which makes me think about listening, the unheard, the sensorial, and how to engage the archive creatively (p. 11).

MT: When I started my work, I went to the archive and typed in Chicano radio and got zero results. I'm speaking about the "official archive," the documents and artefacts housed and controlled by institutions like universities, libraries, and government organizations. There is this thing I know exists, but it also supposedly doesn't. I realized it wasn't silent, it was unheard. I had to take a step back and think about what it means that the thing I'm interested in doesn't exist in the archive? In constructing an archive you're doing

something akin to music production. When you turn one fader up and you turn another down, you're attuning to difference, you're making choices. I think archival practices are the same. The archive is something that gets played and replayed. You return to it. You re-listen. You're picking this really narrow subject that takes you down a deep rabbit hole and you have to choose when and where you want certain notes to come out. Those choices stem consciously or unconsciously from our lived experiences. I focused on women not just because they were silenced or unheard in the archive, but because of my own experience knowing that women play an important role within movement work. I feel archival work has so much in common with musical production and I really want to explore that, not just by myself but in collaboration. Scanning documents and finding and listening to tapes, I thought there was a sense of play in that.

JR: I love that your site, feministafrequencies.com, gathers digitized audio of actual vintage radio programs from Radio Cadena. You really get to hear the grain of that era and what was important to that community. It's such an important online archive and teaching tool that adds listening to the ways folks can engage your book and that history.

SL: Thinking about the silences in the archive or the silences versus the unheard, it's also important to talk about those presences and fragments we find. My exhibition, *Unsettling the Settled: Archival Glimpses of* Abolitionist Futures (2021), focused on the Lincoln Heights Jail, which was the principal jail in L.A. from the 1920s through the 1950s/1960s, before it was decommissioned. In the 1990s community members secured the first floor of the building and opened the Aztlan Cultural Arts Foundation. It was opened in 1992, after the riots that erupted when the police who beat Rodney King were acquitted, despite televised video documentation.

 I frequented the Aztlan Cultural Arts Foundation back then and was part of the collective that ran it. For the exhibition I collected documentation from various community members to begin to build out and share an archive. It was interesting listening to archival material that I had

experienced in person 20-something years ago. It was great to re-experience those live gigs, like the Guateques, for example, which were concerts organized by immigrant youth that hosted a burgeoning Rock en Español and Ska scene extending from L.A. to Baja California. And the Farce of July organized by a Chicano hip hop group, Aztlan Underground, documented through video by filmmaker Elias Serna. To hear and see recordings of these gigs 25 years after the fact creates an immediacy.

At the same time, it's uncanny. Re-experiencing a history that I was a part of through archival material spurred my own awareness of shifts that have occurred in grassroots community and cultural organizing from the 1990s to the present, in how we politic, the language we use, the tones, the feel of culture, and community organizing. In the case of L.A., a lot of community organizing is now in the hands of nonprofit organizations. You don't have the grassroots groups that you had back then. Listening to that fragment in the archive offered insight into subtle, yet substantial, and often unacknowledged, cultural and political shifts. It helped me disrupt my own understanding of that history.

MT: There's an important distinction Sandra illuminated. You created the archive, you collected it. When we talk about archiving, we may think about the traditional, the sanctioned, or the official archive. I'm invoking Ann Laura Stoler's work.[5] I think a lot of us who are doing this work are pushing against that narrative. I find it fascinating that the archive we're all creating in our own work really doesn't belong to an institution. It's unbound in certain ways. I've been mindful of trying not to align my archive with an institution because institutions change things; they co-opt things; they create boundaries and barriers to entry. In producing archives that we control and that are independent, we are continuing this tradition of listening to things that are *unheard*.

AEC: Thinking about the archive and this analogy of making or mixing a record is really fun. You turn certain things up and down because you want to capture and amplify a particular kind of sonic representation, in this case, an archive that tells a story. Regarding my current artistic work with

| | [activist, musician, and producer] Quetzal Flores, he asked if I had field recordings that were meaningful to me. I have too many. I've recorded sound, music, and interviews for over a decade. He asked me to bring some to the studio. We ended up sampling and incorporating them into the sonic bedrock of certain songs. This approach frees you up from having to talk about the "thing/experience" because you bring that literal sonic reference into the mix. I no longer have to explicitly mention Rioverde, San Luis Potosi, because a sample of me walking in San Luis Potosi is featured in the song. We used samples of interviews, sounds, and relatives that have since passed away, that are now all part of this blanket and bedrock of something lovely.
| | Related to the material aspect of an alternative archive, I'm doing work on vinyl records and sonic artefacts. In music production when people say sonic artefact, they mean a disturbance in the recording. If you're playing something back and hear distortion, or something odd, that's an artefact. You tend to take that out. I'm using that metaphor to think about vinyl as an actual sonic artefact, as a different kind of curatorial device through which sound selectors demonstrate and tell the story of migration, mobility, and settlement.
| CC, MD: | I really like how Alex is describing vinyl records as artefacts, and the importance of having a tangible thing to hold in relation to the sonic experience of listening and how listening gives us access to layers of experiences that are no longer physically present, but that we can still engage through echoes and sonic traces.

(((Listening on the Move)))

| JR: | In relation to how spaces and places change and what sound and listening can bring to a multi-layered set of experiences, I thought Misael and Amy might talk about their projects *Dialogues in Transit* (2014-present) and *Future Echoes* (2019). Both use radio in very specific ways to engage communities of listeners within contested geo-social sites.
| CC, ASA: | *Dialogues in Transit* started out as a series of invitations to artists, musicians and scholars to ride in our car as we

waited in line to cross the U.S.-Mexico border through the San Ysidro Port of Entry. Using short-range FM transmitters we live-broadcast our conversations exploring different dynamics and polemics relating to borders. We wondered if radio could serve as a tool to transform an isolated mass of individuals—each in their own car and their own world—into a public of listeners.

JR: How and where you broadcast these conversations is important, from your car. You had the call number of your localized roaming station posted, 87.9 FM, so other drivers could see it and tune it.

CC, ASA: When we were waiting in line at the border this thing kept happening where cars next to us would honk because they wanted to get our attention to let us know they were into a story or a song or something else that we were broadcasting. In that moment we became a fleeting public, intentionally attuned to the sounds and aesthetics of the space of movement and migration we shared.

CC, MD: There is an important distinction between hearing and listening. Someone can be talking to you, and you ostensibly hear them, but you can also not be listening. We've tried to engage this idea by asking ourselves what infrastructures can artists and cultural producers create to make time and space for impactful, resonant, and even transformative listening.

Future Echoes was a site-specific public radio installation we created in the neighbourhood of Little Tokyo in downtown L.A. The broadcast, localized to a specific block, explored the ways residents have confronted and resisted displacement including the colonial displacement and missionization of Tongva peoples, the mass deportation of Mexican and Mexican-American residents from neighbouring communities during the Great Depression, the incarceration of Japanese and Japanese-American residents during WWII, and more recently, threats relating to urban redevelopment and the housing crisis.

As part of the project, we commissioned local authors and poets with neighbourhood ties to create speculative visions for the block's future. It was a way of inviting listeners to imagine and enact a future that does not require the imposition of a singular identity but is built on the basis of shared struggles and solidarity.

CC, ASA: We seized this typically hegemonic technology of radio to question and disrupt how we're grouped and how we group ourselves into communities, to speak with and listen to one another in novel ways, and to see and hear ourselves as speculative communities brought to life in that moment of dialogue. This is related to our interest in notions of cultural citizenship and the way transnational migrant communities are constantly opening up informal pathways for political participation and individual and collective agency. It demands we reimagine who is seen and understood as a U.S. citizen.

JR: And who is "heard" as a U.S. citizen, as well. I'm thinking of Jennifer Lynn Stoever's work around the sonic colour line.[6] In your work on Spanish and bilingual activist radio broadcasting for agricultural workers, Monica, it also matters where people are listening to the radio.

MT: They're listening in the fields because of the transistor radio. That sound is so mobile is another really important point for all our work; its mobility, its accessibility, and the fact that we gravitate to narrative. For me, what radio did specifically for Mexican, Mexican American, and Tejano/a communities in the Pacific Northwest was to signal their presence. Even to this day when I talk about my work and I talk about how one of the first full-time Spanish language community radio stations in the U.S. was in the Pacific Northwest, not in L.A., not in Texas, not in Arizona, people are surprised. What specifically these Chicano radio stations did in the seventies was to explode the notion of Latinos only being in the Southwest.

JR: Thinking of situated listening, taking the specificity of the listening subject into account can give us a different cartography of migration history and an under-examined picture of who is where.

MDT: Early on Radio Cadena was doing national news. They had people calling in from other radio stations across the country to talk about whatever news story they wanted to discuss. They would record the stories, edit them together, and play them back to other stations. These weren't Spanish translations of English news, but their own news specifically for the community. That's where you really see Radio Cadena connecting to the community they invited to be their listeners.

AEC:	This reminds me of Anna Maria Ochoa Gautier's idea of the aural public sphere (2014). Radio can invoke different kinds of publics; it can animate certain types of congregation. I've been working with a youth arts-education group in Chicago, Yollocali, who do everything from public murals to gardening to photography. One thing they are involved in is sound design and podcasts. Not only are they learning about media production and technological literacy—which are valuable skills—they're also encouraged to amplify their own stories. They use these tools to talk about how they live in and experience the city as young people of colour. The students, who are mostly Latinx (though not exclusively), deal with the brunt of dysfunctional city politics: the underfunding of schools, the constant policing and surveillance, urban renewal, gentrification, and all the rest of it. They use this forum in ways not dissimilar from how I imagine people in the 1970s and 1980s were using small radio stations to talk about what was going on in their lives, giving voice to the things that were important to them. There's an echo of people doing similar things decades later which creates this field of exchange.

SL:	I really appreciate the stories of migratory sound embedded in all of your work and how sound circulates and moves along with people on a real and accessible level, in the infrastructure of community radio, for example. I'm also interested in how often that story of migration is a northward story. What about how sound migrates south?

CC, MD:	Folks like my dad grew up in the 60s listening to rock and roll from the U.S. Although it was produced primarily for a U.S. audience and was being broadcast from Mexico, it inspired local bands in Tijuana to record cover versions with Spanish lyrics. Growing up I've heard songs in English that I swore were cover versions of Spanish songs. But it's actually the other way around. I am constantly asking, who is covering who? There's something important and interesting in this practice of listening to sound and making it your own, mobilizing it in different ways, remixing it in ways that can become affirming to one's identity.

CC (ASA):	I remember being in the eighth grade and almost fighting another kid in my class because I really thought that Achy

	Breaky Heart [Billy Ray Cyrus] was a cover of Caballo Dorado's "No rompas mi corazón" and not the other way around.
JR:	That's hilarious.
AEC:	Regarding how sound moves north to south or back and forth in relation to popular culture, I am thinking about my father who migrated from Querétaro, Mexico to Texas. He was a working musician all his life. I'm in awe about what he did as an artist with his bandmates who were also undocumented Mexican migrants. They were signed to Freddie Records out of Corpus Christi, Texas, which was also the first record label to sign Selena. It's part of this 1980s ecosystem of homespun Texas-Mexican record labels that supported regional artists. My father played what we would call *Musica Grupera*, which included everything from ballads, to cumbias, to *musica tropical*. A number of artists who were migrants and part of that musical landscape in the 1970s were first "discovered" in the U.S., and then would go on to make it big in Mexico. A good example is Rigo Tovar who was discovered in Houston, Texas. He then becomes this huge superstar in this *Onda Grupera Cumbia* scene. There's a litany of borderlands musicians who became successful along similar lines—Chelo Silva comes to mind. It's a history that troubles how we imagine flows of music and the politics of cultural and musical authenticity. Where do these sounds actually emerge from, what places, what communities, and why do we so easily label all of it *Música Mexicana*? Los Tigres del Norte is another great example. All their career they've been making their music in California. Los Angeles is the epicentre of the narco-corrido industry.
	When I teach my class on music, I have students rethink their taken for granted cultural atlases regarding where sounds are located and where they're "from," because they can be from multiple places. As they dig deep into that, I try to convince them that the U.S. is part of Latin America, full stop. You can't convince me otherwise, particularly if you are thinking about music. All these examples are mitigated and mediated through particular kinds of technologies that create audiences and publics that facilitate flows

	north to south and south to north. It's about how all this is being consumed, sure, but also how it invokes community, reaches and speaks to people, and creates moments of congregation.
SL:	I'd like to hear that playlist, Alex.

(((The Sonic Commons)))

JR:	This all makes me think of the idea of the commons, especially if we conceptualize history as a type of commons, the history of these specific musical genres or trajectories, for example. There's a way in which we all participate in their fashioning and stewardship. I'm curious what kinds of thoughts the commons might unlock for us in relation to the unheard and situated listening and Anna Maria Ochoa Gautier's aural public sphere.
AEC:	Implicit in this idea of the sonic commons is a politics of legibility, which invokes a certain shared-ness. It's about claiming space in ways that extend citizenship beyond the rights afforded by the state. We're asserting a presence achieved sonically through the shared-ness of being heard. I've thought about it in those ways, particularly in the context of the neoliberal shrinking of public space. How do the commons get sonically ratified or sanctified in different ways? I am invoking Fred Moten, et al., when thinking about the more recent agentive and active exercise of commoning.
SL:	In the last ten years, my neighbourhood, Highland Park in northeast Los Angeles, has been the fastest gentrifying neighbourhood in the city. The summer I moved back, about nine or ten years ago, twenty old-school neighbourhood stores went out of business in three months, all within a four or five block area. The scale and pace is greater than anything I have witnessed. It's strange and difficult to experience the displacement of a whole community, the disappearance of neighbours and neighbourhood stores, the disappearance of the aesthetics of a place, the absence on a street corner that not too long ago was a space where elders gathered and played dominos. There're many ways in which the community that hasn't been gentrified or the community experiencing gentrification claims space. Every now and then when I'm walking down Figueroa along comes an old Monte Carlo cruising, subwoofers blasting

	music, deep bass bumping and shaking windows. For me, that's a way that a sonic common cultural expression occupies space in the gentrifying neighbourhood.
CC, MD:	That resonates with how we've been thinking about sound and its relationship to spaces of belonging. The cruising lowrider is part of this sonic landscape that crafts a sense of home, that feels like *algo propio*, like something that's our own. We've been interested in exploring the connection between sound and home as a way of also getting at some of these questions around belonging, citizenship, and cultural citizenship.

One of the conversations we facilitated as part of our exhibition, Regionalia (2018), responded to the simple prompt: what does home sound like? For a few people it detonated all these memories of being young and waking up in your house to [the Mexican Grupero band] Los Bukis blasting because your mom or parents listened to that while they cleaned. For several of us, that memory embodied a sense of feeling at home and being safe. The conversation started in the domestic space of the home and expanded to how we create a sense of belonging at the scale of the city, thinking about the ways that lowriders and cruising or even the sonics of backyard parties connect us to a place. All of that is related to the notion of the sonic commons and crafting a sense of belonging through sound.

MT: I really identify this idea of the sonic commons as a longing or desire. You're searching for something. In a lot of ways that's applicable to all of us. There's this desire driving our work to either listen to something that we know we have heard before—to go back to that sense of home—or to listen for something that we've not heard but know exists. A lot of that can be generational. We pass on these longings at the cellular level. For me the church bell is one. When I'm in Mexico and I hear it, I feel I'm there. But I can hear it anywhere and immediately feel that I'm in that *Centro* or *Plaza*. I appreciate how it's connected to emotion. It's not logical; it goes against wanting research to be exclusively tangible and verifiable in the academic sense that values logic above all else.

AEC: I love this way of describing how you craft a sense of belonging. It's helpful to consider how visceral crafting that sense is. I love Sandra's example of the lowrider and the bass. That's a claim and assertion: we're here. Those of us

	who recognize those sonic references get it. We feel pulled in and identify with it. In a neighbourhood that's turning over in terms of gentrification, the fact that you still hear that might give you a sense of comfort. Oh yeah, that's still here, there's still a place for me here.
JR:	In a lot of ways this sonic image of the cruising lowrider and its auditory call brings us back to the notion of the situated listener, both spatially and culturally speaking, as well as what it means to attend to the unheard significance of that sound.

Living Crossfader, Embodied Mixing Board

Josh Rios

Take a walk through an area important or near to you. Listen for moments and locations where sounds overlap, for where and when you hear two sounds coming in and out of audibility and mixing as you move through space. Using a field recorder, or any device that can record sound, document what you hear but not from a fixed position. Make your recording as you move through space being sure to note the way sounds intersect, cross, and fade into each other. Embody the moving mixing board slider that blends sounds together. Record the process of moving into and through different sounds. Repeat this process until you have an archive of living crossfaded sounds. Ask others to build the archive of live crossfaded sounds with you. Share your sounds taking note of how you not only recorded what was occurring but used your creativity and body in process. Dispel the notion of the objective documentarian and embrace the performativity of the archive.

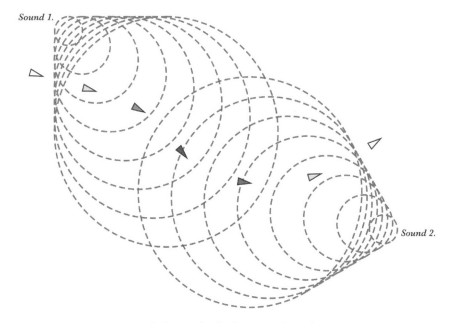

FIGURE 12.1 Living Crossfader, Embodied Mixing Board

Notes

1 De La Torre, Monica, *Feminista Frequencies: Community Building through Radio in the Yakima Valley* (Seattle: University of Washington Press, 2022).
2 Alex E. Chavez, *Sounds of Crossing: Music, Migration, and the Aural Poetics of Huapango Arribeño* (Durham, NC: Duke University Press, 2017).
3 Laura I. Rendón, *Sentipensante (Sensing / Thinking) Pedagogy Educating for Wholeness, Social Justice, and Liberation* (New York: Routledge, 2023).
4 Orlando Fals Borda, *Una sociología sentipensante para América Latina* (México, D. F: Clacso, 2015).
5 Ann Laura Stoler, *Along the Archival Grain: Epistemic Anxieties and Colonial Common Sense* (Princeton, NJ: Princeton University Press, 2008).
6 Jennifer Lynn Stoever, *The Sonic Color Line: Race and the Cultural Politics of Listening* (New York: New York University Press, 2016).

References

De La Torre, M. (2022). *Feminista frequencies: Community building through radio in the Yakima Valley*. University of Washington Press.
Farinati, L., & Firth, C. (2017). *The force of listening*. Errant Bodies.
Gautier, A. M. O. (2014). *Aurality: Listening and knowledge in nineteenth-century Colombia*. Duke University Press.
Hartman, S. (2019). *Wayward lives, beautiful experiments: Intimate histories of social upheaval*. W.W. Norton and Company.
Morrill, A., Tuck, E., & the Super Futures Haunt Qollective. (2016). Before dispossession, or surviving it. *Liminalities: A Journal of Performance Studies, 12*(1), 1–20.

13

THE SONIC SENSORIUM

Listening with the Un(der)heard

Marie Koldkjær Højlund and Morten Søndergaard

Practice-based research with sound, art, and technology is a part of the "practice turn" (Borgdorff, 2011, p. 51) in humanities and social sciences. However, most often "practice-research" is placed as something opposed to "thinking-research". In the following, we are renegotiating the traditional opposition inflating the idea that thinking is not a form of doing and doing is not a form of thinking (Fell & Gilmore, 2021, p. 9). This chapter introduces a structuring principle of meaning creation in complex systems of intermediation between sound, art, and techniques. Furthermore, the concept of "sonic sensorium" is proposed as a transductive layering of meaning creation in situated listening.

Practitioners working with sounding art are constantly faced with the traces and sounds of a chain of material translations between different entities, such as apparatuses used to deploy and empower situated listening. This experience uncovers the paradox that the sounding materiality possesses both thingness (Heidegger, 1977, p. 2), and at the same time constitutes an ambient and inconsistent "here and now". The constant tuning processes when working with sound offer a powerful and concrete manifestation of how we will never be able to unravel the essence of sound. Instead, we argue that practice-based research should not be concerned with reducing phenomenon and objects to consistent knowledge formations but should turn to the inconsistency within and between objects and situations (Højlund & Riis, 2015).

Situations, of course, raises the issue of context and what Haraway termed "a new objectivity", which frames her concept of "situated knowledge" stating that "we are also bound to seek perspective from those points of view, which can never be known in advance, that promise something quite

extraordinary, that is, knowledge potent for constructing worlds less organized by axes of domination" (Haraway, 1988, p. 587).

Throughout our chapter, this premise of constructing worlds as raised by Haraway in her seminal text will be revisited and renegotiated, exploring whether conducting situated listenings to cultures may be said to situate knowledge with which sustainable worlds are constructed in cultures that are un(der)heard. Not yet knowing or listening as situated knowledge opens towards a new perspective structured by (ultra)localities. By taking this position, we abandon the belief that we can distance ourselves from the world; and consequently, our engagement with objects becomes not a matter of producing knowledge about the world, but instead an ongoing process of not knowing or listening.

In more general terms, the questions raised are: How do we open our listening towards the un(der)heard? Which voices do we not hear? What registers do we not register? If the culture we are part of is not attentive to them, how should we be listening *with* them (rather than *to* them)?

More specifically, this chapter will address the un(der)heard cultures of the North Atlantic, the sea island cultures and their harbours as situaters[1] of meaning construction. As carriers of layers of listening, these (ultra)localities designate the journey into the "sonic sensorium": from Handbjerg Harbour near the place in the Limfjord in Denmark where Nordic ships left to sail the North Atlantic Ocean, to Orkney Islands, Faeroya Islands, Iceland, Greenland and the half-mythical Vinland (New Foundland).

The use of the concept of culture is introduced, and it is proposed, with a nod to Susan Leigh Star (Star, 1996) and Yves Citton (2017a), that listening can be understood as cultural structures of "filtering out" and exclusion. What apparatuses may inscribe, culture is filtering. This raises the question of cultures of techniques, and how techniques influence our listening. Then, we ask how such filtering may be described through structures of listening-as-attending, in-between people and apparatuses.

Cultures of Attending – Handbjerg Harbour, Denmark

On a boat in Handbjerg Harbour, Denmark, you are situated on the coast of Limfjorden it faces the exact spot where fleets gathered in the 6th to 9th centuries before sailing across the North Atlantic. Listening to the sound inside the boat, the wind and the water, the lines beating on the masts, fish trekking, birds of all kinds landing, soaring, hunting, surviving, proceeding to the next place on their way south or north (depending on the time of year). All locations in the North Atlantic are pass-through places, for animals with skeel or wings and humans in boats, always in motion, transformation. How do you know it is your turn when you are leaving the harbour or to be waiting in-line? Culture seems to structure how we live in everyday situations.

In approaching culture, the common notion is that culture can be understood as "a set of practices with symbolic and communal meaning" (Star, 1996). Yves Citton proposes to understand culture as a social structuring system operating various (mostly unconsciously layered) strategies of inclusion and exclusion. In particular, culture structures what we filter out from our "attention" – we give attention to what we value, and value what we give attention to (Citton, 2017a, p. 139). Therefore, culture structures what we do and do not do, and – more importantly for this chapter – what we do not listen to.

Culture not only structures which voices can express themselves and which ones are silenced or un(der)heard, but also filters our sensory capacities to receive and understand diverse voices. Where our traditional understanding of a culture of democracy privileges issues of freedom of expression, Citton highlights how freedom and capacity to receive is as important as the freedom of expression. This should not only be seen as an individual capacity but as a culture of collective capacities. Our sensibilities are collectively structured, as we project filters onto all environments. Citton coins this the "projective regime" that allows us, for example, to feel at home everywhere, since we tend to deny the diversity of places in our endeavour to find comparable features through an immunity against external stimuli, to protect ourselves from becoming affected (Citton, 2017a, p. 41). The extreme model of projective attention would be that of colonizing attention where we through projection of power delete local features to impose the colonizers standards (Citton, 2017b, p. 6).

In Donna Haraway's essay on Situated Knowledge, she argues how technologies, entangled into culture, similarly structure our "ways of life, social orders, practices of visualization. Technologies are skilled practices. How to see? Where to see from? What limits vision? What to see for? Whom to see with? Who gets to have more than one point of view? Who gets blinded? Who wears blinders? Who interprets the visual field? What other sensory powers do we wish to cultivate besides vision?" (Haraway, 1989).

However, according to Susan Leigh Star, culture is not stable but affects change over time. It might be added that it affects changes in the spatio-temporal setting of how we think, while in motion. She proposes, therefore, that it is also possible to think of culture operating on another level of "meaning altogether, as in cultured milk or yogurt: a small organism that affects change over time" (Star, 1996, p. 9). Culture, Star proposes, situates epistemic shifts in a series of motions and improvisations, as situatedness that engenders transformations, and at the same time serves as a sort of "memory system" of those transformations. Similarly, Haraway suggests how meaning can be shifted and shared in "partial" and "located" situations, as "local knowledges have [...] to be in tension with the productive structurings that force unequal translations and exchanges – material and semiotic – within

the webs of knowledge and power. Webs can have the property of being systematic, even of being centrally structured global systems with deep filaments and tenacious tendrils into time, space, and consciousness, which are the dimensions of world history" (Haraway, 1988, p. 15).

In this chapter, we aim to explore the concept of the "sonic sensorium", through a series of motions and improvisations that enact epistemic shifts via our situated listening. By tracing webs of knowledge and power, we attune ourselves to the un(der)heard sounds and voices on a speculative journey across North Atlantic localities, examining how the "sonic sensorium" reflects ultra-local cultures of technology. This approach allows us to reposition Donna Haraway's question – we seek to cultivate the sensory power of listening and ask how situated listening can reveal ways of life, social orders, and the limits of visual culture.

It is within these ultra-localities and their inherent tensions that we propose the "sonic sensorium" becomes operative. Situated listening emerges as the key navigational tool of the sonic sensorium, and these un(der)heard locations serve as testing grounds for rethinking world-making processes that are less dominated by global systems of power embedded in the visual culture of technology, which Haraway critiques in her seminal work. Through this lens, we revisit the skilled practices of technology that underpin Haraway's claim that meaning-making is always locally situated.

Motions and Improvisations across Water – Uyeasound, Shetland Islands, UK

When sailing across the North Atlantic Ocean in the 6thto 9th centuries, listening was essential – as part of the limited navigation tools available, and as the primary contact with the vast ocean. Listening indicated the direction of the wind, the movement of the boat in the waves and how the sail and masts were performing. Listening often gave first evidence of nearby land through the sounds of birds.

Uyeasound, as a site "below the horizon", represents a space of appearances that extend beyond conventional visual perception, where the mobility of ships introduces a non-visual mode of production. The act of navigating a vast ocean involves more than just relying on apparatuses of information – it transcends the idea of the ocean as a simple body of water that must be crossed. Instead, it becomes a visual metaphor, as Donna Haraway suggests, that challenges fixed appearances and invites an exploration of the complex apparatuses of visual production. These apparatuses include prosthetic technologies that interface with our biological senses to construct the images we use to understand the world (Haraway, 1988, p. 16).

This metaphor of navigation – especially across the North Atlantic – mirrors the inquiry into varied apparatuses of sensory meaning-making that

Haraway champions. We argue that this metaphor is critical to re-examining prosthetic biology, "übungsatlases" (survival guides), and the fleeting moments of visual culture that contribute to navigation as a form of sonic sensorium. The central question here is: What practices and structures are being cultivated by the sonic sensorium in the ultra-localities of this journey?

Uyeasound, or the fjord you first see, does not become a visual metaphor until it is actively located. The process of "becoming a location" hinges on being located – on the motion and experimental process of discovering and observing Uyeasound. This act of location requires a broader spectrum of knowledge production, which Haraway associates with the intricate machineries that process regions of the electromagnetic spectrum into the images we create of the world. She further explains that it is within these visualization technologies that we uncover metaphors and methods for understanding and intervening in the patterns of objectification in the world. These metaphors reveal the dual nature of scientific knowledge: its concrete reality and its semiotic and productive aspects (Haraway, 1989, p. 16).

Haraway's idea of "visual metaphors" is compelling because it connects the visual and non-visual, urging us to reconsider how we generate knowledge. Uyeasound, with its non-visual location below the horizon, offers an ideal space to explore this interplay. Ships, as mobile technologies of non-visual production, enable us to navigate not just the ocean's physical vastness, but its metaphorical and epistemic depths. This navigation invites us to think of perception not as limited to vision but as embedded in a broader sensorium that includes sound, touch, and motion.

The metaphor of navigation resonates with Haraway's call to interrogate the technologies of visualization that shape our understanding of the world. In this context, the sonic sensorium becomes a tool for navigating and interpreting spaces that are not easily visible or fixed, such as Uyeasound. By focusing on these "ultra-localities", we start to appreciate how cultures of technology and sensory engagement shape our understanding of location, knowledge, and the world itself.

Especially significant is how Haraway's metaphors emphasize accountability. The patterns of objectification she refers to are not neutral – they are deeply embedded in systems of power and representation. The sonic sensorium, therefore, can be seen as an intervention, a way to renegotiate these patterns by attuning ourselves to the un(der)heard, the unseen, and the overlooked. This creates new possibilities for understanding our world in ways that are not solely dictated by the dominant visual culture but are enriched by a more complex interplay of sensory and epistemic practices.

The Shetland Islands, during the 6th to 9th centuries, were the first natural harbour destination when crossing the North Atlantic, serving as a key hub in Scandinavian trade networks. These routes connected Greenland on one end to Byzantium and the newly established Kiev on the other. This extensive

trade web, spanning such distances, functioned within layers of pre-Western and pre-Christian cultures, where sensory experiences were largely shaped by the technological practices necessary for navigating vast oceans and rivers. Over time, as Western, Christian, and Latinized patterns of global domination emerged, these once global navigation technologies were transformed into (ultra)local practices.

By renegotiating Haraway's ideas, we revisit these ancient localities, investigating a pre-dualistic and pre-positivist worldview. The question arises: How does the sonic sensorium operate within these contexts? In a time when science was not yet split into rigid categories, the way sensory knowledge was produced and understood was markedly different. The sonic sensorium, therefore, invites us to explore how non-visual ways of knowing, rooted in sound and movement, navigated the complexities of these networks.

The questions posed at the beginning of the chapter – where to listen from? What limits listening? What to listen for? Whom to listen with? Who interprets the sonic field? – become vital inquiries within this historical and cultural motion. These are questions to be asked while in motion, actively locating places, and navigating a vast ocean of knowledge that is awaiting to be situated and understood.

Haraway's framework helps us reconsider how sensory knowledge – particularly listening – might have operated in these earlier contexts. The "sonic sensorium" offers a powerful tool for rethinking how people navigated their world before the dominance of visual and textual technologies. It emphasizes the importance of sound, rhythm, and movement as central to how people understood space, place, and power. This perspective is especially relevant today as we continue to challenge dominant narratives and seek more inclusive ways of understanding history, knowledge, and culture.

In asking where to listen from, what limits listening, and whom to listen with, we are not just engaging with sensory experience – we are engaging with a way of knowing that calls into question the structures of power and domination that have shaped historical narratives. By revisiting these ancient, (ultra)local practices, we are renegotiating our relationship with the past, asking what forms of knowledge were lost or marginalized in the transition to Western, Christian worldviews. The sonic sensorium, in this sense, becomes a tool for rediscovering and re-situating these forms of knowledge in the present.

Harbour Listening and the Phenomenotechnique of the Huldufolk – Thorshavn, Færøerne, DK

I am standing near the harbour of Thorshavn in Færøerne, listening. I am soon to climb the steep path leading to the nearby cliffs, a path leading me around the cliffs on the edge of the ocean waves 80 meters under me. This is

the place of the whispering Huldufolk, the people or beings said to be living in the stones of the cliffs on Faero Islands. They can make you drunk with sounds.

The whispering Huldufolk creates a web of un(der)heard knowledges in worlds constructed locally along the sailing path in the North Atlantic. Earlier in this chapter, the citation by Haraway reminded us that "local knowledges have [...] to be in tension with the productive structurings that force unequal translations and exchanges" (Haraway, 1988, p. 15). When listening to the Huldufolk whispering I literally do not hear anything. To hear the unheard, I need to attend to something that is completely outside the visual techniques and bioconstructed field of perception. Partial as it is, the web of the semiosis performed by the Huldufolk invisible in the stones sets in motion imaginations through listening to a world you cannot hear by convention.

The theorist Michel Chion proposed "reduced listening" as a term for engagement with non-representational sound, or rather, sound independent of its cause and of its meaning. (Chion, 1994, pp. 25–34). The non-representational status of listening to the Huldufolk mimics the situation where an electronic disconnection of sounds from their origins presents listeners with an unfamiliar experience of sound and its space (Chattopadhyay, 2017). But neither the Huldufolk nor the passage across the North Atlantic in an open sailing ship in the 6th to 9th centuries operates on any level of affirmation. It operates on attending to the techniques that are available, and on the motion and experimentation with listening to a world constantly under construction. The disconnect from any (stable) representation instils a sonic sensorium of a very different kind, unreduced or completely outside the circulation of cause and meaning.

The verb overhearing comes from Oferhieran from Old English, überhæren from Mittelhochdeutsch, or overhøre from Danish. Overhøre is an auto-antonym – as it has opposite or contradictory meanings depending on the context. It can both mean to over*hear*, meaning to zoom in your listening attention towards something that was not directed to you as information in the first place. And, it can mean a peripheral form of "not-hearing" – to *over*hear, where you vaguely sense the awareness of something, but as it is habituated you are capable of not giving it direct attention – you let it go – but you still know it's there, and you accept it being so. Outside the affirmative and representational, the repressive move of *over*hearing allows us to make a home in and through our habituated atmospheres – a home that is there, but to which we pointedly do not need to attend.

Brandon LaBelle, drawing on Michel Serres, introduces the concept of "the overhear" for its generative potential, emphasizing that it plays an essential role in shaping our everyday environments (LaBelle, 2011). Rather than considering the overhear as mere background noise or pollution, LaBelle positions it as the foundation upon which signals are heard, making

it an integral part of the relational process and a productive element in the transmission of information. The overhear forms the horizon to which all sounds are connected in open space, as there is always sound outside the immediate frame of listening. These overlapping sonic perspectives enrich our experience, promising a connection to the outside world. The act of overhearing deepens our sense of spatial surroundings, not just through conscious listening or visual cues, but by embedding us in an expanded auditory space. In this way, LaBelle suggests that the overhear enhances our freedom to act within a space.

This concept aligns with Susan Sontag's ideas, where listening can be approached both hermeneutically and erotically (Sontag, 1967). The erotic approach to listening is not about mapping or identifying spaces to gain an overview; rather, it involves immersing oneself in the sensorial richness of sound, appreciating its material diversity, and tracing imaginary pathways that reflect the ghostly and unpredictable nature of sound. Similarly, Freudian psychoanalysis proposes the method of free-floating attention, where, by not focusing too intently on what someone is saying, we can better grasp the deeper meaning behind their words. In this sense, by *overhearing* what is said, and instead *over*hearing* – allowing attention to drift around the words and resonate with unfamiliar meanings – we can transcend conventional interpretations. This resonates with the concept of "reduced listening", where we intentionally bracket our pre-existing knowledge of the world, ourselves, and others, to open ourselves to what is unknown (Citton, 2017a, p. 117). Citton further argues that this practice allows for the invention of an "excluded third", overcoming binary arguments and deadlocked alternatives by creating new possibilities within a politics of convivial dissensus (Citton, 2017, p. 120).

In this context, over*hearing* the whispers of the Huldufolk (Icelandic hidden people) becomes an imaginative act that escapes rigid taxonomies. The experience is guided by sensory filtering, inviting us to move and experiment freely with sound, reacting to its subtle nuances rather than categorizing or defining them. This openness to the overheard not only expands our understanding of sound but also broadens our engagement with the spaces and meanings that surround us.

The concept of the overhear, as described by LaBelle and others, highlights the richness of our auditory environment, where sounds outside our immediate focus are not simply noise but vital elements of perception. It encourages us to reconsider the boundaries of listening and to recognize that even those sounds we do not consciously attend to contribute to our sense of space, connection, and meaning.

In adopting an erotic or free-floating approach to listening, we embrace the idea that understanding often comes from what escapes our direct attention, what exists in the periphery. This echoes a broader philosophical stance

that meaning and knowledge are not always accessible through focused, deliberate observation but through an openness to the unanticipated and unknown. By engaging with sound – and with the world – through this lens, we may uncover hidden layers of experience, allowing us to navigate complexity and ambiguity in a more fluid and imaginative way.

Cultures of Techniques – Deildartunguhver, Iceland

> Standing on the edge of a hot spring in Iceland. Passing half the North Atlantic Ocean while in transit to this locality. Listening to the spring, the center of the earth sifting out, questioning what we really know about the world? Can a cultured world ventilate its layers? Recording all on the phone. Initially, the microphone picks up wind mostly but when the hot source erupts all the filters in the apps try to cancel out the sound of it, picking it up as 'noise'.

As practice-led researchers, we are challenged by obstacles when studying cultures of techniques. We are studying change, transformation. We are also looking at processes we largely cannot see or observe directly. We are limited by our body in that sense and left alone with our mind, so to speak. This, at least, is where the works we have chosen for this journey "pick our mind up", so to speak. They put our mind in an imaginative relation to hidden techniques, of nature and biological processes.

Approaching a phenomenology of technique since this is the most common and often also most debated area of the overall question of the ontology of a "culture of technicity" software often takes centre stage in the sense that it is generally understood by the underlying leading theories that it does not merely contain and constrain our actions, but also our perceptions of the world.

Paul Dourish likewise contends that software is "philosophical in the way it represents the world and creates and manipulates models of reality, of people, and action" (Dourish, 2019, p. 6). The creative manipulation of reality… "is the manifestation of a system of thought – an expression of how the world can be captured, represented, processed, and modelled computationally with the outcome subsequently doing work in the world. Programming then fundamentally seeks to capture and enact knowledge about the world – practices, ideas, measurements, locations, equations and images – in order to augment, mediate and regulate people's lives" (Kitchin & Dodge, 2011, p. 27).

Media theorist Matthew Fuller consequently argued that software can be understood as "a form of digital subjectivity […] that each piece of software constructs ways of seeing, knowing, and doing in the world that at once contain a model of that part of the world it ostensibly pertains to and that also shape it every time it is used" (Fuller, 2003, p. 42).

However, the physicality of the world and the things in it, not least the sounds, tend to play on the ear rather than on the eye (and the "mind", to ostensibly play on the concepts of Merleau-Ponty's phenomenology of the body). Here, the "digital subjectivity" that Fuller describes and the constructions the software perspective pertains, could be brought into question as the French philosopher Gaston Bachelard did when he proposed to think of our navigation in the situated ontologies and our ideas about them as a "phenomenotechnique" (Bachelard, 1968, p. 25).

The navigation of culture as the system of situating change in motion accommodates unresolved perspectives or processes in meaning creation that one the one hand asks us to "...force the nature to go as far as our mind goes" (Bachelard, 1968, p. 30). On the other hand, he proposes that we should allow "the mind adapt itself to the conditions of knowing. It must create in itself a structure which corresponds to the structure of knowing" (Bachelard, 1968, p. 123).

The conjunction of these requirements defines Bachelard's notion of a dialectic between mind and reality, phenomenotechnique and nature. This raises an epistemic question, which also Haraways raises as a call for a partial and locality oriented, situated, episteme of ways of seeing and listening differently (than totalization and relativistic epistemes propose, the details of which will not be dealt with further here):

> The alternative to relativism is partial, locatable, critical knowledges sustaining the possibility of webs of connections called solidarity in politics and shared conversations in epistemology. Relativism is a way of being nowhere while claiming to be everywhere equally. The "equality" of positioning is a denial of responsibility and critical inquiry. Relativism is the perfect mirror twin of totalization in the ideologies of objectivity; both deny the stakes in location, embodiment, and partial perspective; both make it impossible to see well. Relativism and totalization are both "god tricks" promising vision from everywhere and nowhere equally and fully, common myths in rhetorics surrounding Science. But it is precisely in the politics and epistemology of partial perspectives that the possibility of sustained, rational, objective inquiry rests. So, with many other feminists, I want to argue for a doctrine and practice of objectivity that privileges contestation, deconstruction, passionate construction, webbed connections, and hope for transformation of systems of knowledge and ways of seeing.
> *(Haraway, 1988, p. 15)*

And ways of listening we might add to Haraway's call. The plasticity of listening, as have learned from the ecological approach to perception, opens for transformations of our attentional capacities. With a reflexive attention we pay attention to the constraints, apparatuses, and evaluations that condition

our attention acknowledging its partial perspectives. But how do we foster a reflexive attention? The journey through the vast ocean of epistemologies of partial perspectives enters the sonic sensorium that is Greenland.

The Sonic Sensorium

> Standing at the small natural harbour of Qassiarsuk, deep in one of the southern fjords of Greenland. Here, silence is environment, listening second nature. Something is turning human attention towards the background, listening to the more than silent and wordless environment. The true un(der)heard that surrounds the humans is the discovery of the non-human sonic sensorium in Greenland.

The concept of the "un(der)heard" is not simply a matter of subjugation or marginalization. As Haraway articulates, the position of the subjugated is not immune from critical scrutiny. These standpoints, while not "innocent" are significant, because they possess a heightened awareness of denial, repression, and the mechanisms by which certain knowledge is obscured or erased. Subjugated perspectives, by their very nature, offer insights into the ways knowledge is constructed and denied. Haraway writes, "They are knowledgeable of modes of denial through repression, forgetting, and disappearing acts—ways of being nowhere while claiming to see comprehensively" (Haraway, p. 16).[2]

Greenlandic artist Pia Arke exemplifies this critical re-examination of subjugated positions. Being part Inuit and part Danish, Arke's work reflects her "third" position as an artist navigating both these identities. For Arke, listening to the underheard was a cornerstone of her artistic practice, allowing her to interrogate the ethno-aesthetic frameworks that had historically defined Greenlandic and Inuit art. She references ethnographer Edmund Carpenter, who remarked that "[Inuit] art obeys the ear more than the eye" (Arke, 1995). However, Arke points out that Carpenter's "ears" were European, and thus his perception of Inuit culture was filtered through a colonial lens that reduced the Inuit to the category of "Eskimo". Arke's work, such as *Tupilakusaurus*, challenges these reductive categorizations by deconstructing the ethno-aesthetic positioning that limits Inuit art to a narrowly defined identity, and instead suggests a more complex, layered understanding of cultural expression (Arke, 2010).

Arke's inquiry into the sensory dimensions of culture resonates with Haraway's critique of knowledge production, particularly her assertion that "to see from below" is not easy or straightforward. It requires a deliberate reconfiguration of perception, one that is attuned to the ways different cultures, especially those historically marginalized, produce and engage with knowledge differently. Haraway's point that "the 'eyes' made available in modern

technological sciences shatter any idea of passive vision" emphasizes the active nature of all forms of perception, including listening. She argues that technological and organic "eyes" are not neutral, but instead actively shape the ways we see and understand the world, a point that can be extended to the ways we hear and listen as well.

In this light, Arke's work becomes a practice of "situated listening" – one that seeks to deconstruct the dominant visual and auditory regimes imposed by Western scientific and aesthetic traditions. It echoes Haraway's call to question where we listen from, what limits our listening, and how these limits shape our understanding of the world. Arke's work asks us to reconsider how listening – and by extension, knowing – can be situated differently, offering alternative ways of constructing meaning in spaces that have been silenced or overlooked.

The idea of situated listening, as discussed by both Haraway and Arke, challenges us to move beyond a purely visual or auditory framework and towards a deeper engagement with the conditions that shape what is heard and seen. This requires an awareness of how technology, power, and history mediate our perceptions, and how these forces construct forms of knowledge while silencing others. Arke's work is particularly illuminating in this regard because it foregrounds the importance of listening as a mode of resistance to dominant narratives, allowing for the possibility of new forms of understanding and expression to emerge.

Haraway's critique of the "innocence" of subjugated positions reminds us that these perspectives, while valuable, are not immune to the same forms of critical inquiry that we apply to dominant positions. By engaging with the un(der)heard, we are not simply recovering lost voices, but actively participating in the creation of new forms of knowledge that challenge the boundaries of what can be known. In this sense, listening becomes not just a passive act but a political and epistemological practice that has the potential to transform how we engage with the world and with each other.

Moreover, the connection between listening and technological apparatuses, as explored in both Haraway's and Arke's work, raises important questions about how our sensory capacities are shaped by the tools and technologies we use. Haraway's observation that there is no "unmediated photograph" or "passive camera obscura" in scientific accounts of bodies and machines highlights the degree to which our perceptions are always mediated by specific apparatuses, whether visual or auditory. This insight can be extended to the act of listening, prompting us to ask: What are the technologies that shape how we hear? What kinds of knowledge do they make possible, and what do they obscure?

Ultimately, the practice of situated listening offers a way of rethinking how knowledge is produced, circulated, and contested. By paying attention to the un(der)heard – whether in art, culture, or everyday life – we can begin

to construct worlds that are less dominated by the global webs of power that Haraway critiques and more open to alternative forms of knowing and being. This requires a shift in how we understand both the act of listening and the knowledge it produces, one that values difference, specificity, and the potential for new forms of connection and understanding to emerge.

Situated Listening Critique

This chapter explores "situated listening" building on Donna Haraway's notion of "situated knowledge" to highlight how often-unheard cultures can contribute to create inclusive, sustainable worlds. It challenges the idea of detached knowledge production, advocating for an ongoing process of listening and "not-knowing". Key questions arise about how we can listen to the unheard, what voices we miss, and how cultural and technological filters shape our perceptions.

We introduce the concept of a 'sonic sensorium" to understand meaning-making through situated listening, examining how sound art practitioners engage with sound's materiality and the complexities of its translation. The chapter emphasizes that knowledge creation is rooted in partial perspectives, particularly within marginalized cultures.

Focusing on North Atlantic Sea Island cultures, we investigate how cultural mechanisms filter our listening. Drawing on theorists such as Susan Leigh Star and Yves Citton, we discuss how culture structures our attention, often excluding certain voices. We critique dominant visual cultures, suggesting that listening can challenge embedded power structures.

Citton's idea of the "projective regime" illustrates how people shield themselves from diversity, seeking familiarity even in new contexts. Alongside Haraway's assertion that technology shapes perception, we propose that knowledge is partial and evolving, rooted in shifting cultural structures.

We revisit Haraway's questions on where and how we listen, highlighting situated listening as a vital tool for navigating a non-human sonic sensorium. Here, the un(der)heard reveals worlds less organized by human-centred power. This approach critiques traditional technological or visual frameworks and advocates for a sensory rethinking of knowledge production as inherently social and context dependent.

In examining "overhearing", we explore how layers of attention reveal and obscure what we listen to, using this concept to renegotiate dominant structures. By centering un(der)heard voices, we argue for listening as a transformative tool, recognizing that cultural filters shape what's valued and who gets heard.

We introduce "Situaters" – referring to those who create local listening experiences, to show how situated listening reflects Haraway's idea that world-building is linked to how and where we listen. This echoes her notion

that no scientific account is ever "unmediated", as all perceptions are informed by specific contexts.

Notes

1 'Situaters' is our suggested term for the implied producers of situated 'ultralocalised' listening situations.
2 Haraway writes "the positionings of the subjugated are not exempt from critical re-examination, decoding, deconstruction, and interpretation; that is, from both semiological and hermeneutic modes of critical inquiry. The standpoints of the subjugated are not "innocent" positions. On the contrary, they are preferred because in principle they are least likely to allow denial of the critical and interpretive core of all knowledge. They are knowledgeable of modes of denial through repression, forgetting, and disappearing acts-ways of being nowhere while claiming to see comprehensively." (Haraway, 1988, p. 16).

References

Arke, P. (1995). *Etnoæstetik*. Copenhagen: *Ark* (17).
Arke, P., & Aktion, K. (2010). *Tupilakosaurus: An Incomplete(able) Survey of Pia Arke's Artistic Work and Research*. Copenhagen: Kuratorisk Aktion.
Bachelard, G. (1968). *The Philosophy of No: A Philosophy of the New Scientific Mind*. (G. C. Waterston, Trans.). New York: Orion Press. (Translation of La Philosophie du non, Paris: Presses universitaires de France, 1940).
Borgdorff, H. 2010. "The Production of Knowledge in Artistic Research." in: *The Routledge Companion to Research in the Arts*, ed. M. Biggs and H. Karlsson, pp. 44–64. London: Routledge.
Chattopadhyay, B. (2017). Beyond matter: Object-disoriented sound art. Copenhagen: *Seismograf*. https://seismograf.org/fokus/sound-art-matters/beyond-matter-object-disoriented-sound-art
Chion, M., Gorbman, C., Gorbman, C. (ed.), & Chion, M. (1994). *Audio-vision : sound on screen*. Columbia University Press.
Citton, Y. (2017a). *The Ecology of Attention* (1st ed.). Wiley. https://doi.org/10.1002/9781119384381
Citton, Y. (2017b). Restructuring the Attention Economy: Literary Interpretation as an Antidote to Mass Media Distraction. In Ç. Akdere & C. Baron (Eds.), *Economics and literature: A comparative and interdisciplinary approach* (pp. 239–256). Routledge. https://doi.org/10.4324/9781315231617-15
Dourish, P. (2019). *Where the Action Is – The Foundations of Embodied Interaction*. Cambridge, MA: MIT Press. https://doi.org/10.7551/mitpress/7221.001.0001
Fell, M., & Gilmore, J. (2021). *Structure and Synthesis : The Anatomy of Practice* (R. Mackay, Ed.). Falmouth, UK: Urbanomic Media Ltd.
Fuller, M. (2003). *Behind the Blip: Essays on the Culture of Software*. Brooklyn: Autonomedia.
Haraway, D. (1988). Situated Knowledges: The Science Question in Feminism and the Privilege of Partial Perspective. *Feminist Studies*, 14(3), 575–599. https://doi.org/10.2307/3178066
Haraway, D. (1989). The Persistence of Vision. In *Primate Visions* (pp. 1–15, n384). New York/London: Routledge.
Heidegger, M. (1977). *The Question Concerning Technology and Other Essays*. London: Harper & Row.

Højlund, M., & Riis, M. (2015). "Wavefront Aesthetics: Attuning to a dark ecology. *Organised Sound : An International Journal of Music Technology, 20*(2), 249–262. https://doi.org/10.1017/S1355771815000138

Kitchin, R., & Dodge, M. (2011). *Code/Space: Software and Everyday Life*. London: MIT Press.

LaBelle, B. (2011). Sharing Architecture: Space, Time and the Aesthetics of Pressure. *Journal of Visual Culture, 10*(2), 177–188. https://doi.org/10.1177/1470412911402889

Sontag, S. (1967). *The Aesthetics of Silence. Aspen no. 5 + 6, item 3*.

Star, S. L. (Ed.). (1995). *The cultures of computing*. Oxford, UK: Blackwell Publishers.

Voegelin, S. (2023). *Uncurating Sound: Knowledge with Voice and Hands* (1st ed.). Bloomsbury Academic & Professional. https://doi.org/10.5040/9781501345449

14
TRANSPERCEPTIVE LISTENING

Sonic Meditations for a Pluriverse

Anna Nacher and Victoria Vesna

Introduction

In our chapter, we start with briefly outlining the main concepts and the history and scope of our collaboration. Next, we proceed to introducing the works that were developed into extended forms of online meditations. Finally, we will explain the role of Transperceptive Listening in weaving epistemic communities organized around participatory sense-making so that human cognition can better accommodate non-human agencies, especially the ones situated in the realm of elemental media, such as water and air.

This chapter captures the collective voice of two artists continuously engaging with the world, moving through a landscape that shifts in pattern, rhythm, and tempo, mirroring the transitory spaces of our lives that rely on flexibility and fluidity – sometimes imposed. Through our shared experience of intensive online listening sessions framed as sound-based online meditations, we strive to broaden our audience's understanding to embrace the complex, interconnected web of life that supports our planet. This includes somatic, affective, and experiential cognition. Building on these practices, which we see as a way to interrogate the situatedness of listening and loosely inspired by William James (James, 1996) and the researchers in environmental humanities and development studies (Kothari et al., 2019). We conceptualize this notion for a transformed cognitive realm as the pluriverse as "a world where many worlds fit" (Kothari et al., xxviii). James sketched his idea for a Pluriverse rather than a Universe to emphasize the fact that world cannot be thought as a totalizing and unifying system. To him, the point of departure is always a unique, specific experience in the context of a dense network of all its relationships.

DOI: 10.4324/9781003348528-21

Following this concept, we see the Pluriverse as a domain where multiple ontological realities coexist, and the human and non-human boundaries become porous. Initially inspired by the method of Deep Listening of Pauline Oliveros, we propose the concept of Transperceptive Listening – to be fully explained further in the chapter – to describe the practice of extended listening that incorporates invisible, inaudible, or barely visible and barely audible creatures and phenomena that still exert a kind of agency, often of unpredictable nature. Addressing these agencies in our work, we employ the term "silent agencies," proposed by Morten Søndergaard and Laura Beloff, as the "effects of crisis, and the artistic modalities operating with those effects" as well as "a philosophical inquiry into the epistemological situation of crisis, and the 'speculative' situation of 'a world without humans'" (Søndergaard & Beloff, 2020). Sonifying scientific data and introducing embracing remote collaborative work, we also go deeper into the molecular and nano level. Sound and creation of sonic fields is the web that pulls the ecological complexity into the human realm, with a potential to build empathy and higher awareness across space and time. Having started our project during the COVID-19 pandemic and as a response to its limitations, we invertedly developed work that was focused on sharing frequencies and waves across time zones. As the world came to a stop, we reoriented ourselves to paying attention to the non-human voices that are silenced and drowned out by the noise of consumerism.

Our interpretation of silence and the way we include meditation as a practice of attentive and affective listening, is deeply influenced by our own respective practices, which we translate into forms of public engagement within the art and sound domains. A direct employment of meditation in artistic practice may come across as a risky gesture, considering to what extent it has also become a part of "spiritual consumerism" and the whole industry that commodifies self-care practices, and how often the practice of meditation is associated with a cluster of meanings suggestive of deficit of critical inquiry. Yet, there is an extensive body of scientific research in psychiatry and neuroscience that supports major outtakes known for centuries to the followers of various contemplative traditions. The vast corpus of knowledge is presented in early Buddhist treatises showing an intrinsic, sophisticated, and elaborate knowledge of human mind, in line with the discoveries of contemporary Western neuroscience. Knowledge of the inner workings of human mind developed in early Buddhism sometimes exceeds the current scientific findings, as demonstrated, for instance, by *Visuddhimagga*, a 5th-century canonical text in Pali, offering detailed instructions for Buddhist meditation. With its concept of storage consciousness, this knowledge predates Freud's and Jung's respective theories of subconsciousness. Very recently, the corpus of contemporary Western psychological knowledge has been summarized by

Simon B. Goldberg and Richard J. Davidson, two main specialists in the field, who have noticed an increased significance of both mindfulness-based interventions and interventions based on loving-kindness meditation for clinical psychology over the last 20 years (Goldberg & Davidson, 2024). Davidson has established the Center for Healthy Minds at the University of Wisconsin-Madison, where he conceived and for years has been conducting one of the first major, long-term neuroscientific studies on the effects of meditation on human brain. The findings have been summarized in popular books and articles, where the authors also clarify some popular misunderstandings resulting from shifting cultural contexts and lack of knowledge of Western followers on the original set up of mindfulness in the cultures of its origin (Davidson and Begley, 2012; Goleman & Davidson, 2017). We build on our own lifelong practices and see meditation as a meta-cognitive, deeply transformative act, in terms of "profound alteration of our very being" (Goleman & Davidson, 2017, 2). In relation to our respective projects, we aim at disrupting the illusion of a human subject detached from its environment and bridging the gap between human and non-human life forms.

How the Project Emerged

In what follows, we develop a narrative that may come across as built by two separate voices, one firmly grounded in artistic practice of art and science paradigm, the other – mobilizing the artistic practice mostly as a tool to develop theoretical insights in media theory within the orbit of cultural studies. In fact, the narrative reflects the key aspect of how the whole idea emerged through and because of the COVID-19 pandemic. The nature and story of our collaboration, which weaved around particular artworks and their extensions, also explains why significant part of the chapter revolves around our own work. We started as humans separated spatially and temporally, sitting in front of our screens many time zones apart (a difference between Central European Time zone and Pacific Time zone is normally 9 hours, unless short periods of irregularities resulting from switching between winter and summer time). This element of our pandemic sociality has been relatively often described and analysed, even though it seems that the further away we move from the acute phase of the COVID-19 pandemics, the less we want to talk about it as a society. What has been covered much less frequently was to what extent intensive Zoom participation has been an instance of Situated Listening. Spending hours at a time with headphones covering our ears and transmitting various sounds of less-than-ideal quality certainly felt daunting. All the hisses, glitches, and sudden auditory blips, on top of chopped words and transcoded, electronically sounding voices were our everyday reality, but the sonic aspect of intense Zoom communication has rarely been acknowledged or even noticed (beyond obvious communicational aspect). Yet,

it had a specific affective component, in how the lo-fi sound of average Zoom communication has also been associated with increased craving for connecting with other life forms, human, or otherwise. In most cases described as "squares on the screen," online conversations, however, also bore a distinctive form of attentive listening. Its minutiae are often vanishing from radar, like an uncomfortable moment of not being sure whether the short moment of silence is a pause long enough to chime in or maybe it is a malfunction of the broadband internet connection. So, in many ways, a narrative that we develop in our chapter reflects not so much collaborative writing per se, as rather weaving and meandering that arose from many rivers of online conversations. Meandering proves especially valuable metaphor for all the confluences, displacements, cut-offs, and flows getting suddenly separated. Much like an average online conversation, where all the noise that signifies the real conditions of the communicative network, both analogue and digital, all protocols and an invisible (but apparently to some extent audible) work of transcoding – all the sediment that is carried with the river of online conversation – is cognitively moved to the background and vanishes from a radar. When silence becomes more forefront in online connections, suddenly we are getting situated as listeners, with all the uncomfortable affects and embodied reactions, with bodies shivering when suddenly sound spikes with unwanted, sharp noise of malfunctioning headphone input.

Hence, the fact of being transformed into pandemic listening bodies shaped a design of intensive listening sessions that we came to call online silent meditations, which we developed since 2020 as expansion of two projects by Victoria. They constitute the base of our shared artistic practice and evolve around what was described as "silent agencies." Building our reflections on the experience of fostering online meditations extending already existing media installations, such as *Noise Aquarium* and *[Alien] Star Dust: signal to noise* (by Victoria), and works-in-progress, such as *Breath Library* (by Anna) and addressing as well works gathered under umbrella research project and exhibition, *Atmosphere of Sound. Sonic Art in the Age of Climate Disruption* (a part of *Pacific Standard Time: Art Science Collide* exhibition at the UCLA campus) we follow the general idea of Transperceptive Listening constituting the cognitive realm of plural worlds.

With both the *Noise Aquarium* and *[Alien] Stardust* online meditations, we opted for guided meditations that drew from our experiences in a fully secular way delivered through sound, light, and visualizations. This form is often considered easier for participants who may not have had any prior experience with silent meditations, which initially may amplify scattered minds and bring a sense of anxiety and mind rush rather than calm attentiveness. This observation is based both on our own experience and on many popular guidebooks and suggestions for beginners. A narrative that prompts into developing awareness of certain areas of experience or embodied felt sense

helps to anchor mental activity that otherwise often may feel too overwhelming for first-time or beginner meditators. We wanted this experience to be as open as possible to the broad range of audiences, whom we encouraged just to experiment with their own mind, attention and intention, and check whether it can get in tune with more-than-human life forms and phenomenon: from plankton to stardust.

We are also interested in how communication between human and non-human realms occurs. These reflective states were ripe with a particularly ironic and paradoxical form of silence. In online communication, there is no real silence (aka missing sound) unless there is no internet connection. As such, in mobilizing silence we both tap into the conditions of what often is being conceptualized as an interconnected web of life and deconstruct some presumptions about communicative acts and silent agencies inscribed into them. At the same time, a sense of urgency echoes the concerns raised by numerous artists, scientists, and humanists since 1962, when Rachel Carson's *Silent Spring* was published. Carson begins with a poignant observation: "No witchcraft, no enemy action had silenced the rebirth of new life in this stricken world. The people had done it themselves" (Carson, 2002, 3). As a marine biologist at America's Bureau of Fisheries – now the Fish and Wildlife Service – Carson catalysed the environmental movement and foresaw the ecological crises we now confront.

While developing these online gatherings, we were fully aware and inspired by other worldwide examples of tapping into this energy in a similar way, such as a global, Zoom-based version of The World Wide Tuning Meditation (Fonseca-Wollheim da, 2020). To some extent, similar quality was present in *Utterings*, a series of Zoom networked performances by the Andanconnerdercu collective initiated by Annie Abrahams and Daniel Pinheiro in 2020, also including Constança Carvalho Homem, Curt Cloninger, Nerina Cocchi, and Derek Piotr. However, our project, as we moved forward with the series of *Noise Aquarium* Online Mediations in 2020 and 2021, was focused not so much on the musical qualities of online improvised live performance, but rather on the ideas of shared affectivity via sound and a deep situatedness of listening, including in interspecies communication, as well as multilayered mediations of the processes in question.

Transperceptive Listening

That is how our collaboration during the COVID-19 pandemic emerged, having led eventually to developing somewhat paradoxical forms of online meditations: listening sessions with enough space for all which is the main reason why we borrow the notion of *transperception* from Douglas Kahn. He coined it writing about long sounds and other electromagnetic phenomena. In the context of his writing, it means that long sounds could be "heard as having acquired their character through the course of their propagation,

acoustically and electromagnetically" (Kahn, 2013, 162). He further elaborates that transperception can be simply explained as "a consciousness or intrinsic awareness of an energy that includes what has been traversed" (Kahn, 2013, 163). In other words, it means that through the very process of sound wave propagation, sound is getting imbued with the qualities of environment that sound wave was traversing. Hence, attentive listening becomes an exercise in acquiring knowledge both on environments that have been traversed and, on the work, and entanglements of energies involved in the process. According to Kahn, the process of transperception points out to the fact that – contrary to widespread belief – the time and space have not been annihilated due to increased communication possibilities. The possibility of easy communication across the globe does not completely erase all the physicality of distance or location in space, even though we may fall prey to fantasy of instantaneous, smooth and flawless communication on the internet.

In the case of online meditations that we enacted in our collaborative effort, transperception encompasses a whole multitude emerging across the spectrum of human and non-human, including machines and electromagnetic fields participating in the acts of online remote listening. It does not mean, however, gliding over social inequalities of the human world, but for now we leave this aspect aside for the sake of clarity. Such complexity of attentive, meditative listening during *Noise Aquarium Online Meditations* mediated by extensive communication could also be described in terms of practice known as Deep Listening. It is significant for us that Oliveros outlined this method in a booklet entitled *Sonic Meditations*, where she emphasized its healing potential and incurred physical and mental changes meant as "tuning a mind and body" (Oliveros, 1971, 1). What is even more important, is the fact that for Oliveros, meditations were aimed at building Sonic Energy that enabled "communication among all forms of life," in a process that was primarily socially oriented (to be conducted in groups) and was aimed at dismantling a subject/object binary. The method incorporated all modalities of work with sound, from the actual sound making to sound memories and sound imagination. To some extent, our Online Meditations followed this trajectory. We expand Oliveros's notion of Deep Listening with the concept of Transperceptive Listening by bringing in direct collaboration and dialogue with scientists and listening with awareness of the mediation, including scientific and technologic instruments and expanding into a domain of non-human realm. In a way, it is a method of interspecies listening enabled by technoapparatuses of our time, encompassing online communication technologies.

From *Noise Aquarium and [Alien] Star Dust* to *Breath Library and Atmosphere of Sound*

The transperceptive quality of the experience that we developed as online meditations also encompasses the need to attend to all the aspects that often

go unnoticed and that exemplify the post-digital condition (Cf. Kramer, 2014; Berry & Dieter, 2015). It can be simply described as the process of increased saturation of physical space with data enabled by wireless communication, which – although significantly affects such communication – usually goes unnoticed or unacknowledged (Kahn, 2013; Kahn & Macauley, 2014; Mackenzie, 2010). We were using our meditative sessions as experimental platforms to communally share images, sounds, and breaths, transcending the barriers of time and space. In some instances, a particular emphasis was on real-time improvisation between musicians located in different places on the globe, across a few time zones. The way those experiences framed our listening, had to incorporate all the temporary instabilities of technological setup, manifesting as the unexpected glitches and noises emblematic of transcontinental communication in real time, across a few scales, relying as much on a "fixed flow" of fibre optic undersea cables (Starosielski, 2015) as on less fixed infrastructure of wireless internet networks. That also includes so-called "last mile" connections, Wi-Fi and/or Bluetooth, seemingly almost merging with the air in their employment of electromagnetic fields and analogue radio waves. In essence, we learned to embrace the network's inherent instability, indicative of all the uncertainties characterizing this specific epoch in human history.

As already mentioned, our online meditations were meant to expand and transform two Victoria's installations: *Noise Aquarium* and *[Alien] Star Dust: signal to noise*, which could not be offered in their usual form due to all the pandemic restrictions. The work on *Noise Aquarium* began in 2016, at the invitation of Alfred Vendl, director of the Science Visualization Lab at the University of Applied Science in Vienna. Vendl was keen on having her utilize the 3D imaged planktons by biologists Stephan Handschuh from University of Veterinary Medicine in Vienna and Thomas Schwaha, Integrative Zoology, University of Vienna, and animated by then PhD student Martina Froeschl. Initially, this work was commissioned for a Hollywood movie directed by Terence Malick, but was ultimately not used. It involved a laborious and sophisticated method of plankton visualization that combined microtomography, a technique allowing imaging of very small objects with pixels as small as 100 nm, including their interiors; light microscopy, which uses visible light to render very small objects; and image segmentation, leading to the creation of 3D models which were then animated. There are thousands of species of planktons and in *Noise Aquarium,* seven were introduced: *Amoeba proteus*, Paramecium, *Tomopteris helgolandica*, *Noctiluca scintillans*, Cylindrospermum, Actinotroch larvae, and Oikopleura (Vesna, 2021).

Working on the project, the critical importance of plankton for life on Earth was of a key importance, as they are a major source of oxygen (Witman, 2017). Research into the degradation of this vital source of life, increasingly disturbed by human activities such as noise pollution, motivated her to create an

installation that would highlight these issues and engage the audience. Additionally, the consumerism and fossil fuel economies created the problem of microplastics which the planktons consumed. This too was imaged by the biologists and included in the final version that envisioned the planktons to be enlarged and projected to the size of whales. The project was exhibited in many venues and took on various forms – from VR immersive installations, to simple video projections and augmented reality (AR) prints. But, in all instances, sound, vibrations, and frequencies of destructive underwater noise pollution were primal. By the time the work was going to be exhibited in the Laznia Center for Contemporary Art in Gdańsk in 2020, the pandemic was in full swing, and the idea of oxygen and breath took another meaning. Thanks to the robust visualizing methodology and rich visual resources, the installation took many different forms, adjusting to the immediate context. For the exhibition in Laznia, there was a projection with plankton magnified and blown to large proportions with immersive sound and seats for a few people allowed at the time due to the pandemic restrictions. Additionally, on the wall were prints with the individual species that were animated through AR by the audience using their phones.

As no traveling was possible by then, we invited the public traumatized and segregated by the pandemic to partake in a collective online meditation connecting to the plankton and listening to underwater noise pollution, while reciprocally exchanging sounds, voices, and visuals on the networks in real time (Vesna & Nacher, 2020). The soundtrack was binaural and immersive for those who donned headphones. They experienced a mix of underwater noise pollution such as sonar, fracking, as well as natural sounds of air bubbles. This was "eyes wide open" guided meditation that uses images and animations of planktons and water to focus the viewer on listening to the guide along with layers of sounds including Anna's polyphonic voice. This was all performed live, real-time-sharing sound and visualizations from Poland, New York, Los Angeles, and embracing the network glitches, errors, and dropouts as part of the composition with the understanding that as one location loses connection, another takes over. Paul Geluso, an expert in surround sound technology, was key as well as sound artists John Brumley and Ivana Dama, among others (Figure 14.1).

Several sessions of this extended version that came to be known over time as *Noise Aquarium Online Meditation* were organized in 2020 and 2021.[1] Those participating in the event were encouraged to follow a guided meditation on the role of plankton, the impact of underwater noise on its demise, and the way the very act of breathing interconnects human beings with underwater life. The guided meditation was often followed with a real-time improvised online performance of artists based at the time in several places in the United States and Europe: Los Angeles, Mojave desert, New York, Poland, Slovakia, Serbia, and Bulgaria. Those sessions incorporated sharing

FIGURE 14.1 Augmented reality image from Noise Aquarium.

participants' impressions of such a very attentive listening activity carried out online during the COVID-19 pandemic. Gradually, sessions have incorporated reflecting on the experiences of breathing with an awareness of its situatedness and all the contexts that may hamper it.

First and foremost, we wanted to suggest the possibility of communing with the micro creatures/interspecies. It became natural then that the shared breath emerged as the unifying medium, drawing our collective attention to sound, not just as an auditory experience, but as frequency and vibration resonating across the physical bodies and digital pathways alike. This of course is imaginary and speculative and is bringing this idea to the audiences by their participation in breathing and marvelling at the complexity of these micro creatures. The scientific visualization is contextualized by the artists to create an experience with plankton species we are not able to see and ask the question of our relation and how may the noise we create affect them and by extension us all.

The narrative and prompts provided in guided meditation highlighted the often-overlooked aspect of our ocean's health as a microbiome, with all microorganisms and their well-being so crucial to our very existence. In doing so, we were emphasizing its intrinsic connection to human well-being. We focused on plankton, a foundational element of marine ecosystems, and its susceptibility to underwater noise pollution from human activities like fracking, oil drilling, and sonar. Our exploration into these disruptive anthropocentric noises aimed to raise awareness about the intricate link between the health of our oceans and our own, especially during a time when human health was

at the forefront of global concern. Although cultural values ascribed to noise and silence may bear class or colonial undertones, in this case the question of human-made sounds and the level of noise in the ocean threatening biological life is clear and grounded in research that leaves no space for doubts that constant increase in sound pollution is a threat to marine life. The time of the global pandemic was particularly productive, when it comes to the project dealing with underwater noise levels. A widespread sense of a serious crisis on a global scale (Mbembe, 2021) was at the same time an opportunity to change the course, even if for a limited period of time. Non-human realms became suddenly freed from frantic human activity – and especially so in the ocean. Research done early in the pandemic, in 2020, has demonstrated that it was a decisive factor in the sharp decline of a number of marine vessels in the oceanic waters (Robinson et al., 2023). According to the team who conducted research in the Northern Pacific, the level of noise caused by this source increased by over 3 dB per decade between 1950 and 2007, mostly due to tourism (Gabriele et al., 2021). Other sources of ocean noise are related to intense searching for resources (such as gas and oil) and their extraction. But the noise that comes from marine vessels proved to be particularly dangerous, as it hampers underwater communication, so crucial for cetaceans and fish.

It was this same year, 2020, that *[Alien] Star Dust: signal to noise* premiered at the Natural History Museum in Vienna after two years of work and residency. The installation opened on March 20th, and the following day the entire world closed down. Victoria shifted her focus from the depths of the ocean to space – exploring the idea of a larger cosmological ecology, which was increasingly in the public view with the growing numbers of expeditions in space. Researching meteorites, she discovered and was fascinated by the micrometeorites – the 100 tons of cosmic dust that falls onto Earth every day. Together with the geologists in the museum, she picked seven meteorites, one for each continent, which were imaged and then animated exploding in space, with the resulting dust mixing in with pollution particles that obscure and blind us to the awareness of this larger cosmic ecology we are all part of.

With the lockdowns of the pandemic, the tagline "Dust Knows No Borders" became ever more important. Thus, she moved the project online with a series of distributed sound composition and visual mixing experiments in real time. Participants were invited to an online meditation again – to collectively meditate with *[Alien] Star Dust: signal to noise* and breathe together as meteorites fall on different continents – keeping centred while all is falling apart – using voice and breath over the communication networks in real time.

These "eyes wide open" meditations are meant to go from inner "self" exploration to connectivity with those sharing the experience to those that together are envisioned as meteorites falling on each continent, exploding

and mixing with anthropogenic dust. The sounds and visuals can at times be disturbing so the guiding is critical – for the participants to stay focused as all falls apart, the dust will settle eventually. They are instructed to put into their mind's eye people, animals, plants in Africa, Asia, Antarctica, South America, North America and remember – we are all made of stardust. The micrometeorites mix with earthly pollution anthropogenic and natural particles – fossil fuel, pollen, bacteria, viruses with immersive binaural mix of voice guidance by Victoria from Los Angeles, mixed with real-time data of COVID-19 across the world by John Brumley in LA, with binaural and drone additions by Paul Geluso in NY, NASA and ESA sonifications and the polyphonic voice of Anna in Poland and Rhiannon Catalyst.in New York (Figure 14.2).

As our collaboration matured and took shape through several iterations, there emerged an idea of gathering recordings of these shared breaths, called *Breath Library* (2021–ongoing). This is a speculative and participatory project, where audiences are encouraged to record their breathing and upload a file at the project's website as a donation to other life forms. The practice of meditation using breath as a guide – regardless of a chosen method or tradition – is essentially an activity based on a heightened awareness of breathing and often starts with shifting our focus to the acts of inhalations and exhalations. At the same time, breath and breathing demonstrate how interdependent we are as human beings and how interconnected our planet's ecosystem. It fosters thinking in terms of "ethics of breath as of meso-cosmic exchange of energies" (Škof, 2015, 245). Acknowledging to what extent the

FIGURE 14.2 Distributed team from Left to right: Paul Geluso (NY); Victoria Vesna, Zeynep Abes, John Brumley (LA), Rhiannon Catalyst (NY, Eli Joteva (LA), Clinton van Arman and Ivana Dama (LA), Anna Nacher (Poland), Debra Isaacs (LA). Installation.

ability to live on oxygen is dependent on the well-being of marine microorganisms (mainly plankton) reveals yet another perspective: breathing is a practice that in one tiny somatic act demonstrates transcending elements and materially different environments. Oxygen produced by plankton finds its way into our respiratory system. Shifting the attention to breathing is very simple, yet powerful exercise. Experienced in the framework of Transperceptive Listening, it helps to bridge its sonic qualities and embodied nature, which not only signals the very basic aspect of being alive, but also the fact that on a very basic level we are physically and materially dependent on so many "silent agencies." Respiration becomes much more than just "matter of fact," it may become the first step towards, as Alexis Pauline Gumbs puts it, "another way of breathing" (Gumbs, 2020, 1), the one that incorporates and is guided by other life forms. As poetically put by Gumbs who explained the relationship between her and whales, "If I breathe, I sing your name. I can only breathe because of you" (Gumbs, 2020, 16).

It is this conceptual work around breath and breathing that led to *Breath Library*. The project also tackles all the spaces of "unbreathing" and breathlessness, be it for ecological reasons, social inequalities, gender-based violence, or racial injustice. Very often the spaces of breathlessness are intertwined and focusing on breathing in this context leads to reflections that run deep into how abuses of power and economic inequalities come to the surface with the instances of breathlessness and environmental injustice (Sharpe, 2016; Gumbs, 2020). The project is also being further developed into a multichannel sound installation, soundwalks, and a series of site-specific workshops, and is a part of *Atmosphere of Sound: Sonic Arts in Times of Climate Disruption*. Curated jointly by Anuradha Vikram and Victoria, it is a segment of the *Pacific Standard Time: Art Science Collide* project, which was launched in 2019 under the auspices of the Getty Foundation. The notion of pluriverse actualized through the practice of Transperceptive Listening is also present in works by other artists participating in the exhibition including Robertina Sebjanic, Yolande Harris, Amber Sucke, Joel Ong, and Bill Fontana.

A Deep Situatedness of Transperspective Listening as Participatory Sense-Making

Our online meditations were based on constant dialoguing between sound of breath and external sounds of environment. We frame this approach, also present in associated art projects within The Atmosphere of Sound, as situated affectivity (Slaby et al., 2019). We see it as an element of participatory sense-making, as outlined by Laura Candiotto (Candiotto, 2019). Affective activities constitute the crucial component of the process, where communities emerge not only around shared values, but also follow similar trajectories of knowledge production. Candiotto's philosophical proposition extends this

process into a domain of shared cognitive activity and affects. Aiming at building Pluriverse based on sonic awareness and practices of listening, we further this idea in our sound-based online meditations, weaving epistemic communities that include more-than-human-actors and their contributions that stem from *Noise Aquarium* and *[Alien] Star Dust: signal to noise*. Such endeavour requires, as Haraway puts it, "learning to be truly present ... as mortal critters entwined in myriad unfinished configurations of places, times, matters, meanings" (Haraway, 2016, 2). Attentive listening and focusing on breath can be one of the ways to achieve such situated, embodied presence, in constant dialogue with the world with all its entanglements.

Through our methods, we discovered that sound-based online meditative practices can foster the emergence of epistemic communities weaved around cognition that extends beyond human realms. Laura Candiotto's concept of participatory sense-making seems to be very generative in this regard (Candiotto, 2019). Her proposition of affective social epistemology is grounded in a larger framework of 4E cognition (cognition as embodied, embedded, enacted, and extended), which boils down to understanding cognition as "the activity of embodied agent who makes sense of the environment in which she acts" (Candiotto, 2019, 236). According to her, the whole process of participatory sense-making has a nature of epistemic cooperation that in the end produces shared meaning. According to Candiotto, it is precisely emotions that transform individual knowledge gathering into building blocks of communities that crystallize around shared knowledge. We aim at extending those communities into more-than-human worlds of marine organisms in the acts of affective experience of sound- and breath-based meditation.

The practice of reflective, attentive listening, conscious of breathing and occurring in the framework that emphasizes the role of marine life in oxygen cycle, happens across human and non-human realms. Thanks to connecting listening practice to embodied sensations of conscious breathing, focus is on fostering situated affectivity (Slaby et al., 2019). It simply means accounting for affective and emotional aspects of attentive listening in the situation of the *Noise Aquarium Online Meditation*, including the marine sounds, such as the actual examples of underwater noise pollution, sonification of water movements and plankton behaviour, marine mammals vocalizations but also all the sonic cues signifying the material infrastructure that enables online communication, some of which, namely, transcontinental fibre optic cables, is also placed underwater. The sessions fostered extensive experiential networks that on transindividual level connected participants with non-human and more-than-human agencies on a range of scales: from marine microorganisms to larger animals, like fish and marine mammals. Listening to all the nuances of non-human marine beings rendered sonically in a variety of mediations (from recordings of dry "clicks" and haunting, eerie calls of marine mammals to sonified movements of plankton) as well as experiencing

the gradually increased volume of underwater human-made sounds, to the point where it became almost unbearable wall of thick noise that eliminated all other sonic impressions, became an exercise in fostering hybrid and fragile collectives bound affectively and experientially, with meditative attentiveness to sound playing a crucial role. We learned this from the participants of the sessions themselves, when they shared their reactions, impressions, and insights afterwards.

Transperceptive Listening and Eco-Media

Very attentive listening, in tune with one's own somatic and affective body and at the same time capable of building communicative bridges with other agencies and forces emerging through such practice (including both underwater noise and demise of plankton as well as buzzes and whirrs of online communication) became here an instance of above-mentioned "affective arrangement." It is understood as the case of "heterogeneous ensembles of diverse materials forming a local layout that operates as a dynamic formation, comprising persons, things, artifacts, spaces, discourses, behaviours and expressions in a characteristic mode of composition and dynamic relatedness" (Slaby et al., 2019, 4). Tackling this approach, we think of listening as further development of the idea of situated knowledge (Haraway, 1991) and ground it in sound-based and affective participatory sense-making. Outlining her concept, Haraway deliberately focused on seeing and vision, in order to reclaim its embodied nature. She also revealed that in her crafting this concept, speculating on more-than-human ways of seeing was also at play – when she was wondering "how the world looks without fovea and very few retinal cells for color vision" (Haraway, 1991, 190). According to Haraway, it is a way to introduce a feminist objectivity that is always embodied in a particular way and aware of taking certain perspective or standpoint, steering away from any pretence of totally and fully encompassing vision that would be the result of abstract, disembodied position. Situated knowledge is far from proposing "the false vision promising transcendence of all limits and responsibility" (Haraway, 1991, 190) and instead offers inevitably partial perspective, and at that the one that is aware of being additionally mediated with scientific / technological instruments and apparatuses. In fact, it constitutes a form of Pluriverse.

In our online meditations, we aim at building on these notions and line of reasoning but testing it for sound- and listening-based experiences. Transperceptive Listening allows for attentive listening both to the phenomena that are being listened to, but also to the very act of listening and all its mediations, even those that may come across as not obvious (such as all the apparatuses of online communication). That also signals the shift from the object of listening to the process of listening itself, as is the case in different forms

and schools of meditation. It became an online space for listening to our collective voice and the sound of breathing rendered imperfectly by layers of mediations, ranging from capture with a standard computer or USB microphones to data compression via popular sound formats to all the communicative glitches on the way, including in the undersea networks and between. It may start with the sound of breathing inside one's own body, with barely audible whistling signalling the passage of air into the nostrils during inhalation, then transforming into a hum resonating inside a skull and further down the respiratory system – if we are lucky (or skilful) and switch to deep belly breathing, we can also hear a hum resonating inside our body. This very tangible layer of sound activating body organs mixes up with all the tapestry woven between varied sound sources located in geographically distant places, with the final mix preserving to some extent the spatial characteristic of this artificially created and shared sonic environment. They all seem to almost seamlessly merge into a fabric that is so dependent on individual configurations, e.g., the quality of headphones and the sonic properties of immediate surroundings. Such a fabric is also prone to all kinds of imperfections, whirs, whizzes, and other types of distortions signalling post-digital condition and its underlying infrastructure. Some of them are caused by a broadband noise that can have many sources: from electromagnetic interference caused by proximity to other electrical devices on the way to radiofrequency interference to cross talk with other wires in the surroundings to improper grounding. All those imperfections layered one upon another constitute the whole spectrum of Transperceptive Listening.

Typically, such sonic experiences are relegated to the margins, omitted and removed from the conscious cognitive activity, but in our method, they constitute its vital part – on a pair with the act of breathing that was recorded as an element of workshop on *Breath Library*. Attentive, meditative listening to the full spectrum of Transperceptive sound in an online collaborative and participatory sound performance on Zoom means also transgressing the confines of habituated filtering the sound phenomena considered the unwanted noise – all those imperfections of online sound transmission that we tend to relegate to a sphere of habituated perception of the world, which constitutes a kind of epistemic background, constituted of elements that are often erased from our conscious interactions with the world. In fact, this is also the act of listening to the Internet infrastructure of online communication combined with listening to one's own body.

Transperceptive Listening in this environment becomes a practice of always-getting-closer to the boundaries that seem to ontologically separate us, humans, from non-human realms, as it directs our attention both to this very basic building block of existence uniting humans and animals, i.e., breathing and – at the same time – to all exchanges and transfers in media-, signal-, and data-saturated environments of our post-digital condition. It does not allow

for the illusions of immediacy nor fully intentional communication. In the realm of online collaborative sound performance, while getting ever closer to others with our utterances, at the same time we remain palpably aware that crossing some boundaries (especially those set by language or the very infrastructure and environment of online communication) is a matter of ultimate uncertainty. Conducting the exchange that aims at reclaiming the somatic within radically semiotic, language-based modes of online communication can be a practice of becoming ever more familiar with all the collision and frictions that occur at the threshold of non- or pre-discursive communication that occurs between human and more-than-human worlds of marine life, both microorganisms such as plankton and other marine creatures, such as fish and marine mammals. It may translate into taking a necessary pause while encountering more-than-human entities, allowing for silence that can host all communicative impulses including those coming from embodied realms, or staying humbly in a waiting room before entering the realm of non-discursive communication with nonhuman worlds, which are many, plural, and of radically different configurations. This process also inevitably bears traces of digital communication and tools afforded by all the facets of extractivist practices, related to excavation of natural resources, "dirty" energetic grids relying on fossil fuels, and to all abuses of power and economic inequalities forcing some humans to be equally exploited as a workforce in and for the networks of extraction. In our projects, however, while keeping in mind "networks of toxicity" and such a double, ambivalent role of media technologies in the framework of extractivism, we choose to enter the orbit of eco-media with some restorative work in mind. It is precisely this juncture that comes into our attention: "Eco-media processes catalyze ecological consequences in the form of environmental degradation and/or advocacy for environmental awareness, renewal, and sustainability, making this media genre and assemblage of natural elements and cultural attributes (...)" (Iheka, 2021, 6).

Engaging in this practice of attentive listening, we inevitably find ourselves embracing a state of true openness, based on our willingness to take a pause (to breathe), allow for silence and experience it not as a break in communication, but as its necessary building block. That means acknowledging our own positions while fostering genuine communicative receptivity. This process speaks to the permeability of boundaries, as well as their capacity to inspire and invoke creativity. Such situatedness necessitates a willingness to navigate the complexities of communication – a journey marked by its trials and tribulations, never fully realized in success, yet never succumbing to outright failure. Engaging in the seemingly simple act of listening to the sounds of marine creatures, while being aware of all layers of its mediation, served as a vital guide in our explorative journey. As Yolande Harris has unveiled, and also as reflected in Anna's prior work with the voices of cetaceans in

the Baltic and Northern Seas, attentive listening necessitates a keen sense of pattern recognition, extending to the sounds captured by specific underwater equipment. This also involves making sense of the environmental context, as well as navigating the mediating and reformatting processes inherent in the in-between spaces. Between 1999 and 2002, Anna was engaged in two projects related to the Baltic Sea wildlife, as she contributed to a series of albums with the marine soundscapes of the Polish Baltic Sea shore and the voices of marine creatures, including Baltic grey seals (*Halichoreus grypus*) and cetaeaceans of Nordic and Baltic Seas (harbor porpoise *Phocoena phocoena*). During this work, she listened to many hours of underwater recordings done with hydrophones by Polish military forces, which at the time were the only entities to have access to specialized equipment and was grappling with many challenges of inadequate sampling rate or all the technical errors, but was also captivated every time she could recognize cetaceans vocalizations amidst the whole plethora of non-specific noises. Yolande Harris recounts her profound experience of immersing herself in sounds recorded by oceanographer Kate Stafford from the University of Washington, describing it as an experience that brought about "an uncanny sense of connection with the direct physicality of another body making sound" (Harris, 2021, 472). The same impression often was articulated during *Breath Library* workshops, where listening to recordings of breathing that other participant contributed, proved to be revelatory in how this simple practice opened up a space of a rich non-discursive communication. Of course, it was reflected upon after every session and a challenge to find the right words to describe the practice of attentive listening to the patterns of whistles, wheezing, panting, moanings, and groanings became the space of productive unknown. This is how through this immersive and attentive practice of online listening, both marine voices and breathing, with all the layers of mediation transform into agents, guides, and oracles, offering us wisdom that both validates and transcends our immediate experiential realm.

Conclusion

In our work, informed by our meditation practices, we were inspired and influenced by the same silent call from the invisible web of life to use our skills in media, sonic, and visual arts towards fostering the network of knowledge that could possibly result in expansion of human cognition so that it better accommodates non-human, silent agencies. Due to the pandemic conditions, we chose to focus on full spectrum of attentive, meditative online sound-based practice. Employing the concept of Transperceptive Listening, we conceptually ventured into the field of eco-media and joined forces with collaborators who heeded the same call. Such practice does not forget various forms of technological mediation, which builds on "the primal connectivity

shared by human and non-human worlds" (Cubitt, 2017, 3). Often, we perform online meditations without official invitations or support, as much of this ephemeral, community-based work still relies on voluntary action. Yet, as we daily tune into the complex interconnectedness of intergenerational, interspecies, local, and global through our breath, we continue to invite others to Transperceptive Pluriverse Listening.

Note

1 Aside from Laznia Center for Contemporary Art, *Noise Aquarium* was exhibited in SIGGRAPH 2019 Art Gallery, at the Amore Festival in Pula (Croatia), at the Wiener Rauschen Audio Visual Festival in Vienna (Austria), Ars Electronica 2021 (Austria), MQ Vienna (Austria), The Curve in London (UK), Manhattan Pratt Gallery in New York (USA), The Peabody Essex Museum in Massachusetts (USA).

References

Berry, D. M. & Dieter M. (2015). Thinking Postdigital Aesthetics: Art, Computation and Design. In D. M. Berry & M. Dieter (Eds.) *Postdigital Aesthetics. Art Computation and Design* (pp. 1–12). New York: Macmillan.
Candiotto, L. (2019). The Emotions In-Between: The Affective Dimension of Participatory Sense-Making. In L. Candiotto (Ed.), *The Value of Emotions for Knowledge* (pp. 235–261). Cham: Palgrave Macmillan.
Carson, R. (2002). *Silent Spring*. Boston and New York: Houghton Mifflin Company.
Cubitt, S. (2017). *Finite Media: Environmental Implications of Digital Technologies*. Durham, NC and London: Duke University Press.
Davidson, R. J., & Begley, S. (2012). *The Emotional Life of Your Brain*. New York: Penguin.
Fonseca-Wollheim da, C. (2020). Join a Musical Meditation Bringing Together Hundreds Worldwide. *The New York Times*, 3 April. Available at: https://www.nytimes.com/2020/04/03/arts/music/music-meditation-zoom-coronavirus.html (Accessed: 5 February 2024).
Gabriele, C. M., Ponirakis, D. W., & Klinck, H. (2021). Underwater Sound Levels in Glacier Bay During Reduced Vessel Traffic due to the COVID-19 Pandemic. *Frontiers in Marine Science*, 8, 25 June. https://doi.org/10.3389/fmars.2021.674787 (Accessed: 15 September 2023).
Goldberg, S. B., & Davidson, R. J. (2024). Contemplative Science Comes of Age: Looking Backward and Forward 20 Years after Baer. *Clinical Psychology: Science and Practice*, 31(1), 39–41. https://doi.org/10.1037/cps0000186 (Accessed: 29 September 2024).
Goleman, D., & Davidson, R. J. (2017). *Altered Traits: Science Reveals How Meditation Changes Your Brain, Mind, and Body*. New York: Penguin.
Gumbs, A. P. (2020). *Undrowned: Black Feminist Lessons from Marine Mammals*. Edinburgh: AK Press.
Haraway, D. (1991). *Simians, Cyborgs, and Women: The Reinvention of Nature*. New York and London: Routledge.
Haraway, D. (2016). *Staying With the Trouble: Making Kin in the Chthulucene*. Durham, NC and London: Duke University Press.

Harris, Y. (2021). Melt Me Into the Ocean: Sounds From Submarine Spaces. In M. Bull & M. Cobussen (Eds.), *The Bloomsbury Handbook of Sonic Methodologies* (pp. 469–481). New York and London: Bloomsbury Academic.

Iheka, C. (2021). *Network Forms, Planetary Politics*. Durham, NC and London: Duke University Press.

James, W. (1996). *A Pluralistic Universe*. Lincoln: University of Nebraska Press.

Kahn, D. (2013). *Earth Sound Earth Signal: Energies and Earth Magnitude in Arts*. Berkeley: University of California Press.

Kahn, D., & Macauley, W. R. (2014). On the Aelectrosonic and Transperception. *Journal of Sonic Studies*, 8. Available at: https://www.researchcatalogue.net/view/108900/108901 (Accessed: 29 September 2023).

Kothari, A., Salleh, A., Escobar, A., Demaria, F., & Acosta, A. (2019). *Pluriverse: A Post-Development Dictionary*. New Delhi: Tulika Books.

Kramer, F. (2014). "What is 'Post-Digital'?". APRJA, 3 (1) (pp. 11–22).

Mackenzie, A. (2010). *Wirelessness: Radical Empiricism in Network Culture*. Cambridge, MA and London: The MIT Press.

Mbembe, A. (2021). The Universal Right to Breathe. *Critical Inquiry*, 47(52). https://doi.org/10.1086/711437

Oliveros, P (1971) *Sonic Meditations*. Smith Publications American Music.

Robinson, S., Harris, P., & Cheong, S. H. (2023). Impact of the COVID-19 Pandemic on Levels of Deep-ocean Acoustic Noise. *Scientific Reports*, 13, 4631. https://doi.org/10.1038/s41598-023-31376-3 (Accessed: 15 September 2023).

Sharpe, C. (2016). *In the Wake: On Blackness and Being*. Durham, NC and London: Duke University Press.

Škof, L. (2015). *Breath of Proximity: Intersubjectivity, Ethics and Peace*. Dordrecht-Heidelberg-New York-London: Springer.

Slaby, J., Mühlhoff, R., & Wüschner, P. (2019). Affective Arrangements. *Emotion Review*, 11(1), 3–12.

Søndergaard, M., & Beloff, L. (2020). Silent Agencies: Artistic and Curatorial Practices in a State of Crisis. *Seismograf.dk*, June. https://doi.org/10.48233/seismograf2500

Starosielski, N. (2015). *The Undersea Network*. Durham, NC and London: Duke University Press.

Vesna, V. (2021). NOISE AQUARIUM: Iterations, Variations, and Responsive Ecotistical Work. In I. Reichle (Ed.), *Plastic Ocean: Art and Science Responses to Marine Pollution*. Berlin: De Gruyter.

Vesna, V. & Nacher A. (2020). Diving Deep Into the Blue Planet, Flying High Into the Cosmos In R. Kluszczyński (Ed.) *Towards a Non-Anthropocentric Ecology. Victoria Vesna and Art in the World of the Anthropocene* (pp. 172–238). Gdańsk: Centre for Contemporary Art Laznia.

Witman, S. (2017). World's Biggest Oxygen Producers Living in Swirling Ocean Waters. *Eos*, 98. https://doi.org/10.1029/2017EO081067

15
COLLABORATIVE COMPOSITION

An Exchange of Sounding

Spy Dénommé-Welch and Catherine Magowan

Introduction

This chapter reflects on aspects of our practice as collaborative composers and how we creatively respond to an altered suburban landscape by "listening experimentally" (Campesato and Bonafé, 2022) as aurally situated observers and composers based in southwestern Ontario, Canada. Like Campesato and Bonafé (2022) who describe writing and creating collaboratively in their "desire to build an alternative environment for research and artistic creation" (153), we ruminate on our own interactions and engagements with the Land, as a way of attuning to the natural environment, and how the relationship with a suburban Coyote (and her seasonal mate) living in a woodlot behind our home becomes a focal point within some of our recent improvisational works. For almost two decades, we have been engaging in interdisciplinary and intercultural work and acknowledge that our distinct backgrounds and experiences inform different aspects of our creations and perspectives of creativity. Spy grew up in northeastern Ontario in the region of Timiskaming. An Algonquin-Anishnaabe artist and scholar, Spy draws inspiration for his creative works, music, storytelling and scholarship from his experiences in this northern landscape. Although he pursues Land-based approaches to music creation, composition and research, Spy's scholarship is propelled by an overarching desire to understand and develop ways to nurture and sustain human-to-non-human relations (i.e., human and environment). As a composer and stringed musician (primarily guitars), Spy takes inspiration for conceiving and developing musical ideas that underscores or otherwise bridges and cultivates the imagination, creative expression and sonic forms of storytelling. Likewise, Catherine grew up

DOI: 10.4324/9781003348528-22

in Scarborough, Ontario. Her parents settled in the Greater Toronto Area after coming to Canada as refugees from Hungary. Although Catherine completed post-secondary musical training, she came to formal music education quite late, and as a result, often feels more comfortable playing by ear and improvising than using traditional western music notation. Catherine previously played the bassoon for a wide range of professional orchestras within southern and northern Ontario, and now she mainly focuses on composing, sound design and conducting.

We consider Coyote's influence in parts of our experimental improvisations, and how this may be taken up as a form of biculturalism. Marques, McIntosh and Carson (2019, p. 4) define biculturalism "as an equal partnership between two groups which in turn supports cultural diversity" (196). Recognizing that we are navigating an interspecies exchange (human, Land, Coyote), we assume a form of biculturalism which we imagine as an approach to musical collaboration, playfulness and performance, and reflect on these interactions through a set of ruminations. However, in this case, the interplay between species could also be viewed as largely one-sided, given the significant impacts of human development continue imposing on the natural environment whether it be a compact city (Marques, McIntosh, Hatton, & Shanahan, 2019) or the effects of urban sprawl overreach. Seemingly the more we (humans) encroach on the natural world the thinner the line that once distinguished or separated our worlds becomes, and, consequently such interactions in these spaces which were once prohibitive are now becoming more commonplace.

We also question, however, how do notions of biculturalism transform between different species or animate beings, and what form does the resulting diversity take? Considering the historical model of the "chain of beings" as discussed in Walter Mignolo's (2011) work, the concept of barbarians and primitives is characterized as being "closer to nature", whereas those operating within "civilization" were considered modern and cultured (155–156). Therefore, is there an alternative definition of "culture" that must be considered in this instance? Coyote certainly would not attend a premiere concert of our resulting creative work, and so we must contend with how a collaboration or relationship of this nature would also be to her benefit for it to be an equal partnership per Marques, McIntosh and Carson's definition above. Although we observe Coyote communicating within her environment, we can never be certain of her exact message, having lost the finer frequencies of this skill in past generations. In spite of our own limitations at knowing, Coyote appears cognizant of where and when she is wanted and welcomed, appearing at a moment's notice after we think to ourselves, "Where's Coyote? Wonder what she's up to".

Could her yips and howls be a form of code waiting to be deciphered or translated into human syntax? Maybe her prey trails are patterns, hieroglyphs

FIGURE 15.1 Frequency spectrum from July 19, 2023 recording of Coyote by Spy Dénommé-Welch (scales & numbers removed).

even, yet to be solved? We endeavour to play around these lines and the edges of her frequencies caught on recording devices, shifting into a realm of interpretation that fills in the gaps and spaces between her calls (Figure 15.1).

Reflection 1

We discuss a structure for how to write this piece, beginning with a series of frequency spectra screenshots taken from different Coyote calls and vocalizations recorded by Spy over the span of three years (2020–2023) in southwestern Ontario, Canada. At first glance, the lines might appear as drawings of forest outlines, mountains, a heart monitor, gnarly teeth or cracks in concrete. From the recordings of Coyote we play with structure, harmonic construction, form and idioms and weave a story of improvisational motifs that informs our musical works. Playing together on our respective instruments (strings and woodwinds), we trade musical phrases that attempt to emulate aspects of Coyote's vocalizations, building out the edges to become a more layered scenographic musical soundscape, and then transforming them again through further improvisations of phrase shape, ornamentations and harmonic variances.

A key element of improvisation is a sense of change and transformation within an existing structure. Jazz musicians, for instance, play what to the audience may seem like a random assortment of notes, but are in fact part of a more complex music architecture and, at least in the musician's mind, is leading towards some form of harmonic resolution. How then would this improvisation look in a natural environment? Forests are levelled for farmlands, which are eventually converted to sprawling suburban housing, but

on a macro level these landscapes serve as the harmonic structure to our improvisations. Perhaps then the changing seasons and their effects on landscapes can be regarded as movements within a larger cycle.

So, what then is the role of a composer within this formula? Typically, a composer would provide the main melody, a harmonic structure, and perhaps a musical hook or two. In more abstract jam sessions perhaps only one of these elements would be used as a jumping off point, but it could be argued that the resulting work (or cacophony) is a collaborative product or creation. Would it not be fascinating then to consider Coyote as a principal composer since her recorded vocalizations help provide a "jumping off point" to new artistic creation?

Reflection 2

Coyote responds (Figure 15.2):

Reflection 3

We dial in listening. Coyote's howls and calls are irregular, jarring and jagged even, but always between familiar frequency ranges. Lower frequencies are the domain of the bullfrogs; crickets occupy the higher, but only in the warmer periods. Occasionally, the bats provide some sonic percussion. Is there room to accommodate these sounds in our compositions?

Sometimes a virtuosic solo, other times a haunting chorale. In three years alone we have witnessed her resonant home become subsumed by townhomes, lights, parks, roundabouts, muted by screaming children, barking dogs and revving sports cars and trucks. How does Coyote feel about our human structures altering the acoustics of her territory? Does she make minute

FIGURE 15.2 Frequency spectrum from July 19, 2023 recording of Coyote by Spy Dénommé-Welch.

vocal corrections on the fly, like an oboist adjusting their reed? Does she factor in how her voice ricochets off cement or steel when pitching her howls?

Reflection 4

> Music improvisation in particular is more like everyday interaction in that dynamics emerge spontaneously without a rehearsed score or script.
> (Walton, Washburn, Langland-Hassan, Chemero, Koos, & Richardson, 2018, p. 95)

Coyote reminds us that she has been improvising and ad-libbing since long before musicological definitions and hierarchies separated and distinguished human versus non-human notions of sound production. Is it reasonable to consider ourselves experts in music when the natural world has been utilizing organized sound for far longer than humans? Are birds frustrated when humans fail to understand their different calls, warnings and alarms? How do squirrels and chipmunks feel when we ignore their angry chatters as we obliviously trample above their elaborate tunnel complexes?

After several seasons of listening to the Land around us, we are learning to become closer to the natural worlds and environments, while imagining the meanings behind their secret languages and vocabularies. Through our music we try to express this type of human to non-human relationship and the significance of this form of collaboration. Various works that we have composed have taken inspiration from the natural world in this way, including our operas Giiwedin (2010) and Canoe (2023), chamber works such as Bottlenecked (2017) and *Contraries: a chamber requiem* (2018), a forthcoming album entitled *Transpositions*, and an improvised work we are currently recording entitled *Damn the Mine* (forthcoming). We often approach our compositions by asking various questions including: What does it mean to collaborate with other beings and elements such as Coyote on a sonic art form when they do not necessarily interact with that art form in the manner which we do?

Admittedly, we may never know the depth of Coyote's mind or consciousness, but her habit of appearing just as we are thinking or talking about her gives a sense of hyper-awareness, which may be more, or perhaps less than we give her credit for. Could it be coincidence or a moment that builds on a form of musical spontaneity? Is this a way Coyote demonstrates her own approach to situated listening or collaboration? Is she teaching us new ways of listening, or how to attune ourselves to dynamics that are spontaneous and emergent? Can Coyote help us become better musicians, composers and collaborators? (Figure 15.3)

FIGURE 15.3 Coyote in the woodlot. Photo taken by Spy Dénommé-Welch.

POETICS I.

We learn to anticipate one another.
Notes in memory; like molecules,
structuring to create harmonic frameworks on which to ad-lib.
Somatic listening.
Strike that.
Empathic listening?
Almost.

Similarly, one of our more musically inclined hounds has always had his own musical sensitivity and expression, and will try to pitch match with us when we are playing our instruments, or with some form of recorded sound (including alarm clocks). We wonder whether his vocalizations go beyond

FIGURE 15.4 Screenshot of Samson the dog's vocal improvisations with piano. From video captured by Spy Dénommé-Welch.

communication but rather enter the realm of play or perhaps even expression and collaboration. Although this is purely anecdotal, it is interesting to consider how this might apply to non-domesticated beings that we don't directly cohabitate with (Figure 15.4).

POETICS II.

How singular becomes plural.
Hammering against other distant buildings,
Ricocheting off the trunks in the forest,
Skipping across ponds, sleeping geese, noisy toads.
How plural is singular in this case,
Intervals between howls forming clusters of chords in atonalities.
Coyote cases out the joint.

Reflection 5

Our regular interaction with the natural world informs and shapes how we engage with sound, music and noise. With this we wonder: Is the imagination a space that can exist in solitude? Do some individuals require silence to conjure ideas or vision? Would an innovator be able to conceive of new inventions if they were starved or deprived of space and time to think or ruminate? Watching paint dry becomes less about a state of boredom and more about the luxury to escape into a higher contemplative realm.

Increasingly, the ability to access anything and everything instantaneously (via the internet, livestreaming, personal electronic devices, etc.) develops into a dependence that alters our ways of experiencing the world. The expectation that anything and everything can be pulled from anywhere at any moment deprioritizes time for musing, impedes upon natural increments and variances in time, and impacts invention and innovation. Without the space to wonder or reflect, to get lost in daydreaming or to listen to one's inner self, it is becoming increasingly difficult for new and original thoughts and ideas to emerge, especially when we are in constant competition with the noisy outside world. Furthermore, when we suppress the ability to listen, we increasingly tune out the subtle messages that are communicated by our surroundings and environments. We may miss hints or hidden details and detune our hearing, making our judgements less discerning or nuanced. For instance, the sound of the wind through upside down poplar leaves signalling an impending rain; we humans frequently miss these messages. Sarah Mayberry Scott and Amanda Nell Edgar (2021) note that "Listening requires moving beyond just that which captures our auditory attention and pausing to contemplate the things we hear that challenge our own ideological assumptions"

(232). Perhaps we should contemplate or take notice of sounds or different ways of listening that we may unconsciously dismiss or take for granted. For instance, we may not appreciate the variety of bird songs around us, but what effect would it have on us if they chose to cease singing or disappeared altogether? How long would it take before we even notice their silence? As human development swallows up the Land and green spaces in the name of "progress", the sounds of the natural world are at risk of disappearing. Mignolo (2011) believes that part of the issue stems from a process that began in the late 17th century with the popularization of "still nature" in the visual arts, when the natural world was "no longer conceived as a living system […], but was transformed into an object external to human life, to be overcome by action, and as the prime resource for the needs created by the Industrial Revolution" (173–174).

What effect does this have on our own state of mind or ability to listen and hear when being inundated by progressively growing urban sounds and noise pollution? Would we turn to AI-generated sounds to fill in the sonic vacancy? Would those sounds have any meaning? It might very well come to that. Akiyama (2015) emphasizes the importance of not only recognizing the sounds that are absent in these environments but also becoming attuned to the sounds that are excluded. R. Murray Schafer, for example, created the radio series, Soundscapes of Canada for the CBC, in response to what he referred to as the destruction of Canada's sonic environments due to industrialization. In doing so, however, he neglected to include any Indigenous communities, voices or perspectives in these sonic experiences, who would arguably be the most affected by these changing soundscapes.

How then can we use technology to make connections with the natural world in a way that also compels an audience to feel kinship with their non-human neighbours? With this challenge in mind, we are compelled to experiment with our instruments, and our electronic musical tools (such as guitar pedals, other FX and software) to find ways to create evocative new sounds. For instance, there are ways to run a flute through pitch shifters and harmonizers that can resemble a howl, or certain ways to use a bow on a string that, when synchronized just so, sounds like the crunch of walking through the snow such as what we create in our orchestral work Rouge Winter (2019), commissioned by the Scarborough Philharmonic Orchestra. This orchestral work draws inspiration from an idea about a winter walk through the Rouge National Urban Park (Scarborough, Ontario, Canada) and features a series of sonic tableaus depicting various animals and scenes, such as beavers, otter, raccoons, ravens, a hawk and coywolf. Using extended techniques, we challenged the musicians to emulate sounds that evoke these animals to the audience, such as string harmonics to sound like a hawk call, and flutter tonguing in the trumpets to make the brash croaks of ravens.

Using our more electronic tools, we can layer our sounds to create whiny pitchy noises that resemble motors and the harsh sound of drilling into

rock such as our work *Damn The Mine* (forthcoming). We can also create other-worldly soundscapes to give the sense of drifting in nothingness, or firmly root the audience in a specific place or time in history, as we created live music and sound for Audrey Dywer's play *Come Home: The Legend of Daddy Hall* (premiered in May 2024). This variety of soundscaping is reminiscent of how the Land is eclectic, and of the diverse teachings that can be learned and ascertained through regular engagement. What appears disorderly when compared to our artificial, manufactured urban systems is perhaps in fact a more naturally ordered system. Tangled forests, valleys, winding streams and rivers allow for a more integrated and diverse ecology than our tidy human architectures and manicured landscapes that privilege monocultures.

Conclusion

> To listen is to orient the body to others, not to filter them through our authorized lens.
>
> *Scott and Edgar (2021, p. 232)*

As we write this, we find our attention wandering to the little forest behind us, offering insights into its ecological patterns and cycles. Every morning, the usual birds (chickadees, blue jays, cardinals, sparrows, etc.) stop by to visit the yard and feeders. At night opossum, skunk, raccoons and rabbit (who also visits in early mornings) come by, as caught on our wildlife camera. We observe all the activity, happening during night and day, listening to what the Land and environment have to communicate. How do we respond to or speak alongside this vibrant force of expression and character?

We note that the natural cycles of the seasons are being disrupted. The markers of winter come later, and spring is brief. Regardless of the root of the problem, it is evident that certain cyclical patterns and characteristics of the seasons are changing. Gazing outside today in early December, the trees have shed their foliage and stand naked in the chilly wind; however, the snow and ice that should serve as their backdrop is instead muddy and gloomy from the pelting rains. Uncharacteristically warm weather slows the usual freezing process, and the earth is unable to rest in the ways it used to in past seasons. As the Land and environment shift and learn to adjust to these incremental changes, will our creations also adapt in a similar manner? As urban and suburban development expands, we reduce the ensemble size of many of our recent compositions, mindful of the resulting environmental footprint, as well as responding to economic realities and the cost of hiring large groups of musicians. These artistic and environmental realities will not only affect how we listen and hear sound in general terms, but how we respond and create through music composition.

Maybe Coyote holds the answer?

Pedagogical Score

Spy Dénommé-Welch and Catherine Magowan

Birds are everywhere, obviously, but have we really listened to their voices? In our neighbourhood we have an American Robin (we have named "Pitchii", which means Robin in Anishnaabemowin) who has nested in our immediate vicinity for a few seasons. Unconsciously we have memorized her distinct calls, but did not realize this until recently spending an extended amount of time in another city. There are many Pitchiiwag in our temporary community, and we have come to realize they have different variations to their calls, and different timbres to their voices. This is in line with the notion that birds in different regions have differing dialects, and tuning into these sonic nuances gives a feeling of closeness to the environment.

1. Make a note of what birds are in your neighbourhood. Are there any that are more vocal than others? What do their calls sound like?
2. Next time you are far from home, try to find the same birds and listen to them. How do their vocalizations differ from the birds that live around your home?

Aspects to consider when listening to birds:

- How many notes are in their call? Are they organized into phrases?
- Are you able to speculate on any meanings to their vocalizations?
- Are there any "musical hooks" in their calls that make them distinctive?
- What is the quality of the birds' voices? Are some clear and bright while others are raspy?

References

Akiyama, M. (2015). Unsettling the world soundscape project: Soundscapes of Canada and the politics of self-recognition. *Sounding Out!* https://soundstudiesblog.com/2015/08/20/unsettling-the-world-soundscape-project-soundscapes-of-canada-and-the-politics-of-self-recognition/

Campesato, L., & Bonafé, V. (2022). Dispatches: Cartographing and sharing listenings. In L. O Keeffe & I. Nogueira (Eds.), *The body in sound, music and performance: Studies in audio and sonic arts* (pp. 153–165). Routledge. DOI: 10.4324/9781003008217-15

Dénommé-Welch, S., & Magowan, C. (2010). *Giiwedin* [Musical score]. Unsettled Scores

Dénommé-Welch, S., & Magowan, C. (2017). *Bottlenecked* [Musical score]. Unsettled Scores.

Dénommé-Welch, S., & Magowan, C. (2018). *Contraries: A Chamber Requiem* [Musical score]. Unsettled Scores.

Dénommé-Welch, S., & Magowan, C. (2019). *Rouge Winter* [Musical score]. Unsettled Scores.

Dénommé-Welch, S., & Magowan, C. (2023). *Canoe* [Musical score]. Unsettled Scores.

Dénommé-Welch, S., & Magowan, C. (forthcoming). *Transpositions* [Album]. Unsettled Scores.

Dénommé-Welch, S., & Magowan, C. (forthcoming). *Damn the Mine* [Album]. Unsettled Scores.

Marques, Bruno & Mcintosh, Jacqueline & Carson, Hannah. (2019). Whispering tales: using augmented reality to enhance cultural landscapes and Indigenous values. AlterNative: *An International Journal of Indigenous Peoples.* 15(1), pp. 1–12. DOI: 10.1177/1177180119860266.

Marques, B., McIntosh, J., Hatton, W., & Shanahan, D. (2019). Bicultural landscapes and ecological restoration in the compact city: The case of Zealandia as a sustainable ecosanctuary. *Journal of Landscape Architecture,* 14(1), pp. 44–53.

Mignolo, W. (2011). (De)coloniality at large: Time and the colonial difference. In *The darker side of western modernity: Global Futures, decolonial options* (pp. 149–180). New York: Duke University Press. DOI: 10.1515/9780822394501-007

Scott, S. M., & Edgar, A. N. (2021). Situated listening: Toward a more just rhetorical criticism. *Rhetoric & Public,* 24(1–2), pp. 223–237.

Walton, A. E., Washburn, A., Langland-Hassan, P., Chemero, A., Kloos, H., & Richardson, M. J. (2018). Creating time: Social collaboration in music improvisation. *Topics in Cognitive Science, 10,* pp. 95–119.

AFTERWORD/INVITATION

Stephanie Loveless, Tullis Rennie, Morten Søndergaard and Freya Zinovieff

Over the four years during which we developed and wrote this book, we have witnessed the heightening of a socio-political landscape in which an increasingly self-isolating class of the power elite is further removed from earshot, while simultaneously influencing geopolitics at the deepest level. Populations across the globe are silenced, and many others have their capacity to be heard or agency to proactively instigate meaningful change curtailed. Amid increasingly intersectional crises, a concerted, interrogative, and connecting practice of creative listening is more crucial than ever to hear, listen to, and attend to the un(der)heard entities all around us. This is the landscape into which we offer this collection of disciplinarily diverse studies and practices of listening. Taken together, the chapters and scores collected here offer a distributed rather than an overarching theory of situated listening. In this spirit, we close this volume with an invitational text, inspired by each collaborative contribution.

I

Stretch your ears to listen beyond the signal – the intelligible and the acceptable – to the noise.
 Can we listen, newly, to the troubled histories of the things we love most?
 We are called to attend, not only to the unheard, but to the everyday practices of unlistening that animate our unhearing to begin with.
 Find a body that listens differently from your own. What can it teach us about the ways listening makes our culture, our differences, our self?
 We can attend, too, to what is no longer sounding, that cannot be heard with the ears. We listen, as testimony, for echoes that can be resounded.

II

Attend to the silenced voices – the marginalised, the deceased, the ghosts. Does this alter our ways of making recordings and of listening to them?

Nostalgia for analogue audio can be both a fetish and a way forward.

Can we locate the cracks and leakages of a closed musical system? The sea levels are rising – is it time to learn to sing underwater?

Embrace opacity. Keep your recording and listening messy and unclear. Allow your collaborations to remain endarkened.

Where is our listening located in the meshwork of amplified bodies and technologies? How can co-listening become consensual, attuned and reciprocal?

III

Listen under the noise of propaganda and rhetorics of denial. Extract the truths they aim to obfuscate.

Tune to the auralities of migration and emplacement. Mix a new archive.

How does our location – its density, acoustics, reflections, and elements – shape our listening?

How can we listen to pluriversality in a mono-normative context? How does breath connect stardust, plankton, and us?

If we think of the enunciations of our more than human family as code, what will our listening decode?

INDEX

Note: *Italic* page numbers refer to figures and page numbers followed by "n" denote endnotes.

accelerationism 214–215
accountability 23, 47, 83, 162, 166–167, 241
acoustic ecology 1, 71n1, 206
actor-network theory (ANT) 127
Afro-fabulations 160–162
Afterward/Invitation (listening score) 283–284
Ahmed, S. 22
Akiyama, M. 278
Alaimo, S. 177
[Alien] Star Dust: signal to noise (Victoria) 255, 257–264
Alonso Minutti, A. R. 24, 29n6
amplification 13, 26, 38, 78–80, 84, 114, 176, 179, 186
Amplified States: A Score (listening score) 187–188
Angolan war 136
anthropocentric 75, 84, 111, 198, 260
anthropodenial 83
anthropomorphism 74, 83–84; critical anthropomorphism 83
anthropo-zoo-genesis 83–84
anti-Blackness 39; *see also* racism
anti-colonial listening 36–37; *see also* decolonial listening
antisemitism 199
Anzaldúa, G. 19–20, 22, 99

apparatuses 16, 127, 139, 185, 237–238, 248, 265; boundary-drawing practices of 185; of listening 111–112, 114, 179; as meshwork 176, 178, 182; performativity of 186; of situated listening 4–5; technical 75; technological 26, 111, 248; of visual production 240
archive 24, 57, 75, 103, 116–117; in Latin America 27; mixing board as 224–227; Radio Haiti 120–121; of sound art and activism 16; of sound art and sound studies 12; textual 21
Arke, P. 247–248
artefacts: heritage 136–138; old technologies as 136–138
Atmosphere of Sound: Sonic Arts in Times of Climate Disruption exhibition 255, 263
attunement 97, 105–106, 112, 114, 118, 162, 176, 179, 184; interspecies 88; listening as a practice of 37; relational 44; sonic and social 4
audification 13, 74, 78–80; *see also* sonification

Barad, K. 176, 181, 186
Barthes, R. 58, 181
Beloff, L. 253

Index

Benjamin, W. 107; *The Storyteller* 103
Bennet, J. 83
Birdsall, C. 196, 203–204, 208; *Nazi Soundscapes, Sound Technology and Urban Space in Germany 1933–1945* 203
Black Bach Artsakh (film) 97, 99–100, 103, 108n2
black holes 119–120
Bonafé, V. 271
Bose, J. C. 80
Bottlenecked (chamber work) 275
Breath Library (artwork) 255, 257–263, 266, 268
broadcast word 208
Browner, T. 40
Bubola, E. 149
Buy Dirt (song) 212

Campesato, L. 271
Campos Fonseca, S. 20–22, 24
Canada: Nazi identification with nature 206–208; Nazism in 204–206
Candiotto, L. 263–264
Canoe (opera) 275
capitalism 16–17, 38, 42, 45, 112, 117, 133, 148, 203
Carlyle, A. 1, 179; *On Listening* 1–2
Carson, R.: *Silent Spring* 256
Chacon, R. 40, 42–44, 188
Chicana feminisms 4
Chion, M. 243
choreography 15, 172
Citton, Y. 238–239, 249
civilization 94, 146–147, 152, 205, 272
cohabitation 73, 87–88
collaborative composition 197–198, 271–280
collaborative ethos 2–3
coloniality 13, 96, 101, 112–113; gender 22; internal 20; modernity 104; of power 11–12; and precariousness 112–113, 126–140; of recorded spaces 118; and technologies 112–113, 126–140
colonial listening 36–37
Colonial Nostalgia 211–212
colonized listening 21
Come Home: The Legend of Daddy Hall (Dywer) (play) 279
The Comet (DuBois) (short story) 152
The Comet/Poppea (Lewis) (opera) 113, 144, 152–153

composition 5, 24, 39, 86, 156, 171, 173, 259; characteristic mode of 265; collaborative 197–198, 271–280; electronic 121; endarkened 114, 161, 165; musical 121; recorded and remediated 121; sound 261
Contemporary Christian Music (CCM) 204
Contraries: a chamber requiem (Dénommé-Welch and Magowan) (chamber work) 275
coral reefs 118–119
Co-Regulating the Spectrum Spectrum: Meanwhile the Wave (Rivera) (radiophonic artwork) 122
COVID-19 pandemic 253–254, 256, 260–262
Coyote 5, 195, 198, 271, 272, 273, 274, 274, 275, 276
critical listening positionality 4, 26, 36, 177
Crow Two: A Ceremonial Opera (Oliveros) 40
Cry of the Third Eye (Harris) (film-opera) 33, 44–47, 46, 47
cultures 195; of attending 238–240; DIY cultures 135–136; resistance 135; of techniques 245–247

El-Dabh, H. 121–122
Dakota Access Pipeline project 42, 49n3
Damn the Mine (Dénommé-Welch and Magowan) (album) 275, 279
Dance with Your Listening (listening score) 90
Dark Matter Labs 146, 157n5
Darroch-Lozowski, V.: *Voice of Hearing* 182
decolonial 6, 13, 18, 33, 94, 133
decolonial aesthesis 95–96, 108n1
decolonial listening 43, 94, 96, 98, 99, 103; *see also* anti-colonial listening
Deep Listening 37–38, 55, 257; in critical sites 12, 33–48; critiques of 39–40; deeply listening body 37; listening in dreams 37; Rose Mountain Retreat 40–42
Dialogues in Transit (artwork) 227
digital subjectivity 245–246
Dillard, C. 160
Dispatch (conceptual score) 33, 42–44, 43, 47
Dominique, J. 120, 121
DuBois, W.E.B 203–204; *The Comet* 152

echo chambers 101, 196, 201
ecological 3, 22, 42; awareness 197; complexity 253; concerns 5; consequences 267; contexts 5; crises 1, 197, 256; patterns and cycles 279; preservation 207; responsibility 197; sound politics 82
Elsaesser, T. 137
endarkened feminist epistemology 160
endarkened listening 113–114, 159–174; endarkening and Afro-fabulations 160–162; ethical listening 163; listening-with, responsibly 162
endarkened storywork 160–161, 163
The Energy Bending Lab (Lopez and Garcia) (custom built instrument) 79
epistemic disobedience 17, 20–23, 133
epistemology: endarkened feminist 160; feminist 19; Nazi radio 208–209; social 264; type of 132; white nationalist 196, 199–215
Estévez Trujillo, M. 21–22
ethical listening 160, 163
eurocentric 4, 64–66, 70, 122, 161

Farinati, L.: *The Force of Listening* 217
feminisms: Black 173; Chicana 4; critical apparatuses of 16; cyborg 18
feminist ear 17–18, 27
Feminist Sonographies of Situated Listening (artwork) 18, 29n5
feminist sono-techno-political artivisms 12
feminopraxis ruidistas 24–25
fidelity 82, 164
field recording 16, 84, 114, 122–123, 162, 167, 172–173, 227, 235
Firth, C.: *The Force of Listening* 218
Fuller, M. 245–246
Future Echoes (radio installation) 228

gambiarra (Brazillian term) 113, 126–127, 129–136
Gaskins, N. R. 132
Gatorra, T. da 132–133, *134*
Giiwedin (Dénommé-Welch and Magowan) (opera) 275
Global North 4, 12, 23, 25, 28
Global South 12–13, 80, 113, 129, 133, 136, 139
Gordon, A. F. 117
Grzinich, J. 182
Guerra, P. 136
Gumbs, A. P. 263

Hamadeh, R. 95
Haraway, D. 3–4, 17, 19, 197, 240–241, 243, 247–248, 250n2, 264
Harris, L. 33, 44–45, *46*
Harris, Y. 263, 267–268
Hartman, S. 46, 161
hegemony 5–6, 161, 173
Heisenberg, W. 114, 185, 198
heteronormativity, cis 206, 209, 212–214
Hopkins, C. 33, 42
Hughes, T. P. 129

imagination 38, 44, 82, 85, 113, 143–144, 151, 221, 224, 243, 257, 271, 277; imagined events 42, 44; imagined landscape 207
improvisational listening 163, 173
Instructions for Non-Human Listening (Mackenzie) 86
interspecies 5, 88, 256, 272
Irigaray, L. 162

Jenkins, H. 84–86, *86*
Johar, I. 146–147
Jones, E. 135
Jones, S. 119
The Judas Cradle (operatic duodrama) 147

Kahn, D. 256–257
Kimmerer, R. W. 88
Kite, S. 40
Kuhl, S. 205, 207

LaBelle, B. 243–244
La Conciencia Mestiza (mestiza consciousness) 19
Lane, C. 1
Le bonheur est dans le pré (Hommage à Pauline Oliveros) for two or more sounding bodies, one or more of which are human and at least one that is not (listening score) 154–156
Lentjes, R. 181
lesbian musicality 37
Lewis, G.: *The Comet/Poppea* 113, 144, 152–153
L'incoronazione di Poppea (Monterverdi) 144, 149, 152, 157n8
listening: anti-colonial 36–37; colonial 36–37; as coming to know 114, 176–189; endarkened 113–114, 159–174; ethical 163; experimentally 271; intimate 163; as invisible

mobility below the surface 18–20; listening-care as ethical orientation 197; listening-with, responsibly 162; to our listening 33; and positionality 3–4, 26, 36, 52, 56, 60, 95, 177; and situatedness 3–4, 55, 113, 147, 221, 239, 252, 256; transperceptive 252–269; to the un(der)heard 197; weak power of 13–14, 94–107
Listening Points (artwork) 55
listening studies 2
listening subject 4, 135, 224, 229
listening to noise 11–12, 15–28; collaborative score for 28; as feminist practice 12; lines of affinity within 23–27; as situated epistemic disobedience 20–23
Listening to Noise: Collaborative Score to Be Performed Together at a Long-Distance (listening score) 28
Living Crossfader, Embodied Mixing Board (listening score) 235
Lugones, M. 22, 97, 102
Lux, M. K. 205

McCartney, A. 160, 162, 164, 168
McLung, N. 205
Messias, J. 132–133
Mignolo, W. 133, 272, 278
modern/colonial wound 96, 106–107
Monterverdi, C.: *L'incoronazione di Poppea* 144, 149, 152, 157n8
Muir, J. 206
multidisciplinary 2, 12, 18
multispecies 21, 76, 79; *see also* interspecies
Mussa, I. 132–133

Narcissistic Nationalism 210–211
National initiatives 130
nationalist nation building on Telegram 202–204
National Park system 206
National Socialist Party 207
Nazi-coded Swedish metal 204
Nazi identification with nature 206–208
Nazi radio epistemology/nationhood/bridging 208–209
Nazism in Canada 204–206
Nazi Soundscapes, Sound Technology and Urban Space in Germany 1933–1945 (Birdsall) 203
Nazi war 206

neo-Nazi: groups 200; ideology 204, 206, 208, 210, 212, 213; movement 201; nation building on Telegram 196, 199–215
New Age movement 39, 40
New York Times 119–120
#NiUnaMenos (#NUM) 15
Noë, A. 186
noise: listening to 11–12; white 13–14, 101–102
Noise Aquarium Online Meditations 255–259, 260, 264, 269n1
non-human sensing 73, 85–86, 88
North America 75, 184, 197, 200–201, 207, 262

Ochoa Gautier, A. M. 21–22; acoustic assemblage 17, 21; *Aurality: Listening and Knowledge in Nineteenth-Century* 21
old technologies as heritage artefacts 136–138
Oliveros, P. 4, 11, 33, 41, 44, 55, 150, 179; *Sonic Meditations* 37, 38, 257
opera 144–146; Canoe 275; opening up operatic form 147–149; past future 151–153
oppositional consciousness 19, 20, 26
Ouzounian, G. 3, 55–56

participatory sense-making 263–265
Pedagogical Score (listening score) 280
People of the Global Majority (POGM) 114, 161
perceptual underhearing 53–56
Peters, J. D. 180, 186
Pettman, D. 184
Plack, C. 177
Polti, V. 15–16, 25–26
positionality 3–4, 19, 26, 36, 52, 56, 60, 94, 95, 99–100, 177, 184; and listening 3–4; and situatedness 3–4
power: coloniality of 11–12; weak power of listening 13–14, 94–107
Prescod-Weinstein, C. 119–120
principal composer 198, 274
"progressivism" movement 206
projective regime 239, 249
psychoacoustics 52, 54, 65

Quijano, A. 11, 133

racism 128; *see also* anti-Blackness
Radio Haiti archive 120–121

Ranaldo, L. 133
Re-cognition (Oliveros) (sonic meditation) 55
reduced listening 243–244
reflexivity 4
resistance 5–6, 17, 42, 45, 61, 73, 95, 112, 129, 133, 135, 136, 138, 140, 146, 248
rhizophonia 182–183
Riehl, W. H. 207
Rivera, J. A. 122–124
Rivera Cusicanqui, S. 19–20, 22
Robinson, D. 4, 26, 36, 177; *Hungry Listening: Resonant Theory for Indigenous Sound Studies* 36
Rouge Winter (orchestral work) 278

Schafer, R. Murray 182, 203, 278
schizophonia 182–183
A score for endarkened listening (listening score) 174
Score for Situated Listening (for a Gathering of Humans, Online, or in Person) (listening score) 48
score, listening 28, 48, 70, 90, 154–156, 174, 188–189, 235, 280, 283–284
sexual dissidence 23, 29n7
silent agencies 197, 255–256, 263, 268
situated knowledge 3, 18, 197, 237–239, 249, 265
situated listening 1, 3, 11, 248, 249; apparatuses 4–5; critique 249–250; cultures of 4–5; methodologies 4–5; score for 48
situatedness 56, 147, 239; and listening 3–4; and positionality 3–4
situaters 238, 249, 250n1
Sonic Meditations (Oliveros) 37, 38, 257
sonic sensorium 237–250; cultures of attending 238–240; harbour listening/phenomenotechnique 242–245; listening to the un(der)heard 197; situated listening critique 249–250
sonification 13, 73–75, 78–80, 82, 87, 262, 264; aestheticisation of 82; seduction 73, 82, 85, 88; *see also* audification
sono performance-research 25
sono(soro)rity 16
Sontag, S. 244
sound: soundscape 19, 45, 67, 122, 206, 223, 268, 278; soundwalk 26, 55, 67, 87, 163

sound studies 21, 25, 64, 65, 122, 133, 135, 136, 200; critique theoretical hierarchies in 12; North-centric 136; perspective 200; remapping 136; southern 135
Star, S. L. 197, 238–239, 249
Steingo, G. 59, 135, 136
Sterne, J. 58, 182–183; *The Audible Past* 176
Sykes, J. 135, 136

Tarter, J. 146, 147, 157n3
technologies: and coloniality 112–113, 126–140; models for analysing 127–129; old, as heritage artefacts 136–138; and precariousness 112–113, 126–140
Telegram 202–204
Three Gold Threads (Liz Gre) (installation) 164–165, 173
Toliver, S.R. 160
Tompkins, P.: *The Secret Lives of Plants* 81
Torgue, H. 54
transduction 176–178
transperceptive listening 256–257
Transpositions (Dénommé-Welch and Magowan) (album) 275
Trouillot, M.-R. 117
Tupilakusaurus (Arke) (exhibition) 247

unlistening 13, 52–70; interpersonal unlistening 58–60; perceptual underhearing 53–56; in socio-political contexts 60–62; technological unlistening 56–58
Unlistening/Unscoring (listening score) 70
Unsettling the Settled: Archival Glimpses of Abolitionist Futures (de la Loza) (installation) 225
Utterings (networked performance) 256

Valencia, S. 16
Vanishing Points (Meireles) (album) 167–169, 173, 175n1
Vicuña, C. 98
Vietnam War 37, 39–41
#Vivasnosqueremos 15
Voegelin, S. 19–20, 26, 179
Völkisch National Socialism 200, 210–212

Waterman, E. 36, 39, 163
Watson, T. 58

weak power of listening 13–14, 106
Westerkamp, H. 55
white nationalist epistemology 196, 199–215
white noise 13–14, 101–102
white replacement 209
white settlers 36, 210

Wong, D. 36, 39
World Wide Tuning Meditation 256
Wright, M. P. 160, 162

Zionist Regime 199, 215n1
Zoom 254–255

For Product Safety Concerns and Information please contact our
EU representative GPSR@taylorandfrancis.com Taylor & Francis
Verlag GmbH, Kaufingerstraße 24, 80331 München, Germany